Starting Your Career as a
Freelance
Photographer

Second Edition

Tad Crawford
and Chuck DeLaney

D0957158

ALLWORTH
PRESS

American
Society of
Media
Photographers

Allworth Press books may be purchased in bulk at special discounts for sales promotion, corporate gifts, fund-raising, or educational purposes. Special editions can also be created to specifications. For details, contact the Special Sales Department, Allworth Press, 307 West 36th Street, 11th Floor, New York, NY 10018 or info@skyhorsepublishing.com.

20 19 18 17 16 5 4 3 2 1

Published by Allworth Press, an imprint of Skyhorse Publishing, Inc.
307 West 36th Street, 11th Floor, New York, NY 10018.

Allworth Press® is a registered trademark of Skyhorse Publishing, Inc.®,
a Delaware corporation.

www.allworth.com

Interior page design by Jennifer Moore, Brooklyn, NY
Page composition/typography by Rosanne Pignone, Pro Production

Library of Congress Cataloging-in-Publication Data is available on file.

Print ISBN: 978-1-62153-545-4
Ebook ISBN: 978-1-62153-546-1

Printed in the United States of America

CONTENTS

FOREWORD by Thomas R. Kennedy v

INTRODUCTION TO THE SECOND EDITION vii

PART I. GETTING STARTED

1 Careers in Photography by Chuck DeLaney 3

2 The Value of a Photographic Education by Bill Kennedy 11

3 The Benefits of Apprenticeship by John Kieffer 20

4 Photography, A Many-Faceted Field by Susan McCartney 30

5 Equipment Considerations for Freelance Photographers
by Chuck DeLaney 39

PART II. BUILDING AND PROTECTING YOUR BUSINESS

6 Your Business Plan by Tad Crawford 49

7 Location and Leases by Tad Crawford 56

8 The Going Concern by Tad Crawford 59

9 Designing Your Image by Chuck DeLaney 65

10 Insurance Protection by Arie Kopelman 72

11 Staying Healthy as a Photographer by Chuck DeLaney 79

PART III. MARKETING YOUR PHOTOGRAPHY

12 Markets, Promotion, and Clients by Maria Piscopo 89

13 Building and Presenting Your Portfolio by Maria Piscopo 98

14 Getting the Most from Your Website by Chuck DeLaney 105

15 Personal Branding and Social Media Marketing by Nigel Merrick 117

16 Selling Yourself by Chuck DeLaney 129

PART IV. NEGOTIATING CONTRACTS AND PRICES

17 Negotiating Contracts by Richard Weisgrau 151

18 Contract Forms by Tad Crawford 158

19 Pricing Photography by Michal Heron and David MacTavish 176

PART V. PHOTOGRAPHY AND THE LAW

20 Copyright by Tad Crawford and Laura Stevens 197

21 Taxes by Tad Crawford 222

22 Invasion of Privacy and Releases by Tad Crawford 243

23 Beyond Privacy by Tad Crawford 264

24 Settling Disputes and Finding Attorneys by Tad Crawford 274

PART VI. BEYOND THE STUDIO

25 Growing as a Photographer by Tony Luna 285

26 Staying Fresh by Chuck DeLaney 294

27 Opportunities in Video and Multimedia by Chuck DeLaney 299

28 Transitioning from the Freelance Life by Michal Heron 305

Appendix A 325

Appendix B 327

Copyright Notices 330

Bibliography 331

Index 333

FOREWORD

ASMP IS HAPPY to work with Allworth Press to offer an updated edition of *Starting Your Career as a Freelance Photographer.*

Now that anyone with a smartphone can broadcast still or video images across the globe, is a career as a professional photographer still viable? My answer is an emphatic "yes," but in this rapidly changing world serious photographers need to share their insights.

As an organization founded to support independent photographers, ASMP has always been dedicated to building community, sharing information, and advocating for the rights of photographers with respect to copyright, contracts, and other areas affecting livelihood. This dedication has led to the ability to produce work for publication in all different areas of media. Our members work across a variety of commercial genres, from photojournalism and documentary photography to architecture, food, fashion, fine art, and natural history. Each offers the possibility to work from wellsprings of personal passion and commitment. At ASMP, in order to replenish those wellsprings and inspire creativity, we provide access to a community of like-minded creators and fellow professionals who enjoy sharing their ideas and inspirations. With a long, rich history of supporting the work of the most talented individuals in our profession, we continue to work to build a community that enables all in it to do their best work.

In the same way, this book offers valuable instruction to the emerging photographer. It gives you information essential to building a business, establishing a brand, marketing to clients, and protecting your creative property so you can make a living doing what you love. In addition, you will discover how to take advantage of opportunities offered by technological advances in imaging and how to meet new client expectations for visual communication.

Written by experts and edited to provide essential information, *Starting Your Career as a Freelance Photographer* is aligned with ASMP's educational mission. It offers resources that will keep you focused and on track as you seek to move ahead as a professional photographer. Knowing that the journey can be a long and winding road, we stand ready to offer you the support of ASMP as an organization

of mentors and potential new friends. To learn more, you can visit us at www. asmp.org.

The wisdom in this book will help you maximize your ability to share your vision of the world through photography with a large and appreciative audience. May your journey into professional photography bring you both satisfaction and success.

—Thomas R. Kennedy, executive director,
American Society of Media Photographers
New York City, 2016

INTRODUCTION TO THE SECOND EDITION

THE FIRST EDITION of *Starting Your Career as a Freelance Photographer* appeared at a point in time when the world of photography was in the midst of the rapid shift from silver halide processes to digital technology. This was true for both professionals and amateur enthusiasts. Today, that transition is well behind us. While there are photographers who choose to use film for a variety of reasons, more than 99 percent of the photographs taken today are digital images. While estimates vary, it's possible that a billion images are uploaded to social media platforms *every day*.

When the first edition was published, the smartphone as we know it today did not exist and Facebook was just getting going. There was no Instagram, Snapchat, or Pinterest. A lot has changed. While digital photography is now the norm, what new apps and other photographic innovations we'll see in the coming decade is anyone's guess.

But a lot hasn't changed. While digital technology has supplanted film and provided all kinds of new distribution opportunities, the business model that professional photographers rely on still involves selling or licensing images. While news and entertainment providers use more amateur photographs, the work of professionals is still in demand. Compared to the havoc that digital distribution wreaked upon the music industry, where music sales now yield a pittance and artists need to tour to make money, the photography business model remains more or less intact.

One area where the digital revolution has had a major impact is in the way that photographers promote themselves and the way editors, art directors, and other picture buyers find photographers that interest them. We've added a lot on these subjects to this edition.

And some things haven't changed at all. The freelancer still needs to develop a sense of business and be concerned with issues such as insurance, negotiating contracts, the complexity of copyright, and pricing his or her work. Today's marketing options have been altered by the digital landscape, but you still need to know how to sell yourself and close the deal. The legal challenges facing the professional photographer remain essentially the same.

The art of photography and the technique required to make a well-lit portrait or landscape photograph haven't really changed. Granted, high dynamic

range (HDR) capability and automated retouching tools can solve certain problems, but posing, lighting, and camera position are still essential skills.

This revised and expanded edition of *Starting Your Career* contains six parts:

Part I: Getting Started addresses topics related to careers in photography, the options for getting the necessary education, the different specialties that exist in the field, and some thoughts about equipment choices photographers must make.

Part II: Building and Protecting Your Business covers the nuts-and-bolts topics such as developing a business plan, finding a location for your studio, making basic decisions about the image you want to present to your customers, and protecting your business and your health.

Part III: Marketing Your Photography provides invaluable information regarding the markets available to photographers, ideas for a winning portfolio, creating a website that works for you, and using social media to build your brand. While it's true that most photographers prefer to be behind the camera rather than making the pitch in front of a customer, techniques for selling yourself are an important consideration.

Part IV: Negotiating Contracts and Prices is one of the most important sections of this book. Without negotiating skills and a thorough insight into how to price your work, success is likely to be elusive. The demand for fresh content has never been greater, and the variety of ways that photographs (and video clips) are used continues to expand.

Part V: Photography and the Law answers a host of questions that photographers frequently ask. While the digital distribution formats are having an influence on copyright, other legal issues such as taxes, invasion of privacy, and resolving legal disputes remain subjects that all photographers need to understand. The speed with which images traverse the globe today increases the potential for making larger problems that arise more quickly than ever before.

Part VI: Beyond the Studio concludes the book with a look at the challenges that exist in maintaining, growing, or modifying your business. How do you grow as a photographer? How do you stay fresh and possibly explore related opportunities beyond traditional still photography? You can find ideas and answers here.

Research by the US Bureau of Labor Statistics (BLS) projects the number of photography freelancers to grow in the next decade, partly because of the reduction in staff photography jobs by many companies. It's a competitive world and the barriers to entry continue to drop as equipment becomes less expensive. Photographers trained in the skills of fine portrait and wedding photography will continue to find opportunities. Commercial photography for advertising

and corporate branding will continue to require high-quality images created by trained and experienced professionals. On the other hand, newspapers and blogs often expect reporters to provide pictures, and real estate agents and insurance claim adjusters routinely take their own photographs.

This ebb and flow is nothing new to the world of photography. The ways in which pictures have been used since photography emerged in the nineteenth century have always been in flux. Flexibility is key. As the BLS website notes: "Job prospects will be best for candidates who are multitalented and possess related skills such as picture editing and capturing digital video."

The dozen authors who contributed to this edition of *Starting Your Career as a Freelance Photographer* possess a wealth of knowledge and experience about the multifaceted world in which today's photographers operate.

The appendices include the Code of Ethics of the American Society of Media Photographers as well as a list of organizations that photographers might join or be interested in. The selected bibliography includes many books that belong in your bookcase if you want to succeed in the creative business you have selected for your career.

As Tad Crawford wrote in the first edition's introduction, "The road you are about to take has its challenges, but certainly it has great potential rewards— not only financial, but artistic and personal as well. I hope that *Starting Your Career as a Freelance Photographer* helps ensure that the road ahead will always rise up to meet you."

His observation is equally true in today's digital world. Preparation has never impeded good fortune.

—Chuck DeLaney, New York City, 2016

GETTING STARTED

SOME PEOPLE FALL in love with photography at a young age and decide to make it a career and then stick to that plan. Some find its magic later in life, while still others suppress the desire to work in a creative field and devote their education to a "safe" profession with a nine-to-five workday, only to discover that they're unhappy with that cautious choice.

The good news is that it doesn't matter *when* you decide to become a professional photographer. The important thing is that you act on the impulse and get started. There are plenty of pathways into the field and there are no formal education requirements. In Part I, four photographers explore the flexibility of a career in photography and examine various educational options. Chuck DeLaney addresses the flexibility of career pathways in photography and the fact that the person who takes great pictures and has the right attitude can succeed with very little formal education. He also provides some thoughts about how freelancers getting started can save money on equipment. Bill Kennedy details what to expect in different education settings, including the "open enrollment" opportunities at the School of Hard Knocks. For anyone considering a two- or four-year college major in photography, this chapter is essential reading. John Kieffer explores the many benefits of serving an apprenticeship as a photographer's assistant.

Veteran travel photographer Susan McCartney contributes her classic essay on the principal photographic specialties and explains why specialization is beneficial for many photographers. In some fields, such as photojournalism for newspapers and Internet sites covering medium- and smaller-sized markets, photographers will find it necessary to master several different skills like portraiture and still-life photography as well as covering breaking news. Online sites that specialize in selling stock photography have changed the landscape for photographers seeking to sell stock images.

The Internet has fueled the need for photographs, as the 24/7/365 content cycle requires frequent refreshment of visual imagery for every story. Whether the topic is the winner of a national election or the death of a famous person, large online publications will change and update the images that accompany the story frequently. This means that many of the specialties that McCartney

describes have grown and mutated to address the needs of blogs and social media. The number of celebrity photographers continues to grow to meet the insatiable demand of a curious world. Sport photography is another area where online coverage has increased the need for photographs to be posted on the web at frequent intervals during every major event.

CHAPTER 1 CAREERS IN PHOTOGRAPHY

by Chuck DeLaney

This chapter is adapted from *Photography Your Way* by Chuck DeLaney, a free-lance photographer and writer based in New York City. He served as director of the New York Institute of Photography, America's oldest and largest photography school, for many years and has devoted his career to adult education in photography and other fields.

IN MY LIBRARY, I have a number of books that are traditional career guides in photography. Most of these books survey various fields—portraiture, medical photography, photojournalism, commercial and industrial photography—and discuss the requirements, job opportunities, and financial prospects of each area.

That's not my approach. I firmly believe that photography is a passion and that during one photographer's lifetime the career activities are likely to meld into one another. If you were going to be a doctor, you would need to choose a specialty, such as cardiology or nephrology or psychiatry, and would probably devote many years of training to that specialty. In all likelihood, you would then practice that specialty for the rest of your life.

Similarly, if you want to make a lot of money, you might go to business school or law school, but probably not both. After that training, you would go out and have a career "in business" or "in law." Then you'd (hopefully) grow old, retire, and then die, perhaps with money to leave to your heirs.

PHOTOGRAPHY IS DIFFERENT

To me, that's not what a lifetime in photography is about. Sure, it can be a way to make money, but there's also a lot of fun and adventure to be had, a lot of opportunities to express yourself and your unique point of view, and the chance to change what you do as you go along. Why do one thing all your life? If you want to do that, it's fine, but even if you train to become, say, a medical photographer and then work in hospitals for your entire work life, that's no reason you cannot involve yourself with all sorts of other photographic endeavors at night, on weekends, and on vacation.

That's the beauty of photography—the vocational goals are hazy, and the training in photography technique and technology doesn't need to be that extensive in most fields. You can be a medical photographer during the work-week and pursue fine art or animal photography on the weekend. Try being a lawyer during the week and a brain surgeon on weekends—it won't work. The requirements, and limits, of many fields are set in stone.

To that end, I view photography more as a lifestyle than as a career. There's no sense of either/or. You can be a medical photographer and a wedding photographer. You can be a photojournalist and a child photographer. It's up to you. You may not leave a fortune to your children, but you'll lead a rich life and possibly leave behind images that will have both monetary and social value. That's sure not a bad life to have lived.

PHOTOGRAPHY AS A CREATIVE OUTLET

And, let's not write off all those doctors, lawyers, and MBAs either. There are many professionals in a host of fields who turn to photography to get the creative and expressive satisfaction that their "profession" may not be able to deliver.

So let's start with the basics. We're photographers and we're involved with a very powerful force—photography. And we have the opportunity to shape our careers as we go along. But before you can bask in the potential of photography, locate your interests, and find success in one or more fields, it is essential to address three things: (1) the nature of this magical medium; (2) what you really want to get out of photography and what skills you bring to the table; and (3) what holds you back as a photographer and as a human being and the negative emotions that may confuse and inhibit you.

THE NATURE OF PHOTOGRAPHY

I love photography. I make images almost every day, and I respect the power, science, art, and magic of the medium. I once took a Christmas-greeting portrait on Polaroid film for a young man who was in prison. It took me three minutes at most. Six weeks later the prisoner told me that he had sent it to his deathly ill grandmother who hadn't seen him in the ten years he'd been in prison. Shortly after the photo arrived, she died. Among her last requests was to be buried with the portrait I made of her grandson.

To me, that's powerful. I make images. I show people things. I capture their emotions and expressions, their memories, their past, the things they love. Sometimes I try to express my emotions in my photographs. Maybe, one of my photos will help change something in the world for the better.

And people pay me to do this!

Another key part of what I love about photography is that it is so democratic and accessible. The equipment isn't that expensive, and a lot of equipment isn't necessary anyway. There are many ways to get the training you need, and there's opportunity for you regardless of gender, race, or physical ability.

I know photographers who work from wheelchairs. There are photographers who are legally blind. I have had students over the years who were recovering from serious illness or injuries and who turned to photography as a way to reconstruct their lives. When I started teaching I worked for the nonprofit Floating Foundation of Photography, which ran photography courses in prisons and mental hospitals. Photography can help you grow. And, I know from experience, it can help you heal.

And people looking at your photos won't necessarily know if you're black or white, if you're female or male, or whether you used a Canon or a Nikon. They won't know if you went to college or learned photography in prison.

I recall a television interview with the late Danny Kaye, a performer with many talents. In talking about his interests, he made a very simple but profound statement: "If you can find the form of self-expression that's best for you, then you've got it made."

A CAREER TO THE END

There's one other great aspect of photography. There's no need to retire. Opera singers, supermodels, athletes—even the sharks and traders on Wall Street—all have a prime. When they can no longer take the rigors or hit the high notes, or when the "new (and younger) face" retires the supermodel who may be "over the hill" in her mid-twenties, it's time to move on.

Not so with photography. You can take great photos while leaning on a cane. Photography will never desert you. How many of us are lucky enough to find a lifelong friend?

For me, that's photography. My guess is, it's photography for you too. Now that you've found your method of expression, the trick is to move forward and stay optimistic. Perhaps, as you grow, you may find photography is not for you or that there's something better. Then the trick is to move on to that better something. This is not unheard of in creative professions. For example, the great artist Marcel Duchamp, a pioneer of the Dada movement, gave up making art altogether and turned his passion to chess in his later years. The wonderful French photographer Jacques Lartigue turned to painting in midlife. Not long ago I read the obituary of Myron "Scottie"

Scott, who started out as a news photographer and happened to take a few feature photographs of some kids who had made a toy car out of a soapbox and a set of buggy wheels. He went on to become the founder and guiding light of the Soapbox Derby.

WHAT DO YOU WANT FROM PHOTOGRAPHY?

Knowing what areas of photography are of interest to you isn't always that easy. One problem is that the world of photographic specialties and professional practitioners is highly segmented, particularly in the way photography is taught. There isn't a lot of crossover. For the most part, those in fashion know of their predecessors and peers but are clueless about the history of photojournalists or portraitists. The couple running a portrait studio in Des Moines probably don't know the names of the hotshot fine-art photographers who are currently in demand in New York and Los Angeles.

The key to learning about what possibilities exist out there is to look at other photographers from either the recent past or from prior generations. There's no career guide better than learning about the lives and looking at the works of others who devoted themselves to the pursuit of photography.

Michelangelo, known to most of us for his skills as a sculptor and painter, also wrote poetry. One of his sonnets muses on the potential in a block of marble. Every possible sculpture is contained within that block; the sculptor need only remove the bits of marble that aren't part of that sculpture!

Photography is like that block of marble. It offers everything you could possibly desire. Sometimes it may be easier to determine what you don't want and then make your way toward the areas that are left.

THE NEGATIVE STUFF

We're all susceptible to negative feelings, but until those emotions are examined and either eradicated or put in their place, the good stuff is hard to access in a sustained, trustworthy way. And those despairing gremlins do have a way of popping up again and again, for all of us.

That's important to remember. There may be a few enlightened souls who have put the dark stuff behind them forever—conclusively—and with no hitches. But for most of us, those negative feelings are like houseflies—you never get rid of every single one of them, you just keep them under control.

Over the course of my career, I've slowly come to realize how many people—not just photographers but all kinds of people—take themselves off the playing field, fold their hand, and ask to be dealt out of the game. They end up bitter,

befuddled, or beaten. Or, if they're lucky, just depressed. And they did it to themselves! Well, the hell with that!

A lot of our emotions come out as anger when dealing with customers and suppliers. As you'll see, there are a few situations where you can go ahead and blow your top, and other times when you have to take it easy. There are times to talk and times when the trick is to stay silent.

Occasionally, as you go along, you may find yourself thrown to the ground. Maybe you can pull this book out and reread a few sections and get up, brush yourself off, get back in the game, and get even with those that threw you.

This discussion of negative stuff is written with the wish that it will help you stay in the game right up to the end, that it will help you absorb the bumps, learn to analyze the self-inflicted ones so as to keep them to a minimum, and figure out how to handle those dealt you by others.

FIGHTING THE "IF ONLYS"

Photography is an elusive undertaking. As a form of self-expression, it can fool many people. It's easy to get good, to take technically okay photographs—to record a sharp, well-exposed image of something.

But it's a lot harder to get really good, and for the gifted, it's even harder to get great. It's hard to get other people to take your photography seriously. There are business and financial considerations involved. There are a lot of rejections along the way. Any of these factors can lead to distracted, depressed thinking, a lot of "if onlys":

- If only I had better equipment
- If only I had her contacts
- If only I had his sales technique
- If only I had gone to that school
- If only I could be published in that magazine

And one of the worst:

- If only I hadn't screwed up that job

You can fritter away an entire lifetime dealing with the "if onlys," but this seduction must be avoided. It's not that hard once you see them for what they are, but it's also one of the reasons that, if you're not careful, photography can make you crazy.

IT'S ATTITUDE, NOT SUCCESS, THAT COUNTS

In fact, I know many successful photographers who are still hounded by "if onlys"—what they haven't accomplished or the people who don't respect them—rather than basking in their considerable achievements. And these aren't just run-of-the-mill photographers. I know of one fabulously successful commercial and editorial photographer who is obsessed with getting major shows for his work in recognized fine art museums. He won't rest until he's secured that reputation. I've also met a very successful nature photographer who expressed to me his need to prove himself to his colleagues although he has legions of admirers. "They still think I'm a techno-geek," he told me.

I believe that there is no one way of being. If that's what these photographers want to do, if those are goals of their choosing, and as long as it is a choice and not an obsession, then that's OK.

And, while it can be obsessive at the top, it can be lonely when you're starting out. Photographers spend a lot of time alone—working, traveling, in the studio, or in a darkened room in front of a computer screen. The world is usually on one side of your lens and you're on the other. You need to make certain that you have enough input from the outside world. It's dangerous to get too isolated.

The fact that photography is a democratic medium, with accessibility for all, does have some drawbacks. There's a real potential for deluding yourself, pretending to be a photographer, thinking you're better than you are, or obsessing that you're not as good as you actually are.

Other forms of art and expression are much quicker to discourage people who seek to master them. For example, the performing arts can be downright cruel. If you wish to make your mark as a singer, musician, dancer, actor, or comedian but have little or no talent, your limitations are likely to be made painfully clear to you and your potential audience very quickly. Maybe that's good, because then you can move on.

After all, it's your lifetime, and as it passes, you'll realize a lifetime isn't a long time; it's a short time. There's no benefit wasting any of it.

Like the performing arts, the traditional visual arts—the "fine arts" of painting, sculpture, and architecture—also require talent that many of us lack. You're not likely to paint for very long if you have no skill at all.

If lack of talent weren't a big enough obstacle, many art forms impose financial barriers as well. Authors, poets, and playwrights can curse the lack of interest from publishers. Filmmakers can lament the high cost of producing a motion picture. Worst off may be architects, some of whom must kiss up to the likes of developers such as Donald Trump to get their works realized.

With inexpensive cameras getting better and better and most smartphones offering decent camera options, it's cheaper and easier to take photographs than it has ever been. Anyone can push the shutter and upload photographs (and video) instantaneously. That's a blessing and a possible drawback. You'll have to trust the honest feedback of the people whose opinion you value most to determine whether your sense of your work is on target.

ANYONE CAN TAKE A PICTURE

"He's only an intern!"

I heard this walking to my home in Lower Manhattan's financial district one evening. It was a young Wall Street MBA-type who blurted this out to his friend, but hearing just those four words, it was obvious that the "intern" had somehow bested this fledgling master-of-the-universe.

In the last two decades, technology has made photography even easier. It used to be that you had to have a modicum of understanding of exposure calibration to get the image properly exposed, and you needed sufficient eyesight and a steady hand or tripod to get a sharp image. Now even those requirements are gone—computer chips assist with exposure and focus. *Anyone* can take a photograph.

I remember, years ago, there was a chimpanzee that lived on Manhattan's Upper West Side and took Polaroid photographs at parties, if you hired him and his trainer. Not only could he take photographs, he was a pro! My daughter started taking photographs when she was eighteen months old. When she was three, I was comfortable putting the strap of an expensive SLR around her neck.

Make sure that you have a reasonably accurate estimation of your weaknesses and your strengths. That can require a rigorous self-examination. Is it worth it? It is if you want to be a photographer.

LET'S END WITH THE POSITIVES

One last point. It is fair for the reader to ask, "What are the benefits of the effort to banish those negative emotions? If the goal is photography *without* negatives, then photography *with* what?" The answer is multidimensional:

- Photography with choice, with a sense of play, with assignments, with confidence, and with a plan of roughly defined goals that work for you.
- Photography with freedom, with a respect for the tradition, and with an eye on the pitfalls that come with that tradition.

- Photography with no regrets, with the right to experiment, and *with the right to make mistakes*.

There's another difference between photography and brain surgery or rocket science—it's okay to make mistakes. Sometimes, mistakes are part of the discovery and excitement. Mistakes can show you the way.

CHAPTER 2 — THE VALUE OF A PHOTOGRAPHIC EDUCATION

by Bill Kennedy

Bill Kennedy has been a professional photographer for more than twenty-five years. His commercial business specializes in portraiture and location photography for editorial, corporate, and advertising clients. He has received an NEA/M-AAA Fellowship in Photography, among other grants and awards, and has exhibited widely. An associate professor of photography at St. Edward's University in Austin, Texas, he is also a member of the Santa Fe Workshops Board of Advisors.

THERE ARE TWO traditional and respected approaches to an education in photography. One option is to enroll in a structured academic program that offers a degree or certification of some kind. These programs, ranging from trade schools to community colleges and four-year universities, can vary considerably in their curriculum. Understanding the differences and choices afforded by these programs is the main focus of this chapter.

An alternative is to forgo a formal education and choose instead the "School of Hard Knocks." The advantage of Hard Knocks is open enrollment. You can come and go as you will, learning at your own pace. A Hard Knocks education is a viable alternative to structured academic programs because freelance photography is an unlicensed profession in America. It is possible to work as a photographer without a formal education, certification, or license of any kind. In fact, if you are successful—if you can find the clientele to generate a sustainable profit from your freelance business—your claim to be a "professional" is as legitimate as that of someone with a four-year university degree.

By default, becoming a self-employed professional photographer is determined less by formal education and more by how quickly you learn what is essential to survive and prosper economically. In other words, business acumen will be at least as important as your creativity and photographic ability.

THE LEARNING CURVE

One way or the other—formal education or Hard Knocks—both the photography and business learning curves must be mastered for you to survive ethically and prosper economically as a freelance photographer. Regardless of pedigree, smart

freelancers also realize that an education in photography is never complete. The realities of the marketplace make education a lifelong process. There is always something new to learn as tastes change and new technologies appear (just ask, for example, the studio photographer compelled to learn prepress color management and workflow because they moved from analog to digital photography). The need to learn explains, at least in part, why photography workshops have become increasingly popular.

PHOTOGRAPHY WORKSHOPS

Workshops are intensive experiences usually structured around learning a set of skills (platinum printing, studio techniques, or portrait lighting, for example) or the experience and reputation of the instructor. It is remarkable what can be accomplished, and how far a motivated person can travel, when surrounded—twenty-four hours a day—by people committed to the same pursuit. Workshops typically last a short week (five or six days) but come in a wide variety of flavors and configurations. You may be able to find workshops in your area (check local art schools and museums, the learning extension programs at larger schools and universities, and any local photography groups or professional organizations). Some of the larger and better-known workshop programs include Anderson Ranch, Santa Fe Workshops, Palm Beach, and the Maine Photographic Workshops (Now Maine Media Workshops). Information on these, and many others, can be found on the Internet. Incidentally, workshops are an excellent way to explore the idea of becoming a freelance photographer. You can take a class with working professionals and benefit from their experience and point of view.

One lesson you may learn from attending a workshop is that the desire to become a freelance photographer—intoxicating and compelling as it may be—is inevitably tempered by a career decision: What kind of photographer do you want to be, and what kind of small business should you create to support this decision? In short, becoming a successful freelance photographer means you want to own and operate a small business fueled by your ability and passion to make images. What kind of image making do you want to specialize in?

CHOICES

For the sake of simplicity, we can organize the myriad of freelance choices into a few large categories: commercial photography, retail photography, and fine art photography. These categories differ mainly in the way images are marketed and sold, by the way, and less by image content, talent, or skill. Examples of commercial photography include annual reports, freelance editorial, advertising, fashion and lifestyle, and product illustration. It is a very diversified field.

Photographers who choose a commercial photography career do not usually deal with the general public. They most often market and sell their work to art buyers and art directors, graphic designers, and editors.

Retail photographers, on the other hand, do market and sell directly to the public. This would include portrait studios and event and wedding photography, for example. Fine art photographers also sell to the public but generally try to work with galleries or agents to market their work (and will pay a commission that could approach 50 percent, for the privilege).

To further complicate matters, boundaries are fluid and there are no hard and fast rules, save those that govern commerce in general (a benefit of photography being an unlicensed profession). Commercial photographers can shoot weddings or sell work through fine art galleries, for example. Retail photographers can shoot commercial assignments and exhibit their work in galleries and museums. Fine art photographers often accept commercial assignments and traditionally may supplement their photography careers by teaching. All may work with stock agencies to sell their work to wider markets. In other words, freelance photographers independently define their business; if they operate within the law, they are free to "behave" any way they wish.

Keep in mind, though, that these categories—commercial, retail, or fine art—simply reflect the choices photographers make about their work and how they choose to market what they do. The Internal Revenue Service does not care about the aesthetic decisions, distinctions, labels, or ego that lead photographers to define what they do. The IRS's view of commercial photography is simple and direct: if freelancers earn money from making photographs, they are a business and have entered the world of taxation and regulation. Fine art photographers declaring their earnings from print sales must use the same IRS forms and procedures as an editorial photographer working for international magazines or a commercial photographer shooting automobiles or annual reports. In fact, if there is a "Grand Unifying Theory" of freelance photography, it exists only within the byzantine business code of the IRS.

CHOOSING A PROGRAM

Obviously, the decision to become a freelance photographer is more complex and interesting than it may at first seem. In fact, one strong argument for a structured academic education in photography is the time it affords a photographer to comprehend, appreciate, and find reliable answers to important career questions and issues. School provides time to examine what kind of images you want to make (and learn how to make them). There is time to explore, experiment, grow, change, and refine your thinking and career ambition—ideally,

with the help and guidance of good teachers. You are looking for an education that will fuel your ambitions by challenging assumptions, refining technique and aesthetic judgment, strengthening your work ethic, and establishing a critical dialogue about photography that will mature over the long and sustained arch of your career.

The first decision about a formal education in photography is to determine what kind of program is best for you. The way photography education is organized, especially at four-year colleges and universities, rarely reflects the way commercial photography as a business is organized. (Traditionally, the *art* rather than the *commerce* of photography has been emphasized in higher education.)

This means you need to evaluate and compare programs carefully. There often are considerable and important differences, and it is easy to mistakenly compare apples to oranges. The following is a checklist to help you structure your investigation. Fortunately, most of the information you need can be found on websites or by contacting the admissions office of the schools that interest you. Almost all schools offer online enrollment options, but it is probably worthwhile to schedule a conversation with someone in the admissions office or other department who provides advice to prospective students.

A Photography Education Checklist:

1. What kind of program is it? Is it a trade-school certification, an institute, a two-year associate's degree, or a four-year bachelor's degree?
 * If it is a trade-school certification program or an institute, does it award academic credit that will transfer to a college or university program (an important consideration if you eventually want to enroll in a college or university degree program)? A trade-school education could be an excellent fit, but it is often considered to be vocational training and may not transfer to colleges or universities. If it is an associate's or bachelor's degree, what kind? Associate degrees can vary considerably, depending on what department the photography program is located in. It may be a science or technology degree, or it could be a fine art degree. Traditionally, four-year degree programs come in two variations: fine art (bachelor of fine arts, or BFA) and photojournalism (bachelor of journalism, or BJ). The fine art approach is a studio education that will include art history and coursework in design, drawing, and art theory, for example. Photojournalism programs tend to be majors within schools of either journalism or communication. PJ programs prepare students for careers in journalism. Both, by the way, feed graduates

into freelance photography, usually with little or no practical business training (but more about that later).

2. How is the program structured within the school?
 - How many hours in your degree plan are dedicated to studying photography?
 - When can you begin taking photography coursework? Some schools, including most universities, do not allow students to begin study in their major until late in the sophomore or junior year. There are exceptions to this, but it is an important consideration if you want to get started on your photography education quickly. This can be especially important to older-than-average students.

3. What classes are taught in the program? Always look for a complete list of classes. This will give you valuable insight into how a program's curriculum is structured. For example, what is the balance between production classes (where you are expected to shoot and process images) and history or theory classes (where you are expected to do research and write)? Are only still-imaging courses taught, or does the curriculum include video or multimedia, for example? Also, are there business and marketing classes geared toward the needs of photographers?

4. Who teaches in the program? How many full-time versus part-time instructors are there? This can help predict how much time you can expect to spend with core faculty. Good adjunct faculty can bring depth and vitality to a program that has a sound core faculty, but beware programs that seem to lack full-time faculty. You want to select a program because of its focus and strength, not the lack of it. Another important indicator of a program's strength, by the way, is the professional involvement and expertise of the faculty. Ideally, you want to study photography with people who are passionately and professionally involved in the medium.

5. What kind of facilities and equipment can you expect to have access to? You may be able to gain an informed opinion from printed or online material, but this is one area that is best informed by a campus visit. If that is impossible, try corresponding with a faculty member (email addresses can sometimes be found on school websites). Does the school have an equipment bank that you can use to borrow equipment that you don't have? This is especially important if you will be required to take courses that use specialized or expensive equipment that you may not own (or want to buy). You want to gauge the "tool kit" you will be paying to use. By the way, remember to ask about the hardware/software used

in digital-imaging labs. Because of the expense involved in maintaining digital equipment and purchasing software upgrades, some schools' technology may not be as current as others'.

6. What financial aid programs exist? Are there scholarships or grants that you are eligible for? This kind of information can be found on school campuses. In fact, good schools have specialists who will work with you to arrange any financing needed to attend school.

GATHERING INFORMATION

Gathering this information will help you understand the differences between programs and between the schools where the programs are located. Essentially, what matters most are the people you will spend time with (students, staff, and faculty) and the curriculum (what is actually being taught and learned). After applying and being accepted, registering and paying tuition, buying supplies, and arranging your life to accommodate a class schedule, what can you look forward to? What are the experiences and learning milestones you can expect and want to seek out?

LEARNING COMMUNITIES

Exceptional academic photography programs are more than the sum of their parts. They generate a strong sense of community. In part, people bind together and learn from each other through their mutual commitment and the sheer effort a thorough and demanding photography program requires. If a program does its job properly, classmates become colleagues as they study and learn photography together.

In other words, if a program is a good fit for you, there will be a *process* at work that extends learning well beyond the classroom. It is the process of *learning how to think* in an ordered, disciplined, and joyous way. Yvon Chouinard, adventurer and founder of Patagonia, Inc. (considered by many to be a model ethical business), understands the value of process. He identifies it as a core value in the way his company operates. "It's all about process," explains Chouinard. "Part of the process of life is to question how you live it . . . and it's the same in business. If you focus on the goal and not the process, you inevitably compromise. Businessmen who focus on the profits wind up in the hole. For me, profit is what happens when you do everything else right."

The process of learning how to "do everything else right" that Chouinard refers to is a simple but powerful description of the training and experience a good education can provide a freelance photographer. Learning communities generate and sustain a critical dialogue—essentially, a disciplined conversation—that

lasts for years and extends beyond graduation. This dialogue inevitably reflects one's education and values. Students, discovering that they belong to a group sharing a common agenda and goals, stimulate and challenge each other. It is empowering to be surrounded by people dedicated to learning the same craft, technique, and language of light that you are. From working through a common agenda, students find their own unique and irreplaceable voice. They develop a personal aesthetic and acquire the technical skills to express their vision through the images they make.

This is particularly valuable to a freelance photographer. A freelancer is constantly faced with the challenge of breaking through not only the visual clutter of our mediated society in general but also the piles of promos sitting on a typical art director's desk. Being able to convincingly express a mature personal aesthetic is paramount to survival in the market. Learning what kind of images you are capable of making is a substantial and concrete part of learning how to think. In fact, this method, or way of thinking, can be understood in three parts:

1. Seeing a problem or issue,
2. Understanding it, and
3. Exercising sound reasoning toward its resolution.

Learning to see clearly and incisively, to perceive, is the first step. It involves training the mind to scan broadly and discriminate precisely. Reaching understanding requires an intellectual "tool kit" that enables and conditions one's inquiry. This can include being familiar and conversant with subjects across disciplines. It also includes the confidence that rewards curiosity informed by research. Lastly, reasoning toward resolution is a learned ability—but also the expression of a desire—to struggle toward reliable conclusions rather than settling for convenient and simple opinion. This is the foundation of a liberal arts education and it is also a very adept description of the process of making good photographs.

Ansel Adams believed that young photographers were best served by earning a degree before beginning a career in photography. He understood that the process of educating the mind—of learning how to think—was precisely the kind of training photographers need in order to make successful images (a champion of technique, Adams nonetheless placed technique at the service of one's creativity and intellect).

School has the "silent" benefit of structuring not only time but priorities as well. A degree program mandates a structure for time to be wisely and purposefully used. This structuring of priorities can be achieved on your own (if you are

highly motivated and disciplined), but for most it will be much more difficult to accomplish. Without the structure of school, you may find that life issues—jobs and family, for example—demand attention and compete for your resources. For many, this can be one of the hardest issues to control in the School of Hard Knocks.

If an academic program encourages student membership in professional organizations—the ASMP, NPPA, and PPA, for example—there will be opportunities to extend your education beyond the classroom. Learning about fair trade practices and ethical conduct from working photographers, who struggle with these issues every day, can be a powerful extension of classroom learning. Belonging to professional organizations and attending local meetings can open a window from the classroom to the real world. It allows students the opportunity to benefit from real-world experience while working toward a degree.

It is also an excellent way to begin networking and finding mentors. Mentors are seasoned professionals willing to share their success with students. They take special interest in a student's ambition and career. Mentors share and guide, providing access to information, experience, and opinion that can help a student photographer make good career decisions. Most importantly, they can help you negotiate the inevitable transition from academia to the real world.

Some photography programs include (or require) internships, which can be another way of learning about business issues and of finding mentors. An internship is essentially a temporary job placement for which you can earn academic credit. It is similar to the student-teaching experience that education majors typically go through. It is real-world learning while in school. You may intern with a working photographer, for example, although excellent internships can also include nonprofit organizations, fine art institutions, media providers (like television stations or video production houses), graphic designers, agencies, print publications, and so forth. Good internship programs place students in real-world situations and allow them an opportunity to explore career options firsthand. This is often very helpful when one is managing the transition from academia to the real world.

Entering the market is the final piece of the education puzzle. In hand with an active internship program, there is one more element that a good program should offer to help substantially with the transition from academia to the real world. It should emphasize the importance of a *graduation portfolio*. Many programs leave portfolio development up to the individual student. Consider instead a program that begins portfolio development early on, preferably in the freshman or sophomore year. This approach stresses continual reevaluation and editing. With the help of their teachers, students will, ideally, review and change

their portfolio many times before they graduate. With each edit, the portfolio becomes a stronger and more persuasive statement about the student's skills and vision. An exceptional portfolio translates into a competitive advantage, and that is one thing a freelance photographer should always be interested in learning more about.

CHAPTER 3 THE BENEFITS OF APPRENTICESHIP

by John Kieffer

This chapter is adapted from *The Photographer's Assistant* by John Kieffer, a photographer and writer based in Boulder, Colorado, who spends the majority of his time photographing the natural places of the American West and marketing his and other stock photographers' work through Kieffer Nature Stock.

MANY OF US experienced a special fascination with photography from our earliest encounter, and we continue to nurture the dream of being a professional photographer. Unfortunately, one of the first and greatest stumbling blocks is just getting your foot in the door. The best approach to getting started as a professional photographer is to become a professional photographic assistant.

THE PHOTOGRAPHIC ASSISTANT

Just what is a professional photographic assistant? In general, it's an individual with both photographic and related skills who assists a professional photographer. Being a photographic assistant can be both a transitional period and a learning experience. It can allow the advanced amateur or recent photography-school graduate to turn professional more smoothly. A good assistant has marketable photographic skills but also performs as an apprentice.

Before you can appreciate the importance and responsibilities of the assistant, it's necessary to dispel some *common myths* regarding professional photographers, especially those photographers most likely to hire assistants. Photographers who regularly utilize assistants receive photographic assignments that have budgets for an assistant. They get the better jobs because of their ability to consistently produce a technically excellent photographic product, regardless of the subject or shooting conditions.

Many aspects of high-level photography must be approached very precisely. What is almost perfect is unacceptable. Being a little out of focus, seeing only the edge of a piece of double-stick tape, or overlooking a speck of errant dust on the set is intolerable. Imagine several professionals viewing a 4 x 5–inch color transparency with a magnifying loupe. There's no place to hide mistakes.

Photography is a process where the production of the final image, whether it's a piece of film or a digital file, is the result of many small steps. Failure to

perform any one of these steps satisfactorily can render the outcome useless. Consistently sustaining this high level of output requires both technical and creative skills. It also necessitates a certain fastidious nature, attentiveness to detail, and overall organization by photographer and assistant alike.

Photography is often mistakenly perceived as a fairly laid-back, almost casual occupation. This is largely untrue for professional photography as a whole, and even more so when assistants are utilized. An acceptable product must be delivered on schedule, often by the end of the day.

Besides the assistant, others might be involved with the day's work, perhaps an art director, a client, a stylist, or a model. Either their schedules or the budget may not allow for extending the shoot. A photographic assistant is an integral part of this creative effort and can be a tremendous asset. Conversely, mistakes can cost thousands of dollars and damage the photographer's credibility.

The bottom line is, the most successful photographers are those who won't let something go out of the door until they're satisfied that the work is the best it can be. These are the photographers assistants want to work for the most. Keep in mind, as the day grows longer and the takeout pizza gets colder, there are likely to be only two people left in the studio—the photographer and the assistant. As an assistant, you should expect long days and demanding work. The rewards are financial, educational, and an active involvement with a high-quality photographic experience.

THE ASSISTANT'S RESPONSIBILITIES

A clearer view of the photographer's working environment makes it easier to appreciate why the successful photographer needs a competent assistant. Well, what are an assistant's responsibilities? In general terms, the assistant is hired to free the photographer from many lesser tasks. This allows the photographer to concentrate on what's in the camera frame and, ultimately, on the final image.

The best assistants integrate a variety of skills into many different kinds of photographic situations. Besides receiving instructions from the photographer, a good assistant anticipates the progression of the shoot and takes the initiative regarding assisting duties. Finally, the assistant must be in tune with the photographer . . . a sort of mind reader.

More specifically, assistants work with *photographic equipment*. However, this equipment is rarely the kind mentioned in the popular photography magazines. The 35 mm, single lens reflex camera (SLR), so familiar to amateur photographers, is often the format encountered least by the assistant. The 35 mm SLR is likely to be replaced by medium-format cameras (6 x 6 cm and 6 x 7 cm), and

large-format view cameras (4 x 5 in). These often have digital backs, completely bypassing film.

The need to produce on schedule requires the photographer to control as many variables as possible. Hence, the use of constructed shooting environments. *Artificial lighting* is a big part of this controlled environment. The small flash units that attach to SLR cameras are replaced by more powerful, electronic flash systems. These lighting systems consist of large power supplies and individual flash heads.

In addition, stands and numerous *light-modifying devices* are used to control this raw light. Some of the assistant's responsibilities are to set up the lighting system, subtly change its position and character, and tear it down. Reliance on artificial lighting greatly increases the need for an assistant.

Artificial lighting also necessitates making test photographs to adjust the lighting setup. Generally, a photographer won't make the final image until all that can be done is done. Test exposures help confirm important aspects ranging from composition and lighting to focus and exposure. Everything must be just right to avoid unwanted surprises.

Like an artist, the photographer often starts with only a general idea and a blank camera frame. This means a background or location must be chosen or even specifically constructed.

Both the subject and all props must be selected, and everything must then be precisely positioned, by whatever means necessary. The solution may dictate the simple use of a clamp but frequently demands real ingenuity. It's imperative that everything stays together, at least until the last exposure is made.

A key to being a *good assistant* is the ability to prioritize your responsibilities and be efficient in accomplishing them. At the same time, you keep one ear dedicated to the photographer. There's more to professional photography than what's visible in the final image. To be a successful assistant, you need many skills. Not all are thought of as photographic, but they're still essential in creating successful photography. Certainly strong computer skills and proficiency in software such as Adobe Photoshop are important. In addition to responsibilities that are assigned, a smart assistant pays attention to areas where the photographer may appreciate help.

BENEFITS FROM ASSISTING

The benefits you receive by being a professional photographic assistant are almost too numerous to list. In simple terms, it's an incomparable *learning experience* . . . and you get paid for it. You work with the better photographers, and in the process you're exposed to a vast array of photographic challenges and creative solutions.

By assisting different photographers on countless photographic assignments, the day-to-day tasks of photography gradually become routine. As a result, you'll be far less likely to have difficulties when making the transition from an assistant to a professional photographer with your own studio.

Perhaps of greatest value is the knowledge you gain regarding every aspect of light. As your photographic eye evolves, you learn to appreciate its subtleties. If you're perceptive, techniques used to control light can become invaluable tools for use later on. Assisting also gives you a familiarity with a range of photographic equipment that's impossible to obtain any other way. This hands-on experience makes the inevitable purchase of costly photographic equipment less of a gamble.

The assistant is part of a creative team, commonly working with models, stylists, set builders, and other assistants. Working with these people imparts valuable knowledge. Later in your career, many of these same individuals may even be of service to you. When you are assisting, your daily routine is likely to include running errands. These may consist of stops at rental houses, repair shops, prop stores, and other photo-related resources. Support services are essential to virtually all areas of professional photography and many times require some research and preparation. Bear in mind that some of your errands will take you to the coffee shop or delicatessen.

Finally, assisting provides a unique avenue for becoming part of the local photographic community and for building a *network* of relationships. As a successful assistant, the transition to professional photographer will be more fluid. Gradually, your employers become your peers.

THE PROFESSIONAL PHOTOGRAPHIC COMMUNITY

The field of professional photography is extremely diverse, so it's critical to know which areas of photography require assistants and why. The following list discusses areas with the greatest potential to utilize photographic assistants. It's fair to say that several categories might apply to a photographer over the course of a busy year.

Commercial Photography

Commercial photographers use assistants more than any other group of photographers. These photographers commonly obtain work from advertising agencies, graphic-design firms, and larger companies. The resulting image is then used in some form of commercial endeavor, such as a magazine advertisement, brochure, website, or annual report.

The field of commercial photography isn't precisely defined and holds the potential to expose the assistant to every kind of shooting experience.

Commercial work differs from wedding and portrait photography, where the general public is buying the product. Editorial photography and photojournalism aren't considered commercial work, because the photography is not directly involved with selling something.

Product Photography

Product photography is a branch of commercial photography and is essential to many businesses and photographers alike. When the objects are small, it's often referred to as tabletop or still-life photography. Whatever you call it, you take pictures of things, usually things that are sold. Ideally, this work is performed in the studio, where photographic control can be maximized. Proper lighting is critical, not only to show the product most favorably but also to elicit a response or convey an idea. Utilizing view cameras, professional lighting systems, and every type of related equipment is the routine.

Architectural Photography

Architectural photographers also depend on assistants. Whether shooting interiors or exteriors, they are often called on to illuminate large areas. This translates into a lot of lighting equipment. Photographers often need to be in two places at once, and when large spaces are involved, what's better than a good assistant? As you'd expect, it's always a location job and everything must be transported to and from the site; strong backs are required.

With much of product and architectural photography, capturing the final image is often anticlimactic and almost a formality. Lighting and composition problems have been solved and verified with preliminary test photographs reviewed in the camera's viewfinder or on a monitor. Unless an important variable cannot be precisely controlled, like the pouring of a beverage or rapidly changing natural light, a limited number of final exposures are made.

People and Fashion Photography

Some subjects, such as photographing people, especially in fashion, require making a great number of images. Due to a model's movements, the photographer cannot control the final outcome, and a certain level of tension exists on the set.

This uncertainty means many more exposures are made to assure the photographer gets the shot. For the assistant, it becomes more important than ever to be attentive to the photographer's needs and to what's happening around the set. If there's a delay in the action, it better not be because of you.

Editorial Photography and Photojournalism

Editorial photography and photojournalism are the noncommercial photography found in magazines and newspapers. The photographers producing this work tend to use assistants less frequently than commercial photographers do. Unfortunately, many editorial budgets just don't have any extra money for an assistant.

Besides budget, there is a fundamental difference in the subject matter. In most instances, the editorial subject possesses an inherent quality that makes it interesting to the viewer. A commercial product or idea doesn't have this advantage. It's a box, a thing, and the public often has little interest in it. The commercial photographer has to work hard to evoke any kind of response . . . that's part of the challenge. On the other hand, the very nature of editorial photography and photojournalism requires a less contrived approach, which means less need for an assistant.

Wedding and Portrait Photography

When the layperson envisions professional photography, both weddings and portrait studios quickly come to mind. From an assistant's viewpoint, both share some common traits. First, they draw their livelihood from the general public. This usually translates into a restricted budget. In addition, shooting situations and lighting solutions are less complex. The result is less need for an assistant. It's important to realize, though, that there's still tremendous opportunity to photograph people, although it's usually related to a commercial job. Large-budget wedding jobs may require multiple assistants, and executive portraiture is usually done on location, and an assistant may be needed to make sure busy executives can be photographed without taking up too much of their time.

FREELANCING AND FULL-TIME ASSISTING

Another aspect of assisting must be addressed. This is whether to be a freelance or full-time assistant. As a full-time assistant you are like an employee of any small business, except that the job is with a photographer who owns an independent studio. As a freelance assistant, you provide services to many photographers on an as-needed basis.

Before deciding if one position is best, it's important to examine the city where you intend to work. There may not be a choice to make. Larger, economically healthy, metropolitan areas have larger photographic communities. These markets hold the greatest potential in finding a full-time position. Metropolitan areas with less than half a million people may have only a handful of full-time

positions. Wherever the market, there are always more freelancers than full-time assistants.

If given the opportunity to pursue either, understanding how the two positions differ will help you make an informed decision. The word that best describes freelance assisting is "diversity." One day you're on location, involved with a fashion shoot. You're working with a medium-format camera, strobe, models, and a stylist. On another, you'll spend the day in the studio, fine-tuning a single product shot. Here the photographer utilizes a view camera, different lighting equipment, and, more importantly, a different viewpoint.

No matter how skilled, no single photographer practices every type of photography or utilizes every valid approach. Freelancing allows you to explore the widest range of photographic experiences. You may become more familiar with those areas you think you want to pursue professionally. But it is just as likely that you will become sidetracked by areas you never even knew existed. Try it; you might like it. If it doesn't hold your interest, don't worry—your next assisting job will probably be quite different.

Working with different photographers means different equipment. Freelance assistants get hands-on experience with a vast array of equipment. This helps you decide which style of photography or particular camera format feels right for you.

Don't conclude that freelance assisting is all pluses. As a freelance assistant, you are essentially running your own business. Freelancers don't find one job and then stop looking. They build a clientele and work at keeping it. This means you don't receive a steady paycheck. You bill your clients and wait for payment.

When you are pursuing a full-time position, it's important to evaluate both the photographer and the kind of work he or she performs. The assistant works very closely with the photographer, and a certain degree of compatibility is essential. Does the kind of work the photographer shoots day in and day out fit into your learning and career goals?

GETTING THE MOST FROM ASSISTING

Besides providing a service, assisting is also the best opportunity to learn about all aspects of photography. However, little can be gained by passively observing what's happening on the set. Certainly, you'll learn which processing labs are best and the preferred types of equipment. But there's much more. Realizing this potential takes a conscious and directed effort.

BE A GOOD ASSISTANT

One of the most basic ways to learn is to work hard at being a good assistant. By concentrating on the photographer and the progress of the shoot, you not only sense the photographer's needs, but you also begin to think like a professional photographer.

In addition, the repetition of basic photographic tasks is a tremendous benefit to learning. Eventually, you become proficient at the many photographic processes that, if not done correctly, can subtract from the final image. With consistency comes the ability to improvise and create new solutions.

It's important to remember that assisting isn't one continuous question-and-answer session. Rather than asking numerous questions, try to think of the answer yourself. If you remain perplexed, approach the photographer at a less hectic moment or at the end of the day.

Lighting is one of the most critical aspects of good photography. Here, much can be learned by following the evolution of the lighting arrangement and reviewing the resulting series of test shots. Since these images are usually not deleted during the job, they can be examined later in the day.

On your way home from the job, reflect on the day's activities. This will make you a better assistant, and technical or creative aspects of the shot are more likely to be remembered. Consider keeping a notebook. In it you can record information, such as filter combinations for mixed-lighting conditions or perhaps the name of a unique light-modifying device.

Review the discussion on *freelance* versus *full-time assisting*. Your decision, and how you market your services, can profoundly influence whom you work for and the type of photography you encounter. Ultimately, this affects what you learn.

KEEP SHOOTING

Assisting is so beneficial because you learn by doing. You'll find that your own photography will progress at a faster rate if you continue to shoot frequently while assisting. This is partly because you can employ recently learned techniques, but you'll also become more critical of your own work and, consequently, more demanding.

Unfortunately, your progress can be hindered by a lack of equipment or studio space. If this is the case, consider trading your services for the use of these items. With time, you'll know which photographers might be receptive to your proposal, and they'll know they can trust you with their equipment. If they didn't, they wouldn't continue to hire you.

THINK BEYOND PHOTOGRAPHY

When you're first learning photography and assisting, it's easy to get too focused on photography. I feel that even though you're a photographer first, it's essential to keep an open mind, not only to grow artistically but also to take advantage of new opportunities.

1. *Keep up with business and current events*, so you can get the broader picture. You need to know where the world is going and how your industry fits into it. It's the only way to keep ahead of the curve.

When I began assisting, most photographers had never thought of their images as "content." The web as we know it today was virtually nonexistent. And who'd have thought that a couple of corporations could end up controlling so much of the fragmented stock industry in just a matter of five years?

2. *Acquire computer skills*. Although I'm best described as a landscape photographer and stock-agency owner, it's the computer that has really allowed me to do much of what I want, which is take pictures. That's because it has allowed me to market my photography using my website and other online tools. Without these options, I'd surely be out of business, considering the stock industry today.

3. *Develop graphic design skills*. Since so much can be done on the web, it pays to have some basic graphic design skills. This will not only save you money but will also make you a better photographer. The more design work I do, the more I learn why some photos are easier to work with than others.

4. *Write down your ideas into what's traditionally called a business plan*. Edit it until you feel it can be presented to someone. This is a great way to consolidate your ideas, but, even more important, the very process of writing opens you up to new ideas.

TAKE ADVANTAGE OF WHAT'S AVAILABLE

Many photographers continue to learn and build valuable business relationships by being involved with *professional organizations*. Local branches of the American Society of Media Photographers (ASMP) and American Photographic Artists (APA) have regular meetings, which are open to nonmembers for a small charge. These expose you to a variety of topics, while introducing you to the local photographic community. Try volunteering.

There are also courses, workshops, and seminars available. These cover many aspects of photography, but don't limit yourself. Consider gaining more expertise on computers, multimedia, graphic design, and business. And, finally, immerse yourself into the stream of *information* that's readily available. These include books, professional magazines, websites and online-learning programs, galleries, and equipment catalogs.

Working as an assistant provides many opportunities for you to learn more about the art and craft of photography while gaining experience and meeting people in the field.

CHAPTER 4 PHOTOGRAPHY, A MANY-FACETED FIELD

by Susan McCartney

Susan McCartney started taking pictures at age twelve with a plastic camera. A lifelong photojournalist specializing in people and travel, she has worked all over the world and is the author of *Mastering the Basics of Photography*, *Photographic Lighting Simplified*, *Mastering Flash Photography*, and *How to Shoot Great Travel Photos*.

YOU ARE CONSIDERING a career in photography. That's good. There are plenty of opportunities for talented and motivated newcomers—advanced-level photographers who can successfully handle the pressure of shooting paid assignments.

Be aware that, except in the smaller markets, most photographers eventually specialize. Good reasons for specialization are preference, opportunity, and any contacts that can help you get work. Your area of residence and willingness to relocate are factors, too—it's just not possible to be a celebrity photographer and live in a small town. Another reason for specialization is that equipment suited to one type of photography may not be useful for another. Most importantly, it is easier for a potential client to offer work if they can see that you have experience in photographing what is needed. Finally, when you become known for excellence in a particular area, you can charge premium fees.

It's okay to have more than one specialty—many photographers do just that—but then they show different portfolios, geared to the interests of prospective clients.

Photographic specialties are listed below with general requirements, in alphabetical order. This list is not written in stone—quite a few photographers, including myself, have more than one specialty. To learn more, visit websites for the organizations mentioned. Find helpful books on the Internet, too.

ARCHITECTURE AND INTERIORS

Architecture is a well-paid specialty in an uncrowded area of photography. Opportunities exist just about everywhere. Start small, working for local real-estate firms, builders, contractors, architects, homeowners, and interior decorators and designers. Move up to shooting for nationally and internationally

known architects and construction firms who give out many commissions. So do corporations, architectural publications, and decorating magazines. Top specialists, like Norman McGrath, the author of the now classic *Photographing Buildings Inside and Out*, travel all over the world on assignment.

Good architectural and interior photography requires patience and technical knowledge of how to use medium- and large-format cameras with "swings," "tilts," and "shifts"—camera adjustments that control subject perspective and depth of field. Also needed is expertise in photographic lighting. Color must be rendered correctly and the architect/designers' lighting effects must be reproduced exactly. This may require long exposures, switching lights on and off, and the use of several color- and light-balancing filters, all in one photograph. Today you will also need a good knowledge of Adobe Photoshop. Many technical corrections previously made with the camera or filters are now made on the computer.

BABIES AND CHILDREN

It's possible to start part-time with minimal equipment—any user-adjustable 35 mm film or digital camera plus a moderate-focal length telephoto or tele-zoom lens is fine. Add a portable silver/white fabric reflector if you like to work outdoors, or use a flash off-camera, and you are in business. (Later you may want studio lights, too.) Find clients everywhere, including the birth-announcement columns in local newspapers. This specialty is emphatically *not* just for women or small-time photographers. Yes, you could shoot for an hourly wage at the local Wal-Mart studio, but if you love kids and have energy, ambition, and talent, think about all the baby products advertised in national women's magazines and all those ads and editorial shots of babies that run in parenting magazines. If you have access to cute babies, children, and teens, photograph them often—and attractive parents and grandparents, too. Be sure to get model releases, because baby and family pictures are big stock sellers.

At the highest level of child photography, specialists include Jack Reznicki, an acquaintance who does very well indeed shooting Toys "R" Us catalogs and advertising-related kid pix. Or think about Anne Geddes from New Zealand, whose highly original baby-picture books have sold millions of copies all over the world and made her famous and rich.

CATALOG

Catalog photographers may work on the staff of large corporations that do high-end product advertising, for instance of automobiles or furniture, or they may shoot for a big department store, or a mail-order/web merchandiser.

Alternately, he or she may work for a specialist "catalog house"—a fair-sized, independent photo studio specializing in shooting products for companies that don't have full-time staff.

Most catalog specialists like the security and steady work they get despite the fact that catalog work is not usually highly creative. Technical lighting ability and the love of detail required of all still-life photographers are important. Much catalog work is shot with large- or medium-format digital equipment today. It's safe to say that most corporations recruit catalog staffers who are graduates of photo schools with a reputation for technical excellence.

CELEBRITIES

You must start close to where the celebrities are, which, in the United States, pretty much means Los Angeles, Las Vegas, New York, and top resorts. You also need a lot of chutzpah! I know three celebrity photographers. All have excellent social skills. If you have the charm and persistence needed to be a successful telemarketer, you can probably also make it as a celebrity photographer.

Two former students of mine with excellent flash photography technique started out as freelance "paparazzi," finding photo ops by subscribing to commercial celebrity listing services and selling to supermarket tabloids. One now shoots far-flung assignments for *Us*, *People*, and similar publications; the other successfully made the transition to fashion photography. A longtime friend Ken Regan first shot sports, then features on sports stars. He cofounded a celebrity stock agency and has published several great picture books. He now spends a good percentage of his time shooting movie stills for Clint Eastwood, Sean Connery, and other top stars.

COMPUTER PROGRAMS AND SKILLS, AND COMPUTER-MANIPULATED IMAGERY/ MONTAGES

All but fine art photographers today require at least some computer skills. Especially important is a good knowledge of the industry-standard Adobe Photoshop program. Photoshop is excellent for retouching minor flaws in an image, or for correcting color balance or removing the odd dust spot in digital images, as I do.

Specialists use Photoshop to manipulate photographs as a basis for elaborate computer montages. This obviously requires expert computer skills, and many practitioners have degrees in computer science as well as a good knowledge of photography. Some digital imaging specialists work with their own photographs, whether film or digital originals, while some work with photographs taken by others. Purely photographic montages are as old as photography itself.

CORPORATE/INDUSTRIAL PHOTOGRAPHY

This specialty requires excellent people skills and a strong, even elegant, sense of composition. High-paying annual report assignments are often given out by top graphic design firms. For success in this field you must be flexible: you may shoot in a boardroom one day, on top of a coal car the next—it has happened to me. In both cases you interfere with the workday of busy people, so you must be able to get what you want fast. There are many ways to learn this specialty—the skills of a photojournalist are transferable. Assisting a good specialist for a while is ideal. Entry-level corporate staff photographers are usually hired from top photo schools.

EDITORIAL/PHOTOJOURNALISM

Some people would separate these categories, but I do not. Photojournalists all photograph picture stories documenting actual events and real people's lives. Good reflexes and graphic sense are paramount skills.

"Soft" editorial photographers like myself shoot for consumer magazines and books, most often photographing people and noncontroversial stories, and may on occasion "set up" or recreate situations. "Pure" photojournalists often cover much tougher stuff, including wars and social problems, and, in theory anyway, never set anything up. In terms of equipment, 35 mm is the norm—again it's increasingly digital equipment. Good lighting skills are a plus, but some "photo-j's" never use any lighting beyond an occasional flash pop. See books by Brazilian Sabastião Salgado to view the work of a graphic master and socially committed true photojournalist, who, of all the photographers in the world, I would be most proud to be. Many photojournalists and editorial specialists belong to the ASMP (American Society of Media Photographers), which has regional chapters.

FASHION AND BEAUTY

Top fashion and beauty photographers work almost exclusively for the clothing and cosmetic industries and related fashion magazines. In the United States, most have studios in New York or Los Angeles, traveling to fashion capitals like Paris, Milan, and London for spring and fall shows and special events. Some specialists shoot mostly men, others children; the majority, though, concentrate on women's wear, by far the largest fashion category. Quite obviously, a sense of style and elegance, a love of beautiful people and things, and a respect for the business is required. You need to be able to work well with models, clients, designers, stylists, and makeup artists, too.

Learn basics by assisting a fashion or beauty specialist—many graduates of photo schools come to New York each September to find assisting jobs. Editorial fashion photography can be free and fun and is often shot outdoors or in beautiful indoor locations. Fashion/beauty advertising has a more studied, or formal, "look" than editorial and is done in studios, most often with medium-format equipment and strobe lighting. European fashion magazines are worth studying to preview future trends in both clothing and fashion photography. Specialist magazine stores and websites are places to view them.

FINE ART

Any photograph can be labeled as fine art, and some are. You are free to express yourself in any way you want. For you to be able to sell prints, the craft aspect of your work should be impeccable. Sadly, fine art pictures are most valuable after the artist is dead! If you shoot highly personal work but do not have a nice spouse or comfortable trust fund to support the living you, you might want to consider teaching. Today, minimum requirements for teaching photography at a good art school or college are an MFA in photography, some history of having work published and/or exhibited in recognized galleries, and excellent communication skills. If you are interested in teaching, the SPE (Society for Photographic Education) can provide some information. It has mostly college teacher members. Its web address is *www.spenational.org*.

GENERALISTS

Some photographers are generalists, either because they live in smaller towns or rural areas or because they like variety. They probably shoot portraits, parties, weddings, and products when called for, and they may do some work for the local newspaper, too. This generalization does not mean they are bad photographers—they probably need to be excellent to make a good living! Some generalists have a storefront studio, while others work from home. Space to shoot, a good camera or two, several lenses, a set of strobe lights and stands, and a flash meter are essential to begin. Having a good website can extend your advertising reach, and the many Internet news groups aimed at photographers can keep you current on trends.

ILLUSTRATION/PEOPLE FOR ADVERTISING

Top advertising photographers who can shoot models in elaborate setups convincingly are highly paid. Individuals have widely differing styles and favorite subject matter. See their work in national magazines and, of course, also in "source books" such as the *Workbook,* published in Los Angeles, which can be

found in libraries. These days, you don't have to live in New York or LA or Chicago to work for great ad agencies, because many highly creative shops are now located in Atlanta, Dallas, Minneapolis, Seattle, and other major cities around the United States and the world. Advertising is an image-conscious business; you will need a great portfolio, an attractive studio, good equipment, and at least one assistant to be convincing. Almost everyone works up to this level gradually. Learn by working for an established advertising specialist. Mostly, these folks are choosy about assistants and hire graduates of good photo schools. A computer whiz has a good chance landing a job with a veteran ad photographer who may not want to do computer work him- or herself. APA (American Photographic Artists) is a national organization with a few local chapters. Its web address is *www.apanational.org*.

MEDICAL/SCIENTIFIC

Almost all specialists in this field work on the staff of private, government, or police research labs, hospitals, or universities. Most have scientific training as well as knowledge of photo microscopy. A specialist acquaintance told me that there are good full-time employment prospects. Check out technically oriented photo schools for training opportunities.

NATURE/WILDLIFE/LANDSCAPE

These are all wonderful specialties, but all ones with which it is hard to make a full-time living. Many photographers, like myself, combine their love of nature with travel and other types of photojournalism, and even with writing or teaching. While 35 mm equipment is the norm for wildlife, landscapists may use any camera format. View books by Frans Lanting, Jim Brandenburg, and Art Wolfe to see the finest animal and bird photography. Heather Angel shoots beautiful nature photographs and also writes excellent how-to books. My favorite landscapists include John Shaw, Richard Misrach, and the great Ansel Adams. Many specialists belong to NANPA (North American Nature Photographers Association).

NEWS/SPORTS

I group these specialties because many photojournalists shoot both breaking news and sports. The smallest of small-town papers use photographs, so almost anyone who loves a fast-paced life and has good photo skills and great reflexes has a chance of breaking in. Show a portfolio with people and local sport examples to the news or photo editor. Major newspapers employ staffers. The NPPA (National Press Photographers Association) may have information on employment opportunities. At a high level, top news specialists work for magazines like

Time and *Newsweek*—both good to study. Top sports specialists know a lot about the games they shoot. Many are former players or participants. See *Sports Illustrated*. Specialized magazines cover auto racing, baseball, basketball, bicycling, football, golf, running, skating, soccer, swimming, tennis, and more.

STILL LIFE AND FOOD

While catalog and commercial photographers—even travel specialists like myself— tackle still-life subjects on occasion, the true specialist can make the most mundane of objects look gorgeous. Someone with this talent, training, lighting expertise, eye for detail, and patience can make a lot of money photographing cans and bottles, watches and jewelry, electronic and household gadgets, cars, tubes of toothpaste, liquor, wine and beer, and canned and packaged foods. A still-life specialist photographs just about any product advertised in magazines or newspapers or on posters and billboards. There is plenty of work out there: still life is one of the most in-demand of advertising photography categories. Much product/object imagery today is created with large-format cameras incorporating swings, tilts, and digital backs.

Food is one of the subspecialties of still life and may be photographed with much detail for advertising or in a looser editorial style for food, lifestyle, and travel magazines. I have shot food as part of editorial travel coverage. Then superfine detail is not critical. To work for a still-life specialist is great training; most hire assistants out of good photo schools.

STOCK

I have made a respectable amount of money from my stock images, which are almost exclusively "outtakes" from travel assignments. That makes me an amateur to today's specialists, who work closely with one or more stock agencies, shooting on demand. Now, serious stock shooters function as production houses, some setting up elaborate situations using top models while fronting the expenses. This obviously excludes many younger shooters without access to capital. However, a new development in the industry is that some of the largest stock houses are giving paid assignments to photographers whose style they like and allowing them some residual income from resulting sales. If you can work out an arrangement with a stock house to do this, it may be a good way to make money and gain exposure.

The biggest-selling stock category is called "lifestyle"—model-released pictures of attractive people, families, and business situations, with the "look" of much advertising illustration. There is a market for unposed, editorial-style travel, nature, and people stock, if the images look fresh and the subject matter

is current. Sadly, however, stock prices in most categories have remained static because of the large number of royalty-free images now available.

Most stock shoots are still financed by photographers, so you would be well advised to work closely with an established stock agent if you want to specialize in this area. PACA (the Picture Archive Council of America, now the Digital Media Licensing Association [DMLA]) is the umbrella organization of stock agencies, sometimes called picture libraries. Members subscribe to a code of ethics regarding payment terms and many other important matters.

STUDIO PORTRAITURE

Top studio portraitists may work for advertising and magazines, but most in smaller markets shoot for individuals, local businesses, and corporations. Executives everywhere need portraits, and so do would-be actors and models, families and schools, and high school and college students. Start small, with a home studio and simple lighting equipment. If you get on well with people and can photograph them so they look their best, your reputation will grow. Who knows where that will take you? Many towns and smaller cities have portrait studios whose owners do excellent work—perhaps you can assist to get experience. The Professional Photographers of America (PPA) organization has many studio-portrait photographers as members. Its web address is *www.ppa.org*. Also see WPPI, under "Weddings."

TRAVEL/LOCATION

Travel specialists like myself are photojournalists who love a wide variety of subjects. We photograph sports, interiors, landscapes, still life, wildlife, churches, offices, castles, gardens, food, nightlife, festivals, and all kinds of people. I have made images of actors, artists, aristocrats, chefs, farmers, jockeys, mayors, ministers, and notables all over the world, for advertising, commercial, and editorial travel clients.

You need great curiosity about the world. If you have that, you will make opportunities to travel. You also must be flexible, have a sense of humor, and be well organized, or the little (sometimes big) dramas that occur on all trips may overwhelm you and prevent you from getting needed coverage. Begin by traveling and building a portfolio. Travel photography is a crowded specialty, so adding a few other strings to your photographic bow will add to your income.

Location photography is done outside a studio and uses the same skills as travel photography. Annual reports, business meetings, conferences, audiovisuals, stock, and more are often shot on location. See my book *Travel Photography* for much more.

WEDDINGS/EVENTS

Wedding photography is practiced at many levels, from the part-timer with a day job who shoots occasional low-budget weddings to the specialist with an international reputation who flies to glamorous locales to cover celebrity nuptials. The average professional wedding photographer is full time, experienced, and reliable—to shoot a wedding is a big responsibility—and may work out of a home office or studio. He or she may be the owner or a staffer of a big operation employing receptionists, salespeople, other photographers, and assistants.

Wedding photographers' styles can be formal or editorial, so-called "photojournalistic." Break into the business by working for an experienced wedding specialist. Locate wedding shooters in the Yellow Pages or on the Internet. Many wedding photographers also cover business and social events. The PPA (see under "Portraits") has many wedding specialist members. So does the Wedding and Portrait Photographers International (WPPI).

CHAPTER 5 EQUIPMENT CONSIDERATIONS FOR FREELANCE PHOTOGRAPHERS

by Chuck DeLaney

YEARS AGO, A top photo magazine editor told me he feared the day that the camera became a commodity. "Like a refrigerator," he said. "There aren't any magazines about refrigerators." In many ways, the explosion of digital-camera types and the inclusion of ever-better cameras in smartphones raise that risk. Today it's hard to muster the same type of affection for the latest digital camera that one might have had for a vintage Nikon F or F2. We're ready to upgrade at a moment's notice.

On the other hand, it's safe to say that there are more camera options for high-quality work now than ever before.

Professionals have a wide range of choices in cameras, lighting equipment, and computer software. Apple consistently promotes the quality of photographs that can be captured with its iPhone. Other manufacturers have introduced smartphones that are expressly designed to appeal to serious photographers. Naturally, HD video is included as well. If you want to spend thousands of dollars, there are high-end cameras modeled on traditional medium-format and single-lens reflex body types, as well as mirrorless cameras and a host of other intriguing designs in between. For action-oriented work, there are cameras that mount on helmets as well as aerial drones equipped with high-performance still/video cameras for under $1,000.

For photographers who wish to work with traditional materials, there are still a lot of used film cameras on the market, and a selection of black-and-white and color films are still available online and at the dwindling number of photo specialty stores.

It's still true that different types of photographic work require a different set of tools. The lenses a sports photographer will carry are not the same ones a portrait specialist is likely to use. The tripod a photographer who works in a studio uses will be sturdier and probably much heavier than the one a nature photographer carries attached to a backpack.

The zeal for trading up from last year's equipment to this year's slightly different version does create one important way for a freelance photographer just getting started to build his or her set of tools: there is a lot of used

equipment—cameras, lenses, and computer hardware—for sale. Let's take up that subject first.

USED EQUIPMENT

I have had good luck buying used equipment. Here's my advice for the photographer who would like to purchase good secondhand equipment.

In addition to cameras taken in trade, at a good photo store you may find used lenses, meters, and lighting equipment. Individuals may sell cameras through online listings or at a flea market or garage sale. If the seller is an individual, chances are you're dealing with someone who has bought new equipment or who has lost interest in photography and wants to cash out.

Where to Find Used Equipment

There are a number of places where you can find used camera equipment—your local specialty store, mail-order dealers that advertise in magazines or online, pawnshops, flea markets and garage sales, and online services such as eBay and Craigslist. Each has its own possible benefits and potential pitfalls.

Obviously, you must be careful wherever you buy used equipment. If you buy from a specialty shop, mail-order house, or online vendor, you will want to ascertain that you are dealing with a reputable merchant. Online reviews and ratings can be very helpful in this regard. If you buy from a pawnshop, flea market, or classified ad, you must scrutinize the equipment meticulously before you take it home, since you're not dealing with an entity that has a reputation to maintain.

Online services are working hard to ensure that there are adequate safeguards to prevent abuse. For example, eBay offers escrow services that allow the purchaser to receive and inspect the equipment before payment is released to the seller. In addition, most services supply some reference information about sellers, so you can find out whether the person from whom you are making a purchase has had favorable reviews or negative ratings from past customers.

My friends who are eBay addicts suggest asking as many questions as possible of the person offering the equipment. Obvious examples: How much have you used the camera? Has it ever been dropped? Has it ever been repaired? Also, specific questions about the camera's features will clue you in as to whether the buyer is legitimate and has the camera to sell.

Sizing Up Used Equipment

Assuming you can physically inspect the equipment you may purchase, first look closely at the exterior. Are there signs that the camera has been dropped

or suffered severe physical shock? Don't be concerned about a few chips in the finish or minor dents, although those do indicate that the camera has traveled quite a bit.

It's unreasonable to expect that the camera was owned by a collector who never used it. In fact, it's better if a camera or lens has had light use during its lifetime. What you want to avoid is equipment that has been mistreated by a clumsy owner or used heavily by a professional. Sooner or later, every camera will experience failure of some system after heavy use.

When you inspect a camera lens, feel how the focusing mechanism responds as you run through it. Are there any rough spots? Hold the lens to your ear and listen while you adjust the focus. You shouldn't hear any strange noises. If you're looking at a zoom lens, run through the zoom range. Feel and listen for any abnormalities.

Terms of Purchase and Warranty

When you buy from an individual at a flea market or from your local newspaper's classified section, you're not likely to get any guarantee or offer of warranty. In these instances, you need to trust your own assessment of the equipment you are considering. If possible, ask if you can take some photographs with the camera (or lens). This will give you a chance to determine whether there is anything wrong with the camera.

If you purchase via online or mail order, many reputable dealers state their warranty policy. For example, B&H Photo, the large specialty store in New York City, states that all used equipment is guaranteed to work, regardless of cosmetic condition. Used photo items are guaranteed for a designated period, and there's a fair return policy. Most large sellers also offer some kind of rating service. KEH Camera (www.keh.com) has been a used-equipment dealer for many years, and visiting their site to learn about the rating system they use, their warranty (180 days), and their return policy is a good way to see what kind of standards reputable businesses offer.

There are used-equipment dealers that have been in business for many years and value their reputations highly. Others can be less than satisfactory. I suggest that you ask for references of other customers; make sure you understand what warranty or guarantee is included as well as the return policy. It also makes sense to pay with a credit card, so you have some protection if there is a problem.

When you buy from a photo retailer, you should make sure that you get a written confirmation of the terms. You should be able to expect a sixty- or

ninety-day guarantee and possibly a short period when you can return the item if it does not meet your expectations.

If you follow the advice I've offered in this section, you should have no problem getting great value when you shop for used photo equipment.

LIGHTING EQUIPMENT

There's always the old-school solution. For many years I used two 500-watt quartz hot lights that probably cost me $150, including stands. I'd estimate I billed $30,000 from jobs I shot using just those two lights, principally making slides for artists of their paintings and sculpture and various types of copy work. These were far from the most exciting jobs, but I did meet a lot of interesting people and paid a lot of bills with that work.

The most exciting innovation in lighting in recent years is the cool, continuous-lighting option offered by LED lights. Continuous lighting using tungsten or quartz bulbs used to be called "hot lights," and they offered many problems. High-wattage bulbs tripped circuit breakers and heated up the studio in a short period of time. Today's LED units avoid those problems and also offer the ability to raise and lower the level of illumination and vary the color temperature just by turning a dial or two. Given that many photographers are also making short video clips in the studio at the same time that stills are made, the ability of continuous-light LED units to capture both still and video images is another plus.

When it comes to electronic flash units, my advice is that you shouldn't feel the need to start with expensive brands. Start simply with two or three lights and decent stands. I don't care whether you opt for flash heads that run off a power pack or select monolights that contain their own charging units. However, you want lights with slave capacity and good modeling lights. For me, a good modeling light is one that is bright enough to show clearly the highlight and shadow areas on your subject in regular room light.

Some models are more lightweight than others, which may be a consideration if you plan to travel a lot. Many companies make low-cost units, but I can personally vouch for those made by Photogenic and Paul C. Buff's brands—White Lightning, Einstein, and Alien Bees.

There's a saying: "light is light." When the shutter is tripped and the flash fires, the light put out by an inexpensive unit is essentially the same as that generated by the most expensive one. What counts is your ability to manipulate the light and place it properly. Naturally, bigger, more powerful units put out more light, but most of the time you won't need a lot of power. For most people and photos, a low- or medium-power head will suffice.

LENSES

One of the great attractions of SLRs and many medium- and large-format cameras is that you can use the camera body with a variety of lenses. Today, photographers have the ability to choose between a great variety of lenses, including those made by the camera's manufacturer as well as models made by companies that specialize in making lenses for cameras that were manufactured by another company.

Renting Lenses

I would caution that you shouldn't go out and spend $1,000 or perhaps much more on a telephoto lens or a perspective-control lens or any other special piece of gear if you need it for a single job. Under those circumstances, consider renting. There are many rental houses in the big cities that will even ship a rental item to you. It is customary that you secure the value of the lens by letting the rental house put a hold for an agreed-upon amount on your credit card until the rental is completed and the lens (or other piece of equipment) is returned to the rental house in good condition.

I've had good luck renting equipment, and it has given me the opportunity to use a variety of gear that I would have never been able to purchase.

Lens Maximum Aperture

If, on the other hand, you know that you need to purchase a specific type of lens because it is essential to the type of work that you do, then you should do some research before you buy. One key question is whether you need a large-aperture lens, such as an f/2.8, or whether a lesser maximum aperture will do the job. Obviously, the two benefits to a lens with a maximum aperture of f/2.8 is that it will allow you to use higher shutter speeds in a given situation than an f/4 or an f/5.6 lens, and, using f/2.8, you'll be able to count on a shallow depth of field that will throw your background out of focus and enable you to isolate your subject. This is very helpful for sports and photojournalism subject matter. Naturally, faster lenses cost more. They generally have more complicated designs and use larger glass elements to enhance their light-gathering ability. Compare, for example, the cost of any manufacturer's 80–200 mm zoom lens that has a constant maximum aperture of f/2.8 with the much lower cost of a model by the same manufacturer that might have an aperture range of f/4 to f/5.6.

Zoom Lenses with Varying Apertures

I frequently get questions from students with regard to why zoom lenses often have varying apertures. For example, you'll get a 28–70 mm zoom lens with your

camera, and the aperture reading on the lens barrel might be something like "28–80mm 1:3.5–5.6," or "70–210mm 1:4–5.6." Simply stated, most inexpensive zoom lens designs do not give a uniform light transmission at all focal lengths. In the first example above, the lens barrel notation tells you that when you have the zoom lens set at 28 mm, the maximum aperture is f/3.5, and that when the lens is at 80 mm, the maximum aperture has dropped to f/5.6. When you have the lens set to intermediate settings in between those two extremes, the maximum aperture will be somewhere in between.

Prior to the advent of auto-exposure cameras, this change in light transmission used to require compensation by the photographer. Now, under most circumstances, using either automatic exposure or shutter or aperture priority, the camera will automatically compensate for the drop in light transmission at longer focal lengths. That's one of the reasons that zoom lenses have become both popular and practical with today's automatic cameras. The problem remains that with a zoom lens with a varying aperture, when you're using a long focal length, the small aperture may dictate a long shutter speed that increases the danger of camera shake.

Prime Lenses

In today's zoom-lens world, I still enjoy using a prime lens. I recently bought a used 105 mm 2.8 micro Nikkor, and it got me back on a kick using prime lenses. The sharpest-possible images can be made using a good prime lens and a camera mounted on a tripod. Plus, you'll find most prime lenses have larger maximum apertures than zoom lenses. This means you'll be able to work in lower light and easily use selective focus.

Aftermarket Lenses

Not long ago, a young photographer asked me whether he should buy a 300 mm lens made by the manufacturer of his camera, or whether he should purchase a lens from one of the aftermarket manufacturers for about one-fifth the price of the "name" lens.

Particularly if you want a long telephoto lens or a zoom lens in the telephoto range, you will see that you can buy one from Canon or Nikon for several thousand dollars or more. The same focal-length lens, with the same aperture size, can be purchased from an "aftermarket" manufacturer such as Sigma, Tamron, or Tokina for a fraction of the cost of the name brand.

Can a lens that costs a fraction as much be just as good as a brand-name lens? Put the other way around, what are you getting if you spend five times as

much for a brand-name lens? The answer to the first question is "It depends." The answer to the second question is "A few things." Let me explain.

In photography, the main aftermarket is in lenses for SLR cameras. The three companies I named earlier—Tamron, Sigma, and Tokina—all make very good lenses. In fact, since the companies that make optical-quality glass in Japan sell to all the manufacturers, it's possible that the glass you purchase in a "name" lens is exactly the same as the glass in an aftermarket lens. The difference is that the major manufacturer may assemble the lens using higher-quality rings, fasteners, and lubricants. Quality control and testing at the major manufacturer may be more demanding.

The reason that "It depends" is the answer to whether the lens is just as good is that it depends on who you are and what you're going to do with that lens. If you need a long lens or a long zoom because you plan to photograph eagles three times a year when the weather is nice, you'll be fine with an aftermarket lens. If, on the other hand, you're going to use that lens seventy-five times a year in a lot of nasty weather, and it will be traveling in the luggage compartment of a lot of airplanes, then you'll probably be better off with the lens that has been assembled by the name manufacturer with professional wear and tear in mind.

I have been very satisfied with the aftermarket lenses I've used and owned. They are very well made, and I've seen them stand up under heavy use. For more money, with the name lens, you will get a product that is a bit "better" in some respects, but the truth of the matter is that the aftermarket lenses by the major manufacturers I've mentioned are in most respects "good enough."

TWO SECURITY TIPS

In closing, I have two important tips regarding your equipment. When I first fell in love with photography and owned one camera body and a few lenses and a light meter, I kept everything together in my camera bag, at the ready, so I could just grab it and go. Great idea. The problem was that I lived in a high-crime New York City neighborhood, and a burglar grabbed it and went. Now, when I have a lot more equipment, I keep a body and a few lenses here, my view camera in another room, and other odds and ends in a variety of locations. I might lose some stuff, but no one other than me could find everything. Don't make it too easy for a burglar.

In the same vein, I usually work with a nondescript, dark, cloth camera bag. I shudder at the thought of carrying around gear in a bright metal case. To me, those shout, "Steal me!" If you want to protect your gear from bumps and bruises, line your bag with high-density foam rubber or some other cushioning

material. When it comes to bags, when you work on the street or have to travel in rough neighborhoods, the funkier the better.

A FEW PACKING TIPS

I always keep two small flashlights in each camera bag that I use. There are many times when I find myself in the dark, or working in low light, and I need to see what I'm doing. This way, when you're on location and there's a power failure, you'll be able to find a flashlight quickly. I prefer a small flashlight to the light on a smartphone, because at times I need to have both hands free to manipulate equipment and I can hold the flashlight with my teeth. It sounds crude, but it works.

In addition to a flashlight, I always keep a large plastic garbage bag with my gear. I don't carry waterproof cases and a heavy rainstorm can crop up anywhere, anytime. When it does, there's nothing like having a large garbage bag big enough to contain all your gear to prevent equipment from getting ruined as you wait out a torrential downpour.

Finally, it's wise to pack a set of earplugs, so you have them at the ready in case you find yourself in a very noisy location without advance notice.

BUILDING AND PROTECTING YOUR BUSINESS

LEARNING HOW TO make beautiful photographs can be an exhilarating experience. But starting a photography business requires discipline and planning. The six chapters in this section cover topics that are essential to success in starting and running a photographic studio. We begin with the basic business plan for photographers—how to plan for the costs you'll encounter and how to fund your business during the start-up phase and beyond.

Realize there are going to be many decisions for you to make as you go along. For example, your plan may be to have people pay you to take photographs of their wedding and assemble the best photos into an album that you sell to the customer. You're going to be a wedding photographer! But there are important details—do you want to shoot every wedding yourself and work thirty or more weekends a year? Or would you prefer to do the selling and booking for a larger enterprise and have three crews that photograph one hundred weddings a year under your direction? It's the same business model—selling people wedding albums made by your studio—but the two approaches have divergent business plans.

Regardless, you're going to need a studio, and you may decide to rent space outside your home to conduct your business. You're also going to have to think about how to structure your business. Should it be a sole proprietorship, a partnership, or a corporation? In addition to having a structure for your business, you're going to need to create an image for it. What should you name your business? Do you need a logo? All these topics are covered in Part II.

Finally, you have to protect both yourself and your business. The last two chapters in this section provide insights into how to insure yourself and your business against risk and how to protect your health from the most common stresses and strains that photographers encounter.

CHAPTER 6 YOUR BUSINESS PLAN

by Tad Crawford

STARTING A BUSINESS requires planning. You have to estimate your expenses and your income, not just for the first year but for as many years into the future as you can reasonably project. Some expenses only happen once, while others recur each year.

For starting costs you may only have to pay once, consider the following list:

- Fixtures and equipment
- Installation of fixtures and equipment
- Decorating and remodeling
- Legal and other professional fees
- Advertising and promotion for opening

Of course you must realistically think through the outlays you are going to have to make. Daydreaming can be pleasant, but in business it can easily become a nightmare.

What about the outlays that you'll have to make every month? Here's a partial list:

- Your own salary
- Any other salaries
- Rent and utilities
- Telephone and Internet
- Advertising
- Materials and supplies, insurance premiums, maintenance
- Legal and other professional fees
- Taxes (often paid in installments during the year or in full with the return)
- Miscellaneous

Maybe the last category is the most important, because it's the unexpected need for cash that leads to trouble for most photographers. If you can plan properly, you will ensure that you can meet all your needed outlays. And don't leave

out your own salary. Martyrs don't make the most successful business owners. If you worked for someone else, you'd get a salary. To see realistically whether your business is making a profit, you must compute a salary for yourself. If you can't pay yourself a salary, you have to consider whether you'd be doing better working for someone else.

Your income is the next consideration. What sort of track record do you have? Are you easing from one field of photography into another field, in which you're likely to have success? Or are you striking out toward an unknown horizon, a brave new world? You have to assess, in a fairly conservative way, how much income you're likely to have. If you just don't know, an assessment of zero is certainly safe.

What we're talking about is *cash flow*. It should probably be the most important word in the photographer's business lexicon, although *bottom line* is also a crucial term. *Cash flow* is the relationship between the influx of cash into your business and the outflow of cash from your business. If you don't plan to invest enough money in your business initially, you are likely to be *undercapitalized*. This simply means that you don't have enough money. Each month you find yourself falling a little further behind in paying your bills.

Maybe this means your business is going to fail. But it may mean that you just didn't plan very well. You have to realize that almost all businesses go through an initial start-up period during which they lose money. Even the Internal Revenue Service recognizes this. So after you plan for your start-up expenses and your monthly expenses (with an extra amount added in to cover contingencies you can't think of at the moment), you can see how much cash you're going to need to carry the business until it becomes profitable. Your investment should be enough to carry the business through at least one year without cash flow problems. If possible, you should plan to make a cash investment that will carry the business even beyond one year. Be realistic. If you know that you're going to have a profit in the first year, that's wonderful. But if it may take you a year or two before you have a profit, plan for it. It's easy to work out the numbers so you'll be a millionaire overnight, yet it's not realistic. In fact, it's a direct path to bankruptcy. But once you realize you need money to avoid being undercapitalized when you start or expand your business, where are you going to be able to find the amount you need?

SOURCES OF FUNDS

The most obvious source of funds is your own savings. You don't have to pay interest on it, and there's no due date when you'll have to give it back. But don't think it isn't costing you anything, because it is. Just calculate the current interest

rate—for example, the rate on short-term United States Treasury notes—on what you've invested in your business. That's the amount you could earn by relaxing and not working at all.

What if you don't have any savings, and your spouse isn't keen on donating part of his or her salary to support your studio? Of course you can look for investors among family, friends, or people who simply believe you're going to create a profitable business. One problem with investors is that they're hard to find. Another problem is that they share in your profits if you succeed. And, after all, isn't it your talent that's making the business a success? But if you're going to have cash-flow problems and are fortunate enough to find a willing investor, you'll be wise to take advantage of this source of funds.

The next source is your friendly banker. Banks are in the business of making money by lending money, so you'd think they'd be happy to have you as a client. You may be the lucky photographer who finds such a bank, but most loan officers know that the photography business carries high risks and is unpredictable. Conservatism is ingrained in their natures (otherwise they'd be opening their own photographic studios). So if you're going to have any chance of convincing the bank to make a loan, you must take the right approach. You should dress in a way that a banker can understand. You should know exactly how much money you want, because asking for too much or too little money is going to create a bad impression. It will show that you haven't done the planning necessary to succeed. You should be able to detail precisely how the money will be used. You should provide a history of your business—from a financial standpoint—and also give a forecast.

It's important to keep good business records in order to make an effective presentation to the bank. The loan officer must believe in the quality of management that you offer to your business. One other point to keep in mind is the importance of building a relationship with your banker. If he or she comes to know and trust you, you're going to have a much better chance of getting a loan.

But, frankly, bank loans are going to be very difficult for many photographic businesses to obtain. Where can you turn next? The most likely source is borrowing from family and friends at a reasonable interest rate. Of course, if you give personal guarantees (and also to keep family harmony), you have to pay back these loans whether or not your business succeeds. (If you didn't have to pay back the money, you'd be dealing with investors rather than lenders.) Another possibility is borrowing against your life insurance policy if it has cash value. The interest rate is usually far below the current rate at which you would be borrowing from a bank. And, if you have been able to obtain credit cards that have a line of credit (that is, that permit you to borrow up to $2,500, $5,000, or

more on each card), you can exercise your right to borrow. Depending on the number of cards you have and the amounts of the credit lines, you may be able to borrow thousands of dollars in this way. This is dangerous, however, and not an approach to be taken lightly. At the least, you should plan to repay credit-card cash advances promptly, to avoid the high interest rates imposed on money borrowed in this way.

One other potential source of funding would be to look to Internet crowdfunding and investing sites. There are a variety of sites that seek investors in a single project and others for investors interested in new businesses. Some sites offer loans with interest and a repayment schedule, while other sites offer to locate investors who are interested in owning a portion of the business. This is a relatively new development based on the Internet's unique ability to connect people who would otherwise not be aware of each other. Since the models are still evolving, if this type of funding is of interest, use a search engine and try keywords such as "crowdfunding" and "online investment companies."

How the online audience will react to your proposal is unpredictable. Obviously investors are looking for a good idea and someone with the experience and resources to pull it off. Sometimes the results can be surprising. One photographer proposed publishing two books of portraits, emphasizing one that would feature seriously wounded recent war veterans in heroic (and near nude) poses. The goal for the book was set at $48,000, but a very strong response brought in over $350,000. Different sites have different ways of monetizing this service. Some keep a percentage, others charge a fee, and it's likely that models will change over time as new sites come into existence.

Once you're up and running, trade credit will undoubtedly be an important source of funds for you. It's invisible, but it greatly improves your cash flow. Trade credit is simply your right to be billed by your suppliers. The best way to build up trade credit is to be absolutely reliable. In this way, your suppliers come to trust you and are willing to let you owe greater and greater amounts. Of course you must pay promptly, but you are paying roughly thirty days later than you would pay on a cash transaction.

The other side of the coin is your own extension of credit to your clients. This creates accounts receivable, which are an asset of your business in somewhat the same way that your cameras and your cash are assets of the business. But what is the magic formula by which you convert accounts receivable into cash when you desperately need it? You can *factor* your accounts receivable. This means that you sell your accounts receivable to another company—the factor—that collects the accounts receivable for you. What does the factor pay for the accounts receivable? The factor gives you the full amount of the accounts receivable, less a

service charge. The effect of the service charge can be a very high annual interest rate. So take warning. Using factors isn't the magic trick it appears to be at first. In fact, it's inviting disaster. If your cash flow is bad, factoring is likely to make it much worse in the long run.

But, as the famed economist Lord Keynes said, none of us will be around in the long run. So let's put it another way: The long run may be in the immediate future if you factor. And the reason you would have to factor is poor planning in the first place. You were undercapitalized. Another possible avenue for securing funds is the Small Business Administration (SBA). While the SBA does not make direct loans, it will sometimes give a guaranty for a loan made by another party. The SBA guaranty might be as much as 85 percent for a loan up to $150,000 or 75 percent for a loan greater than $150,000, subject to a maximum guaranty of $1 million. It's certainly worth a visit to the SBA website at *www.sba.gov* and an exploratory telephone call to your local SBA office to find out what is possible.

The true message is *not* to borrow unless you know you're going to be able to repay the money from your business. There's no point in borrowing from one source after another as your business slides closer toward bankruptcy. Not only should you *not* factor your accounts receivable, but you should not borrow against your life-insurance cash value or draw on your credit lines unless you definitely know that you will be doing the business necessary to pay back that money. Being adequately capitalized is a necessity if you are to have that wonderful feeling of confidence that comes from knowing that your business has the stamina to survive early losses and succeed.

EXPANSION

Expanding is much like starting a business. You must be adequately capitalized for the expansion to be successful. This means reviewing your expenses and your income so you can calculate exactly how the expansion will affect your overall business. Then you have to decide whether you have the cash flow to finance the expansion from the income of the business. If you don't, once again you must consider sources of financing. If you're buying equipment, keep equipment-financing companies in mind as a potential credit source.

One of the most important reasons to expand is an economic one—the economies derived from larger-scale operations. For example, pooling with a number of photographers may enable you to purchase equipment you couldn't otherwise afford, hire a receptionist that your business alone couldn't fully utilize, or purchase supplies in quantities sufficient to justify a discount. If you can hire an assistant who earns you enough money or saves you enough time to make

more than the assistant's salary (and related overhead expenses), the hiring of the assistant may very well be justified.

On the other hand, expansion is hardly a panacea. In the first place, you'll probably have difficulty financing any major expansion from the cash flow of the business. Beyond this, expansion ties you into certain expenses. Suddenly you have an assistant, a receptionist, a bookkeeper, and a stylist. You need more space, and your rent increases. You're shooting more jobs, so your expenses increase for all your materials. You find that you must take more and more work in order to meet your overhead. You may even consider a rep, if you can get one, because you need to do a greater volume of business. But the rep will take 25 percent in commissions, so that's hardly going to solve your need for more productive jobs.

Suddenly you realize that you've reached a very dangerous plateau, and that you're faced with a choice that will have lasting consequences for your career. You expanded because you wanted to earn more. But the more resources that you brought under your control—whether equipment, personnel, or studio space—the more time you had to spend managing these resources to make them productive. Now you must decide whether you are going to become a manager of a successful photographic business or cut back and be primarily a photographer. If you choose to be a manager, you had better be a very good one. If you go the expansion route, it's very painful to have to cut back if the business temporarily hits hard times—firing employees, giving up space you've labored to fix up, and so on. The alternative to being a manager is to aim for building a small business with highly productive accounts. You can be a photographer again without worrying so much about the overhead and the volume you're going to have to generate in order to meet it. Of course, you'll make your own decisions, but be certain that you're keeping the business headed in the direction that *you* want it to take.

SMALL BUSINESS ADMINISTRATION

The Small Business Administration was created in 1953 to help America's entrepreneurs build successful small enterprises. The SBA now has offices in every state, the District of Columbia, the Virgin Islands, and Puerto Rico to offer financing, training, and advocacy for small firms. This agency also works with thousands of lending, educational, and training institutions nationwide. Its website at *www.sba.gov* has an abundance of useful information, including advice on "Business Plans," "Frequent Startup Questions," "Expanding Your Business," and "Managing Your Business." Some of the SBA services and financing programs are aimed at "small" businesses with annual revenue in the millions,

but there are micro-financing options and services aimed at selected groups such as veterans and women and minority-owned businesses.

In addition, if you have questions that you can't find answers to on the website, you can call the SBA Answer Desk at 1-800-827-5722 or send an email to the SBA at *answerdesk@sba.gov*. You can also contact your local SBA office and speak to or meet with a counselor who will help you with your specific problem. While these counselors are likely to have had limited contact with photographers, you may still get some helpful advice. The Service Corps of Retired Business Executives (SCORE) has been formed under the SBA and brings the experience and wisdom of successful business people to the counseling program. SCORE offices can be found across the country and are listed on the SBA website.

CHAPTER 7 LOCATION AND LEASES

by Tad Crawford

THE LOCATION OF your business is extremely significant. If you run a photographic studio catering to the public, then you must be conveniently located for the public to come to your premises. The area must have a healthy economy with good prospects for the future, so you can count on a continuing flow of clients who are able to afford your services. If you work on assignment, then you must be able to reach the buyers with whom you'll be transacting business. You must consider the location not only from the marketing viewpoint but also with respect to rent, amounts of available space (compared to your needs), competition, accessibility of facilities that you need (such as labs), and the terms under which you can obtain the space. Speak to other photographers and business people in the area to find out all you can.

Since many photographers have their studios in their homes, it's worth considering this as the first option. You'll save on rent and gain in convenience. However, you may not be near your market and you may also have trouble taking the fullest possible tax deductions for space that you use. The deduction of a studio at home is discussed in chapter 21, "Taxes."

ZONING

Another potential problem with having a studio at home is zoning. In many localities, the zoning regulations will not permit commercial activity in districts zoned for residential use. If you didn't realize this, you could invest a great deal of money setting up a photographic studio, only to find you could not legally use it. But even when the zoning law says a home may not be used for commercial purposes, it is unlikely that you'll be prevented from conducting certain aspects of your photographic business, such as shooting and editing. Problems usually arise when your business requires a flow of people to and from the premises, whether they are clients or people making deliveries. The more visibly you do business, the more likely you are to face zoning difficulties. If you are considering setting up your studio in a residentially zoned area, you should definitely consult a local attorney for advice.

What happens if you rent a commercial space for your studio and decide to live there? This has become more and more common in urban centers where

rents are high. You run the risk of eviction, since living in the studio will probably violate your lease as well as the zoning law. Some localities don't enforce commercial zoning regulations, but you must be wary if you are planning to sink a great deal of your money and time into fixing a commercial space with the plan of living there. Especially in this situation, you should ask advice from an attorney who can then also advise you how to negotiate your lease.

NEGOTIATING YOUR LEASE

It's worth saying a few words of warning here about the risks involved in fixing up your studio. You can lay out thousands of dollars (many photographers have) to put up walls for your shooting space, reception area, and dressing room for models; to put in wiring and plumbing for a bathroom and pantry area; and to redecorate and refurbish your space in every way so that it's suitable for your special needs. What protects you when you do this?

If you're renting, your protection is your lease. The more you plan to invest in your space, the more protection you need under your lease. There are several crucial points to consider:

- Length of the lease
- Option to renew
- Right to sublet
- Ownership of fixtures
- Right to terminate
- Hidden lease costs

You have to know that you are going to be able to use your fixed-up space long enough to justify having spent so much money on it. A long lease term guarantees this for you. But what if you want to keep your options open? A more flexible device is an option to renew. For example, instead of taking a ten-year lease, you could take a five-year lease with a five-year option to renew. But you want to guarantee not only that you'll be able to stay in the space, but also that you can sell your fixtures when you leave. In most leases, the landlord owns all the fixtures when you leave, regardless of who put them in the space. If you want to own your fixtures and be able to resell them, a specific clause in the lease would be helpful.

The right to sublet your space—that is, to rent to someone else who pays rent to you—is also important. Most leases forbid this, but, if you are selling fixtures, it can be important who the new tenant is. Your power to sublet means you can choose the new tenant (who can then stay there for as much of your lease term as

you want to allow). On the other hand, you may not be able to find a subtenant. If your business and the rental market are bad, you may simply want to get out of your lease regardless of the value of the fixtures you've put into the space. In this situation, the right to terminate your lease will enable you to end your obligations under the lease and leave whenever you want to. Remember that without a right of termination, your obligation to pay rent to the landlord will continue to the end of the lease term, even if you vacate the premises (unless the landlord is able to find a new tenant). In every lease you should look for hidden lease costs. These are likely to be escalators—automatic increases in your rent based on various increasing costs. Many leases provide for increased rent if fuel prices increase. Others require you to pay a higher rent each year based on increases in the consumer price index. Of course, you want to know about all these hidden costs—whether to include them in your budget or to try to negotiate them out of the lease.

This is a very brief discussion of the negotiation of your lease. For a more extensive analysis, you can consult *Legal Guide for the Visual Artist* by Tad Crawford. Your attorney can aid you with the ins and outs of negotiating a lease.

CHAPTER 8 THE GOING CONCERN

by Tad Crawford

MOST PEOPLE DON'T leap into a profession. They test and explore it first and gradually intensify their commitment. This is as true of photography as it is of any other entrepreneurial activity. Many photographers start part time while going to school or working at another job. For some it is a dream they work toward, even when supporting themselves with other work, and for others it is the extension of a beloved hobby. But once the photographer begins to market his or her work, questions inevitably arise as to the basics of operating a business. Should it be incorporated? Where can it be located? What kind of records do you need? What taxes will you have to pay?

Making decisions about these kinds of questions requires knowledge. Your knowledge can be gleaned from experience or from advisors with expertise in accounting, law, and business. The most important skill that you must have is that of problem recognition. Once you're aware that you face a problem, you can solve it—by yourself or with expert help.

FORM OF DOING BUSINESS

You will probably start out in the world of business as a *sole proprietor*. That means that you own your business, are responsible for all its debts, and reap the rewards of all its profits. You file Schedule C, "Profit or Loss From Business (Sole Proprietorship)," with your Federal Tax Form 1040 each year and keep good business records for tax purposes. The advantages of being a sole proprietor are simplicity and a lack of expense in starting out.

However, you have to consider other possible forms in which your photography business can be conducted. Your expert advisors may decide that being a corporation, partnership, or limited liability company (LLC) will be better for you than being a sole proprietor. Naturally you want to understand what each of these different choices would mean. One of the most important considerations in choosing between a sole proprietorship, partnership, corporation, and limited liability company is taxation. Another significant consideration is personal liability—whether you will personally have to pay for the debts of the business if it goes bankrupt.

As *sole proprietor*, you are the business. Its income and expenses are your income and expenses. Its assets and liabilities are your assets and liabilities. If the business owns a Hasselblad and has taken a $1,000 loan from a bank, you owe the bank $1,000 and have a great camera. The business is you, because you have not created any other legal entity.

Why consider a *partnership*? Perhaps because it would be advantageous for you to join with other photographers so you can share certain expenses, facilities, and possibly clients. Sometimes two or more heads really are wiser than one. If you join a partnership, you'll want to protect yourself by having a partnership agreement drawn up before starting the business. As a partner you are liable for the debts of the partnership, even if one of the other partners incurs the debts. And creditors of the partnership can recover from you personally if the partnership doesn't have enough assets to pay the debts that it owes. So you want to make sure that none of your partners is going to run up big debts that you end up paying for from your own pocket. The profits and losses going to each partner are worked out in the partnership agreement. Your share of the profits and losses is taxed directly to you as an individual. In other words, the partnership files a tax return but does not pay a tax. Only the partners pay taxes based on their share of profit or loss.

A variation of the partnership is the *limited partnership*. If you have a lot of talent and no money, you may want to team up with someone who can bankroll the business. This investor would not take an active role in the business, so he or she could be a limited partner who would not have personal liability for the debts of the partnership. You, as photographer, would take an active role and be the general partner. You would have personal liability for the partnership's debts. You and the investor could agree to allocate the profits equally but to give a disproportionate share of any tax losses to the investor (such as 90 percent). This hedges the investor's risk, since the investor is presumably in a much higher tax bracket than you are and will benefit by having losses (although profits are naturally better than losses, no matter how much income the investor has).

The next avenue to consider is that of a *Subchapter S corporation.* This is a special type of corporation. It does provide limited liability for its shareholders, which is what you would be. However, there is basically no tax on corporate income. Instead, the profit or loss received by the corporation is divided among the shareholders who are taxed individually as partners would be. The disadvantage of incorporating is the added expense and extra paperwork.

What you normally think of as a corporation is not the Subchapter S corporation, but what we'll call the *regular corporation*. The regular corporation provides

limited liability for its shareholders. Only the corporation is liable for its debts, not the shareholders. You should keep in mind, however, that many lenders will require shareholders to personally sign on a loan to the corporation. In such cases, you do have personal liability, but it's probably the only way the corporation will be able to get a loan.

The key difference in creating a regular corporation is that it is taxed on its own taxable income. There is a federal corporate income tax with increasing rates as follows:

- 15 percent on taxable income up to $50,000
- 25 percent on taxable income from $50,000 to $75,000
- 34 percent on taxable income from $75,000 to $100,000
- 39 percent on taxable income from $100,000 to $335,000
- 34 percent on taxable income from $335,000 to $10,000,000
- 35 percent on taxable income from $10,000,000 to $15,000,000
- 38 percent on taxable income from $15,000,000 to $18,333,333
- 35 percent on all taxable income over $18,333,333

In addition, there may be state and local corporate income tax to pay. By paying yourself a salary, of course, you create a deduction for the corporation, which lowers its taxable income. You would then pay tax on your salary, as would any other employee. If, however, the corporation were to pay you dividends as a shareholder, two taxes would be paid on the same income. First, the corporation would pay tax on its taxable income, then it would distribute dividends and you would have to pay tax on the dividends.

The advantages of the regular corporation include the ability to make greater tax-deductible contributions to your retirement plan than you would be able to make as an individual. The disadvantages include, again, extra paperwork and the need for meetings, as well as the expenses of creating and, if necessary, dissolving the corporation.

All states have passed legislation creating a form of business entity called a *limited liability company*, which combines the corporate advantage of limited liability for its owners while still being taxed for federal income tax purposes as a partnership, a sole proprietorship (in the case of a single-member LLC), or a Sub S or regular corporation (with an election). The limited liability company offers great flexibility in terms of the mode of ownership and the capital structure of the company, as well as what corporate formalities the company must observe.

In general, the tax law requires that a partnership, an S corporation, or a personal-service corporation (which is a corporation whose principal activity is

the performance of personal services by an employee-owner) use a calendar tax year, unless there is a business purpose for choosing a different fiscal year.

From this brief discussion, you can see why expert advice is a necessity if you're considering forming a partnership, corporation, or limited liability company. Such advice may seem costly in the short run, but in the long run it may not only save you money but also give you peace of mind.

BUSINESS LICENSING AND REGISTRATION

Photography is considered innocuous and not a danger to the public welfare. For this reason, state statutes requiring the licensing of photographers have generally been held unconstitutional. While a number of states require that a fee be paid in order to practice photography professionally, there is no examination to determine your proficiency as a photographer. Of course, states and localities can regulate photographers who sell their services from door to door or in public places. And if you're going to be shooting in a way that may disrupt public activities, you should certainly consider whether you need a permit from the local government. A local attorney or photographers' society is obviously the best place to find out exactly which regulations apply in your area.

The registration of your business—or the name of your business—is also important. This is usually done with the county clerk in the county in which you have your studio. The purpose of this registration is to ensure that the public knows who is transacting business. Thus, partnerships must file and disclose the names of the partners. Individuals doing business under an assumed name must disclose their true identity. But an individual photographer doing business under his or her own name might very well not be obligated to file with the county clerk. In any case, you should call the county clerk to find out whether you must comply with such requirements. The fee is usually not high.

SALES AND MISCELLANEOUS TAXES

Many states and cities have taxes that affect photographers. Included here are sales taxes, unincorporated business taxes, commercial occupancy taxes, and inventory taxes. You should check in your own state and locality to determine whether any such taxes exist and apply to you. By far the most common tax is the sales tax, however, and it deserves a more extensive discussion.

The sales tax is levied on sales of tangible personal property. If a book is sold by a bookstore, a sales tax must be paid. We will discuss the New York State sales tax, but sales taxes have many similarities from state to state. In New York State, the sale of reproduction rights is not considered to be a sale of tangible personal

property. Reproduction rights are not tangible or physical; they are intangible. So no sales tax is charged on them.

Generally, no tax is charged on items that are going to be resold.

If a paper manufacturer sells paper to a printer who in turn manufactures books for a publisher who sells the books to a retailer, only the retailer should collect the sales tax from the individual who purchases the book and pay it to the State Sales Tax Bureau (which has local offices in many communities). Sales taxes are levied on the last sale when a product reaches the consumer, not on every step in the series of sales that are necessary to transform the finished product.

The photographer has a number of special considerations with respect to the sales tax. First, sale by the photographer of reproduction rights usually does not require the collection of the tax. Significantly, in an advisory opinion, the Technical Services Bureau of the New York Department of Taxation noted, "[R]eceipts from the electronic transfer of digital photographic images over the Internet represent receipts from the sale of an intangible and are not subject to sales tax." (This particular exemption may not apply in some states. You should check the point carefully in your state.)

But if the photographer also sells a physical object, such as a print, then sales tax must be collected on the full sale price (you can't try to separate the price of the print from the price of the reproduction rights). The photographer can hand over a print as long as it is returned—no sales tax has to be collected. But if the client retouches the photograph, a sales tax will have to be paid because the client has acted like the owner of the physical object (as opposed to just a licensee of reproduction rights).

A common question is whether sales tax must be charged on those components of a bill that don't relate to materials. For example, if your bill lists services, materials, and travel expenses, should you collect tax on the total bill or simply on parts of it? The Sales Tax Bureau insists that you collect and then pay tax on the entire bill. This is true despite the fact that your services would not be subject to sales tax if billed separately, because no tangible object is transferred. And some of the expenses you bill, such as models or travel, would not require collection of sales tax if billed separately. But when your bill relates to the transfer of a physical object, sales tax must be collected on the total billing. It also doesn't matter where the expenses were incurred. Whether they were incurred in or out of the state, the tax must still be collected on the total bill.

There is an exemption from collection of the tax for deliveries of tangible property sold to out-of-state clients. What often happens is that a client will have an office in state and out of state. If you in fact deliver out of state, you do not

have to collect sales tax. However, you must be able to prove that the delivery was made out of state. Your proof should be a signed delivery receipt or a receipt from the common carrier taking your package to the client. This can be very important if you are audited.

Registering with the Sales Tax Bureau has one advantage. You receive a resale number. By presenting a resale form to stores that you buy materials from, you don't have to pay sales tax on materials going into taxable products that you will resell. If, for example, your client keeps the prints that you produce and you charge the client sales tax, you may use the resale exemption when buying the printing paper and other materials such as frames and mounting materials. If you don't deliver the prints or it is not a taxable transaction, you should not use the resale exemption when you buy the materials.

It's worth keeping in mind that certain organizations don't have to pay sales taxes. These are mainly charitable or religious organizations that have tax-exempt status. If you seek to collect sales tax from them, they will present you with their tax-exempt certificate entitling them not to pay sales tax.

Of course, your clients will frequently give you resale forms, because they are planning to reuse what you give them in the final product they are preparing. If you accept such a resale form in the reasonable belief that the client will incorporate your materials into a property for resale, you are saved from liability for not collecting the tax. But if your client has no resale number and you have any doubt about whether to collect the tax, collect it. If you don't collect it and the Sales Tax Bureau decides you should have, you're going to be liable for the tax. Your client is also liable, but imagine how embarrassing it would be to go back to a client several years later to try to collect the sales tax. And the client may have gone bankrupt, moved to another state, or merged into another corporation. When in doubt, collect the sales tax and remit it to the Sales Tax Bureau. You can't go wrong that way.

Contact your local Sales Tax Bureau to find out whether such a tax exists where you are and, if so, the exact nature of your obligations to collect and remit the tax to the Sales Tax Bureau.

CHAPTER 9 DESIGNING YOUR IMAGE

By Chuck DeLaney

THUS FAR IN Part II, we've covered topics that involve the structure of your business—where to locate it, how to fund it, and what kind of legal entity makes the most sense for your plans. These form the framework of what you seek to accomplish. Now it's time to give that structure a look and feel. It's time to give thought to the image you want to project, one that will represent your business and become an integral part of your brand.

There was a time when photographers were mostly known by the type of work they did. There were wedding photographers, fashion photographers, tabletop photographers, and a host of other specialties—food, lifestyle, stock, nature, and so on.

There were a few superstars in various fields whose names were known to the public—Richard Avedon, Scavullo, Yousuf Karsh, Irving Penn, Annie Leibowitz, and Margaret Bourke-White, to name a few. Connoisseurs and art directors could name several dozen more, but the general public couldn't.

In today's world, everyone can be a brand, and in terms of personal branding, there are metrics galore. How many followers/friends do you have on Twitter? Instagram? Facebook? Do you use Snapchat? Are you taking advantage of Pinterest to promote your work?

The teenage sport star angling for a college scholarship is a brand. The local beauty queen and the band practicing in the garage next door are brands. Every blogger needs an identity. In many ways our society has become obsessed with branding, and personal branding is a big part of it. A well-known New York State—elected official who was seeking to regulate a burgeoning start-up in the sharing economy sector was told by the start-up's CEO that if he didn't back off, "We'll ruin your brand."

Like it or not, your good reputation and the high quality of your work may not be enough. You need to make sure that in today's short-attention-span, swipe-left/swipe-right world, you project an image that will cause your potential customer to pause long enough to actually take a look at who you are and what you do.

The proliferation of social media can be overwhelming, and trying to make sure you're visible on the right platforms is hard enough. But what about the new

outlet that's just around the corner? Is it the next big thing, or will it be just a flash-in-the-pan like Geocities or MySpace?

Unless you're a teenager or twentysomething, it's likely that your interest in social media is in whole or in part tied to promoting your business. That means that social media is really another type of marketing opportunity. And, like any marketing effort, the best way to succeed is to design a campaign rather than throw money at different outlets without a coherent plan.

Part III of this book is devoted to marketing your photography, and it includes a chapter on social media marketing. There's no denying that marketing is extremely important to all photographers, but before you start to market your business, it's important to make sure that you've built it on a strong foundation and that you present a clear vision of what your business is about.

Before you start making your presence known in social media, there are some basic decisions that you need to make. You need a name, a logo, and design elements that you can use consistently in all the materials that your customers see. This includes the mundane business card and stationery as well as your website and social media platforms—there should be uniformity across all the visible aspects of your business. These are the initial steps you need to take, whether you're building a business, establishing yourself as a brand, or both.

CHOOSING A NAME

Step one is selecting a name. You need the right name for your business. While that's obvious, choosing the right name is not so easy. For example, what is your expectation for your business? If you succeed in making it a going concern, do you plan to have it be your business and then shut it down when you're ready to retire or change careers, or do you hope to be able to sell it at some point? If you use your name as your business name, it's a vehicle for you to use to make money, but it's going to be hard to keep it going when you're no longer around. Use Google and search keywords such as "top photographer New York City," or search in a large city near where you live. You're likely to find aggregators who have persuaded local photographers to pay to play. When I do this, the majority of the businesses feature the individual's name—either So-and-So Photography or Photography by So-and-So.

Using your own name does sometimes work. A well-known high-society studio in New York, Fred Marcus Studio, was founded more than seventy years ago by Fred Marcus, a German émigré. After a long career, Fred passed away in 2001, by which time his son Andy had become the principal photographer. He now shares the work with his son, Brian.

It's also possible that you don't have a name that works well. You may not want to use your name if it conjures up other people or creates some kind of confusion. If you're, for example, named Bill Clinton or Michael Jordan, would you want to deal with the confusion and bad jokes you'll hear?

If you decide to give your business a name that isn't yours, you might be able to find inspiration in your geographic location or elsewhere in nature. A search shows that there are a number of operations called "Blue Sky Photography." How about "Twin Rivers" or "Foggy Bottom" or "Steel City?" You get the idea. If your area has natural attractions or a nickname, you may be able to incorporate it. Naturally, you'll need to do some searching and also check your state's business records to make sure you don't infringe on someone else's existing business name. You don't need the confusion, and you certainly don't need a lawsuit or cease-and-desist letter.

One thing is certain—no name is better than a dumb or cute name. A large segment of America does not seem to comprehend this. Drive through a small town, and you're likely to find a hair salon called "Klip and Kurl" or "Shear Magic." It's not just small businesses that are afflicted by this lack of taste. Visit any marina, and look at the silly names that rich people give their boats.

In the realm of photography, I suggest you steer away from things like "Precious Memories" or "Soulful Images." Rather than the realm of emotions, words that suggest luxury might be helpful. One way to test an idea for a business name is to discuss it with friends or acquaintances whose judgment you trust. You can also just try saying the name out loud in a sentence. "I just hired (insert name here) for a photography job." Or try this one: "Would you be interested in buying my photography business? It's called (insert name here). If it doesn't sound right, it isn't right.

CREATING A LOGO FOR YOUR BUSINESS

Once you have a name, it's time to design a logo that will work for your business. This may involve using the word or words that are in your business name, or it may include the name of the business and some kind of design that reinforces the type of work that you do.

Years ago, before the Internet disrupted almost absolutely everything, hiring a graphic artist or logo designer was an expensive proposition. It's still possible to spend a good deal of money on creating a logo for your business, but you can get started for free. There are websites that will take your business name and create a bunch of different automated logo designs for your consideration. The most common model is that you only pay if you find something you like. At that

point, to get high-resolution files, you have to make a purchase. Having spent some time playing around with a few of these sites (and trying out a number of different names), I wasn't overwhelmed with the results, but I did get the sense that this can definitely give you some interesting ideas. How would your logo look with a lightning bolt or a dragon, for example?

A step up from letting a machine make logo suggestions is to find an online service that will connect you with a real human being. There appear to be a lot of these, and one I investigated had a bunch of interesting suggestions/questions: Do you want text only, or an illustration, or perhaps an emblem (think Starbucks) as part of your logo? Do you want to use negative space, have a modern look, or have something with a retro feel? My guess is that these outfits have found a number of talented freelance designers who don't work for high-budget agencies and steer work to them for a portion of the fees. It looks like you should be able to get a pretty good logo for several hundred dollars.

Sooner or later, the question will come up: What about colors? One simple answer is to start with red. Think of all the famous brands—Coca-Cola and Marlboro are two examples—that use red as the basis of their advertising, branding, and packaging. You can't go wrong with red. But what if you don't like red? Or what if you have a color you absolutely love? For that matter, what if your last name is Green and you plan to use your name in your company name? One easy way to come up with a harmonious color scheme that you like is to seek inspiration in the world of textile design. I learned this trick from a very successful interior designer who would often start a color scheme for a room based on a piece of fabric that he had put in his clip file. Textile designers work with color all the time, and they come up with some very beautiful combinations. You're not going to copy the pattern or weave; you're just going to use the colors that appear in a printed or woven pattern for inspiration. The designer has made sure the colors work well together, so even if you don't have a lot of skill in this area, you can find two or three colors that will work well together.

Bear in mind that sometimes you won't want to use all the colors in a logo. Make sure your design works when reduced to simple black and white, just in case you need to use it in that format for some reason.

As mentioned earlier, you do want to come up with a design that will work well for all the places your work will be visible—in print, on the web, perhaps on awnings or a sign in the front of your business. This means that you want something that fits in a rectangle or square without some large element that juts outside the frame. Chances are your logo won't go on a bottle or other consumer packaging, so you don't have to be concerned with that.

TYPE FONTS

Selecting the proper font for a book, magazine, or newspaper is one challenge. Finding a type font that works for your logo and business name may turn on a few limited factors. For example, if your business name includes the word "photography," you'll want to select a font that has an attractive design for the letter "p." A thorough discussion of the different types of fonts and what works well in a given medium is beyond the scope of this chapter, but if the notion of working with different type fonts is new to you, it would be a very good idea to spend several hours reading up on the subject. Your favorite search engine should provide you with a lot of well-written articles. As you'll learn, there are many people who are passionate about type design and have very strong feelings on the subject.

The first consideration may be—serif or sans serif? Serifs are little projecting elements that are appended to each letter in a serif font. These are used frequently in books and newspapers, because the serifs were thought to make comprehension and reading easier. They don't work as well online as they do on the printed page, so you're likely to see more sans-serif fonts on your favorite screen. If this concept is new to you, you can just open Word and try a few fonts. *Times New Roman* is a popular serif font. *Calibri* is a frequently used sans-serif font. If you prowl around and look at the choices offered by Word, you'll see fonts that look like they were made by a funky typewriter or some that mimic the appearance of stencils or handwriting.

Bear in mind that novelty fonts often limit quick comprehension. You might be able to use a word or two from some exotic font, but you won't want to use them for a paragraph of text. Mixing different type fonts takes some skill, but if you experiment a bit, you'll find that there's a lot you can learn without taking a graphic arts course.

BUSINESS CARDS

In this day and age, why would anyone need a business card? That's easy. You're going to meet people who will ask if you have a card. Showing a card may help get you access in certain circumstances. It identifies you as a professional photographer. This can help reduce concerns in these uncertain times when someone in law enforcement wants to know why you're taking pictures of something that you had no idea would cause an official to want to know. Admittedly, having a card doesn't guarantee that you're not a terrorist, but it should help frame the conversation in a way that will avoid excessive questions and rebut the presumption that you're up to no good.

In terms of what goes on the card, my experience is less is more. I prefer a business name, or your name and the word photographer, and a limited amount

of contact information—your email address, your website, or a phone number. Having a photograph or a list of specialties on your card isn't, in my opinion, necessary. People can always find out more by visiting your website. If you are a sole proprietor, you don't need to identify yourself as the chief executive officer or anything like that.

LETTERHEAD

Despite all the things that are now digital, you will need letterhead for billing, for writing cover letters, and for other business tasks. You may also need printed release forms, contracts, or other items. It helps to have both letterhead and envelopes prepared, although you won't use them as frequently as you would have twenty years ago.

DIGITAL ASSETS

Before you spend money printing anything—cards, letters, envelopes—you'll want to make sure that your logo will work well online—on both large screens and small ones. That way, whether someone is looking at your website on a phone or a large monitor, your image comes across the way you intended it to appear.

As you work through ideas for your logo and the different ways you will use it, there are two ways you can evaluate what you've come up with.

First, look at the logos and designs used by other photographers. Not with an idea of stealing a design but to sharpen your sense of what works and what doesn't. Look at sites maintained by the big-name photographers of the past several decades. Look at the sites of the most successful photographers in your market area or in your field. Interested in food photography, for example? Google the term. Look at the sites that are spending money on advertising, and also look at the sites that appear to come up in the organic area (not that money hasn't been spent to get that position). Use your judgment to determine how the photographer's name, brand, and logo are communicated. Make note of what you like and what you don't like.

Second, as you develop your initial ideas, consult your friends and colleagues. There's a danger that you'll fall in love with something that doesn't strike others the same way that you see it. Here's a time when your picky and critical friends and acquaintances can provide a real service. You don't need the opinion of people who like everything they see. That won't provide real help. You need feedback from people who are demanding and have high standards for everything from food to entertainment. You need to gather opinions of what works and what doesn't from the people you know before you try to attract people you don't know.

In the corporate world, logos get redesigned from time to time, and websites get either refreshed or overhauled. The important thing to remember is that you need to get off to a good start. Be critical, speak with your friends, and don't fall in love with your first idea until you generate a few more. Then, review the options, factor in the opinion of others, and make a decision.

CHAPTER 10 INSURANCE PROTECTION

by Arie Kopelman

Arie Kopelman is special counsel at the New York City law firm of Greenberg & Reicher, which specializes in the legal problems of photographers and other artists.

CONSIDER THIS SITUATION: *A photographer is informed by his physician that he needs an operation and will be unable to work for three to four months. Upon returning to his studio, he finds a "summons and complaint" (that is, notice of a legal action against him) to the effect that he is being sued for $25,000 for invasion of privacy. The claim is by a model who asserts that the photographer's client has made an unauthorized use of a photograph that the photographer had taken some five years ago.*

Undaunted, the photographer goes into his studio, accompanied by a former associate who trips over a tripod lying in front of the door and severely injures his head. Hearing this commotion, the studio assistant storms over to the doorway to inform the photographer that the person who had broken into the studio the night before had stolen most of their cameras and lenses, as well as the computer, which contained all of the photographer's tax and business records and client lists.

The photographer is relieved to find out that one of his prize portfolios has not been harmed in the turmoil, since his agent picked it up the day before to show it to a prospective ad agency client. Hours later, the agent duly reports the inevitable. The agency can't find the portfolio, which had been left for an overnight review.

Surprisingly, insurance coverages, many of them available at reasonable cost, would afford protection in most of, if not all, the situations referred to above.

FINDING THE RIGHT INSURANCE AGENT

The amount of insurance you will need in any category depends on your personal circumstances. If you add up the cost (or replacement value, where that is what the insurance covers) for all your equipment and it comes to $40,000, then that is the amount to cover.

Similarly, if you earn $50,000 per year, then the insurance to protect that income in case of sickness or an accident should provide for a benefit of about $800 to $1,000 per week. In each case, simply ask yourself what is at risk. What is the minimum amount needed to restore or maintain functionality? Then you will generally know how much coverage to secure.

When seeking insurance, try to deal with an agent whose clients are in business for themselves. That agent will have greater-than-usual exposure to your type of problems. Naturally, the best solution is to find an agent who is already dealing with a few of the other photographers in your area. If you are unable to locate someone on your own, consult with one of the professional societies, such as American Society of Media Photographers (ASMP), American Photographic Artists (APA), National Press Photographers Association (NPPA), or Professional Photographers of America (PPA). Contact information and a short description of each organization are located in Appendix B. If the national headquarters of the organization doesn't have the information, a local chapter or affiliate can probably help you. Be sure to ask the headquarters office for the organization's local contact or phone number.

Finally, when you are buying insurance, there are some crucial strategies you must employ to keep the total cost at a level you can afford. These are covered in the next section.

STRATEGY FOR BUYING INSURANCE ECONOMICALLY

There are a few key points to bear in mind when buying professional insurance:

- **Package purchasing.** Get your insurance all at once and all at the same place, if possible. Many business risks in this field are so unusual that they might never be covered if you had to have a separate policy for each (such as invasion-of-privacy insurance, incorporated into "errors and omissions" coverage). But as part of a broad business package, the coverage can probably be secured and, hopefully, at an affordable level.
- **High deductibles.** Look for policies in every area with high deductibles, that is, policies where you personally cover the first several hundred or even several thousand dollars of losses. A major cost for insurance companies is the administrative expenses of handling small claims. If you eliminate that problem for them on your policy, you may get a very substantial saving (often in the range of 20 percent to 40 percent). That approach will allow you to get more of the different coverages you need for your business. The money you save by self-insuring for small losses that you can afford allows you to pay for protecting against the really big risks that can kill you.
- **High limits.** Get the highest coverage you can where the risk is open-ended. For example, on "general liability" policies that cover personal physical injuries you (or your staff) might cause to innocent third

parties, you should be covered up to about a million dollars, or possibly more. Jury awards of many hundreds of thousands of dollars and much more are commonplace today.

- **Focus on major risks.** Focus especially on a situation that could put all your personal or business assets, or your entire income, at risk. One would be the unlimited risks associated with injury to third parties— just mentioned above—that are covered by general liability insurance. Another would be a disabling injury or illness that kept you from working for many years (your income could be replaced by disability income insurance). Obviously, these situations are more fraught with danger than loss of a few cameras or your portfolio. As one New York insurance expert with roots in Iowa put it: "Imagine that your business operation was a farm with cows that give milk. You can afford to lose a lot of milk (your product) and even some of the cows (your tools), but you're completely wrecked without the farm."

BUSINESS PROTECTION

On the business side, the basic coverages encompass the following:

1. **Injury to third parties.** General commercial-liability insurance covers claims of third parties for bodily injury and property damage incidents that occur inside or outside your studio. You need a specific extension to cover invasion of privacy, encompassing right of privacy and right of publicity claims, as well as plagiarism (including copyright violations), libel, and slander. Sometimes these coverages are obtained in the "errors and omissions" segment of a publishers' liability policy. You may also want to add to your general business insurance the specific use of non-owned cars that you rent in connection with jobs. This coverage will kick in when the insurance on the vehicle itself is exhausted.

2. **Injured or sick "employees."** Those freelance assistants and stylists you hire on a day-to-day basis may be classified as employees in many states for the purposes of claims arising from injury on the job and sickness off the job. Accordingly, you may well be required by law to have *worker's-compensation insurance* to protect freelance staffers in case of on-the-job injury and *disability benefits coverage* to provide income for employees who lose work time in the event of injury or sickness off the job. In any event, you absolutely must have worker's-compensation coverage for your regular staff employees, both full and part time.

In addition, with a large staff, you may consider the usual medical, retirement, and disability income-benefits programs often made available to longer-term employees.

3. **Your business property.** At stake here are your studio and fixtures, equipment, photographs, business records, and cash accounts.

- *Studio and office contents.* A package policy will cover studio and office contents against fire, theft, smoke, or water damage. Special improvements, such as a darkroom or other unique structure, should be specifically indicated in the coverage. If your studio is in your home, it is part of your residential owner's or tenant's policy and would cover these risks *if* the insurer is informed of the partial business use.

 Additions to the package policy may be of interest to established professionals: a so-called *extra expense* or *business-interruption rider* will cover extra overhead expenses you incur, for example, if you temporarily rent another place in the event of fire or other destruction at your own studio. Similarly, you can get *business-overhead coverage* to temporarily pay for ongoing studio expenses while you are disabled from sickness or accident.

- *Cameras and equipment.* The most common coverage for photographers is the *camera floater*, which can encompass worldwide coverage for loss or damage to cameras, lenses, strobes, and other movable equipment. If you are just starting in business, you may have a nonbusiness floater policy that you use to cover personal property, including your cameras. As your business becomes significant, you must convert the camera coverage to a commercial policy to be sure that the insurance is in effect in the event a loss occurs. Floaters cover only the specific items named in the policy. Therefore, you must update the coverage list every six or twelve months with your new purchases during that period. Most policies insure only against losses up to the amount of your cost (less depreciation). That may not be enough to cover the cost of replacements, given the escalating price of equipment. Accordingly, you should consider getting "stated value" floaters, which will reimburse you for the current replacement cost in the event of loss. Of course, that increases the premium.

- *Photographs and business records.* The package policy covering studio contents usually sharply limits recovery for loss of photographs or business records (often to as little as $500). To cover those items

directly, you need *valuable-papers coverage*. Its best use is for the time and effort that might have to be spent to replace business or computer records that are lost or damaged (in a fire, for example). Consider the problems that would arise if you lost the index to your picture file or all your tax records. You can also use this coverage for negatives and transparencies, if you have those, as well as prints. The problem is that these may be so numerous that the cost will be prohibitive. Many believe that the cheapest solution if you have valuable negatives or transparencies is to simply store them in the safe deposit box of a bank vault. Of course, if you have only created digital images for your entire career, this is not an issue. There are many storage solutions that will prevent this type of loss, as long as you are careful, back up your work on a regular basis, and keep a copy off site or in the cloud.

For those photographers who either continue to work in film or use film occasionally, it should be noted that film damaged in a lab presents special problems. Virtually all labs waive liability for any loss or damage (except to supply replacement film). Your best defense here is to take all film from important shootings and break it into separate batches that are sent to the lab over several days. In addition, never have your film processed on the first day after long holiday weekends, when lab procedures may be slightly awry.

- *Cash accounts.* An established photographer may be jeopardized by the acts of a dishonest employee. While it happens very rarely indeed, an employee could forge your signature on studio checks or devise other means to secure unauthorized payments from the studio. Insurance for such situations is referred to as *fidelity coverage*, which, in effect, is a bonding procedure for your employees.

On a related issue, bailee coverage is needed if you photograph valuable objects, such as jewelry or furs. Often the client will pay for this if it is unique to a specific job.

PERSONAL PROTECTION

On the personal and family side, a photographer's insurance needs are similar to those of most other members of the public and should encompass the following:

- **Sickness and injury.** Basic hospitalization or membership in an HMO (or other private plans) is essential but not enough. Extended

hospitalization, intensive care, and major surgery make *major-medical coverage* almost mandatory. Interestingly, once you have the basic hospitalization, the added expense of major medical is not great.

- **Disability.** Often overlooked, however, is what happens to your income in the event of long-term or permanent disability due to sickness or an accident. Insurance coverage that provides income replacement is called *disability income* insurance and is generally considered essential for freelance people. If you elect a fairly long waiting period (say, sixty to ninety days of disability) before you start collecting, the cost can be quite reasonable.

- **Personal property.** The most common protection in this category is a homeowner's or tenant's policy. These policies cover all of the property associated with your house, apartment, and personal possessions. These policies often have options to cover general liability for injury to third parties who visit your residence. For expensive property that you take out of the residence, such as cameras or other valuables, you need a floater, rider, or separate policy, which is an additional premium. Remember that business uses of your residence or property almost always require a separate commercial policy.

- **Automobiles.** Automobiles, of course, are covered separately for fire and theft under a comprehensive policy and personal injury or property damage to third persons under a general-liability auto policy.

- **Life insurance and accidental-death benefits.** Life insurance is necessary only in cases where others are dependent on your income or services. That could include your family or business partner. Life insurance can be obtained either as *term insurance*, which is purely a death benefit without cash value, or as a form of savings combined with the death benefit, referred to as *whole life*. Since photographers tend to travel extensively, they may also see value in an *accidental death and dismemberment* (AD&D) policy, which in effect is basic-term life insurance, covering only the limited situation of accidental death. On an annual basis it is quite inexpensive, covering all possible accident situations, including travel. For example, it is certainly far less expensive than taking out coverage at the airport for each trip. AD&D coverage should not, however, be confused with medical coverage. AD&D pays only a death benefit and in certain cases pays for loss of sight or limbs.

- **Personal umbrella.** High-net-worth individuals may want additional coverage on top of the maximum coverage provided by a homeowner's policy or an automobile policy with respect to injuries to third parties.

An umbrella policy can be used to increase the protection against recoveries that might exceed the maximum recoveries allowed under the homeowner's or automobile policies.

CHAPTER 11 STAYING HEALTHY AS A PHOTOGRAPHER

by Chuck DeLaney

IN PRIOR CHAPTERS, we covered a variety of topics related to starting your photography career—getting an education, creating a business plan, selecting a legal structure, designing your brand, and protecting your business with insurance. Now it's time to look at the ways that you can protect yourself.

It's not easy being a photographer, and it can take a physical toll.

Many aspects of photography have changed drastically in recent years. We've seen the transition from film to digital as the principal method of capture. Most freelance photographers have found it essential to get involved with social media as a way of promoting themselves and their work. The form factors of cameras have evolved—serious work can be done on a smartphone. In many ways, photography has been transformed.

Yet, as much as the world of photography has changed, one thing has stayed pretty much the same—the photographer's body and the demands that get placed upon it. We still carry a lot of heavy gear, endure the stress of work and travel, and often find ourselves working in contorted positions. Add to that the fact that we now spend a large number of hours peering at the computer, whether it's postproduction of our images, tweaking a website and posting to social media, or dealing with correspondence, billing, and client relations.

But we love what we do, and if that means enduring those stresses and strains, so be it. Right? Well, not necessarily. There are things you can do to take better care of yourself, reduce stress, and enjoy better health overall. I think that includes proper medical care for your mind and body, a good bed, good shoes, and the proper kind of carrying tools to help you. You're a photographer, and you'll end up carrying a lot of gear and moving a lot of heavy stuff. Be kind to your body. Here's an example.

THE CASE OF THE SHORT ARM

About the time I could afford to purchase suits, I learned that one of my arms was one and a half inches shorter than the other. This, for close to ten years, led to extensive alterations whenever I bought a suit.

Then, prior to leaving for a month-long job in the Philippines, I sought the advice of Dr. Joseph Askinasi, a chiropractic kinesiologist. I had been

experiencing some neck and back pain, and I was concerned that I would be in discomfort carrying a lot of equipment through the jungle.

My MD at that time told me the pain came from tendonitis and that I should learn to live with it as, he observed, tennis stars did. He referred me to an orthopedist who suggested medication—muscle relaxers. But I wanted relief, not to make a lifelong companion of pain. A friend recommended her chiropractor—Dr. Askinasi. I made an appointment.

The first visit was unlike any other medical workup I had ever experienced. The doc's approach considered diet, my exercise habits, and the nature of my work. He checked my blood pressure on both sides of my body—a first for me. Over a period of more than two decades, I've reaped many different benefits from the doc's treatment, including some very levelheaded advice on vitamins and exercise. But on my first visit, he asked about my arms, and I told him about the diagnosis I had gleaned from the various tailors who had fitted me for suits.

"That's ridiculous," he told me. He measured my arms. They were the same length. He had me stand and look into a mirror. He pointed out that one of my shoulders was rigid and stuck at a higher angle than the other.

"You carry a heavy bag, probably always on the same shoulder," he told me. "From now on, use a backpack to distribute the weight evenly, or carry a case and switch back and forth so you use both arms evenly."

I felt like I had met Sherlock Holmes. Prior to meeting the doc, I had held chiropractors in the same category as medicine men. For all I knew, I was going to get chicken bones and magic spells. But I gave the doc a chance because I was in pain and I wanted help. Now, it only hurts when I do something stupid.

I find that chiropractic treatment is kind of like body and fender work for automobiles. There are still many reasons to consult an MD internist, for example, but, as photographers, we do tend to experience a lot of wear and tear on the muscles in our backs, legs, and arms. There's gear to hump, furniture to move, and cameras to crouch over. If you're built like an ox and things never ache, you're a lucky devil. If not, I suggest you investigate chiropractic help. However, I must caution that there are different schools of training and approach, so you might want to check with a few people before settling on someone.

This chapter is based on what I've learned from the doc over the years, along with an interview we conducted to address the types of stress and strain that are particular to photographers. If you get helpful information in this chapter, thank Dr. Joseph Askinasi, who practices in Manhattan and Rye, New York.

None of what follows should be taken to be any kind of medical advice. These are just guidelines for people who are fundamentally healthy—nonsmokers, not overweight, with no extreme health issues.

BODY POSITION AND POSTURE

Let's start with the photographer on the sidelines of an NFL football game or seated courtside at an NBA basketball game. There's a danger that you may get hit by a ball, or a three-hundred-pound linebacker, but the real physical toll comes from kneeling or sitting in an uncomfortable position for extended periods of time.

Kneeling and Crouching

If you're working from a kneeling position, never have both knees on the ground. This puts undue stress on your back, and it's going to pay the price. Instead, keep one leg upright. You can vary this by occasionally stretching one leg behind you for a brief period. The goal is to distribute the weight of your body so it isn't all on your knees and back. Change from one knee on the ground to the other frequently. While you need to be still during the play to keep your camera steady, take advantage of time-outs or other breaks in the action to change your pose. Stand up and stretch as often as you can.

Standing

If you need to stand for long periods of time without a break, make it a point to regularly bob up on your toes or shift your weight briefly to your heels. Your legs are bearing the full weight of your body, and you need to keep the muscles limber. Also, instead of having both feet directly under you, put one foot slightly in front of the other and change the position frequently. You may have to stand for a long period of time, but you don't need to hold the rigid pose we associate with the British royal guards at Buckingham Palace or the US Marine posted at the entrance of an overseas embassy.

If possible, when you're working in a standing position, it helps if there's something you can lean on. Rather than being a sign of laziness, leaning against a wall or other upright structure allows you to shift part of the support of your weight onto that surface, taking some of it off your feet. It's also a helpful way to steady your body for long exposures.

Along the same lines, did you ever wonder why there are foot rails in bars? Because pub owners discovered generations ago that if you're standing but can raise one foot a few inches off the floor, it makes standing for an extended period of time easier. This means patrons stay longer and drink more. The same principle can apply to photographers. If there's something you can use to elevate one leg when you're working in a standing position, it will help ease stress and strain. Remember to shift from elevating one leg to the other from time to time.

DEALING WITH HEAVY OBJECTS

The main danger is trying to carry too much at one time. It's great if you can make several trips, but sometimes that may not be practical. An alternative is to distribute the weight evenly among several bags or cases. A backpack is better than a shoulder bag. If you use a backpack, the higher up it rides on your back, the better. If the bag is too low, it puts additional strain on your back. If you do use a shoulder bag, it helps if the shoulder strap is long enough that you can have the strap on one side of your body and the bag on the other side.

Many photographers use cases that have rollers. This puts the weight on the ground rather than your back and shoulders. But pulling a bag behind you puts stress on the shoulder of the arm that is pulling the bag. That stress ultimately puts strain on the back muscles. A much better solution is to use a bag that you can push in front of you. Pushing the bag distributes the weight through your entire body rather than stressing one shoulder. If you're old enough, you may remember that the postal worker delivering mail in the neighborhood used to pull the cart that contained the letters, magazines, and small packages behind his/her body. The post office learned the lesson the hard way—via medical bills and disability claims. Now, the postal service uses carts that the letter carriers can push.

WORKING AT THE COMPUTER

Today's photographer spends hours looking at a computer screen. It's essential to every part of our work. This means prolonged sitting. This is true of almost everyone who works in an office these days as well, so feel free to share this information with your family and friends.

Some people use special ergonomic chairs, such as the one that makes you look like you're riding a racehorse. Others invest in a good chair that looks like a chair. Regardless, even with a good chair, sitting for prolonged periods puts a great deal of the weight of the head and upper torso on your pelvis and rear end. Standing or kneeling, the stress is on your back. Sitting, the stress is on the lower back. Just like the foot rail at the saloon, if you can put an object that's perhaps three or four inches high underneath one foot, it will change the weight distribution because one foot is higher than the other. Switch every thirty minutes or so, moving the object under your other foot.

Take frequent breaks. Stand up. Stretch. When sitting, don't slouch. Don't hunch over the screen. Maintain good posture. If possible, perform a simple stretching exercise. Sit in a chair that has a low back that will act as a hinge point for your spine. Clasp your hands behind your head (not your neck), and extend your elbows out as far as you can. Gently lean up and back over the chair, tilt

your head up, and look at the ceiling. Take a deep breath, and then exhale. If you're sitting for a prolonged period, do this every half hour or forty-five minutes. If your chair has a high back, you can lean forward and raise your head to flex your spine. Leaning back puts some of your weight against the chair back, taking weight off the hips.

To help shift the weight from time to time, in addition to elevating one foot, you can also put a small, rolled-up towel under one thigh to elevate it slightly. After a period, move the towel and elevate the other leg and thigh. As the doc says, "Do this right away if you're going to be sitting for a long time. Don't wait until it's hurting to do it."

As you peer at the screen, remember to keep your shoulders down and relaxed. Otherwise you're in danger of stressing the trapezoid muscles.

EYESTRAIN

While you're in front of the computer, you're also likely to be straining your eyes. There should be some ambient light in the room. It doesn't need to be extremely bright, but you should not work at a computer in a dark room. To ease the strain on your eyes and your neck, take advantage of today's flat screens and move the screen up and down—just a change in elevation of half an inch will alter the position of your neck and the placement of the muscles in your eyes. If you're using a laptop on a table, put something under the laptop to elevate it. You can also just move the screen a little bit to the right or left. If you're going to be working for, let's say, four hours, try to introduce a slight change every thirty or forty-five minutes.

The purpose of these changes is not to find the optimal position—there isn't one. Rather, you're working to introduce change and variety in the position of your neck, head, and eyes.

TABLETOP PHOTOGRAPHY

Advertising and commercial photographers spend a lot of time in a studio, frequently working with small- and medium-sized objects that are placed on a table or other surface. The problem with this is that the standard table height is about thirty inches off the ground. If you're less than five feet tall, this might be OK, but otherwise it's too low, and you're going to suffer back strain. Thirty-six to forty inches is a better height range, similar to the height of kitchen counters. The right height for you will depend on how tall you are. The surface that works for a 5'8" photographer is lower than the height that's right if you're 6'4".

And, since you're going to be spending a lot of time making little changes to the objects on that surface and a lot of time peering into the viewfinder of the

camera that's on a tripod, a small box in each location so that you can elevate one foot or the other will also keep the strain from all being concentrated in one area.

TRAVEL AND OUTDOOR WORK

Most people know that drinking water in the low-humidity environment of an airplane is helpful. Avoid alcohol, which dehydrates the body. Drinking a reasonable amount of water is always a good idea whether you're traveling or working in the studio. The trick is to sip regularly rather than force yourself to drink a twelve-ounce glass at one sitting. A big drink of water first thing in the morning is a good idea, as it gets the digestive tract moving. It's also better for your kidneys to be flushed with water, rather than coffee, after a night's sleep.

When travelling or on location, try to have some readily available food within reach. Don't let yourself get hungry. It drops the blood sugar. Keep some protein bars in your camera bag. Frequent little bits of a protein bar or a sandwich are helpful when you're doing physical work. Everything you eat that gives you energy has to be broken down by the body into glucose.

When you're outdoors, use sunscreen. Wear sunglasses when you can, even on a cloudy day. Protecting your eyes is always a good thing. A hat with a bill that keeps the sun out of your eyes should be worn most of the time.

DIET AND NUTRITION

I'm convinced that there's no one right way to eat. Each person's ideal diet depends a lot on body type, overall health, and the work that he or she does. There are people who should never drink coffee, while others are fine with a few cups a day. If being a vegan works for you, that's fine. If you like a thick steak from time to time, that's OK, too. In his recent book, *In Defense of Food*, Michael Pollan gives a fine and short bit of advice in seven words: "Eat food, not too much, mostly plants." By "eat food" he means real food—the less processed, the better. As an interesting aside, he points out that the real food—fruit, vegetables, meat, and dairy—are usually found around the edges of a supermarket, while processed food occupies the center.

In addition to following Pollan's simple maxim, you may want to consider some vitamins. This is an area where I've taken advice from the doc for many years. I see studies that conclude various vitamin regimes to be of little or no value, but I know that I feel better and have been healthier since I started following the doc's suggestions. To his way of thinking, vitamins aren't necessary in exorbitant amounts. If, for example, one wants to take vitamin C, it's better to take it several times a day in smaller amounts than in one large dose.

According to Dr. Askinasi, "If someone is willing to take one or two vitamins a day, to stay healthy in general, I'd recommend a good plant-based multivitamin that is naturally produced, not crushed. Everyone could use a good multivitamin and fish oil." He notes that fish oil is not a vitamin but rather a nutritional supplement that contains Omega-3 fatty acids. "Fish oil is a good, important food."

Another suggestion is vitamin D, particularly vitamin D3, with a slightly higher dosage in winter when there's less sunshine. (The UV rays from sunlight produce vitamin D components upon contact with skin, although exactly how that vitamin D is made available to the body is still under study.) As with all vitamins, vitamin D also exists in various foods (herring, eggs, and various mushrooms) and is often added to milk. Another supplement you might want to consider is coenzyme Q10.

Two other considerations: First, with regard to overall nutrition and the use of vitamins and other supplements, it makes sense to consult with your doctor or other medical professional before starting on a regimen. Conduct a little research to become familiar with any side effects or conditions you may have that would suggest avoiding certain supplements. Second, vitamins and other supplements are made by different manufacturers from different sources and may have different degrees of purity. With fish oil, for example, it's important to make sure that the oil is pure, that it's gathered from fish in a sustainable way, and that it contains the essential components EPA and DHA.

EXERCISE

In addition to the exercise you get as a photographer, consider something for stress management. What you do, whether it's running, walking, swimming, or riding a bicycle, matters less than that you do *something*.

In situations where you have limited time or can't get out for a run or a ride, some basic yoga poses will help you stretch your muscles and work on balance. Some extreme yoga positions aren't always a good idea for most people. As the doc says, "It's not necessary to stand on your head." He also advises that the pictures you see online or in magazines illustrate yoga poses done by very experienced practitioners. For example, when you see photographs of someone in tree pose, you'll see someone who can tuck the elevated leg onto the upper thigh or right against the crotch. As the doc notes, "Consider those illustrations of the pose as your goal, not what you have to do right away." If you start with tree pose, you may only be able to put your foot below the knee of your other leg. That's fine for a start.

Basic poses the doc recommends are the warrior poses, downward-facing dog, tree, and mountain. For the hips and lower torso, a movement that has a complicated Sanskrit name but is commonly known in English as "windshield wiper" can be viewed on YouTube. As with the other poses, start with caution and don't ask your body to move further than feels comfortable. As you continue with these basic poses and movements, your body will become increasingly supple and limber over time.

EMOTIONAL HELP

I've gotten help from a lot of friends and a few pros in my time. Among other challenges, I've had to watch some grisly terminal diseases and some other tough stuff, including being under the shadow of American Airlines Flight 11 as it flew over my head and into One World Trade Center on September 11, 2001. Over the next few hours, I helped several kids get reconnected to their parents, but I also saw some things that still bring tears to my eyes.

There are times when you may find that you can't really get the help you need from your friends. That's a good reason to consider professional help.

I'm told the country with the greatest number of shrinks per capita is Brazil. I don't think professionals have to be limited to psychologists and psychiatrists. Over the years, I've met some very effective religious folk and social workers who have helped many people. I also know a lot of individuals who have been helped greatly by twelve-step programs, principally Alcoholics Anonymous.

If there's no one way of being, and no one way of healing, then it follows that there's no one way of getting help. Don't be afraid to ask for assistance. Also, if possible, don't refrain from offering help if you can.

MARKETING YOUR PHOTOGRAPHY

AFTER YOU COMPLETE your training and open your business, you need one more prime ingredient to make your business successful—customers.

This brings us to the issues of locating potential customers, marketing your work to them, and, when necessary, closing the sale with a personal visit. For some photographers, sales and marketing skills come easily. For others, these tasks seem overwhelming. Regardless, if you follow the steps outlined in these five chapters, you'll learn all the steps necessary to market your photography.

This part contains a wealth of information and ideas about how to market your business using both old and new techniques. Photo-marketing expert Maria Piscopo contributes two chapters—one on researching the possible markets for your work and the way to promote yourself to those potential clients and another on how to create and present your portfolio. The next two chapters provide ideas for building an effective website and using social media to advance your brand. The social media chapter is written by Nigel Merrick, who is both a photographer and a photography-marketing coach.

Finally, because you are likely to be the head of your own sales team, we take a detailed look at in-person sales techniques that can help you close the deal. After all, other than shopping for goods on the Internet, when it comes to services such as photography, people buy from people.

CHAPTER 12 MARKETS, PROMOTION, AND CLIENTS

by Maria Piscopo

This chapter is adapted from *The Photographer's Guide to Marketing and Self-Promotion* by Maria Piscopo (*www.mpiscopo.com*). A photographers' rep for more than twenty-five years, she currently teaches at the Academy of Art University in San Francisco. She has consulted, lectured, and written extensively about the business of selling photography and is a frequent speaker at seminars and conferences. She is based in San Francisco, California.

MARKETS FOR YOUR photography are divided into two types. One is the commercial client. The other is the consumer client.

This distinction is based on how the photography is used. Commercial clients have a business reason for buying the use of your images. It could be a low level of commerce, for example, to communicate with their customers. It could be a high level of commerce, for example, to sell their products or services.

Consumer clients (often called the wedding-and-portrait market) have a strictly personal reason for hiring you. There is no commerce or profit-making use of the images. If there is, then they become commercial clients.

Clients who commission fine art photography can be either consumer or commercial. If the photography is for display in the home of an individual for noncommerce purposes, then you have a consumer client. If the photography is for display in the office and/or lobby of an individual's business, then you have a commercial client.

DIGITAL IMAGES

There are two distinct types of clients who want digitally produced images. The first type of client hires you to create illustrations, images that no longer look like photographs. The second type of client hires you to create an image that still looks like a photograph. With digital technology, both of these clients are still buying the use of the images. How you get there (digital capture versus film and then scanning for digital enhancements) is not as important to the client as what it looks like when you are done.

For example, the client hires you as an illustrator, to create a unique, new expression—using your personal style. Because this is style and not a

subject-specific strategy, you would sell to a very broad audience of potential clients for this work. For any illustrator, advertising in a creative sourcebook (print or online) is probably the best marketing tool, because it exposes the greatest number of clients to your style. Clients can then contact you through your website or ad when they have just the right job for your style.

The second kind of client hires you as a photographer using digital technology, to create something that still looks like a photograph. In this case, you create the final image instead of an outside service the client previously used to put all the pieces together. The most likely client is the one you already have! This is the client who used to tell the photographer, "Shoot this so I can go have the photograph retouched or assembled later." Now, the photographer can do the image enhancement and assembly. The best marketing tools here are direct-mail campaigns and sales calls. Because your studio will do the image enhancement and assembly, this expands your services and billings on jobs to existing and new clients. You can also expand your digital billings and business by working on supplied photos.

It is important to recognize that the subject matter is not an issue for your client. The determining factor is *how the client will use the photos*, not the subject. A digitally produced portrait can be for a consumer client (family portrait to hang in the living room) or a commercial client (executive portrait for an annual report).

STOCK PHOTOGRAPHY

Stock photography is a growing market and profit center for the traditional assignment photographer. Clients have become increasingly discerning and educated. It is hard to sell second-level-quality images, because clients have easy and quick access to so many first-level ones. You have the option of marketing stock on your own website or as a page on a website dedicated to stock sales. Try to avoid creating a complicated web presence, one that is difficult for clients to navigate. To successfully compete as a photographer, be prepared to offer personal assistance in the client's search for the "perfect" stock image the client has in mind. If you do go outside for representation by a stock agency, make certain it is not competing with you by selling its own images and that it has a lot of expertise in rights-controlled e-commerce.

YOUR MARKETING MESSAGE

There are four ways to identify your "marketing message." They are style, subject, industry, and use of the images.

1. By a particular style of work, based on how you "see" the world. Selling style is selling your personal vision and tends to be used by high-end clients or clients in cutting-edge industries, such as editorial or entertainment.

2. By naming a subject, based on what you are shooting. This is the most common approach to marketing and self-promotion of photography. Both consumer and commercial photographers use this successfully. It could be the photography of people, products, architecture, or nature—any subject you can name.

3. By a specific industry, based on who buys the photography. This is also a good marketing message, because it is so easy to identify clients. It also shows clients that you have experience with their product or service.

4. By the use of the images, based on how the photography is used. For example, annual report photography or catalog photography. This targeting works well because it also makes it easy to identify clients.

Once you have your marketing message, you will look for new clients in three steps: the primary research to build a database, the secondary research to upgrade and maintain new lead development, and the tertiary research to turn each lead into the name of the true client you'll be selling to—your "prospect."

For commercial photography clients, it is very important to use all three steps. It is especially important to do your research, so you can knock on the right doors. Trying to sell to commercial clients who do not buy the type of work you want to do is a waste of their time and your time. In addition, the rejection factor is sky high.

While commercial photographers go out and knock on *client's* doors (selling), consumer photographers are more dependent on the reverse. Your wedding-and-portrait marketing plan of advertising, websites, and direct mail must be designed to bring clients to *your* door, and then you can sell to them. For consumer photography clients, there are no precise directories of "people that want a family portrait," but you will certainly want to take the third step of turning a lead into a prospect.

PRIMARY MARKET RESEARCH

Most of the directories are now available online or through social media, but some of this research for commercial photography clients will be done "old school" at your public library. The business reference section will be more useful if you know what you need; librarians will also be more helpful if you can

tell them exactly what you are looking for. After a visit to the library, you can do the rest online. Because you can search and sort the lists by job title or city, the "Groups" on LinkedIn are especially effective for primary client research. For example, at publication time, there are more than four thousand Groups on LinkedIn for advertising agencies—some of them even client specific (e.g., Sports & Entertainment Marketing and Advertising Agency Professionals).

From manufacturers to advertising agencies to book publishers, there is a website or directory for every commercial photography services market. Because many of these directory books are now available online by subscription, you can download the information for making sales calls, email blasts, or direct-marketing mailing labels.

Look specifically for some kind of qualifier for a company to be listed in their directory. When you are looking for new clients, you want to work with the highest level of information possible. Some directories will list book publishers simply because they exist, while others will list only book publishers that answer an annual survey of what kinds of photography assignments are available (and this is better-qualified research).

Advertising Agencies

When looking for advertising photography clients, there are two ways to research prospects. One, you are researching an advertising agency based on the type of clients it represents, which will dictate the type of photography it buys. For example, food photography is purchased by an agency with food clients. Even the subject categories as broad as people or product photography can be broken down into specific client types. For leads on people photography, you will look at ad agencies that have service-sector clients such as healthcare, financial, or insurance. For product photography, look at agencies with manufacturing clients such as computers or electronics. True, you do see people in computer advertising, but when doing primary research, you are taking your best guess at the most likely leads for the work you want to do.

Two, you can sell your personal style to an advertising agency. This kind of research is not specific to any industry or subject category. You can make an educated guess, however, and take a close look at agencies with consumer-advertising clients and ad agencies winning creative awards as more likely to use style in their advertising photography.

Here is a partial list of directories and databases:

- Standard Directory of Advertising Agencies (www.redbooks.com)
- Communication Arts Annuals (www.commarts.com/annuals)

- Agency Access (www.agencyaccess.com)
- Workbook Directory (www.workbook.com)
- Agency Compile (www.agencycompile.com)
- LinkedIn Groups: AgencyScoop, Advertising Freelance (to just name two!)

Corporate Clients (also called Client Direct)

The following resources are just a few of the dozens of directories that list the names of companies you can use to create and develop photography leads. Watch for more qualified information, such as a chamber of commerce or a trade-association directory (the client has to be a member to be listed). Again, the value of this level of information is that it weeds out the less aggressive companies *not doing marketing* and leaves you with firms that are actively promoting their products and services. What can you guess from this qualifier? If they have joined these groups, they are probably doing more marketing and promotion and need more photography.

Here is a partial list of directories and databases:

- Standard Directory of Advertisers (www.redbooks.com)
- Chamber of Commerce Directory (use the county chamber in your area)
- Business Journal Book of Lists (www.bizjournals.com) and look up your city
- Agency Access (www.agencyaccess.com)
- LinkedIn Groups: Corporate Communications Network (just one example!)
- International Association of Business Communicators (www.iabc.com)

Editorial/Magazines/Publications

Though the photo-fee rates are usually fixed by the publication at a page rate, many photographers pursue editorial clients because of the credibility of having published work, the contacts they can make with the advertisers, and the creative freedom to pursue their personal style.

When you pursue editorial clients, make sure you have thoroughly read and reviewed copies of the publication, so you are familiar with the magazine's own style—what they call their *focus*—because this will dictate the direction of its photography needs. Some magazines are cutting edge; some are conservative; know what the magazines are looking for before you knock on their doors.

Here is a partial list of directories and databases:

- Standard Rate & Data Service (www.srds.com)
- Gebbie Press All-In-One Directory (www.gebbieinc.com)
- Editor & Publisher Databook (www.editorandpublisher.com)
- Agency Access (www.agencyaccess.com)
- Workbook Directory (www.workbook.com)
- LinkedIn Groups: Creative Jobs (Check it out, there are more!)

Graphic Design Firms

Graphic designers and graphic design firms are wonderful clients for photographers. Like ad agencies, they work with the projects a company wants overseen by an external creative source. Like editorial clients, they work very collaboratively with their photographers and often use the photographer's perspective for the project. Their photography projects often have extensive photo shoots, such as brochures, annual reports, catalogs, and, of course, websites. Sometimes their photo needs are regular and seasonal, and some will be year round. Though more difficult to research and less visible than ad agencies, they are very good clients for repeat business—for both stock and assignment photography.

Here is a partial list of directories and databases:

- Agency Access (www.agencyaccess.com)
- Workbook Directory (www.workbook.com)
- DesignFirms (www.designfirms.org)
- LinkedIn Groups: AIGA, Freelance Graphic Designers, Graphic Artists Guild (to name a few)

Paper Products/Book Publishers/Trade Magazines

Subject-specific marketing-message clients who produce paper products are also great for stock- or conceptual-photography sales. This includes publishers of calendars, greeting cards, posters, and other novelty products. In this marketing category, photography projects or assignments are often purchased on a small-advance-plus-royalty payment plan. Be sure to have your personal attorney or a reliable agent look over any paper-products or book contract before you agree to the use of your work. Trade magazines are industry-specific publications and, in this case, are looking for specific photography needs.

Here is a partial list of directories and databases:

- Photographer's Market or Writer's Market (www.artistsmarketonline. com—includes subscription to the database!)
- WritersNet (www.writers.net/publishers.php)

- LinkedIn Groups: Publishers & Book Sellers Association, Music Labels & Publishers

SECONDARY MARKET RESEARCH

Once you have finished your primary research, here are some additional resources and areas of research for developing leads for your photography business.

In a *newspaper's* (print or online) business section, you will find news released by companies that includes: new products, expanded services, and changes in personnel. Any of these are opportunities for you to get in the door with your photography services.

Trade publications exist for every possible industry and business. These publications, much like newspapers, include news releases that are specific to the area of photography you're interested in. You may even want to get the information to subscribe in print or online, so that you can use them for contacting clients for photography services on a more regular basis.

Trade associations often have a membership directory you will have online access to when you join, and it may be all you need as a source of new business. If you do not know the trade association your prospective clients belong to, then check the resource book *National Trade and Professional Associations of the United States*, which lists tens of thousands of industry groups. Whether it is travel, food, architecture, or healthcare, there is an association for companies that are more qualified for your leads. By joining, you know they are aggressively pursuing new business. When companies aggressively pursue new business, you can safely suspect they need photography services, which makes them the better leads.

Trade show's exhibitors need photography, and every industry also has some kind of annual trade show. The value of this research is that they are prequalified for buying photography. Many companies in today's economy choose not to participate in their own industry trade show. You can make a good guess that the ones that do participate will need more photography for brochures, flyers, videos, and displays than their competitors who have decided to stay home. Check out websites such as www.eventsinamerica.com and www.expocentral.com for tradeshow information. At this writing, many trade shows are shifting over to the virtual world, but they still need photography for marketing materials.

Editorial calendars are essential when researching any kind of publication for editorial-photography clients. The editorial calendar identifies the issue-by-issue articles for the year. Knowing the articles the magazine is writing means knowing the photos it will be buying. Keep in mind that magazines work three to six months ahead of publication date (shorter timeline with online-only

publications). With the information from the editorial calendar, when you approach the publication, you will be able to reference your work to a specific need the magazine will have for photography for an upcoming issue. You can get the editorial calendar by calling the advertising sales department and asking for a media kit. However, today it is common and easier to the magazine's website to look it up. Remember, you are still in the research stage (not selling anything yet), so you do not need to talk to a client or decision maker to research an editorial calendar.

Awards annuals are good for research when you have a very strong visual style. You'll find that these clients, who buy style, tend to win the creative awards in their industry. If a client used a strong photography style once, he or she is more likely to do it again. Research these clients by reviewing award directories for the advertising and design industries, which can be found through trade associations and in publications such as *Communication Arts* magazine (www.commarts.com), *Applied Arts* magazine (www.appliedartsmag.com), and *HOW* magazine (www.howdesign.com/designawardgalleries).

QUALIFY LEADS TO PROSPECTS

In this final stage of research, your objective is simple. You will call to get the name of the true client, the person in charge of buying photography. Since this step is still research and not selling, it is very easy to delegate it to your marketing coordinator or studio manager.

You can start by using the following scripts to get the most information with the least amount of effort. It is very important to prepare ahead for even the simplest verbal interaction. You must not waste time or frustrate a potential client because you don't know what question to ask. Be sure to be specific as to the type of photography work you are looking for (your marketing message), so that you will get the correct contact name. You can use the variations depending on what kinds of company you are calling. You can even use job titles if you have the correct title information in advance.

Your phone-call script for finding and qualifying new client leads:

"Hello, my name is Maria from Creative Services Studios, and I'm just updating our files. Who is in charge of hiring for your (fill in with a specific type of work) photography?"

"Hello, my name is Maria from Creative Services Studios, and I'm just updating our files. Who is the art director for the (fill in with a specific client name) photography?"

IN CONCLUSION

You will find a higher level of marketing success by simply separating the steps of identifying your marketing message, finding the clients that buy that type of work, and then qualifying to get the name of your client prospect. With this information, you can now decide how to proceed. You can approach clients for an appointment to show your portfolio or you can add their names to your mailing list—or both. The name of the prospective client who buys the photography you want to do is the key. With that key, you will open many new markets for your photography services.

13 BUILDING AND PRESENTING YOUR PORTFOLIO

by Maria Piscopo

This chapter is adapted from *The Photographer's Guide to Marketing and Self-Promotion* by Maria Piscopo (*www.mpiscopo.com*), a photographers' rep for more than twenty-five years, she currently teaches at the Academy of Art University in San Francisco. She has consulted, lectured, and written extensively about the business of selling photography and is a frequent speaker at seminars and conferences. She is based in San Francisco, California.

IF THIS IS your first attempt to put together a portfolio, congratulations! You will not be burdened with a lot of preconceptions of what works and what does not work in a portfolio. If you have been in the photography business any length of time, this is probably the part where you ask, "Who changed the rules, and how come no one called me?"

For all photographers, your portfolio still provides the focus and direction for your photography business, but, because it is so personal, it is hard to be objective. Just because you are tired of looking at an image, that does not mean it will not do the job and encourage the people who see it to give you work.

For most photographers, portfolio presentations do not work due to a lack of *packaging*, or planning. Many photographers show a collection of images they have done and hope the consumer or commercial client will find something they want. This is not a multiple-choice test! You must show a portfolio that shouts out your marketing message (reread chapter 12 for marketing messages), so that any type of client can retain the visual information and remember when to hire you. As much as you may hate to be "pigeonholed" this way, there is simply too much visual information presented to most clients every day. They need your marketing message as the "hook" to hang you on and to find you when they need your type of work.

So let's start by redefining the term *portfolio*. A mixed assortment of images is not a portfolio. All the images you have are not a portfolio. Your image files make up a body of work. Whether you are a consumer or commercial photographer, a portfolio is a slice out of the whole, and it should be *customized by your marketing message* with the specific client who is viewing it in mind. Each portfolio

you pull out of the body of work must also target the level at which you want to work (not necessarily the level where you are now).

PLANNING FOR YOUR PORTFOLIO

There are two major areas to concentrate on when planning your portfolio presentations: first, what you show in your portfolios (image selection), and second, how you show them (portfolio formats).

Before you do anything else, however, go to your planner or calendar and schedule the time to do this work. Overhauling your portfolios is not the kind of project where you can just wait for the time to get around to it. You will be rushing around at the last minute every time you need a portfolio. That does not work! It should be treated like a real assignment and be given the proper budget, time, energy, and attention.

WHAT YOU SHOW

You have certainly heard that you get what you show in your portfolio. So, first you must look at the work you want to get. What kind of work do you want to do more of? Be specific as to the marketing message (style, subject, industry, use of the images) and to the type of client (consumer or commercial). Then you can select images and formats for your various portfolios considering both of these factors.

Often, the work you want to do is *not* the kind of work you have been getting from word of mouth or referrals from friends. Paid jobs may not even show your finest work. Photographers do work with budget or creative restrictions that keep them from making the images they would be most proud to show. The basic rule is don't show this work. Never include a piece in your portfolio just because you got paid or if you have to make some excuse for it. The portfolio must reflect your best work and your passion for photography.

What if you don't have the images you want to show in your portfolios? What if you are making a transition and looking for different types of assignments or are just starting out? What about the client who says, "But I want someone who has experience!" Your problem is the classic dilemma: How do you get a job without experience when it takes experience to get the job?

The answer is *self-assignments*. People hire you as a creative professional because of what you can do, not necessarily what you have done. So your portfolio work at this step is to pull out images from your portfolio that don't meet your marketing message and your highest level of creativity and technical ability. Retire them back into the body of work somewhere. Once that is done (be merciless),

you can more clearly see the holes in your portfolios that need to be filled with self-assignments.

For example, if you want to do more annual reports, you need to create self-assignments built around the problems and solutions you would find in an annual-report assignment. If you want to do more fashion assignments, select a fashion product and produce a portfolio of images to promote it. Self-assignment work is not the same as personal work. Self-assignments must have a client in mind, with a problem/solution scenario. Personal work is just that—created for you. To come up with your self-assignments, either work with a client who can supply ideas, or collect samples of the kind of work you want to do. Then create your self-assignments from this "ideas file." *Do not* copy another photographer's work; you are looking for your own solutions and creations. Be careful of copyright violations. When looking at someone else's work, think in terms of adapting the idea with your own visual solution, not adopting their solution.

For further assistance, try checking with your local professional photography associations. Many of them sponsor annual "portfolio reviews," where you can get your photography portfolio critiqued and evaluated by reps or photography clients. Not being an official sales presentation, this review can be the most honest and open source of feedback you can find.

HOW YOU SHOW IT—COMMERCIAL PORTFOLIOS

Consider the target client. What format is the client most familiar with? Don't format your portfolio and then decide on your target client. Target your client first, *and then* format your portfolio. This is not just about what you want to show, it is about what the client wants to see. The target client will influence both the format and the presentation.

How many different portfolio formats will you need for your target markets? Almost all clients today start out at your website, but then—what's next? Depending on what you are selling and whom you are selling your photography services to, you could create as many as four different portfolio formats. Keep in mind that any of these formats can be presented as any type—traditional print or transparency, or as a digitally produced format, which could be your website, an iPad, or a thumb drive you can mail or leave with a potential client.

First, the *show* portfolio is your personal portfolio that goes with you to all your client presentations. Traditionally, this is the beautiful custom case you save to show in person. It does not get shipped out for clients to view. Many photographers have changed over to using their traveling portfolios instead, as they are making fewer in-person presentations as clients take fewer and fewer in-person meetings.

Second, if you choose to use one locally or to send a physical portfolio to an out-of-town client, you will need a *travel* portfolio. It is a duplicate of all the content in the show portfolio, but these travel portfolios are usually smaller and lighter for easy and less expensive shipping. Bound books are very popular as long as they are lightweight enough to avoid expensive shipping costs.

Third, sometimes a local client will ask that you *drop off* a portfolio, so the client can easily evaluate whether he or she wants to see you and the full show portfolio. This *drop-off book* is actually another book—and a partial portfolio designed to only give the client an idea of what you can do. It should take a small number of images (perhaps five or six) to help the client make this decision, and the work should be bound into some kind of book so that nothing gets lost.

Fourth, many clients need a *mini-portfolio* of more than one or two promo pieces or mailers to remember what you do as a photographer and why they should hire you. They use this mini-portfolio so that they can keep you on file or so that they can present your work to other people when you are not around. You can use this portfolio format to produce a distinctive combination of concept, design, copy, and photography, so that it becomes a unique piece for the client—or you can keep it simple. Most photographers start off with a simple presentation folder (with a logo on the cover) that holds a number of samples, printed promotional material, and a business card that is easy for the client to keep on file. You can always get creative later!

WEDDING AND PORTRAIT PORTFOLIOS

Again, clients here are always going to start from your website or some social media platform, but they will then need to consult with you to determine what you can do for them. Portfolios for consumer (wedding and portrait) clients are presented in the form most familiar to them—the album—but there is more to a successful consumer portfolio than your choice of album style. Many consumer photographers now combine traditional and digital portfolio presentations. Thumb drives and even special "client only" access pages on your website for creating a portrait-session album or wedding album are very popular with consumers, and they are especially simple to send or link to out-of-town clients for presentation or even for print sales.

Regardless of whether you're using digital or print, for weddings, because the albums are most often the finished product, you should show two different albums. One album shows different people, locations, and poses, and a second album shows an entire wedding from start to finish.

You will also need to show prints, another important consumer-photography sale item. Use the PPA standard competition format, 16 x 20 prints mounted

on triple-weight art board. They have a great impact and are small enough to carry in a nice case for presentations at the client's home or office.

STEPS TO SHOWING YOUR PORTFOLIO

Being a great photographer is only half the job of being a successful photographer. The other half is getting your photography into the right hands so that you can sell that photography, which means that at some point, you will have to talk to people. To get portfolio appointments, close a sale, follow up—all are verbal contacts with your clients you might not feel comfortable doing. You may have the greatest portfolio, promo piece, or direct-mail campaign, but you still have to talk with clients.

Talking to clients should be done with some preparation, because you want to make the best use of your time and their time, get more information about what the clients want, and have the best chance to get the work.

The best preparation for any kind of portfolio-related phone call or client meeting is called "scripting." This is simply a process of writing down the expected interaction between you and your client. You need to do a careful, thorough preparation, in the same way you would prepare before going out on any photo shoot. Preparing scripts to get portfolio appointments and do follow-ups are the most useful portfolio tools you can develop.

Start by writing down the anticipated conversation, as you would like it to go. Be sure to plan for all variations. In other words, no matter what the client's response, you have anticipated your reply. Not only will this technique help you get more out of every call, but you will also approach the entire chore of portfolio presentations with more motivation and inspiration. You may even get to like it!

STEPS FOR WRITING SCRIPTS

STEP #1. Open with a brief and specific introduction of your services. First, you get people's attention, and then you tell them what you want. For example, "Hello, I am a food photographer, and my name is _____. We are interested in the Daily Diner Restaurants account and would like to show our food portfolio to you this week. When would be a good time to come by?"

The first key phrase is "food photographer," which allows the client to more accurately picture his or her need for your work than if you had just said, "I am a photographer."

The second key phrase is "when would be a good time," because it gives the client more options in terms of having a conversation than if you had asked the closed question, "May I come and show my portfolio?" (see step #4 below). The

easy answer to the closed question is "No," and the client will not take the time to seriously consider your request and his or her specific photography needs if you ask a closed question.

STEP #2. Find out from your research what the client does or needs, and then decide what portfolio you will talk about. Talk food photography to food clients, portrait photography to portrait clients, corporate photography to corporate clients, and so on. What you do as a photographer depends on whom you are talking to. Clients can and will only care about what they need. Anything else is just entertaining them, which may be fun but is not a good use of your time.

STEP #3. Come up with something interesting. After all, it is likely that you are trying to replace another photographer who the client is already working with and with whom he or she feels secure. Why should the client switch? For example, "When would you like to see our digital background samples?" or "Our style of photography has helped our clients sell more of their products," or "We offer consultations for those clients who are expanding their product lines or offering a new service. When would you like to schedule your consultation?"

STEP #4. Always use open-ended questions that begin with "how," "who," "what," "when," "where," and "why," instead of closed questions that begin with "can," "could," "would," or "do." This will encourage your information gathering, save time, and reduce the rejection that comes with the "NO" you get when you ask a closed question. For example, when you are showing your portfolio, you could ask the following open questions to get information, confirm the information, and verify agreements you have reached:

- "How often do you use different photographers?"
- "What other photography needs do you have at this time?"
- "When will you be looking at portfolios for your upcoming needs?"
- "Who else in the office buys this type of photography?"

STEP #5. Anticipate objections and questions about your services, and have very specific information you want to acquire. Please, never hang up the phone without achieving some specific objective. Your objective to build and present your portfolio is to get either an appointment or a piece of information. Successfully accomplishing your objective keeps you motivated to do this day after day. For example, when you want more information from the client, you can ask:

- "When would be a good time to check back on that job?"
- "How do you feel about a follow-up call in three weeks?"

- "What will you be looking for in the bids on that job?"
- "Who will have final approval on the photography?"

STEP #6. This is the most important step and the entire reason you have built a portfolio and contacted this client. It is called the *follow-up*. The objective of follow-up is to find out what happens next. This step needs a good, strong script to get the information; you need to be in charge. Choose any of the following sample follow-up questions when you conclude the portfolio presentation or any contact with your clients. You want to always be the one in charge of the follow-up; it is not the client's job.

- "When should we get together again?"
- "What work would you like to see more of?"
- "When should I call you back about that project?"
- "How about a call next month?"
- "How do you want to keep in touch?"
- "When should I send more information on our services?"

IN CONCLUSION

Finally, portfolio scripts do not have to be elaborate, but they do have to be planned ahead and written down with all possible responses (yours and the clients) indicated. It is simply a matter of thinking through what you want to communicate and what you want to learn from the client, so that you can make the next move. With scripts, you will find your communications and portfolio presentations not only easier but also more effective.

Don't expect these new techniques to feel comfortable at first. Anything not practiced regularly is quite uncomfortable. You will feel like you are being blunt and too aggressive. The truth is that you are not. What you are actually doing is "pulling" out the information you need to present your portfolio and create the follow-up instead of "pushing" yourself on a client who does not need you.

CHAPTER 14 GETTING THE MOST FROM YOUR WEBSITE

by Chuck DeLaney

FROM THE VERY early days of the Internet, many photographers saw the possibilities offered by the web. Studies in the late 1990s showed that among different professions, photographers ranked very high in claiming URLs. As digital images became easier to capture, transmit, and display on the Internet, the interest only grew. Today, it would be hard to be a professional photographer without some type of website. The trick is to make sure you have one that does the best job meeting your particular needs.

The Internet provided exciting solutions to several specific challenges facing photographers. It made the transmission of individual images fast and simple. For many photographers, their website became an online portfolio that replaced cumbersome physical portfolios and CDs. Best of all, the web allowed clients as well as friends and relatives (if given password access) an opportunity to see "proofs" from a wedding or other event and place orders directly with the photographer or a designated fulfillment service.

A key factor in making the Internet as vital as it is today for photographers was the growth of high-speed Internet delivery. Seventy-five percent of American homes now have broadband service, and the number will continue to grow. The days of waiting for a website to load, sometimes ever so slowly, are behind us.

In addition to solving problems, as the Internet evolved, it also provided new opportunities for photographers. Now, photographers can use social media to promote their work and their brand, as discussed in detail in the next chapter. Photographers can send images for additional processing and printing to online labs around the world that provide all the same services of a local lab or the "mail order" lab of yesteryear. Regardless of your location, you can order prints on traditional silver halide paper or all sorts of other surfaces, including high-end papers, metal, wood, fabric, and anything else that can be run through a printer. Do you want your client's portrait ink-jetted with frosting onto a chocolate cake? No problem. Photographers can also file copyright applications online.

Now that we've lived with the Internet for several decades and it's become an indispensable method of communication for most of us, certain standards have become routine. Navigation tools and bars are familiar. We expect to be

able to click on the site's logo from any page within the site and be transported back to the home page. However, there is still the danger that a website can be overdesigned or feature too many images and/or too many bells and whistles. Over-the-top sites will either confuse a visitor or create a negative impression. Your website should incorporate the design and branding elements we discussed in chapter 9. The logo, colors, type fonts, and overall style that you use elsewhere should be used to design your website.

Whether you already have a website that features your photography or you're just getting started, I suggest you conduct a three-part review to make sure you're working toward a site that will be the best representative of your business:

- Comparison shopping: Looking at sites that belong to your competitors *and* to well-known photographers who do the same type of work that you do.
- Taking an inventory: What features do you need on your website? What don't you need? What do you want your site to do? Showcase your portfolio? Attract customers for future jobs? Sell your stock photography? Provide an ordering platform for your current clients? All of the above?
- Building and hosting: Chances are you won't design your site by writing all the code from scratch. If that interests you, more power to you, but for most of us, there are companies that provide hosting, technical support, and templates that produce elegant solutions for all the features a photographer might require at a reasonable price, often based on a monthly fee.

COMPARISON SHOPPING

Start by looking at the websites maintained by your competitors or your future competitors. If, let's say, you're interested in fashion work in the Dallas area, or wedding jobs in New England, jot down any competitors that you know about, and then use your favorite search engine to find others. Try to look at a minimum of ten related sites. For each site, use the following criteria to evaluate the features.

First Impression—the Home Page

As you look at each photographer's home page, jot down the first five things you notice. It could be that you like (or don't like) the photo (or photos) that is displayed. What types of subjects are portrayed? How about the overall color scheme? What about the logo and typography? At first glance, does the site seem friendly or cold? Do you know from the home page where the photographer is located? Do you know what types of work are the photographer's specialties?

Is there anything confusing about the home page? Is the navigation to go deeper into the site clear? Is contact information visible on the home page? Is there anything surprising or unusual? If so, do you like that feature, or does it distract? Does the page load quickly?

It's also important to view the site using different types of devices. Chances are all websites look good on a desktop or laptop, but does the site also work when viewed on a tablet or smartphone? While art directors and commercial clients may well be using a desktop computer to research photographers, today's consumers are likely looking at your site on a phone or other mobile device. This is generally called "responsive design," meaning simply that the pages on your website are able to detect the type of device that is accessing the content, so that they can deliver the content to the device in a way that looks best on that device.

Viewing the Photographer's Work

How are the photographs displayed? In separate portfolios? If so, how are they labeled? By number? By type of work? By name or title? Does the presentation make it easy to view work and get a sense of the photographer's style? Do the photographs load quickly? Are they presented as small images, or does each fill the screen? If there are multiple images on the screen, can you click on each one to view a larger version? If there are thumbnails, does each show the entire image or just a portion? Sometimes, programs that show a portion of an image in a thumbnail don't make the best choices of what gets displayed, and the portion shown misrepresents the work.

If there are multiple portfolios, how many images are in each group? Does it seem like there are too many? Are the photos well edited, or do you see too many weak images or multiple images of the same subject? If the images don't fill the screen completely, what is the background? White? Gray? Something else?

Who Is This Person?

Is there an "About the Photographer" tab on the navigation? What do you think of the way the photographer presents himself or herself? Is there a portrait of the photographer? Is it serious? Does the photographer come across as a professional? Is there anything about the person's presentation that turns you off?

Contact Information

How can you get in touch with the photographer? Is there a telephone number, a street address, or an email address? If there's an email option, does the photographer provide an address, or does the site offer a form that you need to fill out? Is there any call to action?

Unless you're a very successful photographer, it probably makes sense to try to capture email addresses of people that visit your site, so that you can follow up with them. We will discuss this in more detail later in this chapter, but check to see if your competitors are pushing to capture information about their visitors. If they do so, how is the request made?

Blog

If there's a blog on the site, is it up to date? If the most recent post is more than a month old, that's a concern. Having no blog is better than an underused or neglected one. If there is a blog that's being updated regularly, what kind of content does it contain? Is it mainly about the photographer, or does it provide additional content that might be of use to visitors? Read three or four blog posts, and see if they make you feel like you would want to meet the photographer. While you're doing research and may not be necessarily interested in meeting the photographer, do you think potential clients looking at the "About" page would get a sense that they would get along well with the photographer?

Social Media

Does the site provide links to the photographer's social media sites? If so, which ones are listed? Click on the links, and see how many followers/likes/friends are visible. How often does the photographer add new material? What kind of content is visible? Is it helpful to the people viewing this material, or is it more like self-serving promotion?

TAKING AN INVENTORY

We've already raised the question of what you want your website to do. In general, a simpler site is better, as long as it accomplishes your goals. In addition to viewing your competitors, you should also look at the work of highly successful photographers.

Consider, for example, the sites of ten highly accomplished photographers from different fields. Search each of these names, and compare how their respective sites represent each individual:

- James Nachtwey
- Annie Leibowitz
- Jerry Uelsmann
- Eric Meola
- Pete Turner
- Barbara Bordnick

- Sebastiao Salgado
- Sally Mann
- Herb Ritts
- Gordon Parks

I selected these photographers to cover a variety of specialties and artistic sensibilities. Feel free to view the sites of other photographers you hold in high respect.

As you'll see, these sites are all over the place. Some are simple and only show images, while others do everything short of selling photo mugs. By the time you view these, some or all of the sites will have been changed, refreshed, or redesigned compared to when I viewed them. Despite how they have been changed, I'm confident you will see that successful photographers don't gravitate to a single approach. Note that Herb Ritts, who died in 2002, and Gordon Parks, who died in 2006, each have active websites administered by nonprofit foundations that perpetuate the photographer's work.

In addition to the variety of approaches that are taken by these various sites, take particular note of the way the portfolios are presented and the "about" and "contact" information. Because these are all well-known photographers, you may not see as clear a call to action as you may wish to offer when you're getting started.

At this point, it makes sense that you try to describe in words what you want your website to do, in essence creating a mission statement for your site. Imagine that you're going to call a web designer to discuss the possibility of that person designing and building your site for you. We'll explore whether that's actually an option for you a bit later on, but for now, it's a good way for you to refine the vision you have for your website.

Here's an example:

Hi, I'm a photographer based in New York City who specializes in food and travel photography. I want to build a website that will showcase my work in both fields by showing three portfolios—one showing travel images, one showing formal food photographs, and one showing restaurant settings to combine both food and travel themes. Each portfolio will have about a dozen images. I want the site to have an "about me" section, a tab for my blog, and a back end that will allow me to sell various sizes of my travel images by linking to my lab, which will fulfill the orders. I also need a "client's only" password-protected section, which will allow me to give access to current food clients who want to view my work on their respective projects. They will be able to leave comments but won't

order images. I'll deliver those separately. The site should have an elegant feel and a color scheme that uses black, silver, and red. It's also important that the site be optimized for search engines using a list of keywords that I will provide.

Now take ten minutes and write your own site description. We'll touch on search engine optimization later in this chapter.

BUILDING AND HOSTING

Unless you know how to code and want to build your site from scratch, you're going to need some help. Many of the services that will host your website and allow you to use various templates to design it are very good. In addition to engaging such a service, you might also consider enlisting the services of a professional designer to help you customize the site to meet your particular needs and give it an overall look. You can then update it without needing the designer's services for each little tweak.

For example, I know a performer/designer who became enamored of the potential offered by the Squarespace platform. She used it to build several sites for a performance company with which she was involved. She has subsequently offered her services to a number of other small business owners who liked the platform but wanted the benefit of someone who could show them how to use it to maximum advantage, which helped them avoid the need to start from scratch and learn through trial and error. Enlisting the help of a "hired gun" to help you set up your site on a platform such as Squarespace is an idea that has been embraced. Poke around on Squarespace, and you'll find that the company provides a listing of dozens of individuals who do just that. There are even "starting from $XXX" and hourly rates quoted for each of the designers that the company has chosen to feature.

Having mentioned Squarespace, let's list some of the other companies that offer front-end and back-end templates and hosting services. Realize that there will be newcomers, and some may merge or rebrand. Before you pick a service, you need to make certain what you want to accomplish and whether that service will meet your needs. Some may have more robust ordering and e-commerce features, for example. If you're selling prints or stock images, that may be important. On the other hand, if your site is designed to get you work in photojournalism, a robust back end may not be important to you.

These are listed in no particular order, and I won't detail the services offered or the costs involved, as these are likely to change. In addition to Squarespace, you should check out PhotoShelter, Format, Zenfolio, and Smugmug (if you can get past the name). A smaller outfit that has devotees and offers low-cost starter

options is 22Slides. If you want to keep track of new developments and read reviews and other commentary on various options, you might want to take a look at www.sitebuilderreport.com, which provides reviews and other information.

Note that we haven't considered content management systems (CMS) such as Wordpress. To be sure, there are many successful photographers who have sites that reside on Wordpress or Blogspot, and there's a lot of information available online for people who want to take that route. If you have good technical skills in content management, there are certainly options available using the CMS approach.

Another option would be to hire a designer to build a customized website for you. That might make sense if you have a set of very special needs or have a lot of money to spend. A custom website could run in the range of $5,000 to $10,000 or more. On the other hand, the monthly fee for hosting a site and building it yourself on a platform like the ones that have been mentioned can be under $20 if you only need a limited set of features.

WEB ANALYTICS

One thing to consider as you look at various platforms is the degree of reporting that you can get from the platform. You want to know how many people visited your site, how long they stayed, and what pages they viewed. You may also want to know how they got there and where they went next.

You don't need to drive yourself crazy reviewing a host of data, but you should have a basic understanding of how many people visit your site and what they do while they're there. If you're using advertising on search engines or other websites, it will be helpful to see if your visitors came to you directly from those sites.

SEARCH ENGINE OPTIMIZATION (SEO) AND ADVERTISING

This is a vast and fascinating topic that's beyond the scope of this chapter, but it is important that you're aware that search engines use various techniques such as "bots" and "crawlers" to evaluate the merit of content on websites. The search engine wants to deliver valuable content to searchers, so these algorithms are designed to give high rankings to sites that the search engine thinks are relevant to the terms (usually called "keywords") that people use to search—think "best pizza NYC" or "best wedding photographer Wichita," for example.

In fact, I suggest you search that last term. It's a good example. Not that you need a wedding photographer in Wichita at the moment, but you'll likely see some paid advertising entries at the top of the search results, then some aggregators who function as middlemen. These aggregators solicit photographers to

sign up and then create a site that purports to rank photographers in a given area. After those listings, you're likely to find individual studios that appear to rank high "organically."

If you're at the top of the search page because you've set up an advertising program with the search engine, you're probably spending advertising dollars on a pay-per-click basis. If you've done a good job with search engine optimization, you may get noticed because of the perceived relevance of the content on your site.

Hosting platforms will provide some assistance in SEO, but you'll need to do some research on your own to determine how best to take advantage of the way search engines work. Also, bear in mind that the cost of advertising on a search engine or the expectation of success in SEO will vary. If you're a wedding photographer, it's likely much easier to get a top ranking in Wichita, with a population a little under 400,000, as opposed to, let's say, Chicago, which has about three million people living in the city and a total of 10 million in the metro area often known as "Chicagoland." In a big market, there's more competition, and naturally the pay-per-click costs are much higher.

Let's look at some of the specific elements, or building blocks, that you may want to include in your website.

Home Page

If you've looked at the sites of your competition and those of some master photographers, you should have a good idea of what should appear on your home page to represent your work. After all, it is the most important page on your site. If it doesn't grab viewers and give a positive impression of what you have to offer, viewers are likely to be gone very quickly. One good thing about being a photographer is that you have a lot of great photographs, so you can select one or two from a large variety to display on your home page, as opposed to other businesses that have to pick stock photos for their imagery.

Portfolio

Your review of other sites should give you an idea about how you can display samples of your work to maximum advantage. As a reminder, every image you show should be your best work. A dozen great photos are better than a dozen great photos *and* a dozen more that are less than great. People have short attention spans, and it's easy to move quickly through a lot of websites looking at pictures. The best way to ensure that your work will be remembered is to show only spectacular images.

About

You need to have a page that tells visitors about you and the work you do. If you have employees, you may want to include some information about them. In today's world where human contact is limited and people often prefer to text each other rather than speak, potential customers are very likely to check you out via your online presence before investing the time and energy involved in making a phone call or visiting your studio. People have become accustomed to getting a sense of who you are without making the investment of direct personal contact. This is not necessarily a good thing for the human race over the long term, but it does seem to be the way things work. The days of having to pick up and answer the telephone in order to find out who is calling are over.

Your information should include a picture that shows clearly who you are, and biographical details should be presented in a straightforward manner. If you try to be cute or funny, you may miss the mark. The important ideas to convey are that you're good at what you do, you have experience, and people will enjoy working with you. That said, it doesn't hurt to present information that people can relate to. If you have a family, or pets, you can make a short mention of that. If you speak another language, let people know. If you volunteer at the local hospital, that's worth a mention as well. Bottom line: you want to give people viewing your site the sense that you're a good photographer, a nice person, and an upright citizen.

One thing I urge you to avoid is any kind of "Artist's Statement." The work you do should be your statement. The very notion that you, as an artist, have a "Statement" to make comes across as conceited. Plumbers don't make a Plumber's Statement. Neither do programmers or comedians.

When people read about you on your site, they're basically asking themselves two questions: "Is this person a good fit for the work I need?" and "Would I like to meet this person and spend time in his/her company?" Design your "About" page to address those questions.

Contact

Make it easy for people to get in touch with you. Let them know where you're located (at least the town you're in if not your street address) and at least two ways to get in touch—probably an email address and a telephone number. If someone's ready to speak with you about a job, don't make it difficult. I have a preference for providing my email address and letting the person use his or her own email program. Some photographers prefer a form that the visitor has to fill out, but I'm always a little wary of those.

Content Marketing

From the early days of the Internet, the pundits would repeat, "Content is king." It's still true. When we're searching, we're often looking for content—whether it's a recipe for how to poach a chicken breast, or a podcast about stock picking, or a free download of a white paper on a topic that's of interest to your visitor.

As a photographer, you have all kinds of information that might be of interest to your visitors. If you're a wedding photographer, it might involve helpful links to local florists, bakeries, catering halls, etc., or something in greater detail, such as "What types of flowers look best in wedding photographs?" or "How makeup for a portrait session differs from makeup for a night out." It's not that hard to come up with ideas. Jot down a list of things you are knowledgeable about, and then evaluate each of them to decide which ones would be of interest to your potential customers.

Naturally, your content should be branded with your business name whenever possible. If you decide to provide information about other business services that your wedding customer will need, you may contact your favorite vendors and see if they have something you can offer. Perhaps the catering hall has information on the most popular meals that have been chosen in the past year or advice on pairing wines with food. If an engaged couple visits your site first, providing that information, along with a link to the caterer that provided it to you, benefits everyone.

Helpful content doesn't even have to be related to the wedding. It could be "Ten great locations for photographs within a short drive," or you could provide tips about good cameras or easy editing software for amateur photographers.

Call to Action and Lead Capture

If you're looking for customers, one way to encourage them to get in touch is to provide a call to action. This could be the offer of a discount, or to learn about the special fall pricing, or anything else that will cause your visitor to stop browsing and contact you. If you're providing free content, it's not really free. Your potential customers must give you something in exchange—they either have to call you so you can get names and addresses or contact you online and provide email information. This way, you have a name that *might* be a prospect for your services. We'll discuss how to sort prospects (real leads) from suspects (people who may just be poking around and aren't serious) in chapter 16.

Email Marketing

Once you have an email list of possible customers, you can start to send out email marketing offers. These should include more informative content, along

with news about the studio and special offers. You may be able to get ideas for this by looking at what your competitors provide. Another way to study email marketing is to sign up on the mailing lists of some photographers who do the same thing you do but in another part of the country. This way you're not likely to make a direct competitor angry.

If you amass a significant number of names, using an email service such as Mailchimp or Constant Contact may make sense rather than trying to manage the list yourself. Whatever you do, you need to provide people with a clear and easy way to opt out of your email program if they wish to do so. Sending spam email to people, or continuing to email them after they've requested that you stop contacting them, is a good way to get in trouble with your Internet service provider.

Blog

Earlier, it was pointed out that no blog is better than a stale blog. It's a lot of work to maintain a good blog. Ideally, you should add a new post about once a week. Having a blog provides new content on your site, and that brings the bots back, which enhances your SEO.

However, more important than attracting bots is attracting the attention of your potential customers who can read blog posts to learn more about who you are and what you do. It's another way they can get to know you better without taking the risk of direct contact. One common mistake I see is the blog that's always showing a dozen or more photos of the most recent wedding, portrait session, or engagement sitting. First, there are too many pictures in the post (and often no words), and the main people who will look at that post are the people whose pictures appear in it. It would be far better to show two or three really good photographs from the session along with a few paragraphs about the location, why the people chose the clothing they did, or something unexpected that happened. That kind of detail is of interest to future customers.

All the same ideas about content marketing can be used in a blog. You could write about your favorite music for dancing at a wedding, or why you choose certain colors for backgrounds based on people's hair color, complexion, or the color of their clothes. You could offer basic posing tips or ideas about how people could get better photos using their smartphone.

The key point to bear in mind is that while it's your blog, it's not really about you. It's about your readers and what they would like to know. Some of the information may be about you, but it's designed to give them a better idea about who you are and your philosophy, thereby allowing them to feel comfortable about the idea of working with you.

Frequent short posts are better than less frequent longer posts. As journalism has turned to what's often referred to as a "listicle" style, such as "Ten celebrities that have aged poorly," or "Seven reasons to eat avocados," you too can attract people with lists. It might be, "Three things to remember on your wedding day," or "The top five mistakes people make in choosing a wedding album," or anything else that can be the subject of a list.

If you have a good idea for a longer blog post, it's also worth considering making it into a series. If you can generate an illustrated article about the best clothing to make men look fit and slim that features a bunch of before-and-after photos and perhaps five hundred words, you might break it up into two or three parts.

Social Media
Finally, your site should provide easy access to your social media platforms, which stand apart from your website. These days, Facebook and Twitter are usually featured, but there are others that might work for you depending on whose attention you're trying to attract in today's too-much-information world. We'll look at this in detail in the next chapter.

15

PERSONAL BRANDING AND SOCIAL MEDIA MARKETING

by Nigel Merrick

Nigel Merrick (primefocuslab.com) is an online marketing advocate who specializes in helping professional photographers simplify their marketing so they can focus on their creative purpose. He teaches all aspects of marketing a photography business online through the Prime Focus Lab website and coaching program, and he is dedicated to working with photographers of all genres and skill levels. Originally born in the UK, Nigel now lives near Memphis, Tennessee.

IN THE EARLY days of the Internet, when a "tweet" was the noise a bird made and clout was something that happened to you if you were caught with your hand in the cookie jar, businesses and their customers were divided into two separate groups.

Businesses (especially the larger corporations) had it good back then—they could safely and incessantly broadcast their company messages to the world through their interruption-based advertising, essentially forcing themselves into the lives of the masses. Annoyances, such as banner ads and disruptive pop-ups, became something to be endured by the helpless web surfer.

On the other side of the fence, consumers were denied a useful communication channel back to the companies they did business with. There was no way for them to publicly voice their concerns, other than through the age-old system of customer service where they were often treated with disdain. Attempts at voicing their frustrations to the world quickly dissipated, like smoke on the breeze.

The advent of blogs, review websites, and particularly social media permanently changed all that. Suddenly, consumers were no longer anonymous. They now had names and faces, not to mention a voice that could be heard and (more importantly) spread further by anyone armed with an Internet connection.

Like the dinosaurs, the transition was a tough one for many companies. The larger corporations found themselves caught off guard, unable to adapt to the changing environment as quickly as the smaller businesses. The evidence of such problems filled the news of the time with colorful stories where a disgruntled

consumer had single-handedly created an online firestorm of negative publicity that caused actual harm to a big brand that was previously seen as untouchable.

It was the story of David and Goliath all over again, and consumers led a revolution that changed the way brands are created, changed, or occasionally destroyed, as seen by the public eye. Suddenly, and to the horror of the previously unassailable big brands, bad press had the devastating potential to create a viral sensation overnight.

But, while all this seemed like terrible news for the larger businesses, it presented a wonderful opportunity for small business owners, such as professional photographers. For the first time, photographers working by themselves had the power to manage exactly how their personal brands were seen by their customers and target clients. Small size, combined with the advantage of agility and maneuverability, allowed professional photographers to present their unique personal face to their customers and effectively manage what has become a two-way conversation between customer and business.

The tools and technologies now available to almost anyone—tools once reserved for the corporate giants or large media companies—have now found their way into the hands of individuals, making everyone a potential content producer able to put his or her message in front of thousands at the click of a mouse.

For example, websites are no longer the stale and clinical versions of "online business cards" they used to be and have evolved far beyond the "name, rank, and serial number" style they started out as in the early days. Blogs have given photographers an easy-to-use platform from which to show their personality and artistic inspirations—and anyone in the world can now talk back to them through comments or share their content with others in their own networks.

The major social media networks are the gasoline that fuels the promotional fire and have truly brought to life the two-way conversation between brands and consumers. Because of this, your own personal brand as a professional photographer has never mattered so much. We're not talking about logos, colors, fonts, or other physical attributes we often associate with branding. Yes, those are important, and they do have a big part to play, but this has a lot more to do with how people *feel* about you, your photography, and your business.

For example, how do people express their feelings about their experience of working with you when talking with family and friends, both online and in the real world? If you were to ask them how they perceived your business—what it stands for and your philosophy about the role photography plays in their lives— what do you think they would say?

Those expressions by others are some of the elements that make up your personal brand in the world of social media, and one of your biggest responsibilities as a professional photography business owner is to manage those elements so that your clients' perceptions match your intentions. One thing you don't want to happen is for people to suffer a disconnect between what they believe about your business and the experience they actually get when they hire you.

Yes, it sounds like a lot of work, but managing your personal brand online is one of the keys to successful marketing. The good news is it doesn't have to completely take over your life, and you'll find some good tips on how to do that later on in this chapter.

But first, what is social media marketing really about?

SOCIAL MEDIA MARKETING IS NOT BROADCASTING

Traditional marketing is based on interrupting people during their normal daily activities. Consider, for example, TV and radio ads, print ads, or pop-ups on the Internet. Those kinds of advertising systems make it difficult for the consumer to avoid them without changing the channel, simply looking away, or skipping forward through a recorded TV show. Such ads are annoying because of the interruptions they generate, but consumers learned to filter most of them out, making them part of the background noise. This is where the term *ad blindness* comes from. Essentially, consumers have conditioned themselves to ignore these kinds of ads and promotions, vastly reducing their effectiveness.

When social media marketing came along, many marketers viewed these new channels simply as more places they could advertise. This was a big mistake, because social media networks are nothing at all like TV, radio, magazines, or even basic websites on the Internet. The two-way communication that embodies social networks created a new medium where the main content is in the form of a conversation. It's no longer a one-way system of broadcasting but rather a thriving place of interaction where the consumer's voice is actually *more* important than that of the marketer.

Early social media marketers, and especially those for whom marketing was not their main job (such as professional photographers), made the mistake of treating social media just as they always had—by broadcasting marketing messages into the conversation and trying to force themselves into the social stream. Most photographers followed the same path, posting constant updates about upcoming mini-sessions, events, special offers, promotions, sales, discounts, and other tactics in an attempt to gain the attention of their fans to make bookings or sales. The results (as you can imagine, given what we now know) were

quite disappointing and created much frustration and confusion over how best to reach the right people in this new and exciting world of social media.

The answer to these problems lies in the realization that social media marketing must be *conversational*, rather than *dictatorial*.

WHAT IS CONVERSATIONAL MARKETING?

Imagine for a moment you're in the local supermarket, and someone walks up to you to ask if you're the photographer her friend told her about—the one who photographed her friend's family, kids, or wedding. You know exactly which client she's talking about, and so a friendly conversation ensues. In a sense, this is a social-media-marketing conversation taking place in the real world, rather than on Facebook. The place is different, but the content is very similar.

What do you think would happen if you monopolized the conversation? How might she react if you did *all* the talking, constantly telling her how amazing you are, what you do, and how much you charge, and flashing a set of photographs at her, without giving her the chance to actually interact with you? Common sense will tell you that it probably won't go as well as you would like, right? She would most likely nod politely, smile, say thanks, and walk off thinking you were a self-centered, arrogant individual and not at all like the friendly professional her friend said you were.

Clearly, you wouldn't fall into such an obvious trap in the real world. And yet, paradoxically, photographers fall into the very same trap *online* during their social media interactions. Take Facebook, for example. If you visit a random selection of photographers' business pages, you'll likely find a series of very self-promotional updates ranging from "like our page" to "don't forget to book your mini-session next week." That's not the best way to manage your personal brand online, and the most important thing to learn here is to loosen up on the hardcore marketing on social media; treat it more like you would the supermarket conversation we just talked about. In other words:

- Show a genuine interest in the lives of your prospects.
- Ask pertinent and interesting questions to try to understand their needs.
- Demonstrate empathy.
- Help them see why you're different from the other photographers they might choose instead.
- Make it easy for them to take the next small step on the path to working with you.
- Avoid asking them to make giant leaps (for example, "book now" is too big a step).

One of the big hurdles to overcome in online marketing is to successfully answer a burning question in the minds of all your prospects, even though they're not consciously aware of the question itself. The question is this: "If I am your ideal client, why should I hire you instead of someone else?" Obviously, you can't just say to someone, "Hey, you look like my ideal client, and this is why you should hire me!"

Instead, the conversation you have and the content you share with people through your social media channels can serve to answer that important question in a way that feels natural and logical, which brings me to the next big point about social media marketing.

PEOPLE HIRE PHOTOGRAPHERS THEY KNOW, LIKE, AND TRUST

Have you ever needed to find a car mechanic or a plumber in a hurry but got stuck because you worried about finding someone honest who could do the job quickly and properly without ripping you off? No offense to car mechanics or plumbers in general, and I know there are many great ones out there, but a certain minority do have a colorful reputation for being the kind of folks who might take advantage of the unsuspecting customer trying to solve an emergency problem. For example, being caught out by a broken-down vehicle hundreds of miles from home and trying to find a reputable repair shop can only add to the already high level of stress of the situation, making you an easy target for anyone lacking business scruples.

The fact is that we would much rather take our car to a mechanic we already know, like, and trust—probably someone we've used in the past or who at least came highly recommended by a trusted friend or family member.

Another example would be looking for somewhere good to eat in an unfamiliar city. How many times have you avoided a restaurant that looked good from their website but had even a small number of poor reviews? It seems a little unfair for the restaurant, because it may be the victim of people who just enjoy leaving poor reviews, but that's the way the Internet and social media work these days.

I hate to break it to you, but you're not much different than your potential photography clients in this regard. Personal photography, such as a portrait or wedding, is mostly a luxury investment with a high level of emotion present in the decision-making process. Even commercial photography is not immune; it's not uncommon for personal feelings, mutual connections and friendships, direct recommendations, or a simple gut feeling to influence the final choice of photographer.

The bottom line: people hire photographers they know, like, and trust. However, such relationships are not built overnight. They take time to nurture

and grow, and social media is one way for you to work on planting the right seeds, cultivating the relationship over time, and then helping prospects to take the next step when the moment is right for them.

Combined with your website (which sits at the center of your online marketing system) and your email marketing campaigns (which help fuel repeat interactions with your website content), your social media presence can fuel your marketing system to make it even more effective at generating quality leads with whom you can have real-world sales and booking conversations.

In addition to your social media presence, you'll also need to work at managing the online reputation of your personal brand through the reviews other people leave for you. These are essentially testimonials and can be positive or negative.

Your aim is obviously to maximize the number of positive reviews, and you should encourage all of your clients to leave a review for you on their favorite review site. The best time to have that conversation with them is at the height of their excitement when you deliver the finished photographs to them. You also need to make the review process as easy and friction-free as possible for them.

SOCIAL MEDIA MARKETING AND ITS ROLE IN LEAD-GENERATION

The overarching purpose of your online presence, including your website and social media channels, is to get more clients. But clients don't simply materialize out of nowhere, and it's rare for someone to look at your website and decide to hire you on his or her first visit or encounter with you.

Your job, as a marketer of your photography, is to turn your best website visitors and social media connections into leads. These are people who love what you do and want to learn more about the possibility of working with you. Instead of watching them vanish from your radar, your goal should be to entice them onto your email list with an irresistible free giveaway or get them to call you on the phone to chat about their needs and how you might be able to help them. Of the two options, the email list is usually the one with the least amount of resistance.

Social media has a big role to play in the success of your lead-generation system, because it acts as one of the main drivers of visitors to your website, so you must use social media strategically to get the best return from it.

If you're not currently attracting and collecting qualified leads from your social media marketing activity, then it's a good indicator that you're not using your time as effectively as you could be on the various social channels, or even on the best channels, for your business. Here are some tips to make better use of social media in your lead-generation efforts:

- Focus on using the right social media channels.
- Be seen as a helpful resource by sharing content designed to be valuable, interesting, and entertaining.
- Wherever possible, drive your audience back to useful content on your website and blog.
- Be personable, approachable, open, and social.

Let's expand a little bit on these ideas.

Choosing the Right Social Networks

It's important to know where to focus your efforts with social media, but I won't get into a discussion about the individual networks themselves for several reasons:

- Networks pop up or disappear on a regular basis.
- Established systems, such as Facebook, are highly fluid and constantly evolving. Anything technical that I might write here would more than likely be obsolete or inaccurate by the time you read it.
- There's already a wealth of up-to-date information available online about how to use each of the networks, so any repetition of that here would be redundant.

Certainly, right now there are many social networks to choose from, and it's tempting to believe you have to be active on as many of them as possible or risk being left behind. This is especially true when a new network emerges, luring people in droves to sign up and get on board or face missing out.

Three examples that come to mind include Google Buzz, Periscope, and Ello. Google Buzz failed to live up to its name and eventually mutated into Google Plus (itself in a perilous state of uncertainty), while Ello was little more than a flash in the pan, vanishing almost as quickly as it launched. Periscope (like Vine) is officially part of Twitter and has made very little impact so far, but the jury's still out for the moment.

Yet, how much time and effort have been wasted by the people who scrambled to join these networks out of fear of missing out on something or being overtaken by the competition? Sure, someone has to jump on board first to get these networks off the ground, otherwise they'll fail, but we have to weigh the need to keep up with the crowd against the potential personal return on investment in time and other resources.

The best advice I can offer about choosing the right social networks is to look at your target audience and ideal clients to see where they're most active, and

then focus mostly on those networks. Typically, this will almost always include Facebook, with a mix of LinkedIn, Twitter, Pinterest, Instagram, and possibly Google Plus. For personal-service photographers, I would look at Facebook, Pinterest, and Instagram as the primary channels, while still maintaining an optimized presence on LinkedIn and Twitter. For commercial photographers, LinkedIn is going to be a major player, followed by Facebook and Twitter.

If your clients happen to be other photographers (for example, if you offer technical workshops), then you might consider including Google Plus in the mix, as it seems to be an active network for landscape, nature, and fine art photographers, although the role of Google Plus in the future seems to be hanging in the balance at the time of writing.

Being Seen as a Resource

The most popular people on social media seem to be those with varied interests who like to share other people's content in addition to their own. In fact, they tend to share content and ideas from others *more* often than they do their own material. However, they don't just share things at random. The content they post for their followers is usually carefully selected to help solve problems, answer questions, provide entertainment, or educate on key topics related to what they do. Some good examples might include:

- Wedding planning tips from other industry experts
- Family-related articles or topics about parenting
- Advice from interior decorators on how to choose the right artwork for a home or office
- Pet-grooming advice and tips from veterinarians
- Lists of things to do or places to go to keep children amused during vacation times

The key idea is to create a place for your social followers where they will naturally and habitually go for the latest useful information they can consume and then share with their friends.

Drive Visitors to Your Lead-Capture System

Of course, your social media presence isn't there purely for you to be a friendly resource; it's there to help you be seen as an authority or expert and to drive people into the lead-capture system on your website.

The best way to accomplish that is to create content-rich pages on your website and blog with a specific goal in the form of a call to action. The call to action

is usually an email sign-up form where visitors can get something from you in exchange for their email address. The more closely your giveaway matches the content of the page itself, the better the chances of someone completing the call to action.

For example, let's say you're a wedding photographer, and you create a page with hair and make-up tips for prospective brides. Let's also suppose you offer a bridal-portrait session as part of your wedding collections. Your free giveaway (more commonly called a *lead-magnet*) in such a case might be a short PDF guide on how to make sure the bride's hair, make-up, and wedding dress not only look their best but also survive the potential hazards of an outdoor bridal portrait session, especially if it takes place on a date before the actual wedding itself.

Sharing these types of pages and valuable content in your social media channels, or creating social ads to promote those pages to a wider audience, can only serve to drive more visitors to your central marketing hub, which then produces more leads you can later turn into clients.

Being Authentic and Genuine Online

There's a lot of talk in marketing circles about being authentic in your marketing, and the word has been used so much in so many contexts that it's lost much of its meaning as a result. But the core idea remains, which is this: *Marketing is all about communication in the full two-way sense. We communicate to our prospects what it is we do, why we do it, and whom we do it for. On the other side of the conversation, our clients and prospects communicate their needs, ideas, beliefs, and values about everything, including the role photography plays in their businesses or personal lives.*

As in everyday life, we can do much better in the social media game by listening more than we talk. Also, it's tempting for business owners to use formal vocabulary or industry jargon, which can only serve to increase the emotional distance between business and customer. Instead, especially if you're a solo photographer, simply be yourself and be as transparent as you can. There's no need to feel like you have to be seen as a perfect person or have to be a great writer, or anything like that. Just write on social media using the same words you would when talking to someone face to face, while keeping it (mostly) grammatically correct.

Most importantly, allow your social media updates and blog posts to show off your personality, your sources of inspiration, your motivations, and your lifelong journey as a photographic artist. People love to know these things, and it makes them feel closer to you, the photographer, and the photography you create.

In fact, the more human you can be on social media, the more people will resonate with who you are and respond to what you have to say. I know all this

might seem easier said than done, especially at first, but the key is actually no more complicated than being able to relax and let go of any need to impress or seem important. After all, this is social media, not the boardroom of a multinational conglomerate, so there's no need to take yourself too seriously.

Nowhere is this more important than when responding to comments from your followers. Generally speaking, it's good practice to acknowledge and respond to the comments people leave on your posts and updates, and this is also a great place to encourage and answer questions. The rule of thumb is to always be positive and upbeat; never allow yourself to get drawn into an online argument with disgruntled clients where you might be perceived as the bad guy—those situations are far better dealt with offline.

Connection Quality Beats Quantity

A particular area of anxiety among photographers is the question of how to get more followers and fans. For some reason, people get hung up on the idea that they need to have more "likes" or followers, because it makes their business appear more successful to potential clients. This is simply not true. In fact, the *quality* of your social connections is far more important than the *quantity*. What do I mean by "quality"? Here are just some of the contributing factors:

- How closely do your followers fit the profile of your ideal clients or target market?
- How engaged are your followers with the content you share?
- How likely are your followers to recommend you to their friends or share your content?
- How active are they on social media in general?

If you concentrate on attracting the right people to your social networks, rather than simply trying to get higher numbers, your updates and posts will be seen by a higher percentage of your fans each time you post a new update.

On the other hand, if your pool of followers is diluted by people outside of your target market, other photographers, or people outside your service area, then your updates may be served instead to people who would never actually become a client, vastly reducing their effectiveness.

One way to find more people who are looking for your type of photography is to use social media searches, for example on Twitter, to identify potential clients who might be asking questions about photography in your area. You can then answer those questions, point them toward some of your useful resources, and connect with them directly. You can also encourage them to connect with

you on other channels, such as, for example, your Facebook page, where they can find even more useful content leading to your website or blog.

Another group of people you probably want to connect with are other vendors in your area who serve the same target market you do. Working together, you can reach more people and do it with more authority, especially if you promote each other on social media or exchange content such as guest blog posts.

Present a Consistent Face to the World

Your social media profiles also play an important role in helping to maximize the effectiveness of your outreach on social media, and it's vital to present a consistent profile across all of your networks. This means:

- Using the same profile photograph, preferably one taken by another professional photographer.
- Ensuring a perfect match of address and other contact details across networks.
- Writing bio text that's consistently worded and altered only to comply with the space allowed.
- Linking consistently to your website resources.
- Using a similar "voice" when posting status updates.
- Making sure you don't contradict yourself.
- Keeping *all* studio news information up to date (for example, promotions and offers).
- Maintaining similar background or header images to create more seamless branding.

As you can see from this list, it's important that your followers and visitors don't lose sight of your core branding elements when crossing from one social network to another or from social media to your website and blog. In marketing terms, this is called *maintaining the scent*, because it helps keep prospects engaged and interested, as well as reassuring them they're in the right place when they make the switch.

SOCIAL MEDIA MARKETING IS PART OF A LARGER SYSTEM

The final point in this chapter is that we have to think of social media marketing as being part of a larger marketing system, rather than as a standalone set of tactics. Often, I see photographers making the mistake of asking questions such as "Which social media channel is the most effective?" or "Is Facebook better than LinkedIn at bringing in clients?" or "Should I bother with Instagram or

Pinterest?" There's no real answer to these kinds of questions, because social media marketing, and especially individual channels, can't function in isolation from the rest of your overall marketing strategy, and the results from specific networks vary tremendously from photographer to photographer.

Social media is useful for building and nurturing relationships but not for taking care of the actual lead-capture or sales process. That's your website's job. Social media is almost always used as a prospect attracter and as a funnel to guide people to your website where the lead-generation process can take over.

If you work consistently at creating meaningful connections and relationships with both customers and business partners who also serve your target market, and you share quality content and information with those people, you'll see a definite improvement in the quality of leads you get and the number of people you successfully turn into clients.

CHAPTER 16 SELLING YOURSELF

by Chuck DeLaney

This chapter is based on several chapters on selling technique that originally appeared in Photography Your Way: A Guide to Career Satisfaction and Success.

PHOTOGRAPHY MAY BE both an art and a science, but unless you are one of the very select few, you won't just spend your time taking photographs. As you've read in previous chapters, there are a lot of other tasks that will come your way. You'll be a technician, a secretary, a bookkeeper, a messenger, a furniture mover, a bill collector, and, most importantly, a salesperson.

You may think, "I don't want to be a salesperson, I want to be a photographer!" That's not really an option. Until you reach the level where you can hire someone to sell your work or your services, or partner with a sales rep, you have to be at least a part-time salesperson.

If you work in portraiture and weddings, you're going to have to sell yourself over and over again to each new client. This kind of selling is the principal topic of this chapter. But even if you become a big-name fashion or advertising photographer and hire a rep to do some of the selling, you'll still have to get involved on a regular basis. And selling, like photography, is both an art and a science. In fact, it's one that scares a lot of people. I hope this chapter will persuade you to overcome any reluctance; with any luck, you'll actually start to *like* doing sales work.

Selling is one of the activities that stirs up more fear and anxiety in many photographers (and artists in general) than any other business-related part of the undertaking.

I've studied selling at every level. Whenever I get the chance, I watch acknowledged masters in action and attend their seminars. I also see many examples of good and bad sales techniques in retail stores, restaurants, and anywhere else that people provide goods or services to others.

Without selling, goods wouldn't get exchanged and buildings wouldn't get built. Advertising, for better or worse, would not exist. Plus, we do a lot of personal selling—I've come to see that selling is the way we navigate adult life, make

choices, find a mate, earn money, advance in a career, and even structure the system of laws and leaders that govern our democratic society.

Unless you're a connoisseur of sales technique, the salespeople you notice are the ones who call attention to themselves—those are the bad ones. They tend to take the customer's mind off the product. You need to study good sales technique as well as bad. You'll find you can learn from salespeople everywhere, from the top photo studio to the deli where you get your lunchtime sandwich.

Good selling isn't so much selling to customers as it is a case of helping customers sell to themselves. That requires, first and foremost, the ability to listen.

Here's a functional definition of the term:

"Selling" is supplying accurate information about a product or service that you hold in high regard, providing answers to questions and giving potential customers the opportunity to decide whether that product or service is right for them.

"Selling" is gently leading prospective customers up the ladder of knowledge to the status of informed consumer. Selling is openly sharing information, patiently listening, honestly answering questions and objections, and then, when your customer has reached the top of the consumer ladder . . .

"Selling" is taking a momentary pause to relish your handiwork and then ruthlessly shoving the customer down the slippery slope to purchase. This last step is so much fun that it has its own name: *closing the sale.*

If you've done the job right, only a gentle tap is needed to send your prospects over the edge down the slope direct to the close. Then, your only task is to decide whether to upsell them on the way down or wait until they've reached bottom to upsell them and perhaps sell them again, presuming you wish to do so.

Some experts refer to the "sales funnel" as if the customer is gently spiraling down a drain. I think the image of leading them up a ladder is more precise. You're moving them a step at a time to the decision point.

Let's define the term *upsell*, because it's a very important concept for photographers who deal with wedding and portrait customers. That's when you *add* to the initial sale and *increase your total profit* by either selling more of what you sold your customer in the first place or selling other related items. For a wedding photographer, an upsell might be more prints in the albums, or it might be large framed portraits to display in the home. To the camera dealer, it's an additional lens, a set of filters, or an expensive camera bag.

You see, once you gain control of your sales technique, you have a lot of power over your customers. Depending on how much you like your customers, you may *permit* them to buy from you again. If they've been difficult, perhaps

you'll send them packing. Possibly, if they're real nightmares, you'll send them forth with the suggestion that they visit your closest competitor.

When it's done right, selling is touchy-feely, it's empowering people, it's helping them, and it's also blood sport. When you sell, you learn a lot about human nature, it's far more exciting, interesting—and instructive—to watch than, say, televised sports. And, the best part—the better you are at it, the more money you make!

SO, HOW DO YOU SELL?

Step one is to relax. Step two is to find your own style.

The unsuccessful salesperson is the uptight one. I've spent a number of years on the road at trade shows, both working in show booths and shopping and visiting shows. One day, a great salesman by the name of Dale, who worked for a photo lab that exhibited at the same trade shows we did, paid us the ultimate compliment, telling me that my road partner and I had mastered selling to people around the country by working with our New York attitude.

We were casual, fast talking, and a little flip—but honest. Dale said it was clear we loved our product, we believed in it, and it showed. Also, we didn't try to hide the fact that we were from New York. And when we had to, we could put on the pressure and "sell down their throats."

Dale, from a small town in Tennessee, took a much more casual approach to his work. No jitterbugging and jumping around for him. He wouldn't buttonhole people the way we did. He explained that he'd learned his technique from studying the way his four-year-old son "sold" him on buying him toys and certain types of treats in the grocery store. Dale was friendly and laid back; he smiled a lot, and before you knew it, just as his son "worked" him, Dale had worked you. In fact, he sold Joe and me on taking him to dinner after he paid us that compliment.

NO ONE WAY OF SELLING

The point is that to sell effectively you need to do it your own way, consistent with your own style and personality. While you may take tips and tricks from someone else, you don't need to do it someone else's way or feel constrained to do it the "right" way.

Don't get the idea that there aren't any rules, or that anything goes when it comes to selling. There are a number of rules, tactics, and techniques, and I guarantee that if you follow the suggestions in this chapter, you can be a successful salesperson too.

THE EIGHT RULES FOR SELLING SUCCESS

Overall: relax, study your customer, and plan your approach.

Rule One: People Buy from People

Except for the supermarket, gas station, and a few items that sell themselves, in our society we have not only a vast choice of goods but also a vast choice of outlets where we can purchase those goods. So we almost always make our decisions on what to buy and where to buy it based on three things: price, the people or experience we encounter, and the service we get. In terms of online shopping, we will make decisions based on the experience with the website/brand that we're viewing. For photographers, where a customer's online research will lead to hiring a person who will actually take the photographs, the consumer is trying to get an idea of whether the photographer is talented and whether the consumer will like the photographer and the process of being photographed. That's one reason your website and social media activities are important. We'll take up those topics in later chapters.

Here's an example of good sales technique. There used to be two delis in the neighborhood where I worked. Of the two, one had obviously trained all of its staff. Each person wore a pressed and starched, red and white—striped shirt with the shop's name on it. They had been instructed to be friendly with the customers and to give prompt service. The other shop had nice staff, but they dressed as they wished, and the service, except during rush hour, could be a little laid back. They both had the same offerings, the coffee was about the same in both places, and the cost was the same. And the locations were equally good.

The place with the red-and-white shirts and the snap-to-it service did more business. Is it any surprise?

As a salesperson, you need to like people, or at least like your customers. You need to give them good service, be polite, listen to them, return their phone calls promptly, dress well, wash your face, and brush your teeth.

People buy from people, so don't give your customers any reason to want to buy from someone other than you.

Rule Two: Suspects Aren't Prospects

Not everyone who calls you up or visits your studio is going to buy. Maybe they're spies test shopping for the competition. Maybe they're just amusing themselves and can't afford your services. Maybe they're killing time before a dentist appointment. This means that you have to sort out *suspects*—let's define them as anyone who might be eligible for your services—from *prospects*, people who are definitely interested in your services, ready to buy, and able to afford them.

The best way to sort them out is to ask questions to determine whether an individual is a suspect or a prospect. The best single question is: "How can I help you?" or "What can I do for you?"

Notice that I specifically did not suggest the question "Can I help you?" because it is too easy for the suspect to just answer "No." Good salespeople never ask "yes/no" questions; in fact, that is sales tactic number one, which we will cover later.

If you ask "How may I help you?" the possible client has to utter a sentence that will start a conversation and, with luck, begin the trip up the sale ladder. Once a suspect starts talking, you'll be able to determine if the suspect is serious about buying your photographs or service, thereby becoming a serious prospect.

You may also get an idea about whether the suspect understands what you do, and whether the suspect can afford your services. Also, after you've had some experience, you can determine not only if the suspect is really a prospect, but also if you really want to work for this person or undertake the job she might have in mind.

For example, suppose someone calls me up and says: "Chuck, I understand you do a lot of architectural and location work, and I manage a vast hazardous waste site that must be photographed as evidence for an upcoming federal trial. I would like to know if you're available next week, and what is your day rate?"

From that opening statement, I know the following: this person is a real prospect, has a real need that I can fill, and sounds ready to buy. But I also think: wait a minute, a hazardous waste site? How hazardous? What wastes?

I can either turn down the job outright, or I can ask more questions about the risk involved in the job. But, if I'm going to ask questions and possibly take the job, let me name a day rate *so high* that if I end up taking the job, I'll be satisfied that the reward is acceptable in relation to the risk. We'll cover this topic when we turn to price conditioners.

It isn't always easy to separate suspects from prospects, particularly in a field such as photography, where aesthetics are involved. Let's say you make portraits—whether they're of high school seniors, children, executives, or headshots for actors. You may well know that you're the best around. But chances are, your suspects don't. They may not even know how to tell. They may not have enough money to afford your services, or they may be looking for a bargain, seeking a price that would be unacceptable to you.

How do you sort all that out and decide whether the subject is a serious prospect? The overall answer is slowly, and you must decide, based on your schedule, whether you have the time to devote to the job. When in doubt, presume your suspect is a prospect and move on to the next step. Let's qualify the prospect.

Rule Three: Prospects Must Be Qualified and You Have to Listen to Them

Qualification of prospects simply means determining that they are ready to buy, they are aware of what you offer, and they are able to meet your price. Try to get them to be specific about their need and their time frame, and then educate them about what you do, the way you go about it, and how you charge for your services.

As you're qualifying your prospects, you're starting to lead them up that ladder to the status of educated consumer. You have to listen, really listen, and understand precisely what it is that they need. You will probably need to ask them some questions along the way. I can't stress how important it is to listen—and not just to figure out what you're going to say next but to make sure you understand what the prospect is really saying.

With portrait prospects, I have developed a useful trick. Many times, someone would ask me about taking his portrait with a comment such as: "I have some photographs, but I don't like any of them" or "No one has ever taken a good portrait of me." I would explain that I would meet with him in my studio at no charge, but that I wanted him to bring the photos he didn't like, so we could look at them and discuss what he was unhappy about. I assured the prospect that I would only charge him if we agreed to a sitting.

Invariably, this offer was accepted. I would book the consultation at my convenience, the prospects came to me, and they brought material for us to discuss. After all, I could show them a lot of nice photos I've taken of other people, but unless they know the other subjects, how do they know what kind of job I've done?

Many times, I could see right away what it was that was lacking in the photos prospects showed me. We could talk about those photos, I could explain how I would handle certain things differently, and they would grow to trust me and feel confident.

From there, it was easy to shift to a discussion of how I charge and to determine what they really needed. I had helped them learn a little bit about photography, listened to them, reassured them that I would help them, and then given them one little push to the close.

Rule Four: Price Is in the Salesperson's Mind

This is the most cosmic of the eight rules. It's one I still ponder and, as time passes, grow to appreciate even more.

It means, in its simplest form, that if you think the price is a good, fair price, it is. No matter how high, no matter how outrageous. Sometimes, this can be a bluff. You can name a price and give the customer your "game face," and the customer shouldn't know if it's the same price you've always charged for that

type of job or a number so high you've never had the notion to ask for it before. At that moment, when you quote the price, that's your price. It's not low; it's not high. It's not necessarily a fair price. It is simply the price.

In fact, I use the same game face when I quote a low price. Let's say I *really want* to work for someone. An arts group or a civic group that does work I admire. I name a price, and I don't tell them it's low or discounted because I admire them, or feel sorry for them, or whatever. That's my price. Period.

I see bad salespeople stumble on this one all the time. When the moment comes and the prospect asks, "How much?" they stumble, hesitate, blink, or start to dither. Gong. They've blown the sale. The prospect knows the price is too much, that you're stumbling, and that there's something else going on. They're going to check with someone else before they buy, and if that someone else is any good, he or she is going to close the sale. You lost the sale.

I know a wedding photographer who has a "basic" package that starts at $7,500. There's another studio on his same street in the suburbs where the basic package is $1,000. When he's asked how he compares his package, or his work, or anything else with the $1,000 studio, his answer is simple: "I don't. Come look at my work, and you'll see why."

Silence Can Be Golden

Here's another trick: sometimes you are asked a price for the use of a photograph, or you bid on a job when it's something you don't know about. In this instance, I've found that meditating silently on an "upset price" and letting the prospect name a price works well.

Here's an example. I get a call from a musician whose photo I took for a newspaper. He doesn't have any good photos of himself, and a German record executive is in town to sign him to a deal to put out a CD in Germany. The musician is a good musician, but hardly a star, and the music he plays is traditional stuff, nothing I can imagine being a big seller.

Would I, the musician asks, be willing to sell reproduction rights of the photo to the record executive? Of course I would. How much, he wonders, would I charge? That, I tell him, I will have to discuss with the record executive. The musician says he'll have the executive call me.

Notice that I didn't talk price with the musician. He's not the client in this case, so nothing good can come from getting started with discussions with him.

As it happened, I was in the middle of finishing a big project at the time the musician called. I didn't have much time to consider the price I would charge. The next morning, the record executive called, and because he was leaving for Germany that afternoon, he wanted to close the deal.

Well, there was no need to qualify him. He was ready to buy. But what would I charge? I'd already been paid for the portrait job, so this was found money. I liked the musician, and I didn't want to foul up his CD, so I didn't want to name too high a price. Also, because I don't sell photos of musicians for CD covers, I had no idea what the going rate was in the United States, much less Germany.

So, I decided on an upset price in my mind: $250. In auction terms, an *upset price* is a minimum. If I put up a painting for auction and tell the auctioneer $250 is the upset price, the bidding must reach at least that level or the painting won't be sold, it will be "called in." An upset price is also sometimes known as a reserve price.

OK, now I've got an upset price in my head, and I'm ready to make the sale. I use a neutral technique: "Herr Executive, I really like the musician you're recording, and I want to provide you with a good photograph of him. In fact, in addition to the one photo of mine that you've seen published, I have several others. I'd be happy to send you several so you can make a selection. By the way, although they were published in black and white, I shot the job in color."

"Color? That's good. But I'm in a rush; the photo I've seen in the paper is fine. How much do you want for it?"

Do I blurt out "I'll take $250!"? No. Instead, I ask a question. "Herr Executive, is your company a big record publisher in Germany?"

He replies, "Well, we're medium sized and we specialize in classical music. There are many far bigger, but why do you ask?"

"Because, since you are an established company, I'm sure there is an established rate that you are accustomed to paying for photos of musicians that you use on the CDs you release. I assume you're using this photo on the front cover."

Notice I haven't said I'll take the established rate—that would be surrender. Instead, I've put the ball back in his court with a question.

"No, there will be a painting on the cover. This photo will run on the back cover . . ."

(Now I'm expecting to hear a really low offer—this is like an author photo on the back of a book jacket, except this is a CD to be released in Germany of classical music as played by a musician who I don't think is particularly well known.)

". . . and our standard price for musician's portraits that we commission is $500 US. Will you accept the same?"

Bingo, the sale is closed, and the deal is done! Herr Executive is no dummy, and had he put the ball back in my court, I can't imagine that I would have opened asking for more than $300. But, he was in a rush, and he's used to paying a certain figure, and I can only presume it wasn't worth his time to beat around the bush.

The close was quick. I also told him that I had many photos of other New York–based musicians, and I would be happy to work with him in the future.

I should also add that I trusted him and sent the image with no advance payment or signed agreement. I received a check for $500 US by airmail two weeks later.

Rule Five: Never Offer Anything "Free"

To close a sale, you may be tempted to throw something in "for free." You're barking up a good tree, but you're coming at it from the wrong side. Nothing is ever "free." Everything has a value. If I give you a "free" gift, I'm not a salesperson, because it means nothing. If, on the other hand, I'm visiting you and your family because you're interested in having me photograph your wedding, and I want to close the deal tonight so some other photographer won't take advantage of everything I've taught you this evening and sell you her services tomorrow night, I might be willing to sweeten the deal.

For example, I might be willing to "give" you a "valuable" 16 x 20 bridal portrait. But here's what I'm going to say:

"You know, I think this is going to be a beautiful wedding, and I'm so happy for all of you. You two are going to make a lovely couple, and I already feel like I know your families. I really want to photograph your wedding, and if we can make an agreement tonight, as my gift to you, I would like to present you with a 16 x 20 print of the bride and groom that I normally sell for $500."

It's not free; it's a $500 present! Who could resist? Will I charge them for framing? Perhaps. When they see that print, naturally I'll suggest they might want to purchase two more for their parents. That's a hidden upsell on a "valuable" gift.

Whether I make an upsell or not doesn't matter. I have given them a valuable present—not a free gift.

Rule Six: Sell the Benefits, Not the Product

This is a cardinal rule of selling any product. It's possible your customer might care about what the photograph is made of, how long it will last, why your retouching is the best, why your lab is the cleanest, and so on and so on. But what you really need to stress is the benefit to the customer—how much everyone will marvel at his portrait when they see it in the newspaper, and how touched his family will be at seeing this wonderful portrait of him hanging on the wall in the living room.

There's an old saying: "Sell the sizzle, not the steak." If you appreciate what that means, and if you can apply it to your photography and your services, then you'll never starve.

Let's start with that steak. It's a great source of protein, and a lean cut doesn't contain that much fat. You can freeze it; you can enjoy leftovers; and you can have it rare, medium, or well done. And steak has less danger of disease transmission than pork. Perhaps the cow only ate organic grain. So what? A steak is just a piece of meat, sitting there on the plate. You look at it. It used to be part of a cow. It's just a steak.

Ah, but can you smell the delicious odor of that steak cooking on an open fire? Can you smell that steak when it's put before you on a fine china dinner plate with a baked potato, your favorite green vegetable, and an attractive garnish? Can you imagine how well that steak is going to taste along with a glass of your favorite cabernet sauvignon?

That's sizzle. Sizzle sells.

Take time to think through the benefits that are the sizzle of the kind of photography work you're seeking. These are the points to stress to your clients.

Rule Seven: Don't Forget to Ask for the Sale—the Close

You have talked to your suspect and determined that he or she is indeed a prospect. You've listened, and you understand what your prospect wants. You've extolled the virtues and benefits of your photography product or service. You've injected sizzle where possible.

Some customers close for themselves. They say, "OK, I'm sold," or words to that effect.

But many times the prospect lingers at the top of the slide. It's your job to get him or her moving. After all, your time is precious. Here's an example. It illustrates one way to ask for the sale, and get the close going.

Cut to the Chase

I used to work with a printer who told me one day that he had purchased a new press, but only after an extended series of sales calls by the sales representative of the press manufacturer. The sales rep had studied the printer's business and listened endlessly to what type of jobs the printer did, what the maximum press runs were, and what kind of deadlines and price margins applied to the printer's business.

The rep had extolled the virtues of the press model that he felt was right for the printer. He had explained how this press would save money, speed delivery time on rush jobs, do better printing—everything.

Finally, in near exasperation, the sales rep got a little testy. He told the printer that he just didn't understand why the printer hadn't expressed a desire to finalize the deal and buy the press.

"I've studied your business, I selected the perfect press for you, and I've told you at great length how this press will benefit your business. Why haven't you placed the order?" the beleaguered rep moaned.

"Because you haven't asked," the printer cheerfully explained.

Don't get so caught up in your sales pitch that you miss the opportunity to ask for the order. If you don't ask, with some customers, you'll never get the order. So you may as well ask early, since if the deal is ready to close, why not move forward and save your energy for the next sales job?

On the other hand, what if the customer says no? That raises a key point: the selling really begins when the customer says no. This is a very important concept. Here's the challenge—you ask for the sale and your prospect says "No." That doesn't mean your job is over, nor does it mean that you won't be able to make the sale.

What it does mean is that you have to prod your customer to explain to you *why* she has said no. Chances are, if she gives you a real reason, you can work around her objection and still close the sale. If she doesn't like the price, perhaps you can refigure the price. If she doesn't like the frame, you can change it. If she doesn't like the schedule, you can change that. In fact, there's very little you can't change once you understand what the customer really wants.

How about four in the morning and three in the evening?

If you like reading philosophy, I recommend to you one of my favorites, the Chinese Taoist Chuang-Tzu, in my opinion a more interesting Taoist philosopher than the better-known Lao-Tzu. Unless you read Chinese, your appreciation of the wisdom conveyed turns on the talent of the person who does the translation. I heartily recommend the translation of Chuang-Tzu by Burton Watson that has been in print for roughly fifty years.

Here's the gist of one of Chuang-Tzu's parables. The monkeys come to Chuang-Tzu one day. They're dissatisfied with their food. They get three nuts in the morning and four in the evening. Things have to change, they insist. Chuang-Tzu reflects on this for a bit and, after a period of silence, offers a proposal: How about four nuts in the morning and three in the evening? The monkeys are happy. That will be fine.

Let's put this into modern terms. Not long ago, I leased a new van. After shopping around, I found the best deal at a small Ford dealership one hundred miles outside New York in a very small town. This dealership beat the prices of others by more than $100 per month over the entire lease term with a smaller down payment. A great deal.

But it meant that I had to take a bus to the small town to pick up the van. When I got there, the salesperson with whom I had struck the deal was out on a family emergency. I would have to wait for an hour or so.

I don't know about you, but for me, killing time in a car showroom, particularly a small showroom, is a grueling experience. I had already read most of the newspaper on the bus, and it was raining, so I couldn't go for a walk and look for something to photograph.

There was, however, one benefit to this particular showroom—the other salesperson, Roger, was very good. Roger had a couple sitting at his desk, and I couldn't help but overhear the conversation. He obviously knew them well. They were considering trading in their current leased car for a new one. This area has a lot of farms, and as I eavesdropped, it became evident that this couple ran a farm. And, since it was mid-November, it was abundantly clear that they had little else to do that day other than ponder whether or not to make this deal. It was also clear that they had leased or purchased their last several cars from Roger.

Roger listened patiently and answered all their questions. How much money would they need to put down to make the change? How would it affect their insurance payments? How would it affect their monthly lease payments?

The clock in the showroom ticked, an old windup model you could actually hear. Tick. Tock. The pace of their conversation was agonizingly slow. I stepped outside and stood under the porch and watched the rain for a while.

I returned to the showroom. They were still going over the same points, again and again. A fly buzzed in the corner. It was, in a word, tedium. Tick. Tock.

I wondered, would Roger close this thing, and how and when? I've never had to sell anyone a car. It sounded like these folks were reasonably happy with their current car. The crops had been harvested, and the hay was in the barn. Were they just killing time making Roger crunch numbers, or was there a real desire on their part? I couldn't tell.

Finally, Roger took the initiative. He reminded them that he had sold them their last three or four cars. He reviewed the cost of the current proposal, right down to the fee for a new vehicle registration. "What are you going to do to make a decision about whether to go forward?" Roger asked.

"Well," said the farmer, "I guess me and the Mrs. will go home and talk it over." (I promise this happened just as I'm recording it. I know it sounds unbelievable, but it can get like this in a small-town car showroom.)

Now, if the salesperson misinterprets what has just been said, the sale falls through. They're going to go home and discuss it? You folks have wasted an hour of my time talking over every aspect of a piddling deal, and you're going to go home and *discuss* it? *Kaboom!* This sale isn't going to happen today.

But Roger heard the key point. That's because he's a good listener. He probably knew the key point all along, but he had to wait for the point in this dance (which moved at the pace of a minuet) when he could strike.

What the man had really said was that his wife was going to make the decision. He was going to go home and discuss it with her, even though they had both discussed it to death with Roger right now. She would make the decision whether this upgrade made sense for the family budget.

From that moment until the handshake, which occurred less than ten minutes later, Roger talked only to the woman. What were her objections, he wondered? In the end it came down to the monthly lease payments. She could accept a little higher insurance payment because it was a nicer car, but it seemed extravagant to her to pay that much a month. Remember, the sale begins when the prospect says "No."

The objection was on the table. If he could get the monthly payments down, Roger asked, would she say yes right then and there and not wait until she and her husband went home and talked about the matter over dinner. She agreed that she would.

Roger solved their problem just like Chuang-Tzu fixed up the monkeys. He fiddled with the front-end payment and increased it a tad and left a little more residual value at the end of the lease. As far as he and the dealership were concerned, it was the same deal, but to the customers, it was better.

He closed. I never could have done it. But I don't have to do it. I don't live in that community, I don't sell cars, and I'm not Roger. But he did a great job and saved himself another round or two with these people.

No one way of selling.

Now, I've illustrated rule seven with two examples that have nothing to do with photography. Bear in mind that selling techniques can apply to any product. Always keep an eye out for good sales technique. Learn to sell, learn to love to sell, and you can sell anything.

Rule Eight: Know When to Stop Talking

This is essential in every sale. I've already stressed that you shouldn't get so hung up in reciting the benefits of your product that you forget to stop and see if it's time to close. In addition, you have to stop talking during the sales process in order to listen to your prospect's needs, fears, and desires. If there's an objection, you have to stop talking long enough to assess whether there's a buying signal in that objection and, if there is, to redirect your sales pitch to address that signal.

In photography, particularly when you're selling a contract for your future services, there's a point where a deal must be struck without immediate

gratification. If someone is interested in buying your photograph, when he says yes, he gets the photo. But if he's hiring you to photograph a wedding that is a year away, there's no particular time pressure and no reason to stop shopping right now. It's key to realize that there is a point at which you have to stop making your presentation and see whether the deal is ready to close.

Particularly if you're dealing with a wedding or other type of job where there are several people who must make a decision, it may make sense to excuse yourself for a few moments so that they can discuss the matter without you. Go get them coffee. Excuse yourself to visit the bathroom, even if you don't actually need to do so. Stop talking (and selling), and give the prospects a chance to assess the situation.

After you name a price for the first time, or present your letter of agreement (isn't that a much nicer term than contract?), it's important to stop talking. Give the prospect a moment to absorb and reflect.

I know one very successful wedding photographer who presents his letter of agreement with a flourish and then waits in silence. "The first person who speaks loses," he likes to say. What he means, of course, is that if he were to start trying to explain or apologize for his terms (price, percentage of deposit, and the like), he'd likely have to modify things. He'll sit silently until the customer says yes, or no, or asks about a specific provision. Then it's time to resume discussions and push for the close.

The One Secret Rule: The Customer Is Often Wrong

It's true; the customer is often wrong.

But, wait a minute, haven't we all heard that the customer is always right? Sure, and it's true. The customer is always right, because the customer has the right to say "yes" or "no" to the selling proposition or to the service that is being offered.

But the truth of the matter is that the customer is often wrong. Not always wrong, but often wrong. The customer could get a better deal from you or a better deal elsewhere. The customer could pick a better-looking frame, or she could choose the images you prefer as opposed to the one she prefers.

Yet the customer is the boss, and therefore, even when you know customers are wrong, unless they're making a decision that you cannot ethically allow them to make or that you know will end up backfiring on you later, let them make their decision and let them feel good about it.

This is a lengthy chapter, but hopefully it contains ideas that you can use. In addition to the eight rules that we've covered, there are a few sales tactics that you can use to help you.

TACTIC ONE: DON'T ASK QUESTIONS THAT HAVE "YES" OR "NO" ANSWERS

This came up in the idea of sorting out the prospects from the suspects. Getting your suspect or prospect talking is the first step to making a sale. A question that can be answered "yes" or "no" is a close-ended question. Avoid them. "How may I help you?" is far preferable to "May I help you?" But there are many ways to extend and advance the sales conversation.

A lot of photographers answer the telephone and simply say, "Studio." Or the assistant answers and says, "Hello, this is the Chuck DeLaney studio."

Answering the telephone gives you a chance to learn your suspect's name if you handle it right. I prefer, "Hello, this is Chuck," or "Chuck DeLaney studio, this is Jane Jones." If you make the last words of your standard telephone answer a name, many times callers will give you their names in response.

"Oh. This is James Rodgers. I got your name from Alice Adams. I need to have a portrait photograph taken."

Whenever anyone calls, I jot down the caller's name so I have it in front of me when we talk. I'll worry about getting the name spelled right and gathering a telephone number and address later. At this point, I don't want to interrupt the flow of our initial conversation with details. I just want to be able to address my suspect by name every now and then during our conversation.

Depending on how things go, I may call him "James" or I may call him "Mr. Rogers." But at least I know his name. Right now, I want to build a relationship. The particulars can follow.

Remember the well-run deli I mentioned earlier? The people behind the counter had obviously been trained to propose alternatives rather than say no. If I ask for a poppy seed bagel, for example, rather than say, "We're out of poppy seed," and wait for me to react, they say, "We're out of poppy seed; would you prefer a sesame bagel or an onion bagel?"

You'll have to study exactly what you sell and to whom you usually sell in order to find the ways to translate your end of the conversation into the most probing possible questions. Consider phrases such as "Tell me a little bit more about what you have in mind" or "If you could wear any outfit for your portrait, what would you choose?"

Consider how much better those two questions are than the following statements: "I don't understand what you want" or "Have you given any thought to clothing?"

TACTIC TWO: USE A TIME HAMMER WHENEVER POSSIBLE

A time hammer is a reason for the prospect to act now. Most consumers don't notice these, but they're everywhere. The one-day sale, the President's Day sale,

the limited-time offer for collectors' plates—all these are devices to get the consumer to act—to decide to buy. In email marketing, it's usually "expires at midnight."

There's no real reason most things are cheaper on a given day. There's no magic price cut in effect on President's Day, and the people who make collectors' plates would be happy to sell you a plate any old time, but these time hammers are put in place to give the buyer a sense of urgency. To get you to go forward and buy.

What kinds of time hammers are available to photographers? First and foremost, your calendar. You're a professional, and your time gets filled up. Let your customer know that.

Most wedding photography studios, when they get started on a telephone conversation about wedding photography with someone who's just gotten engaged, will make a point of inquiring about the wedding date and then take a brief moment to check that they "still have that date available." They will do this even if they know full well they do have that date available. By taking the time to check, they plant the thought in the prospect's mind that their studio is very busy, and that if the prospect doesn't act quickly, someone else may take that date that is "still available."

I remember the first car I bought. It was a used car that ended up costing me a lot in repairs. I bought it too quickly, because as soon as I spotted the thing on the lot, someone else popped up and expressed keen interest in the same car. I bought the car in a hurry, because I was sure that if I didn't, he would.

When I went back to pick up the car several days later, I saw the same person pop up twice in the span of an hour, each time, suddenly interested in another used car that someone else was looking at. I don't know if this walking time hammer worked for the dealership or lived next door and was available at the push of a buzzer, but he was very effective.

How's this for a time hammer: "As long as I'm going to set up on location to photograph the president of your company, wouldn't it make sense to photograph the three vice presidents at the same time? That way, I would only have to charge you one location fee."

TACTIC THREE: EVERYONE LOVES A PRESENT

We've covered the "If you sign tonight, I'll give you a $500 print as my present." In that example, the gift is used as a time hammer. I also pointed out that no present is ever "free." Quite the contrary, every present's value must be made explicitly clear.

Buyer's Remorse

Even if you don't need to offer a present as a time hammer or other form of motivator, there's another reason to consider leaving the customer with a little something to remember you by, particularly if you're booking customers for future events such as weddings or parties.

Even if you get a signed agreement and a deposit, sometimes customers suffer what's known as *buyer's remorse*. This is particularly likely to happen when you get to be a great seller, because sometimes you'll succeed in selling someone something that she really didn't intend to buy. Afterwards, if there's a period where the purchase can be returned for refund, or if there's a period when the deposit is refundable upon prompt notice of cancellation, every now and then the customer will get concerned. It was really too expensive. They don't need that thing anyway. Yes, they need a portrait, and they're prepared to pay for the sitting, but they hadn't planned to order six enlargements before the sitting even commenced.

A present—something they can take with them to remind them of you, the pleasant experience they had dealing with you, your generosity and professionalism—can help ward off buyer's remorse. If you've taken some great scenic photos of your area, give a print to every wedding couple you book who comes from the same area.

Some photographers have deals with local jewelry stores and other purveyors—caterers, florists, wedding boutiques, and the like. If the engaged couple buys a ring that costs more than $2,500 (or whatever number works where you live), they get a certificate that gives them a 25 percent (or 50 percent) discount on a sitting with you for an engagement portrait. You're going to be very helpful and give them a great deal on an engagement portrait. And, applying your sales techniques, your goal is to have their wedding contract signed before the sitting ends.

TACTIC FOUR: HAVE A PRICE CONDITIONER

Whenever I lecture beginning professionals about sales technique, I ask for a show of hands with regard to who can define the terms *time hammer* and *price conditioner*. Very few people know these terms, and, in particular, the use of a price conditioner is one thing (besides learning to upsell) that can help boost your business.

Simply put, a price conditioner is an item or service that you supply that conditions the prospect to a comfortable price range for you.

If I enter a men's store with the idea of buying a suit, and there are $400 suits and $800 suits on display, I, like most people, will start by looking at the

$400 suits. If I find something to my liking, and I'm only looking to purchase one suit, I'll never even look at the $800 suits. They cost twice as much!

However, if the store offers suits for $400, $800, and $1,500, then I'm more likely to start by looking at the $800 suits. They seem to be in the middle. Not cheap, not extravagantly expensive. Hmm. There's a nice suit, and while it is a little more than I had thought about spending, it looks to be very well made and the fabric is very pleasing to the eye.

I've just bought an $800 suit, and I did so because I was *conditioned* to the price.

If you conduct portrait sessions and you charge a sitting fee, figure a way to make a deluxe version that costs twice as much as you would like to charge the average customer. Maybe a sitting is $250, but for $500 the subject gets an extra change of clothes for a more formal (or less formal) portrait. You don't care. You want the customers to feel OK about the $250 sitting fee, and if for some reason they want the more expensive treatment, you'll be happy to give it to them.

Keep the Offer Simple

I find a lot of wedding photographers have too many packages. You should have no more than two, or at most three, basic packages. Any more options and you're just going to confuse the prospect. Remember: your job is to educate the prospect to the degree necessary to make the sale. It's very hard to close the deal if the customer is more confused after your sales pitch than he was before you started.

For example, if you want to book your average wedding for a $2,500 package, then I suggest you offer a $2,500 package and a $5,000 (or $6,000) deluxe package as a price conditioner.

TACTIC FIVE: UPSELL THEM (THE OLD TIE-OVER-THE-SHOULDER TRICK)

One of the reasons I cite so many selling examples from retail salespeople is because we all buy a lot more stuff in retail settings, so we're more likely to see good and bad examples of sales technique.

Upselling simply refers to any method you use to increase the sale. After all, the prospect is ready to buy. Why not add to the package?

I buy that $800 suit. The salesperson should try to sell me a few shirts and ties "that will look great with that new suit." Assuming that I'm going to have a few simple alterations done on the suit, the clerk may get another shot at me when I'm picking up the suit once the alterations are finished, but because I'm ready to buy, the best time to upsell is now, when I'm purchasing the suit.

A master salesperson will just assume I'll make some additional purchases. Do I agree this tie would look great with the pattern in the fabric of the suit I just bought? I agree. The tie goes over the salesperson's shoulder. So does another "perfect" tie. The shirt that I also agree would be perfect, he holds in his hand. Off we go to the sales counter, where the ties and shirt are added to the ticket. He never even asked me. He just assumed that I would buy them.

I don't have to. I can object at the counter. But he's maneuvered me into a position where instead of his having to get me to say "yes," now I've got to be a bit stubborn (after all, I already agreed they were perfect) and tell him "no."

How can you upsell your goods and services? If you're selling wedding photography and portraits, you can sell thank you cards, portraits (sometimes called "wall art"), frames, and display portfolios. You can have higher-quality albums, name imprinting, or extra albums (or prints) for parents, grandparents, and other relatives. You can offer to shoot portraits of other family members at the same time you schedule a location sitting for one person.

DEALING WITH LOW-BALL COMPETITION AND CHAINS

There is no photographer's union. One of the benefits of a union is that it sets pay levels based on some kind of scale. Need a union plumber for a plumbing job? Don't expect to negotiate price too much.

With photographers, particularly in lucrative and competitive commercial areas, competition on price rather than quality is a sad fact of life. There is little in the way of a set price for anything. The market controls price.

Let's examine the core of this issue. Many photographers lament the "good old days," now at least three decades gone, when ad budgets were bigger, stock photography was used less, and long assignments at healthy day rates were the norm. There was no micro stock available on the Internet. There weren't so many people calling themselves photographers.

But the world has changed. As photography has become more important to communications and many more photographers emerge from colleges and other types of training, competition has undeniably increased more rapidly than the market has grown.

Without drawing a conclusion, it's safe to say that the profit margin for some types of photography work is down. There's a lot more competition out there for corporate and editorial work. But I don't hear wedding photographers complaining much, and for the local portrait studio, the low-balling "villain" is often not another photographer but rather the local discount store.

They can also offer wild low-ball prices on portraits as a way to get customers to enter the store, since after the portrait "session," the customers will (I

guarantee) have to wait a while or come back another day to pick up their package. So the discounter is offering the portrait deal as a "loss leader" to get people into the store.

For those who don't know the term, a *loss leader* is a price-sensitive item that the retailer is willing to sell at a slight loss in order to increase store traffic. Sure, a few cheapskates may come in just to buy that one item, but most customers will shop while they're there.

I saw a loss leader for one of the big chains the other day that offered something like "Three large prints and 250 postage stamp prints for $4.99!"

How can you compete with that? You can't. And you certainly can't low-ball that deal either.

But, before you close up shop, I have a suggestion. Go have your portrait (or a family member's) taken at the local Target, then go to Wal-Mart, Sam's Club, or any of the other discount outfits in your area that claim to have a portrait "studio." Go to each. See what they do. Get samples of their work. See how long you wait. Takes notes on how you're treated and what options you're offered. Most important of all, see all the things they don't do. All you can do is explain how your work differs. I wouldn't argue with anyone who calls and asks you to justify your fees in relation to the discounters and chains. You can't. Don't try to talk them out of going to the chain. Explain your benefits and let them know that when they're ready for an individualized portrait sitting, you'll be happy to accommodate them. You could always give them a helpful tip such as "Since it sounds like you're going to take your child to [Name the Store], I do have a couple of suggestions. Try to get there early in the morning, since the wait at midday is very long and will be hard on your child. I also suggest the plain backgrounds, they're not very creative, but they're much better than those hideous plaid ones. Good luck."

Remember, selling is educating your customers. The suspects will make their way to the mall, but you just may flush out a prospect occasionally.

NEGOTIATING CONTRACTS AND PRICES

ALTHOUGH PART IV contains only three chapters, don't underestimate the importance of the material covered here. For the photographer who has already found some clients, Richard Weisgrau's observations on how to negotiate contracts is extremely informative. It is aimed principally at the photographer who works with agencies and other commercial clients, but the underlying philosophy of how to negotiate topics is valuable for all photographers. Pay particular attention to the nine negotiating tactics that Weisgrau lists. Learn to "nibble," and you'll never go hungry.

The chapter on contract forms is taken from Tad Crawford's authoritative *Business and Legal Forms for Photographers*. The commentary provided for each form addresses the significance of every provision. There's a great deal of information that you need to know about each contract, and it's all presented in clear and understandable language.

It could be argued that "Pricing Photography" is the most important chapter in this entire volume. Written by two experts in the field, it details all the steps every photographer should take to develop a job's price that is fair and clear to the client and also profitable for the photographer. The initial discussion of why a "day rate" doesn't work in today's economy is of particular importance to anyone who is thinking of using that yardstick for pricing. If anything is unclear after reading this chapter, take the time to read it again.

CHAPTER 17 NEGOTIATING CONTRACTS

by Richard Weisgrau

Richard Weisgrau followed his twenty years as a professional photographer by holding the post of executive director of ASMP, American Society of Media Photographers. He has written and lectured on many topics of the photography business with a strong specialty in negotiating.

YOU CAN'T BE in business without sooner or later being handed a contract to sign. It might be a contract to purchase goods or services or, even more likely, to provide them. Regardless of which it is, there is never any reason to assume that a contract is ready to be signed the second it is presented for your signature. In spite of that fact, many business people are all too ready to sign on the bottom line without a critical examination of the contract, a discussion of its terms, and a negotiation of those terms to arrive at a more acceptable agreement. There seems to be an instinctive belief that a contract is a take-it-or-leave-it offer, and no negotiation is possible. The simple fact is that there are few contracts written that are not negotiable. The few that do exist are usually products of a negotiation that preceded the drafting of the contract. So let's learn how to negotiate a contract so that you have a say in the terms to which you are being asked to agree.

DEVELOPING EXPERTISE IN CONTRACTS

Developing expertise in contract negotiating requires four things. First, you have to know what a contract is and is not. Expertise means specific knowledge, and you get that by study. Second, you have to have an understanding of language. You do not have to have the word skills of a writer, let alone a lawyer, but you do have to have a reasonable grasp on the language of the contract. If you don't have that, then get help before you try to negotiate. Third, you have to know the tactical means of negotiating. By that, I mean knowing how to explain why your counterpart's demands are unacceptable and how to offer alternatives that are acceptable. If all you do is reject without offering alternatives, you are simply refusing and not negotiating. Fourth, you have to learn to keep the issue in perspective. Contracts are not enforceable until the parties sign them. There is no liability in negotiating. There may be some if you do not.

WHAT IS A CONTRACT?

From a business perspective, a contract is a mutual understanding. Legally, a contract is an enforceable agreement. "Enforceable" is the key word. We can enter into many agreements in life, but most of them are not enforceable. Here's an example. A client asks you to do some work for him. His budget is low, and your price is high. He asks you for a price reduction on the work, and he says that he will make it up to you on the next job you do for him. You agree and give him the discounted price that he is looking for. A few weeks go by, and he calls you with the next job he has. Does he have to provide you with that extra payment he promised? No, he does not, because the agreement that you made with him is not an enforceable agreement. In short, it is not a contract. He made you an offer, and you accepted it, but the deal lacked one critical component: consideration. Consideration is something of value that the parties exchange to support the offer and acceptance made in the course of the deal. All your client did was to conditionally promise you a better deal. You accepted the promise. Both of you agreed, but you did not form a contract. A contract must have three things: offer, acceptance, and consideration. When all three are present, there is an enforceable agreement, a contract, on the table.

Contracts can be either written or spoken. Spoken contracts are sometimes referred to as "verbal" or "oral." Let's call the spoken contract "oral," since all contracts consist of words, the meaning of verbal. While the principles of negotiating are applied to both written and oral contracts, if you are going to go to the trouble of negotiating a contract, you ought to have it written down when you are done. Bad memories of oral contract terms have probably led to more avoidable business disputes than any other cause. Avoid oral agreements in business. They are generally worthless in any subsequent dispute. That is why your client often presents you with a contract to sign when offering you work.

NEGOTIATING A CONTRACT

Negotiating a contract requires three important first steps. Skipping any one of these is almost a guarantee of failure. When you receive a contract, it is wise to make at least one photocopy of it, or if it's transmitted as a digital file, print two copies. This way, you have an editing copy so you can mark up the contract with notes, cross outs, and additions without making the original unusable. Once that is done, you are ready to take the first three steps.

Step one is reading the proposed contract. I say "proposed," because it is not a contract until you agree to it. You are reading an offer from your client. Keep that mindset. It is an offer, not a decree. As you read the document, make pencil notes on your photocopy. A few key words to jog your memory on what

came to mind as you read that section will usually do. I also like to use a yellow highlighter to mark the parts that I know I will want to negotiate. Usually, those deal with fees, rights, and liability. I underline in red any word that I do not understand. There are many words in the dictionary, and if the person who drafted the contract used words that you do not understand, you cannot have a "mutual understanding" until you understand those words.

Keep a dictionary at hand. Look up any word for which you do not have a clear understanding of the meaning. Misinterpretation of the meaning of a word can often lead to future problems, and sometimes those problems end up in the courtroom at great expense to the parties. One example of how a definition can mean so much can be demonstrated by the word "advertising." A photographer signed a contract granting "advertising rights" to a client. The client placed ads in magazines and printed brochures to sell its product. The photographer protested the brochure use, claiming it to be promotional, not advertising, use. The case went to court. The photographer lost the case. The judge relied on the dictionary definition of the word "advertising," which is "the act of calling something to the public's attention." The judge said that the magazine ads and the brochures fit the definition perfectly. The judge rejected the photographer's argument that photographers had a different understanding of the word. He said people relied on dictionaries for meanings and not on photographers' interpretations. The lesson learned is to keep a dictionary nearby. A broadly defined word is exactly that. If you don't want to accept broad interpretations, then don't accept broadly defined words. Specifics are better than generalities in contracts.

Once you have edited the contract, you are ready to move on to step two. First, write down any words that are underlined in red. Then write the dictionary definition of the word next to it. You will refer to this list later on. Review your editing copy, and make a list of each problematic clause in the same order as they appear in the contract. These should be highlighted in yellow and easy to find. Then think about possible alternatives to the clauses that you have listed. Maybe it means adding words, or deleting them. You might have to rewrite the entire clause. In the end, you should end up with a clause that you want to substitute in place of the one offered. These newly constructed clauses will be your counteroffer. Make sure that you have them spelled out exactly, word for word. You do not want to be formulating your position in your head in the middle of the negotiation, unless you have no alternative. Then make some notes about why you can't accept the clause as offered. A good negotiator has a reason for rejecting any word, clause, or contract, and at the same time has an alternative to offer. As a final step in this process, you should also write down the minimum

you will accept for each of the clauses in dispute. This is what negotiators call the "bottom line." It is the point beyond which you refuse to concede. If you have no bottom line, there was no reason to begin the negotiation. Having no bottom line ultimately means that you will likely be accepting the offer as it was made to you in the first place.

So far you have evaluated the offer and come up with a counteroffer. Now it is time to move on to step three, negotiating the contract. It is time to talk to your counterpart. Simple negotiations can often be handled with a brief phone call. Complex ones often require an exchange of written drafts commingled with phone calls to discuss the reasoning behind positions. Note that I said "reasoning." Negotiation is more about reasons that make sense than it is about power. You should never do something that does not make sense for you. Nor should your counterpart. A meeting of the minds results in a mutual understanding when the parties are reasonable. You cannot negotiate with an unreasonable party, and there are such people and companies. Sometimes, if the situation permits, you will want to negotiate face to face. It is amazing how much more reasonable people can be when you can look them in the eye. By nature, most people want to be "seen" as "reasonable." I did not write the words "heard as reasonable." The most difficult negotiations are best handled face to face when the situation permits, because most people want to be "seen" as reasonable.

USING NEGOTIATION SKILLS

Once you have made the contact, it is time for you to employ your tactical negotiation skills. These skills can be learned by study and developed by practice. No one starts out as an expert. It takes time, trial, and (yes) error. Nobody scores 100 percent. Some people seem to think that negotiating is a mystical skill possessed by only a few who were given the gift. In fact, negotiating is something that most of us do regularly without even realizing it. A friend or spouse proposes dinner and a stage show for a night out. That is a sizeable bite of your budget. You suggest dinner and a movie as more affordable. Your counterpart really wants to see the stage show. You offer an alternative of a stage show and late-night snack. Agreed! You have just completed a successful negotiation. Negotiation is the process of reaching a meeting of the minds by exploring alternatives in an effort to resolve differences of opinion or position. When you apply that definition, you realize that even three-year-olds can negotiate, as parents learn this early on. If a three-year-old can do it, so can you. The advantage that they have is that they haven't been intimidated by the mystique that has been built up about the process.

Successful negotiation requires common sense and an ability to set a "bottom line," the point beyond which you will not go. That line will usually be one of value. You won't take less than X amount for Y level of performance. You can become a better negotiator if you take some time to learn the principles of negotiating and the tactics used by expert negotiators. While common sense and a bottom line should protect you from making a bad deal for yourself, tactical knowledge will help you make a better deal. There are dozens of books on the topic of negotiating, but if you want the basic course in negotiating for a photographer, you should read the section on negotiation in *ASMP Professional Business Practices in Photography*. Here are a few more useful tactics that negotiators use:

1. Asking the question *why* is a good tactic to use when you are concerned about an unreasonable demand. It can lead to one of two things. The other party explains why, and that helps you understand the objectives and frame an alternative to meet them. Or, they fail to be able to explain their reasons, and it becomes more difficult for them to hold onto an inexplicable position.

2. The *red herring* is a less important point at issue to which you assign a higher value in order to have it later when you need it. When negotiating, you often need to have something to concede, or trade, in order to match a concession by the other person. You trade the red herring. Maybe you ask for an advance on fees, knowing full well that you will not get it. Later, as you discuss expenses, you ask for an advance on them because they will be very high. Your counterpart balks. You reply that he is asking you to bankroll his work, which is like asking you to be a lender without interest, and your cash flow is important to you. You then offer to drop the demand for the advance on fees, if you get the advance on expenses. He wants to move the bigger obstacle off the table and agrees. You have just traded off your red herring for something that you wanted.

3. Silence, intentionally remaining quiet, is an important tactic of the successful negotiator. Listening is an art. You can't listen while you're talking. The person who asks a question and waits for an answer is in control. If they listen to the answer, the opportunity will arise to develop an option. Or, the silence will often compel your counterpart to keep talking. That can lead to new openings in a stalled dialogue. One time that you should always be silent is immediately after asking *why*. Do not explain the reason for asking *why*. You do not have to justify a perfectly

reasonable question. The question *why* is always appropriate when you are trying to reach an understanding. It can often lead to a very productive dialogue.

4. Flinching is using a visual sign to let the other person know in a nonverbal way that you can't really accept what you are hearing. It can be unnerving to the other party. Think of it as a psychological tactic. Needless to say, a visual tactic can only be used in face-to-face meeting. A flinch can be as simple as shaking your head from side to side just a tiny bit as someone is saying something that you know you will reject. It telegraphs the word "no" before he has all the words out of his mouth, but you never interrupted him. Never interrupt the other person. It is too adversarial and counterproductive. When your counterpart sees "no" as he is speaking, it has a way of putting him off balance. Maybe he will then be a bit more flexible on the point he is making.

5. The broken-record tactic is simply repeatedly asking for what you want until you get it. While it is unlikely to get you a major concession, it frequently works to get small ones as your counterpart just gives up from being tired of hearing it. One of my favorite broken-record lines was "But I have to have an advance on expenses." I could say it half a dozen times in a negotiation as our dialogue went on to cover the full scope of the agreement.

6. Nibbling is done after you've made the deal. You have completed a successful negotiation. Then you come back at the person and ask for one more point. If you don't get it, you have not undone the deal. If you do, you have expanded the deal. Let's say that you have wrapped up everything required to meet your bottom line. The deal is done, for all intents and purposes. Then you nibble. You float the example in the "trial balloon" tactic below. If you get what you asked for, you have successfully "nibbled" a bit more for yourself.

7. The trial balloon is an excellent tactic. It is framed as a question. For example, "What would you say if I needed a $5,000 advance?" You haven't made a demand. You have tested the waters. If you get an answer like "Out of the question," you can drop the item, but if you get one like "I'd consider it," you can put it on the table for discussion.

8. Be direct in your statements. If you don't like what they offer, and you have an option, tell them. Say, "No, I can't accept that. Let me offer this as an alternative." Don't use three sentences to say "no." Just say "no" and offer your alternative.

9. When negotiating a contract, you will have to agree on each clause in dispute. Resolve the easiest ones first. This sets a tone for future agreement, and the word "yes" is easier to get if it's part of a pattern of "yeses." Prove that the two of you can agree on the easy ones, so it will be easier to reach agreement on the difficult ones.

If you have taken some time to understand the principles, psychology, and tactics of negotiating, you will soon find that negotiating a contract is simpler than you thought.

CHAPTER 18 CONTRACT FORMS

by Tad Crawford

The contracts in this chapter are reproduced by permission from *Business and Legal Forms for Photographers* by Tad Crawford. *Business and Legal Forms for Photographers* has a large number of forms, all available as digital files for ease of customization, as well as explanatory text and negotiation checklists. The forms selected for this chapter meet the basic needs of commercial photographers, wedding and portrait photographers, and fine art photographers.

THIS CHAPTER HAS the basic contract forms you need to get started, whether you are a commercial photographer, wedding or portrait photographer, or fine art photographer. While the needs of the disciplines differ, the photographer must always balance what the client needs against what the photographer is willing to give. This may be an issue of reproduction rights or of ownership of physical objects, such as prints. While the following forms contain provisions for lost or damaged transparencies and insurance that are far less important in the digital age than before, there is no harm in retaining these provisions for the atypical case in which an original transparency or visual print may be delivered.

ASSIGNMENT ESTIMATE/CONFIRMATION/INVOICE

Designed for the commercial photographer, this form serves multiple purposes. If the box for estimate is checked, then the form is an estimate by which the photographer seeks to obtain an assignment. If the box for confirmation is checked, then the form is the contract under which the assignment will be done. And if the box for invoice is checked, the form is the billing for an assignment that has been completed. Reviewing the terms of the form gives you a checklist that you can also use to evaluate forms offered to you by clients.

To begin, the assignment must be described with clarity. Otherwise, it will be impossible to establish a fair fee and estimate expenses. The grant of rights should be large enough to let the client do what he or she wants, but no larger. If the client wants to exceed the initial grant of rights, then another negotiation can determine a reasonable fee for the additional use. Whether the photographer shall receive credit, and the placement of the credit, is important, especially in editorial work where such credit is expected. The timing of payment bears on

the photographer's cash flow. Expenses, a markup for expenses if agreed to, and the photographer's fees all have to be detailed.

The Terms and Conditions on the reverse of the form are not only favorable to the photographer but also list many of the terms the photographer should seek in this type of contract. The time for payment, advances (especially against expenses), reservation of any rights not granted, and the right to an additional fee if usage is to be made beyond the rights granted are all spelled out. If the form is used as an estimate, expenses can vary by as much as 10 percent. Reshoots and cancellations are also covered. Instead of putting the whole burden for releases on the photographer, the client also takes a certain amount of responsibility. The right to samples of the client's finished piece is included. Also, the photographer is given the right to assign money owed to the photographer, but neither party can assign other duties under the contract. For speedier and less expensive dispute resolution, the contract specifies that the parties will arbitrate disputes in excess of the maximum claim that can be pursued in the local small claims court.

The Miscellany provision of the contract is boilerplate, common provisions that appear in most contracts. This doesn't mean such provisions are unimportant. For example, the Miscellany provides that the contract is binding on the parties' successors-in-interest; that it is the entire understanding between the parties and can only be modified in writing, except that the client may authorize additional fees or expenses orally; and that waiving a breach of one provision of the contract doesn't waive future breaches of that provision or other provisions. Which state's laws will govern the contract should be inserted in this provision, which can be significant if the laws vary between states.

WEDDING PHOTOGRAPHY CONTRACT

Because the wedding photographer is selling to consumers who are novices with respect to buying photography, it is important that the contract be easy to understand. The contract has to resolve who is making the contract with the photographer. Is it the bride? The couple? One set or the other of the parents? What photographs will be taken of what groupings in what locales? What style will the photographer use? Is there a checklist of must-have photos?

Setting the fee has to be done in such a way that no disputes arise later on. One approach is a package fee that covers the photographer's time and expenses as well as the cost of a certain number of photographs (perhaps in an album). The other approach is to charge a sitting or session fee but not require the purchase of additional prints. In either approach, the purchase of additional prints would be based on the photographer's standard price list. The contract should

also deal with the possibility of additional time for work in Photoshop, the need for a reshoot, cancellation, and similar contingencies.

Dealing with consumers is not like dealing with businesses. You want to be certain that you will be paid. A deposit, perhaps half the total, is a good safeguard against nonpayment. The balance of the fee can be paid at the time of the wedding or when the order for photographs is filled.

The copyright in the photographs will belong to the photographer—a fact that will surprise many clients. The contract is a good place to determine what the photographer can do with the photographs in terms of advertising, portfolio, or promotional use.

The photographer needs protection against certain risks, such as camera malfunction or loss of images due to some type of accident. An arbitration clause is probably wise to include, so both parties can resolve disputes in a speedy and relatively inexpensive manner.

Again, the provisions of the contract serve as a checklist to help you develop a form that will suit the special circumstances of your photographic specialty and clientele.

PORTRAIT PHOTOGRAPHY CONTRACT

The contract for portrait photography is similar to that for wedding photography. The clients are likely to be unfamiliar with practices in the photography field, and a carefully drawn contract fulfills an educational as well as a legal role.

Fees can be established based either on a package fee (in which case specified prints are purchased) or a sitting fee (in which case the charge is for the time and expense of the photographer). In either case, additional prints can be ordered, and the photographer has to develop a standard price list.

It's imperative to receive a deposit from the client before starting the assignment and then have the final payment made when the proofs are reviewed or the order is placed or delivered.

The contract should clearly state that the photographer owns the copyright in the images. This helps ensure that the client will come back to the photographer for additional prints. Usage by the client should be described and limited to personal uses, not any sort of commercialization or sale.

The contract should try to protect the photographer from being liable for damages in situations in which the session doesn't take place, digital files are lost, or other mishaps prevent successful completion of the assignment.

To avoid the time and expense of litigation, it may help to include an arbitration provision. It's wise to seek the advice of a local attorney as to whether this is best.

CONTRACT FOR THE SALE OF FINE ART PHOTOGRAPHY

The fine art photographer will exhibit in galleries and earn income through the sale of physical artworks, although some images may also be licensed and earn royalties. Because photographs can be reproduced over and over, the photographer has to create a system to ensure collectors that they are buying either unique or limited-edition works. The contract deals with this issue by having the photographer give a warranty—a statement on which the buyer can place reliance and recover damages if the statement is false—to the effect that the work is unique or part of a limited edition (in which case the nature of the edition is described). The artwork is described, including whether or not the photographer has signed the work (which adds to its value).

The contract details the sale, the price, the manner of delivery (including insurance), when the risk of loss shifts from the photographer to the collector, the reservation of copyright by the photographer, and the usual Miscellany provision.

However, there are other provisions that can be added to this contract of sale. In part, these provisions mimic the moral rights and *droit de suite* created under foreign laws, which give an artist the right to be acknowledged as the creator of his or her work, the right to maintain the integrity of the work as created, and the right to a small percentage of resale proceeds when the work is sold under certain conditions. Contractual attempts to achieve these outcomes might include a provision for nondestruction of the work, integrity and attribution, a right to borrow for purposes of exhibition, a right to restore the work if damaged, and a right to a portion of resale proceeds. The artist might also want a security interest in the artwork until such time as payment is made in full. With proper filings of UCC Form 1, this would protect the artist against creditors of the collector seizing the artwork in the event of the collector's bankruptcy. While those who pursue the fine arts might hope to escape the mundane tussle of business, it is impossible once the artworks go into the world (and often before), so knowledge and preparation are likely to be the better part of valor.

DELIVERY MEMO

The photographer will often want to leave a print, transparency, or digital-storage medium with someone else. Particularly when the object left has great value or is unique, the photographer will have to make certain that the party holding it accepts liability and that a suitable amount of damages is specified in the event of loss. This is the purpose of the Delivery Memo, which can be used to deliver images to a lab, a gallery, a client, or a stock agency.

The Delivery Memo creates a contract between the photographer and party receiving the images. The copyright and reproduction rights are stated to belong

to the photographer, so that no confusion can arise and no illicit reproductions will be made. The recipient agrees to a high standard of care for the images, and the parties agree as to when the recipient responsibility will commence. In addition, the Delivery Memo specifies whether or not the recipient will insure the images. If the images are held longer than a certain time period, it is agreed that a holding fee will be paid. Arbitration and a Miscellany provision complete the Delivery Memo.

You should not give images to another party without having a Delivery Memo signed. Otherwise, in the event of loss or damage, you may find yourself in an unanticipated dispute without clear guidelines as to the level of the recipient's responsibility for the images.

LICENSE OF RIGHTS

The License of Rights covers a situation wherein the photographer has already created a work in which he or she owns the copyright and now is approached to license a certain usage to another party. The key provision here is the grant of rights, which refines exactly which usage rights are granted and which are retained. This form does not grant any electronic rights, such as the right to use the image on a website.

Other important provisions include the fee, a prohibition against alteration, a time for payment, how loss or damage will be handled, samples, copyright notice, authorship credit, releases, arbitration, and miscellany. A form such as this one aids the photographer in maximizing income from residual uses of an image beyond the initial use for which the image was created.

MODEL RELEASE

Every living person has a right to privacy. While statutes may vary from state to state, the basic thrust of the law is to protect an individual from advertising and trade uses of his or her image or from embarrassing uses that would damage the person's reputation.

Editorial usage, including a photograph to illustrate an article that is newsworthy or in the public interest, is protected by the First Amendment freedoms of speech and press. Ordinary people and especially celebrities have limited rights to privacy in the context of journalism.

Advertising and trade uses are another story and require permission. A trade use might be using an image of a person on product packaging and requires permission. In addition, however newsworthy or famous a person may be, he or she benefits from celebrity rights that forbid the commercialization of the celebrity's image or name without permission. Using a celebrity in advertising

or to make money from the sale of products is quite different from a newsworthy article, and First Amendment protections aren't available for the photographer.

If there is any chance that an image will be used in advertising, trade, or commercially for profit, you should obtain a release form. The form should be written, signed by the model during the session, and show what consideration was given to the model (such as a fee, prints, or other things of value). You must have a recordkeeping system that can connect the release to the images for which it was given. While a witness to the release isn't necessary, it does no harm to have one and may be helpful if any dispute arises.

Keep in mind that if an image is distorted when used, the release may no longer give protection to you. If you're asked to use someone else's release form (perhaps by a client), make sure it protects you. If you're dealing with a minor, you will have to obtain the signature of the parent or guardian.

Assignment Estimate/Confirmation/Invoice

Client _____ Date _____

Address _____ ❑ Estimate

_____ ❑ Confirmation

Client Purchase Order Number _____ ❑ Invoice

Client Contact _____ Job Number _____

Assignment Description _____

_____ Due Date _____

Grant of Rights. Upon receipt of full payment, Photographer shall grant to the Client the following exclusive rights:

For use as _____

For the product, project, or publication named _____

In the following territory _____

For the following time period or number of uses _____

Other limitations _____

This grant of rights does not include electronic rights, unless specified to the contrary here _____

in which event the usage restrictions shown above shall be applicable. For purposes of this agreement, electronic rights are defined as rights in the digitized form of works that can be encoded, stored, and retrieved from such media as computer disks, CD-ROM, computer databases, and network servers.

Credit. The Photographer ❑ shall ❑ shall not

receive adjacent credit in the following form on reproduction _____

Fee/Expenses. The Client shall pay the Balance Due, including reimbursement of the expenses as shown below, within thirty days of receipt of an invoice. A reuse fee of $_____ shall be paid in the following circumstances: _____

Expenses		Fees	
Assistants	$_____	Photography fee	$_____
Casting	$_____	Other fees	
Crews/Special Technicians	$_____	Preproduction $_____/day;	$_____
Digital Processing	$_____	Travel $_____/day;	$_____
Equipment Rentals	$_____	Weather days $_____/day	$_____
Film and Processing	$_____	Space or Use Rate (if applicable)	$_____
Insurance	$_____	Cancellation fee	$_____
Location	$_____	Reshoot fee	$_____
Messengers/Shipping	$_____	Fee subtotal	$_____
Models	$_____	Plus total expenses	$_____
Props/Wardrobe	$_____	Subtotal	$_____
Sets	$_____	Sales tax	$_____
Styling	$_____	**Total**	**$_____**
Travel/Transportation	$_____	Less advances	$_____
Telephone	$_____	**Balance due**	**$_____**
Other expenses	$_____		
subtotal	$_____		
(Plus _____% markup)	$_____	Client _____	
Total expenses	**$_____**	Company Name	

Photographer _____ By _____

Authorized Signatory, Title

Subject to All Terms and Conditions Above and on Reverse Side

Terms and Conditions

1. **Payment.** Client shall pay the Photographer within thirty days of the date of Photographer's billing, which shall be dated as of the date of delivery of the Assignment. The Client shall be responsible for and pay any sales tax due. Time is of the essence with respect to payment. Overdue payments shall be subject to interest charges of _____ percent monthly.

2. **Advances.** Prior to Photographer's commencing the Assignment, Client shall pay Photographer the advance shown on the front of this form, which advance shall be applied against the total due.

3. **Reservation of Rights.** Unless specified to the contrary on the front of this form any grant of rights shall be limited to the United States for a period of one year from the date of the invoice and, if the grant is for magazine usage, shall be first North American serial rights only. All rights not expressly granted shall be reserved to the Photographer, including but not limited to all copyrights and ownership rights in photographic materials, which shall include but not be limited to digital files, transparencies, negatives, and prints. Client shall not modify directly or indirectly any of the photographic materials, whether by digitized encodations or any other form or process now in existence or which may come into being in the future, without the express, written consent of the Photographer.

4. **Value and Return of Originals.** All photographic materials shall be returned to the Photographer by registered mail or bonded courier (which provides proof of receipt) within thirty days of the Client's completing its use thereof and, in any event, within _____ days of Client's receipt thereof. Time is of the essence with respect to the return of photographic materials. Unless a value is specified for a particular image either on the front of this form or on a Delivery Memo given to the Client by the Photographer, the parties agree that a reasonable value for an original transparency is $1,500. Client agrees to be solely responsible for and act as an insurer with respect to loss, theft, or damage of any image from the time of its shipment by Photographer to Client until the time of return receipt by Photographer.

5. **Additional Usage.** If Client wishes to make any additional uses, Client shall seek permission from the Photographer and pay an additional fee to be agreed upon.

6. **Authorship Credit.** Authorship credit in the name of the Photographer, including copyright notice if specified by the Photographer, shall accompany the photograph(s) when it is reproduced, unless specified to the contrary on the front of this form. If required authorship credit is omitted, the parties agree that liquidated damages for the omission shall be three times the invoiced amount.

7. **Expenses.** If this form is being used as an Estimate, all estimates of expenses may vary by as much as ten (10%) percent in accordance with normal trade practices. In addition, the Photographer may bill the Client in excess of the estimates for any overtime which must be paid by the Photographer to assistants and freelance staff for a shoot that runs more than eight (8) consecutive hours.

8. **Reshoots.** If Photographer is required by the Client to reshoot the Assignment, Photographer shall charge in full for additional fees and expenses, unless (a) the reshoot is due to Acts of God or is due to an error by a third party, in which case the Client shall only pay additional expenses but no fees; or (b) if the Photographer is paid in full by the Client, including payment for the expense of special contingency insurance, then Client shall not be charged for any expenses covered by such insurance in the event of a reshoot. The Photographer shall be given the first opportunity to perform any reshoot.

9. **Cancellation.** In the event of cancellation by the Client, the Client shall pay all expenses incurred by the Photographer and, in addition, shall pay the full fee unless notice of cancellation was given at least _____ hours prior to the shooting date, in which case fifty (50%) percent of the fee shall be paid. For weather delays involving shooting on location, Client shall pay the full fee if Photographer is on location and fifty (50%) percent of the fee if Photographer has not yet left for the location.

10. **Releases.** The Client shall indemnify and hold harmless the Photographer against any and all claims, costs, and expenses, including attorney's fees, due to uses for which no release was requested or uses which exceed the uses allowed pursuant to a release.

11. **Samples.** Client shall provide the Photographer with two copies of any authorized usage.

12. **Assignment.** Neither this Agreement nor any rights or obligations hereunder shall be assigned by either of the parties, except that the Photographer shall have the right to assign monies due hereunder. Both Client and any party on whose behalf Client has entered into this Agreement shall be bound by this Agreement and shall be jointly and severally liable for full performance hereunder, including but not limited to payments of monies due to the Photographer.

13. **Arbitration.** All disputes shall be submitted to binding arbitration before _____ in the following location _____ _____ and settled in accordance with the rules of the American Arbitration Association. Judgment upon the arbitration award may be entered in any court having jurisdiction thereof. Disputes in which the amount at issue is less than $_____ shall not be subject to this arbitration provision.

14. **Miscellany.** The terms and conditions of this Agreement shall be binding upon the parties, their heirs, successors, assigns, and personal representatives; this Agreement constitutes the entire understanding between the parties; its terms can be modified only by an instrument in writing signed by both parties, except that the Client may authorize additional fees and expenses orally; a waiver of a breach of any of its provisions shall not be construed as a continuing waiver of other breaches of the same or other provisions hereof; and the relationship between the Client and Photographer shall be governed by the laws of the State of _____.

Wedding Photography Contract

Client_____ Date_____ .

Address_____ Telephone _____

_____ Order Number_____

Bride's Name_____ Groom's Name_____

Address_____ Address_____

_____ _____

Couple's future address _____

Description of Photographic Services to be Provided

❏ Black and White print for Newspapers ❏ Bride only ❏ Bride and Groom

Number of previews or proofs to be shown to Client ❏ Color _____ ❏ Black and White _____

Locations for Photography ❏ Studio Date_____ Time_____

❏ Home, address_____ Date_____ Time_____

❏ Rehearsal, address_____ Date_____ Time_____

❏ Ceremony, address_____ Date_____ Time_____

❏ Reception, address_____ Date_____ Time_____

Special Services, if required _____

Charges. The package fee is based on the Photographer's Standard Price List and includes the photographs described therein. If the fee is not based on a package but is a session fee, all photographs shall be billed in addition to the fee and in accordance with the Standard Price List. In addition to either the package fee or the session fee, the extra charges set forth below shall be billed if and when incurred.

❏ Package Fee (Package number _____) ... $_____

❏ Fee Without Package.. $_____

Extra Charges

Additional prints ... $_____

Resitting... $_____

Special retouching .. $_____

Special finishes.. $_____

Rush service... $_____

Unreturned previews .. $_____

Overtime .. $_____

Travel.. $_____

Other _____ $_____

Subtotal $_____

Sales tax $_____

Total Due $_____

Less deposit $_____

Balance Due $_____

The parties have read both the front and back of this Agreement, agree to all its terms, and acknowledge receipt of a complete copy of the Agreement signed by both parties. Each person signing as Client below shall be fully responsible for ensuring that full payment is made pursuant to the terms of this Agreement.

Client _____ Client _____ Client _____

Photographer _____ Date _____

This Agreement is subject to all the terms and conditions appearing on the reverse side.

Terms and Conditions

1. **Exclusive Photographer.** The Photographer shall be the exclusive photographer retained by the Client for the purpose of photographing the wedding. Family and friends of the Client shall be permitted to photograph the wedding as long as they shall not interfere with the Photographer's duties and do not photograph poses arranged by the Photographer.

2. **Deposit and Payment.** The Client shall make a deposit to retain the Photographer to perform the services specified herein. At such time as this order is completed, the deposit shall be applied to reduce the total cost and Client shall pay the balance due. If the Client refuses delivery of the order or refuses to pay within thirty (30) days of this order, Client shall be in default hereunder and shall pay _____ percent interest on the unpaid balance until payment is made in full.

3. **Cancellation.** If the Client shall cancel this Agreement thirty (30) or more calendar days before the wedding date, any deposit paid to the Photographer shall be refunded in full. If Client shall cancel within thirty days of the wedding date and if the Photographer does not obtain another assignment for that date, liquidated damages shall be charged in a reasonable amount not to exceed the deposit.

4. **Photographic Materials.** All photographic materials, including but not limited to digital files, negatives, transparencies, proofs, and previews, shall be the exclusive property of the Photographer. The Photographer shall make proofs and previews available to the Client for the purpose of selecting photographs, but such proofs and previews shall be on loan and, if they are not returned within fourteen (14) days of receipt by the Client, shall be charged to the Client at the same rate as finished prints of the same size. The Photographer may, with the Client's permission, make the proofs available on a Web site or CD-ROM.

5. **Copyright and Reproductions**. The Photographer shall own the copyright in all images created and shall have the exclusive right to make reproductions. The Photographer shall only make reproductions for the Client or for the Photographer's portfolio, samples, self-promotions, entry in photographic contests or art exhibitions, editorial use, or for display within or on the outside of the Photographer's studio. If the Photographer desires to make other uses, the Photographer shall not do so without first obtaining the written permission of the Client.

6. **Client's Usage.** The Client is obtaining prints for personal use only, and shall not sell said prints or authorize any reproductions thereof by parties other than the Photographer. If Client is obtaining a print for newspaper announcement of the wedding, Photographer authorizes Client to reproduce the print in this manner. In such event, Client shall request that the newspaper run a credit for the Photographer adjacent to the photograph, but shall have no liability if the newspaper refuses or omits to do so.

7. **Failure to Perform.** If the Photographer cannot perform this Agreement due to a fire or other casualty, strike, act of God, or other cause beyond the control of the parties, or due to Photographer's illness, then the Photographer shall return the deposit to the Client but shall have no further liability with respect to the Agreement. This limitation on liability shall also apply in the event that photographic materials are damaged in processing, lost through camera or computer malfunction, lost in the mail, or otherwise lost or damaged without fault on the part of the Photographer. In the event the Photographer fails to perform for any other reason, the Photographer shall not be liable for any amount in excess of the retail value of the Client's order.

8. **Photographer.** The Photographer may substitute another photographer to take the photographs in the event of Photographer's illness or of scheduling conflicts. In the event of such substitution, Photographer warrants that the photographer taking the photographs shall be a competent professional.

9. **Inherent Qualities.** Client is aware that color dyes in photography may fade or discolor over time due to the inherent qualities of dyes, and Client releases Photographer from any liability for any claims whatsoever based upon fading or discoloration due to such inherent qualities.

10. **Photographer's Standard Price List.** The charges in this Agreement are based on the Photographer's Standard Price List. This price list is adjusted periodically and future orders shall be charged at the prices in effect at the time when the order is placed.

11. **Client's Originals**. If the Client is providing original prints, digital files, negatives, or transparencies owned by the Client to the Photographer for duplication, framing, reference, or any other purpose, in the event of loss or damage the Photographer shall not be liable for an amount in excess of $_____ per image.

12. **Arbitration.** All disputes arising under this Agreement shall be submitted to binding arbitration before _____ in the following location _____ and the arbitration award may be entered for judgment in any court having jurisdiction thereof. Notwithstanding the foregoing, either party may refuse to arbitrate when the dispute is for a sum less than $_____.

13. **Miscellany.** This Agreement incorporates the entire understanding of the parties. Any modifications of this Agreement must be in writing and signed by both parties. Any waiver of a breach or default hereunder shall not be deemed a waiver of a subsequent breach or default of either the same provision or any other provision of this Agreement. This Agreement shall be governed by the laws of the State of _____.

Portrait Photography Contract

Client _____ Telephone_____

Address_____

_____ Order number_____

Description of Photographic Services to be Provided

Portrait of _____

Location for photography _____

Date_____ Time_____

Number of previews or proofs to be shown to Client ❑ Color _____ ❑ Black-and-white _____

Special services, if required _____

Special Usage Requirements _____

Charges. The package fee is based on the Photographer's Standard Price List and includes the photographs described therein. If the fee is not based on a package but is a session fee, all photographs shall be billed in addition to the fee and in accordance with the Standard Price List. In addition to either the package fee or the session fee, the extra charges set forth below shall be billed if and when incurred.

❑ Package fee (package number _____)................................	$_____
❑ Fee without package..	$_____
Extra Charges	
Additional prints...	$_____
Resitting..	$_____
Special retouching...	$_____
Special finishes...	$_____
Rush service ...	$_____
Unreturned previews..	$_____
Overtime ..	$_____
Travel ...	$_____
Other_____	$_____
Subtotal	$_____
Sales tax	$_____
Total	$_____
Less deposit	$_____
Balance Due	**$_____**

The parties have read both the front and back of this Agreement, agree to all its terms, and acknowledge receipt of a complete copy of the Agreement signed by both parties.

Client_____ Date_____

Photographer _____ Date _____

This Agreement is subject to all the terms and conditions appearing on the reverse side.

Terms and Conditions

1. **Deposit and Payment.** The Client shall make a deposit to retain the Photographer to perform the services specified herein. At such time as this order is completed, the deposit shall be applied to reduce the total cost and Client shall pay the balance due. If the Client refuses delivery of the order or refuses to pay within thirty (30) days of this order, Client shall be in default hereunder and shall pay _____ percent interest on the unpaid balance until payment is made in full.

2. **Cancellation.** If the Client shall cancel this Agreement _____ or more calendar days before the session date, any deposit paid to the Photographer shall be refunded in full. If Client shall cancel within _____ days of the session date and if the Photographer does not obtain another assignment for that time, liquidated damages shall be charged in a reasonable amount not to exceed the deposit.

3. **Photographic Materials.** All photographic materials, including but not limited to digital files, negatives, transparencies, proofs, and previews, shall be the exclusive property of the Photographer. The Photographer shall make proofs and previews available to the Client for the purpose of selecting photographs, but such proofs and previews shall be on loan and, if they are not returned within fourteen (14) days of receipt by the Client, shall be charged to the Client at the same rate as finished prints of the same size. The Photographer may, with the Client's permission, make the proofs available on a Web site or CD-ROM.

4. **Copyright and Reproductions.** The Photographer shall own the copyright in all images created and shall have the exclusive right to make reproductions. The Photographer shall only make reproductions for the Client or for the Photographer's portfolio, samples, self-promotions, entry in photographic contests or art exhibitions, editorial use, or for display within or on the outside of the Photographer's studio. If the Photographer desires to make other uses, the Photographer shall not do so without first obtaining the written permission of the Client.

5. **Client's Usage.** The Client is obtaining prints for personal use only, and shall not sell said prints or authorize any reproductions thereof by parties other than the Photographer. If Client is obtaining a print for reproduction, Photographer authorizes Client to reproduce the print only as set forth under Special Usage Requirements on the front of this form. In such event, Client shall request that a credit for the Photographer be placed adjacent to the photograph on publication, but shall have no liability if the publication refuses or omits to do so.

6. **Failure to Perform.** If the Photographer cannot perform this Agreement due to a fire or other casualty, strike, act of God, or other cause beyond the control of the parties, or due to the Photographer's illness, then the Photographer shall return the deposit to the Client but shall have no further liability with respect to the Agreement. This limitation on liability shall also apply in the event that photographic materials are damaged in processing, lost through camera or computer malfunction, lost in the mail, or otherwise lost or damaged without fault on the part of the Photographer. In the event the Photographer fails to perform for any other reason, the Photographer shall not be liable for any amount in excess of the retail value of the Client's order.

7. **Photographer.** The Photographer may substitute another photographer to take the photographs in the event of Photographer's illness or scheduling conflicts. In the event of such substitution, Photographer warrants that the photographer taking the photographs shall be a competent professional.

8. **Inherent Qualities.** Client is aware that color dyes in photography may fade or discolor over time due to the inherent qualities of dyes, and Client releases Photographer from any liability for any claims whatsoever based upon fading or discoloration due to such inherent qualities.

9. **Photographer's Standard Price List.** The charges in this Agreement are based on the Photographer's Standard Price List. This price list is adjusted periodically and future orders shall be charged at the prices in effect at the time when the order is placed.

10. **Client's Originals.** If the Client is providing original prints, digital files, negatives, or transparencies owned by the Client to the Photographer for duplication, framing, reference, or any other purpose, in the event of loss or damage the Photographer shall not be liable for an amount in excess of $_____ per image.

11. **Arbitration.** All disputes arising under Agreement shall be submitted to binding arbitration before _____ in the following location _____ and the arbitration award may be entered for judgment in any court having jurisdiction thereof. Notwithstanding the foregoing, either party may refuse to arbitrate when the dispute is for a sum less than $_____.

12. **Miscellany.** This Agreement incorporates the entire understanding of the parties. Any modifications of this Agreement must be in writing and signed by both parties. Any waiver of a breach or default hereunder shall not be deemed a waiver of a subsequent breach or default of either the same provision or any other provision of this Agreement. This Agreement shall be governed by the laws of the State of _____.

Contract for the Sale of Fine Art Photography

AGREEMENT, entered into as of the _____ day of _____, 20_____, between _____ (hereinafter referred to as the "Photographer"), located at_____

_____, and _____ (hereinafter referred to as the "Collector"),

located at _____, with respect to

the sale of an artwork (hereinafter referred to as the "Work").

WHEREAS, the Photographer has created the Work and has full right, title, and interest therein; and

WHEREAS, the Photographer wishes to sell the Work; and

WHEREAS, the Collector has viewed the Work and wishes to purchase it;

NOW, THEREFORE, in consideration of the foregoing premises and the mutual obligations, covenants, and conditions hereinafter set forth, and other valuable considerations, the parties hereto agree as follows:

1. **Description of Work.** The Photographer describes the Work as follows:

 Title _____

 Medium _____

 Size _____

 Framing or Mounting _____

 Year of Creation _____

 Signed by Photographer: ❏ Yes ❏ No

 The Photographer warrants that this work is unique (one of a kind): ❏ Yes ❏ No

 If the Work is part of a limited edition, indicate the method of production _____; the size of the edition_____; how many multiples are signed_____; how many are unsigned_____; how many are numbered_____; how many are unnumbered_____; how many proofs exist_____; the quantity of any prior editions_____; and whether the master image has been cancelled or destroyed ❏ yes ❏ no.

2. **Sale.** The Photographer hereby agrees to sell the Work to the Collector. Title shall pass to the Collector at such time as full payment is received by the Photographer pursuant to Paragraph 4 hereof.

3. **Price.** The Collector agrees to purchase the Work for the agreed upon price of $_____, and shall also pay any applicable sales or transfer taxes.

4. **Payment.** Payment shall be made in full upon the signing of this Agreement.

5. **Delivery.** The ❏ Photographer ❏ Collector shall arrange for delivery to the following location: _____ _____ no later than _____, 20____. The expenses of delivery (including, but not limited to, insurance and transportation) shall be paid by _____.

6. **Risk of Loss and Insurance.** The risk of loss or damage to the Work and the provision of any insurance to cover such loss or damage shall be the responsibility of the Collector from the time of_____ _ _____.

7. **Copyright and Reproduction.** The Photographer reserves all reproduction rights, including the right to claim statutory copyright, in the Work. The Work may not be photographed, sketched, painted, or reproduced in any manner whatsoever without the express, written consent of the Photographer. All approved reproductions shall bear the following copyright notice: © by (Photographer's name) 20____.

8. **Miscellany.** This Agreement shall be binding upon the parties hereto, their heirs, successors, assigns, and personal representatives. This Agreement constitutes the entire understanding between the parties. Its terms can be modified only by an instrument in writing signed by both parties. A waiver of any breach of any of the provisions of this Agreement shall not be construed as a continuing waiver of other breaches of the same or other provisions hereof. This Agreement shall be governed by the laws of the State of _____.

IN WITNESS WHEREOF, the parties hereto have signed this Agreement as of the date first set forth above.

Photographer _____ Collector _____

Delivery Memo

Recipient _____ Date _____

Address_____ Delivery Memo No. _____

_____ Purchase Order No. _____

Per Request of _____ Telephone _____

Photo Return/Response Due _____ Extension Granted _____

Purpose of Delivery _____

Value*	Quantity	Format/ Size	Original or Dupe	Description/File Number	BW/Color

*Value is in case of loss, theft, or damage. If digital files are submitted, the Value, Quantity, and Original or Dupe columns should not be completed.

Total Color_____ Total Black and White_____

Please count all photographs and confirm that the count is accurate by returning one signed copy of this form. If objection is not immediately made by return mail, the Recipient shall be considered to accept the count shown on this form as accurate and that the photographs are of a quality suitable for reproduction.

Acknowledged and Accepted _____ Date_____

<div align="center">Company Name</div>

By _____

<div align="center">Authorized Signatory, Title</div>

<div align="center">Subject to All Terms and Conditions Above and on Reverse Side</div>

Terms and Conditions

1. **Purpose.** Photographer hereby agrees to entrust the photographs listed on the front of this form to the Recipient for the purpose specified. "Photographs" are defined to include digital files, transparencies, prints, negatives, and any other form in which the images can be stored, incorporated, represented, projected, or perceived, including forms and processes not presently in existence but which may come into being in the future.

2. **Acceptance.** Recipient accepts the listing and values as accurate if not objected to in writing by return mail immediately after receipt of the photographs. If Recipient has not signed this form, any terms on this form not objected to in writing within 10 days shall be deemed accepted.

3. **Ownership and Copyright.** Copyright and all reproduction rights in the photographs, as well as the ownership of digital files and the physical photographs themselves, are the property of and reserved to the Photographer. Recipient acknowledges that the photographs shall be held in confidence and agrees not to display, copy, or modify directly or indirectly any of the photographs submitted, nor will Recipient permit any third party to do any of the foregoing. Without limitation to the foregoing, Recipient shall not tamper with or alter in any way metadata that accompanies the photographs and shall, in addition, safeguard the photographs to prevent any violation of this paragraph. Reproduction, display, sale, or rental shall be allowed only upon Photographer's written permission specifying usage and fees.

4. **Loss, Theft, or Damage.** Recipient agrees to assume full responsibility and be strictly liable for loss, theft, or damage to the photographs from the time of ❑ shipment by the Photographer ❑ receipt by the Recipient until the time of ❑ shipment by the Recipient ❑ receipt by the Photographer. Recipient further agrees to return all of the photographs at its own expense by the following method of transportation: _____.
Reimbursement for loss, theft, or damage to a photograph shall be in the amount of the value entered for that photograph. Both Recipient and Photographer agree that the specified values represent the value of the photographs. If no value is entered for an original transparency, the parties agree that a fair and reasonable value is $1,500 (Fifteen Hundred Dollars).

5. **Insurance.** Recipient ❑ does ❑ does not agree to insure the photographs for all risks from the time of shipment from the Photographer until the time of delivery to the Photographer for the values shown on the front of this form.

6. **Holding Fees.** The photographs are to be returned to the Photographer within _____ days after delivery to the Recipient. Each photograph held beyond _____ days from delivery shall incur the following weekly holding fee: $_____ which shall be paid to the Photographer when billed.

7. **Arbitration.** Recipient and Photographer agree to submit all disputes hereunder in excess of $_____ to arbitration before _____ at the following location _____ under the rules of the American Arbitration Association. The arbitrator's award shall be final and judgment may be entered on it in any court having jurisdiction thereof.

8. **Miscellany.** This Agreement contains the full understanding between the parties hereto and may only be modified by a written instrument signed by both parties. It shall be governed by the laws of the State of_____.

License of Rights

AGREEMENT, entered into as of the _____ day of _____, 20 _____, between _____, located at _____ (hereinafter referred to as the "Client") and _____, located at _____ (hereinafter referred to as the "Photographer") with respect to the licensing of certain nonelectronic rights in the Photographer's photograph(s) (hereinafter referred to as the "Work").

1. **Description of Work.** The Client wishes to license certain nonelectronic rights in the Work which the Photographer has created and which is described as follows:

 Title_____Number of images_____

 Subject matter_____

 _____ .

 Form in which work shall be delivered ❑ computer file (specify format _____)

 ❑ original transparency (size _____) ❑ dupe (size _____)

2. **Delivery Date.** The Photographer agrees to deliver the Work within _____ days after the signing of this Agreement.

3. **Grant of Rights.** Upon receipt of full payment, Photographer grants to the Client the following nonelectronic rights in the Work:

 For use as_____in the_____language

 For the product or publication named_____

 In the following territory_____

 For the following time period_____

 With respect to the usage shown above, the Client shall have nonexclusive rights unless specified to the contrary here_____

 If the Work is for use as a contribution to a magazine, the grant of rights shall be for one time North American serial rights only unless specified to the contrary above.
 Other limitations_____

 If the Client does not complete its usage under this Paragraph 3 by the following date_____, all rights granted but not exercised shall without further notice revert to the Photographer without prejudice to the Photographer's right to retain sums previously paid and collect additional sums due.

4. **Reservation of Rights.** All rights not expressly granted hereunder are reserved to the Photographer, including but not limited to all rights in preliminary materials and all electronic rights. For purposes of this agreement, electronic rights are defined as rights in the digitized form of works that can be encoded, stored, and retrieved from such media as computer disks, CD-ROM, computer databases, and network servers.

5. **Fee.** Client agrees to pay the following: ❑ $_____ for the usage rights granted, or ❑ an advance of $_____ to be recouped against royalties computed as follows _____

6. **Additional Usage.** If Client wishes to make any additional uses of the Work, Client agrees to seek permission from the Photographer and make such payments as are agreed to between the parties at that time.

7. **Alteration.** Client shall not make or permit any alterations, whether by adding or removing material from the Work, without the permission of the Photographer. Alterations shall be deemed to include the addition of any illustrations, photographs, sound, text, or computerized effects, unless specified to the contrary here_____

8. **Payment.** Client agrees to pay the Photographer within thirty days of the date of Photographer's billing, which shall be dated as of the date of delivery of the Work. Overdue payments shall be subject to interest charges of _____ percent monthly.

9. **Loss, Theft, or Damage.** The ownership of the Work shall remain with the Photographer. Client agrees to assume full responsibility and be strictly liable as an insurer for loss, theft, or damage to the Work and to insure the Work fully from the time of shipment from the Photographer to the Client until the time of return receipt by the Photographer. Client further agrees to return all of the Work at its own expense by registered mail or bonded courier which provides proof of receipt. Reimbursement for loss, theft, or damage to any Work shall be in the following amount: _____ Both Client and Photographer agree that these specified value(s) represent the fair and reasonable value of the Work. Unless the value for an original transparency is specified otherwise in this paragraph, both parties agree that each original transparency has a fair and reasonable value of $1,500 (Fifteen Hundred Dollars). Client agrees to reimburse Photographer for these fair and reasonable values in the event of loss, theft, or damage.

10. **Samples.** Client shall provide Photographer with _____ samples of the final use of the Work.

11. **Copyright Notice.** Copyright notice in the name of the Photographer ❏ shall ❏ shall not accompany the Work when it is reproduced.

12. **Credit.** Credit in the name of the Photographer ❏ shall ❏ shall not accompany the Work when it is reproduced. If the Work is used as a contribution to a magazine or for a book, credit shall be given unless specified to the contrary in the preceding sentence.

13. **Releases.** The Client agrees to indemnify and hold harmless the Photographer against any and all claims, costs, and expenses, including attorney's fees, due to uses for which no release was requested, uses which exceed the uses allowed pursuant to a release, or uses based on alterations not allowed pursuant to Paragraph 7.

14. **Arbitration.** All disputes arising under this Agreement shall be submitted to binding arbitration before _____ _____ in the following location _____ and settled in accordance with the rules of the American Arbitration Association. Judgment upon the arbitration award may be entered in any court having jurisdiction thereof. Disputes in which the amount at issue is less than $_____ shall not be subject to this arbitration provision.

15. **Miscellany.** This Agreement shall be binding upon the parties hereto, their heirs, successors, assigns, and personal representatives. This Agreement constitutes the entire understanding between the parties. Its terms can be modified only by an instrument in writing signed by both parties, except that the Client may authorize expenses or revisions orally. A waiver of a breach of any of the provisions of this Agreement shall not be construed as a continuing waiver of other breaches of the same or other provisions hereof. This Agreement shall be governed by the laws of the State of _____.

In Witness Whereof, the parties hereto have signed this Agreement as of the date first set forth above.

Photographer_____ Client_____
 Company Name

 By:_____
 Authorized Signatory, Title

Model Release

In consideration of _____ Dollars ($_____), and other valuable consideration, receipt of which is acknowledged, I, _____(print Model's name) do hereby give _____(the Photographer), his or her assigns, licensees, successors in interest, legal representatives, and heirs the irrevocable right to use my name (or any fictional name), picture, portrait, or photograph in all forms and in all media and in all manners, without any restriction as to changes or alterations (including but not limited to composite or distorted representations or derivative works made in any medium) for advertising, trade, promotion, exhibition, or any other lawful purposes, and I waive any right to inspect or approve the photograph(s) or finished version(s) incorporating the photograph(s), including written copy that may be created and appear in connection therewith. I hereby release and agree to hold harmless the Photographer, his or her assigns, licensees, successors in interest, legal representatives and heirs from any liability by virtue of any blurring, distortion, alteration, optical illusion, or use in composite form whether intentional or otherwise, that may occur or be produced in the taking of the photographs, or in any processing tending toward the completion of the finished product, unless it can be shown that they and the publication thereof were maliciously caused, produced, and published solely for the purpose of subjecting me to conspicuous ridicule, scandal, reproach, scorn, and indignity. I agree that the Photographer owns the copyright in these photographs and I hereby waive any claims I may have based on any usage of the photographs or works derived therefrom, including but not limited to claims for either invasion of privacy or libel. I am of full age* and competent to sign this release. I agree that this release shall be binding on me, my legal representatives, heirs, and assigns. I have read this release and am fully familiar with its contents.

Witness: _____ Signed: _____
 Model

Address: _____ Address: _____

 Date: _____, 20 _____

———————————————— **Consent (if applicable)** ————————————————

I am the parent or guardian of the minor named above and have the legal authority to execute the above release. I approve the foregoing and waive any rights in the premises.

Witness: _____ Signed: _____
 Parent or Guardian

Address: _____ Address: _____

 Date: _____, 20 _____

* Delete this sentence if the subject is a minor. The parent or guardian must then sign the consent.

by Michal Heron and David MacTavish

This chapter is adapted from *Pricing Photography* by Michal Heron and David MacTavish. Michal Heron works on assignment for editorial and corporate clients, is actively involved in stock photography, and is the author of *How to Shoot Stock Photos That Sell* and *Stock Photography Business Forms*. She was formerly based in New York but now runs her studio from a farm in the Catskills. David MacTavish worked as a photographer for twenty-two years and is now an attorney specializing in intellectual property law—specifically, copyright, art, entertainment, trademark, computer, and Internet law.

IN PRICING PHOTOGRAPHY for publication, you must always remember that you are rarely "selling" your images. This is true whether the images were made on assignment or are in your stock photography library. Photographers who do portrait and wedding photography make images that are sold to customers and are products. These images are not intended for publication.

If you are a publication photographer, get in the habit of thinking that you are only letting your clients temporarily use your images. You are, in essence, allowing the client temporary use of your work. This is called "licensing," and it is not to be confused with "leasing," "renting," or, especially, "selling." Each of these terms has distinct legal significance, and they do not describe your arrangement with your clients. Always think *licensing*!

WEDDING/PORTRAIT PRICING

If you are in the business of making images for sale to customers, you can nonetheless benefit from considering the factors that go into setting fees for photographers whose goal is publication. The consideration given to overhead, salary, and profit in this chapter especially are important for all photographers to keep in mind. Studios will usually create price lists for wedding and portrait photography. The prices for wedding photographs will usually be based on a basic package, which includes a certain number of images in an album, and specified charges for additional images or albums. For portrait photography, in addition to charging for prints, there will usually be a basic creative fee for the sitting. As Ed Lilley points out in his book *The Business of Studio Photography*, "Most successful studios use a mixture of

the fixed markup, what-the-competition-is-charging, and what-the-market-will-bear techniques." His book should be referred to for its excellent discussion of the special pricing issues facing wedding and portrait photographers.

WHAT ARE WE PRICING?

Publication prices, whether for stock or assignment, are based on general industry assumptions—namely, project budget size (and therefore the value to your client) and the usage rights demanded. These factors directly affect what a client should pay.

In other words, because advertising projects generally have the largest project budgets (and the most potential for realizing profit), larger fees are usually paid. Additionally, if clients want to use a photograph on a billboard, on a package, and as a two-page spread advertisement, they should expect to pay more. But a price must be based on more.

Background

Over the years, methods of pricing have developed differently in specific areas of photography. In editorial and corporate work, the day rate was a prominent feature of pricing. In advertising, a creative fee was the norm—with the day rate being incorporated as part of that fee. In recent years, a day-rate-only mentality has gained precedence, and photographers have lost sight of the many other factors that affect pricing. It may not be coincidental that photographers have suffered a steady erosion in fees during this time.

Traditionally, photographers based assignment pricing on a "day rate plus expenses" for each billable day. A billable day was usually considered to be any day during which photography actually took place. If there were multiple days, the number was multiplied against the day rate for a total. This approach worked somewhat well for decades, although it didn't accurately reflect the real values of the assignment or the photographer's talents. And it brought about some friction with photo clients.

Too many clients, when confronted with the term "day rate," react negatively, comparing a day rate to the eight or so hours *they* toil daily. Because of the simplistic (and, therefore, deficient) "day rate" concept, clients expect to pay only for actual photography days. Worse, they probably don't realize that you may have fewer than one hundred billable days per year. Because they don't understand, clients may compare the amount that they make each day, possibly $100 to $300 per day, to the hundreds and perhaps thousands you may charge on a day rate basis. "Why," they may ask themselves, "should I pay this photographer so much for taking a few photographs?" Clients can't be expected to know that each billable day you work for them will take several additional days for preproduction and possibly another for editing, preparing the photographs for delivery, and so on. And they probably

aren't aware that your fee goes to help pay for overhead items like insurance, health coverage, and the many benefits they take for granted as employees.

Conceived during the heyday of magazine photojournalism, the concept of "day rate," in today's marketplace, is philosophically and financially unwise. Do yourself and your client a big favor: quote a "creative fee" for the assignment and *not* a "day rate."

A creative fee encompasses much more than the simplistic day rate and consists of overhead (what it costs you to be in business each billable day), a profit (usually expressed as a percentage of overhead), and, based on the particular assignment, other relevant factors of value (like time, experience, hazards, value to the client, and so on). The grand total will be your creative fee. (Note: Expenses related to the assignment are not included within the creative fee but are usually listed as separate items.)

At first glance, it may seem easier to use the concept of day rate, since it is easily quantifiable and understandable, especially if you are inexperienced or if your authority over an assignment is limited. Some may ask: What if you incorrectly calculated, and additional time is required to complete the assignment? If you estimate by using a creative fee, as their reasoning goes, you might find yourself working extra days without pay. The simple solution is to note in your estimate or bid that "the creative fee assumes a specific time period . . ." a range within which you feel you can do the photography, possibly one you've already agreed to based on discussions with your client. "Should extra time be required . . ." your terms and conditions continue, not of your own causing, you "will have to revise the creative fee accordingly."

You will find clients commonly asking for your day rate. Don't be trapped. It's best to tell them that quoting a day rate is not the way you work because you price by the job, and quoting a rate is impossible without knowing all the factors of a job. Why not say instead, "If you care to tell me about an assignment you recently did, or an upcoming one, I'll be glad to give you an idea of what I would charge." This approach has two benefits: not only are you able to offer a more accurate idea of price, but you also have the client involving you in discussions directly related to assignments.

Day Rate versus Shooting Time

In the seminars given around the country by the authors of this chapter, the most difficult concept in pricing seems to be relating the day rate vis-à-vis accounting for time spent shooting on an assignment. How can this be reconciled? If not through a day rate, how can we be sure our time is covered? Simple—photography shooting time is well accounted for under the umbrella of the creative fee. But, instead of

being expressed in a flat fee, time expressed within a creative fee is calculated in a way that relates to your cost of being in business. The day rate, despite everyone's best intentions, becomes a flat fee when a client asks your day rate and forever categorizes you by that number. No longer can you account for the many factors that may affect a price—your day rate becomes permanently fixed, regardless of the type of assignment and the rights that are requested. Later, we will dissect the creative fee and show how to use your own costs to build a creative fee tailored to your business. For now, remember that time spent is *not* day rate; time must be a factor in your calculations, and a value must be assigned to it. Time spent reflects the days involved in the assignment, and these days are valued when you include a percentage of your overhead and profit, prorated over the number of potential billable days.

ELEMENTS OF PRICING

Let's take a brief look at the various elements that make up assignment and stock prices.

Assignments

An assignment price is the amount you will actually charge a client. It is important to remember that all costs associated with production (including your time and overhead) are borne by the client in exchange for the first use of the image(s). The elements that constitute the assignment's bottom-line price are expressed as fees or expenses. This approach to assignment pricing works whether you are making images with a camera, computer, finger paints, or any other tools.

I. **Creative Fee**: This fee is made up of a number of separate elements, expressed as a single fee:
 - **Overhead.** The costs you have to account for even if you never take any photographs (e.g., the cost of photographic equipment, studio rental, using your vehicle in business, insurance, salaries, profit, and so on). Later, you'll see how to calculate overhead.
 - **Time.** The total amount of time you spend working on the assignment, and not necessarily just the time you spend photographing. Some photographers include in the creative fee a modest amount of time for pre- and postproduction, such as phone calls to arrange the assignment, casting, or meetings, unless the assignment calls for extensive logistical arrangements.
 - **Value factors** are components affecting your creative fee that include the market where the photos will appear, usage rights or how the client intends to use your image(s), and various photographic elements like

special skill or creativity, special risks or hazards, and so on. (See the box, "Value Factors," below.) For example, you may charge less if your image is used in a nonprofit foundation newsletter but far more if a Fortune 500 company uses the same image in their annual report. When pricing usage, remember the old adage, "What the market will bear." Some types of use simply pay more than others. (Note: The pricing charts in this book are a visual explanation of what this means.)

The creative fee is the basic fee that must be charged (no matter what you call it), and for any assignment it can be formulated as: annual overhead total divided by the number of assignment days you expect in a year, multiplied by the number of days in the assignment you are pricing, added to various usage or value factors. Don't panic—these terms will be fully explained later. The equation could be drawn as:

Creative Fee = Annual Overhead ÷ Annual Photography Days x Assignment Days + Value Factors

2. **Noncreative Fees:** These are charges for your time working on an assignment that is not generally thought to be part of the creative act of photography. These fees can include:
 - Travel time
 - Casting
 - Postponement
 - Cancellation
 - Pre- and postproduction
 - Reshoot fees
 - Weather delays

 These fees are charged as required to compensate you for your time or time lost and likely won't be charged very often, but they must be charged when necessary, or you will put yourself in the position of losing money.

3. **Reimbursable Expenses:** These are the costs you incur doing an assignment and are billed to the client. Assignment expenses do not include any of your overhead, because those costs are already incorporated into your creative fee. Some expense categories include: casting, crew, insurance, film/lab, location, messengers/shipping, props,

rentals, sets, studio, talent, transportation (local), travel, and wardrobe. Reimbursable expenses are generally those items that are disposable or consumable, as opposed to items that are not consumed, like cameras, lighting equipment, and so on.

4. **Miscellaneous Charges**: Assignment prices may include a number of other, miscellaneous charges:

- **Expense markups** are a small percentage added to the amount you have spent on expenses. Smart photographers add this charge to compensate themselves for the client's use of their money until they are paid. If you extend "credit" on expenses, you should expect to be paid for it.

- **Reuse fees.** Compensation for a client's later, additional use of your assignment photographs. This is a fee that is seldom charged along with your assignment invoicing. It usually comes later, when a client requests additional use of your images. If negotiated at the time of the original assignment, future reuse can be billed as part of the creative fee or as a separate fee amount. If reuse is requested at a later date, these fees may be negotiated and invoiced as reuse fees, similar to stock-reproduction fees. The smart photographer will bring up the subject of reuse charges in the original negotiations, because it puts clients on notice that additional use is not free, that they don't own the images, and that you are thinking of their needs and willing to extend a lower rate for reuse.

SOME ASSIGNMENT FEES AND EXPENSES

The list below contains many, but not all, of the fees and expenses traditionally billed for assignments.

Fees

- Photography
- Nonphotography

Expenses

- Casting
- Crew
- Insurance
- Processing/Lab
- Location
- Messengers/shipping
- Props
- Rental
- Sets
- Studio
- Talent
- Transportation (local)
- Travel
- Wardrobe
- Miscellaneous

Stock

Because stock photographs are existing images, and since you, not a client, may have shouldered the costs of production, the elements that make up the bottom-line price for a stock photograph differ from those related to assignments. A word of advice: bill all fees separately so that the reproduction fee doesn't appear to be excessive and so that it only reflects usage and the cost of image production.

1. **Reproduction, License, or Use Fee:** Much like the creative fee in assignment photography pricing, the reproduction fee, also known as a use or licensing fee, compensates you for overhead and additional value factors that apply.
 - **Overhead** may now have to reflect additional salaries for an assistant or secretary.
 - **Pricing factors** are incorporated into the price because of the uniqueness of a particular photograph, the difficulty or danger in obtaining the image, special costs (e.g., equipment rental), the client's licensing use requests, and so on. See the "Pricing Factors" chart for more information.

 Reproduction fee = Overhead + Pricing Factors

2. **Research Fees** may be charged to compensate for the cost of selecting and refiling submission requests and to help discourage casual requests by buyers who are not really serious or are only shopping for ideas or inspiration. In the highly competitive world of stock photography, many stock agents have foolishly given up this charge to gain a competitive advantage. Of course, if everyone does the same thing, there goes the advantage. Research fees are often waived by crediting them against reproduction or license-fee charges, but only if a client actually negotiates a license.

3. **Holding Fee** compensates you for the period of time photos are kept out of circulation by a client, thus preventing you from licensing them to others. If you provide digital files, this fee is necessary if you are withholding the image from use by others until the client decides whether to use the image. For unique images recorded on film, a holding fee is a routine fee, because you cannot even show the image to other potential clients until it is returned to you.

4. **Loss or Damage Fees** are levied for any lost or damaged images to compensate you for lost potential income that you will be deprived of

because the image cannot be used, or to compensate you for repairing damage (assuming it can be done digitally), or for having another duplicate image made.

You've seen that in pricing both stock and assignment photography, the main components are overhead, pricing factors, and time. Let's now explore each as they affect photographers, beginning with overhead.

OVERHEAD

Determining overhead is an important factor in pricing in every business except photography, it seems. Other pricing aids prefer simplicity. "Here are our prices, isn't that easy," is frequently their approach. Because photographers who depend upon such pricing aids remain ignorant of their overhead requirements, they too often engage in price-cutting. Again and again, however, these photographers struggle to get ahead, go out of business, and depress photography fees for everyone.

Overhead consists of many things that you have to make enough money to cover, from your salary to camera and other equipment purchases to utilities and many other things you take for granted—but you can't afford to take them for granted if you are in business.

If you only consult pricing charts, without knowing your overhead, you are on a short track to nowhere.

What Is Overhead?

Overhead, for photographers, is comprised of all of the costs that you incur that aren't directly attributable to specific assignments or stock licensing. The total of these costs is typically thought of as what it costs to be in business for one year, but it can also be figured on any other time basis—monthly, weekly, or daily. Overhead is a combination of two kinds of costs: fixed and variable.

Fixed costs are inevitable. Rent or studio/office ownership costs, for instance, are as inescapable as telephone bills and business insurance. Variable costs, on the other hand, will change in amount, depending upon the level of your activities. Some variable costs are inevitable, even if you never have a billable day. For example, you may hire a part-time research assistant to prepare for a job that never materializes. Such costs will vary week by week, month by month, but you will need to budget and account for them even though many variables can only be estimated.

Note: fixed and variable costs are not the same as those expenses billed to a client that will be incurred in support of an assignment. Since assignment

expenses are usually reimbursable, they are usually billed to your client and therefore do not become part of your overhead commitment.

After you have listed all of your overhead costs, fixed and variable, add them up to derive your overhead subtotal. In our two hypothetical photo businesses:

The "Calculating Overhead" chart shows that photographer 1 has fixed costs of $60,102, variable costs of $8,150, and profit of $6,825, for an annual overhead total of $75,077.

Photographer 2 has fixed costs of $156,863, variable costs of $56,987, and profit of $21,385, for an annual overhead total of $235,235.

CALCULATING OVERHEAD

Fixed Costs	Photographer #1	#2
Depreciation:		
cameras, lighting, etc.	2,200	9,891
computers	940	2,366
office equipment	650	1,861
office furnishings	985	2,129
van/car/truck	2,450	6,667
insurance	1,800	4,276
rent (or mortgage or percent of home office)	6,000	24,000
Salaries:		
yours	30,000	45,000
others	10,500	43,000
Taxes		
city	387	1,321
federal	1,783	2,489
property	1,007	4,541
Utilities (telephone, electric, gas)	2,400	9,322
Fixed costs subtotal	**$60,102**	**$156,863**
Variable Costs	**Photographer #1**	**#2**
Production:		
model fees		8,923
props		2,734
permits		500
assistants fees (freelance)		1,800
		(cont.)

Professional Fees:		
legal, accounting		1,240
bank charges		98
retirement		8,450
(pension plan, Keogh, IRA)		
Repairs:		
studio/office		1,400
photographic equipment	75	721
business equipment		373
Studio/Office:		
messengers		445
promotion/advertising	3,000	8,490
subscriptions/books		750
professional dues	275	275
education		
printing	2,000	3,215
postage	1,200	4,717
office supplies	1,000	2,786
Transportation:		
car	477	1,740
taxicab	123	429
other		313
Travel:		
hotel		2500
meals		876
airfare		3267
car rental		945
Variable costs subtotal	**$8,150**	**$56,987**
Fixed costs subtotal	**$60,102**	**$156,863**
Variable costs subtotal	**$8,150**	**$56,987**
Overhead Subtotal	$68,252*	$213,850*
Profit: 10%	$6,825	$21,385
Annual Overhead Total	$75,077	$235,235

*The total of fixed and variable costs added together.

If you have a significant investment in computer equipment, you must add into your overhead analysis all the costs of computer(s), monitors, film and flat-bed scanners, and any large printers that you use to produce images for clients. These are fixed costs that will likely be depreciated over only three years. Technological advances will require you to replace imaging equipment with ever faster tools.

What Are Your Personal Needs?

Most people want to make money. But how much income do you really need on an annual basis? To start with, you have to figure a salary (i.e., your personal income) for yourself—otherwise, why go into business? Too often, especially when starting up, owners (and that is what you are) approach their small business without factoring in a salary for themselves, hoping instead to live off of any "extra profits." As a result, they never have a clear picture of the financial health of their operation, never get ahead, and slowly find they have to siphon more and more from their business, depleting its resources in order to ensure their own personal survival. Not properly accounting for your own salary (or for every other cost) in overhead is a sure prescription for failure. Another trap small business owners fall into is paying for personal items with company money, instead of investing it back into the company. By not setting up your business with hard and fast rules controlling finances, you will tap the business treasury until it's tapped out! The IRS does not look kindly on business owners who mix business funds and personal needs. Learn early one of the cardinal rules of running a profitable business: thou shalt not pull the wool over thine own eyes!

Determining salary is somewhat simplified if you have recently been earning a regular salary; if your paycheck met all of your personal and family needs, you know how much you have to make. If it wasn't enough, you need to earn more.

On the other hand, if you haven't received a regular paycheck, you must formulate a budget showing what you spend on housing, food, clothing, insurance, transportation, entertainment, and all other personal or family needs each year. The total is what you need for an annual salary. Remember, though, if you are starting up a new business, be prepared to sacrifice somewhat until you've become established. Also understand that your salary is not all of your overhead—it is just one item of overhead.

Profit as Part of Overhead

You need to determine an amount that can be considered profit—after all, isn't the reward for being in business for oneself a profit? Simply put, profit is money that allows your business to grow.

You can easily approach profit calculation from one of two ways: making it a fixed amount or dealing with it as a percentage of overhead. A fixed amount for profit could be any reasonable sum you wish, say $50 or $100 for every billable day, although it may have to be much more for a large operation. Better yet, multiply your overhead subtotal by some percentage to derive your profit amount. Since many businesses find 10 percent of overhead to be a more than adequate level, why not try that to start?

In our example for photographer 1, the overhead subtotal of $68,252 is multiplied by 10 percent, and the result ($6,825) is added to the overhead subtotal ($68,252), to make an annual overhead total of $75,077.

Caution—this is not a time to indulge in fantasy. The profit amount you use must maintain a reasonable relationship to your experience and value to your clients. The important point is to understand the concept and importance of profit and always to include it in your calculations.

Finally, the easiest way to ensure that you cover your overhead costs is to determine what your overhead is on a daily basis.

Calculating Daily Overhead

Planning how to cover annual overhead total is difficult. Instead, think about "daily overhead"—that is, your annual overhead total evenly apportioned on a daily basis to the days when you will shoot an assignment.

Take the overhead total and divide it by the number of annual billable assignment days you can reasonably estimate or expect to have. The result is the minimum amount you must recover for every day you are actually photographing in order to cover (only) your overhead costs. Bill less than this, and you'll soon be getting midnight phone calls from debt collectors.

To help you better understand daily overhead, think about a business that is open fifty-two weeks per year, five days per week. The owner needs to know what overhead is each day the business is open, or 260 days per year. A business that is open six days per week, but that is closed two weeks for vacation, needs to know daily overhead for three hundred days per year. Calculating daily overhead is easy: divide annual overhead total by the number of days the business is open per year. Thus, a business open three hundred days per year, with annual overhead of $300,000, has daily overhead of $1,000.

The problem for photographers is that although many work five or six days per week, many of those days are devoted to non-income-producing activities like showing portfolios, mailing promotional materials, keeping abreast of technological and software developments, talking to insurance agents, interviewing assistants and other specialists, and so on. All photographers need to earn

enough on the days they do billable work or licensing to make up for the days when no income is brought in.

Businesses engaged in stock licensing—and many photography studios and digital imagers—will tend to follow a more traditional Monday-through-Friday schedule for fifty-two weeks per year. They expect to do work every day that earns income. However, because there are several holidays each year, let's consider that the business will be open only fifty weeks each year. Multiplying fifty times five, one sees that the business will be open 250 days in a year.

Let's assume that photographer 2 operates a studio that is open 250 days per year. Annual overhead total for this firm is $235,235. By dividing annual overhead by 250, it is easy to see that daily overhead will be $940.94. If no sales are made on Monday, it must be made up on Tuesday, along with Tuesday's $940.94 daily overhead (now $1,881.88). Alternately, one could look at recovering Monday's overhead by apportioning the $940.94 over the following days, so that on Tuesday, Wednesday, Thursday, and Friday, $1,176.16 must be brought in.

Location photographers and some digital imagers generally aren't able to earn money on a day-of-the-week basis. For them, it may be easier to look at covering overhead on a different basis. Many will estimate how many days per year they will spend photographing for clients and will divide this number into their annual overhead total. Others will use actual photography days and add to that all days spent doing other things that support assignments. For example, if photographer 1 estimates she will have seventy-five actual days of photography for clients, her daily overhead will be $1,001.03 (i.e., $75,077 annual overhead divided by seventy-five). On the other hand, if that same photographer estimates another ninety days working in support of her assignments, she will divide $75,077 by 165 days (i.e., ninety added to seventy-five) for a daily overhead estimate of $455.01.

Use the following equation to calculate daily overhead. (Note: This is *not* a day rate but the minimum amount you must recover every billable day. If you don't, you are losing money, running in the red, out of pocket, going in the hole . . . Got it?)

Annual Overhead Total ÷ Days = Daily Overhead

Here is the daily overhead calculation for our two hypothetical photographers:

Photographer 1
$75,077 ÷ 75 assignment days = $1,001.03 Daily Overhead

Photographer 2
$235,235 ÷ 250 days = $940.94 Daily Overhead

Notice the difference between the two? Even though the two photographers have considerably different annual overhead totals, photographer 1 has a greater daily overhead, $1,001.03, than photographer 2 at $940.94. These daily overhead numbers could be considerably different if photographer 2 knew she would have her studio open and did photography for a greater number of days.

Your daily overhead amount becomes part of your creative fee for assignment photography and digital imaging, or part of your license fee in stock photography.

A Mix of Stock and Assignments

Our examples tend to present photographers engaging in either a pure assignment or a stock photography business. However, in today's market, most photographers find that they engage in both, finding a blend of the two to be more rewarding. It will be up to you to decide artistically if a blend will work, as it will be to determine how you will blend the two financially.

When you do a mix of work, you need to apportion annual overhead by the amount of assignment, stock, or other work, such as consulting or retouching, that is done. If you find, for example, that assignments are 75 percent of your business, then use 75 percent of your annual overhead total when calculating daily overhead for assignment pricing. The other way you could account for overhead, when you have a mix of work, is to base daily overhead on all of the days per year you work, whether it is doing assignments, stock, or other types of work. Therefore, if you do a mix of photography and other assignments, add these together and use that total number of days to determine daily overhead.

CAUTION!

We stress the importance of calculating overhead as a basis for establishing your billable-day overhead primarily because most photographers ignore this basic business premise. You should annually refigure it as a control on your business costs.

Warning—this can be a trap! Although you need an understanding of your overhead, and billable-day overhead, never forget that this is only a foundation. Be very careful that you don't let these numbers dictate your pricing. Remember, client usage and budget remain important factors in determining price. One prominent photographer suggests keeping a sign by the phone, "IT'S THE USAGE, DUMMY," to remind you to include all relevant factors when calculating your price.

The next step in pricing is possibly the most difficult. Value factors (see "Value Factors" chart) will be added to daily overhead, resulting in the fee you will actually charge a client.

PRICING FACTORS

This area of pricing is understandably the most difficult to quantify. Don't despair; understanding the process of pricing is akin to learning to drive a manual shift car. Once you know how, it's hard to remember what made it so tricky, yet it's difficult to explain the process so another driver will be equally skilled and smooth. Photographers skilled at pricing have picked up their knowledge through years of experience, absorbing it as they went, making mistakes but also a few coups.

The box "Pricing Factors" gives an overview of the relationship of the many factors that affect pricing. The better you understand them, the easier it will be to negotiate prices like those listed in the charts. Remember as you read the following material: pricing factors are all about value.

What about My Photography?

Determining "Do my photographs have value?" and "What is the value of my photography?" is not much less difficult than the age-old question, "Which comes first, the chicken or the egg?" It's a dilemma that puzzles many photographers as they wrestle with pricing as a balance of their time, creativity, and the client's need for and use of your work. Each question raises more questions:

1. Is it the value of my time?
2. Is it the value of my creativity?
3. Is it the value of my technical skill?
4. Is it the value of the effort or risk involved?
5. Is it the value of my photography vis-à-vis the client's project?

They all are part of the equation, but is any one worth more?

Pricing—The Salad Test

For the purpose of untangling the perplexities of placing a value on usage, let's say that photography is analogous to a restaurant meal and that the photographer is the restaurateur. The meal, or any one of its courses, from appetizer to dessert, will vary in the quality of the ingredients, skill in preparation, exquisiteness of flavor, and elegance of presentation, and the graciousness of service and

atmosphere will vary from restaurant to restaurant. Prices for meals in individual restaurants will vary according to the level of quality inherent in all of these aspects, and the price to be charged will largely be based on perceived value to the customer. Some clients require only basic meat-and-potatoes photography, while others will be willing to pay more for the delicious flavor of your special lighting or elegantly decorated establishment.

That still leaves the problem of how to evaluate and price each element, whether food or photography.

Let's start with broad categories. The cost of a meal will depend on the category of restaurant a patron chooses: deluxe, middle of the road, or neighborhood bistro, with costs running from high to low. Which one is selected will often be based largely on the patron's ability to pay. Restaurant classification based on cost can be roughly compared with the categories of photography—advertising, corporate, editorial—and the general difference in payment they offer, in their willingness to pay, from high to low.

Now we'll narrow the analogy. Say the photograph itself is a salad. Imagine that all salads contain the basic ingredients of lettuce (your time), tomatoes (your skill), and a dressing (your creative ability). Special and more expensive salads may include endive or radicchio or rare mushrooms; the list is practically endless.

Further, the waiter needs to know what size salad you need (analogous to client usage). Will it be an appetizer, a side dish, or the main course? How important is the salad to your meal (is it for major advertising or a small brochure)? And finally, how many salads (the number of times they want to reproduce your photograph) will your party order?

It's that simple, and that complicated. However, if you don't make the effort to understand the relationship of pricing elements, you'll be charging prices for lettuce no matter how many exotic ingredients lavish your salad—a sure recipe for failure.

PRICING FACTORS

Four general groups of factors can be said to affect pricing. They are all equally important in pricing your work. Two are client- and marketplace-related, and the other two are linked to you the photographer and business owner.

1. **Market Type (Client/Market)**: Photo fees traditionally relate to the budgets (media-buy and total production costs) and profitability of the market area:

Purpose of Use	Definition	Price Range
Advertising	Selling a product or service	High
Corporate	Selling a corporate image	Medium–High
Editorial	Selling or decorating a product	Lowest
Other markets	Miscellany like mugs or calendars	Varies

2. **Usage Needed (Client)**: These concern the visibility and length of time requested by a client.

Visibility Factors	Details
Size	One-quarter, half, full page, double-spread
Placement	Interior, display, part opener, front or back cover
Number of uses	Circulation of newspaper or magazine, press run of brochure or book, number of insertions for advertisement
Time	Length of time used (e.g., one-year billboard)
Distribution	Local, regional, national
Versions	Examples: One language and two translations; or point of purchase and product packaging

3. **Overhead (Photographer)**: Fixed and variable costs incurred whether or not you license images, including rent, utilities, insurance, and office and photography equipment purchases.

4. **Photographic Elements (Photographer)**: Everything that goes into a photograph:
 - *Time:* photography, pre-/postproduction, editing
 - *Skill:* expertise, special equipment
 - *Creativity:* imagination in color, lighting style
 - *Special:* hazards, risks, unique contributions
 - *Expenses:* all job costs—materials, equipment, assistants

All of these factors come into play when pricing either assignments or stock licensing.

The value you place on the pricing factors will be based on your level of experience, creative ability, difficulty or danger involved in producing the images, and so on. This will affect your choice of the high-middle-low price range when you use the price charts. You will notice the "Pricing Factors" chart is absent

any financial figures. Because it is impossible to place a specific value on them, experience will become your best guide.

Value to Client

As client need increases, so, usually, will the client's willingness to pay. A perusal of the pricing charts, for instance, will show that advertising assignments generally bring higher fees than will editorial. In part, this has come about because of the demands of advertising—bigger productions, more prominent display of the finished product, and, frankly, because you will be helping some company make more money. So, too, within any one category (e.g., corporate, advertising, editorial, etc.), you will also find varying rates. For example, corporate annual reports, because they help "sell" a company to investors, will usually support higher fees than photographs destined for an in-house magazine.

One of the most important indicators of importance to a client is found either in the publication's "space-rate/media-buy" in the case of advertising, or in the total production costs of corporate, editorial, and even advertising projects.

The advertising agency has to place the advertisement where the public can see it, usually in print publications and on the Internet. The cost of space varies—the rate for one page in *Vogue* magazine will be much more than for a local publication; likewise, a billboard along a major city freeway will cost more than one in a small town, and a display ad on a website that has hundreds of thousands of visitors per month will cost more than the site of a local blogger that gets a few hundred visits in the same time period. You should have an understanding of the relationship between space rates and the value of your fees. You will need to do some research online to get an idea of the rates that different print and online publications charge advertisers.

In corporate photography, an estimate of the value of a project to your client can be made by knowing the total project production costs; production costs can also be used as a guide for advertising and editorial assignments. More difficult to determine because there is no easy guide book is the final size of the image as it is used in relationship to the advertisement, magazine or annual report page, brochure, computer screen, web page, press-run size, and so on. Sometimes, your client will offer some or all of this information if you just inquire. Why not simply say, "This looks like a major effort, and I'd like to be part of it. You say the annual report is going to be sixty-four pages with a press run of one million! Who is going to be the lucky printer?" If you can't elicit this information, talk to printers, talk to graphic designers, or guess.

Editorial photographers will probably not discover the production costs incurred by a publisher but instead will have to rely more on the press run and/or circulation of the publication as a guide to the importance and value of the work. Publishers tend to work with set rates for photography, so you may hear terms like "page rate," which simply means that they have budgeted a certain amount for photography per page. If it is by page rate, an indicator of project value would be any variance in the page rate from other projects this publisher has produced. Try to research the space rate of a publication you are thinking of working for. Higher rates denote that a greater value is placed on each page by the publisher, and it may mean higher fees for you—but only if you ask.

Value to You

Never undervalue the time you have to spend producing photographs, including research, equipment testing, dealing with the vendors, traveling to a site, locating images, preparing them for the specifications required by the client, searching for and preparing stock images for shipment, and so on. Your time—all of it—has value, whether you are doing an assignment or creating stock.

Although it wouldn't be advisable to routinely factor this into your pricing and negotiating routine, some photographers give consideration to whether an assignment's photographs will be desirable as stock or for promotional use. If a job promises great photographic possibilities, some photographers may consider a slight downward pricing adjustment to ensure capturing the assignment. They are willing to risk the reduction in income, knowing that future stock sales will offset the lower assignment fees. Warning! This should be considered only by experienced photographers with established stock sales records, who can accurately assess the outcome.

Rid yourself of a misconception that many inexperienced or naïve business people cling to: that clients who beat you down on price will someday make it up to you. Don't give your work away. No one will really appreciate it, and you can't operate a business for very long on hope.

PHOTOGRAPHY AND THE LAW

WOULD YOU ENTER this contest? A major corporation recently held a photo contest inviting people to submit a photo of "your happiest moment." Among the rules was a provision that every entrant would grant the sponsor *"the non-exclusive, royalty-free, perpetual, irrevocable, and fully sublicensable right to use, reproduce, modify, adapt, publish, translate, create derivative works from, distribute, and display the Photo throughout the world in any media, to the extent permitted by applicable law."*

Huh? Can they do that? Sure they can, but you don't have to enter. Digital photography, coupled with the ease with which the Internet allows photographs to travel around the world in seconds, has only made the legal issues surrounding photography more complex. It's also easier than ever for someone to steal your work if it is displayed online. Copyright issues are more complicated than ever, but online registration with the Copyright Office is easier and cheaper than filing the old paper forms.

At photographers' conventions, there's always great interest in presentations that deal with legal issues. For everyone other than lawyers, many legal issues are dense and confusing. Plus, as photographers, we have to struggle with issues such as the subject's right to privacy, the need for releases, property rights, and a host of other issues. Additionally, there is always the risk that you'll have to start, or defend, a lawsuit to protect your rights.

Part V contains a great deal of useful information on all these subjects and more. In today's world, you need to know how to enforce your rights to protect your work and how to avoid running into any problems with infringement on the rights of others.

CHAPTER 20 COPYRIGHT

by Tad Crawford and Laura Stevens

Laura Stevens is a publishing attorney in Boston with a special expertise in copyright and intellectual property.

THE RIGHTS THAT you sell to your photographs come from your copyright in those photographs. *All rights* or *world rights* is the transfer of your entire copyright; *first North American serial rights* is the transfer of a limited piece of your copyright. Your authority to sell rights to your photographs stems from the United States federal copyright laws that protect you. These laws were first enacted in 1790 and are periodically revised, the most recent comprehensive revision taking effect on January 1, 1978. The 1978 law has now had a number of important amendments, including the Visual Artists Rights Act (1990), the Sonny Bono Copyright Extension Act (1998), and the Digital Millennium Copyright Act (1998), all of which are covered in this chapter.

If anyone wishes to use your copyrighted photographs, he or she must get your permission. You will then be able to set a suitable fee for the requested use. Anyone who reproduces, publicly displays or distributes, or alters your work (creating a derivative work) without your permission is infringing upon your copyright rights, and you can sue for damages and prevent him or her from continuing the infringement. Your copyright is, therefore, important in two ways: it guarantees that you will be paid when you let others make use of your photographs, and it gives you the power to deny use of your photographs if, for example, the fee is too low or you don't believe that particular person or company will use the photographs in a way you consider aesthetically satisfactory.

In learning about copyright, you should keep in mind that the United States Copyright Office makes available many downloadable publications, circulars, and forms. Visit the Copyright Office website at http://copyright.gov to see the full extent of the information available.

WHAT IS COPYRIGHTABLE?

Protection under copyright law extends to original works of authorship fixed in any tangible medium of expression, including, but not limited to, literary works, musical works, dramatic works, pantomimes and choreographic works, pictorial,

graphic, and sculptural works, motion pictures and other audio visual works, sound recordings, and architectural works. There are, however, specific classes of works that are exempt from copyright protection. Among the works ineligible for copyright protection are works that have not been fixed in a tangible form of expression (e.g., an improvisational performance that is not written or recorded), works of the United States Government, titles, names, slogans, ideas, methods, procedures, systems, processes, concepts, principles, discoveries, or devices. However, it is important to keep in mind that these classes of works may be otherwise protected under trademark, patent, or other theory of law.

RIGHTS TO COPYRIGHTED PHOTOGRAPHS

If "copyrighted photographs" sounds ominous, it shouldn't. You have your copyright in a photograph as soon as you take it. This copyright is separate from the digital file or physical transparency, negative, or print. For example, you can sell a transparency but reserve the copyright to yourself. The buyer would get a physical object—the transparency—but no right to reproduce your work. Or you could sell the copyright or parts of the copyright while retaining ownership of the transparency. It is common practice to require the return of the transparency, print, or negative when selling reproduction rights. Given the ease with which digital files can be copied, protection of digital image files is more problematic.

To you as copyright owner, the copyright law grants the following exclusive rights:

1. The right to authorize reproductions of your photographs;
2. The right to distribute copies of your photographs to the public (although a purchaser can resell a purchased copy);
3. The right to prepare derivative works based on your photographs. Derivative works are creations derived from another work of art. Thus, a photograph could be the basis for a lithographic plate used to make fine prints. In such a case, the fine prints would be derivative works based on the original photograph;
4. The right to perform your work if it is audiovisual or a motion picture; and
5. The right to display the photographs (except that the owner of a photograph can display it to people who are physically present at the place where the display occurs).

The exclusive rights are yours to keep or sell as you wish. Other users of these rights must first obtain your consent.

ELECTRONIC RIGHTS

Most of the copyright principles discussed in this chapter (i.e., protectability, exclusive rights, permitted uses, etc.) apply to works in the online and digital realms in the same manner in which they apply to works in the traditional off-line world. A copyright owner may control the distribution of his or her photographs on the Internet in much the same way as would be done with respect to books or magazines. The Digital Millennium Copyright Act, enacted in 1998, extends copyright protections that already existed with respect to traditional media (e.g., books, photographs) to their online counterparts (e.g., ebooks and photographs made available on the Internet). Although the DMCA contained some specific limitations on liability for particular classes of parties, it may be generally assumed that a use that requires permission offline (e.g., to include a photograph in a magazine) would require permission online (e.g., to include a photograph in an e-zine).

TRANSFERRING LIMITED RIGHTS

As the copyright owner, you could always transfer *all rights* in your photographs, but that may not be the wisest choice. Whenever you sell rights, you naturally want to sell only what the user needs and is willing to pay for. The copyright law helps by requiring that transfers of exclusive rights of copyright be in writing. This requirement of a written transfer calls your attention to what rights are being given to the user. Such a transfer must be signed either by you or by your agent (if the agent has authorization from you to sign copyright transfers).

How can you tell whether the right that you are transferring is exclusive or not? Just ask the following question: If I transfer this right to two different users, will my transfer to the second user be a breach of my contract with the first user? If you transfer *first North American serial rights* to one magazine, you cannot transfer *first North American serial rights* to a second magazine. Obviously, both magazines could not be first to publish the work in North America. So *first North American serial rights* is an exclusive transfer and must be in writing and signed by you or your agent.

However, it is also possible to give a nonexclusive license to someone who wishes to use one of your photographs. Such a nonexclusive license does not have to be written and signed but can be given verbally or in the course of dealing between the two parties. If you have not given a signed, written authorization, you know that you have sold only nonexclusive rights. This means that you can give the same license to two users without being in breach of contract with either user.

A photographer had done a freelance advertising assignment for a cosmetics company and delivered a number of photographs. Nothing in writing was signed

by the photographer. He asked: (1) Can I sell these photographs used by the advertiser to some other user? (2) What use can the advertiser make of the photographs? *Answer*: The photographer was free to resell the photographs to other users. Since no written transfer had been made, the advertiser had gotten only nonexclusive rights. As a practical matter, however, the photographer would almost certainly ask for the client's consent in order to keep on good terms and obtain future assignments. The question of what uses the advertiser can make of the photographs is harder to answer. If the advertiser's purchase order or the photographer's confirmation form or invoice specify what uses can be made, the problem may be solved. In the absence of a complete, written contract, what the parties verbally agree to about usage would be considered. This can be quite difficult to prove and points to the value of having a clear, written understanding before starting any assignment. Prior dealings between the parties or accepted practice in the field will also be considered by the courts if there is no written contract or the contract is ambiguous.

Since you want to sell limited rights, it's important to know how rights can be divided. Always think about the following bases on which distinctions can be made:

- Exclusive or nonexclusive transfer
- Duration of the use
- Geographical area in which the use is permitted
- Medium in which the use is permitted
- In a case involving words and photographs, the language in which use is permitted
- Electronic rights may be granted or specifically withheld

If a magazine or book publisher wants to publish your photograph, you should make it a practice, whenever possible, not to sell *all rights* or even exclusive publishing rights. It is preferable to sell the most limited rights that the publisher needs, since it is presumably paying for only those rights that it intends to use. Your transfer might be as follows: *exclusive first-time North American magazine rights*. The shorthand for this, of course, is *first North American serial rights*. Any of your exclusive rights as copyright owner can be subdivided and sold separately. The rest of the copyright still belongs to you for further exploitation.

COPYRIGHT ASSIGNMENTS

If you transfer some or all of the exclusive rights owned by you in a copyright, you will want to memorialize this in a written document. The party who receives

usage rights from you might then want to record the assignment with the Copyright Office. If you have transferred rights (for example, rights to use photographs in a book) and the rights are reverted to you, you might also want to record the reversion document with the Copyright Office. The same would apply if other creators transfer rights to you to use their work in a project you're creating. If you are assigning rights, you could use the Copyright Transfer Form shown here or one of the forms that provide for a limited rights transfer (such as the Assignment/Confirmation/Invoice or the License of Rights found in chapter 18). If you are receiving back all rights that a user of your work acquired, you would indicate "All rights" on the Copyright Transfer Form.

Recording a copyright transfer with the Copyright Office is easy to do, since you need only send a fee, two copies of the Copyright Office Document Cover Sheet, and the original or a certified copy of the assignment to the Copyright Office. After processing and recording the assignment document, the Copyright Office will send you a copy of the document along with a certificate of record. By recording the assignment within one month if it is made in the United States or within two months if made abroad, you establish your priority over others to whom the user may later, by mistake or otherwise, transfer the same copyright. In order to have priority, you will also have to register the copyright if it hasn't already been registered. The recordation process is more fully described in Copyright Office Circular 12, *Recordation of Copyright Transfers and Other Documents*.

SEARCHING THE COPYRIGHT STATUS OF A WORK

This system of recording is useful in another way. If you are trying to find out whether a work that you want to use is copyrighted and who the copyright owner is, the Copyright Office (for a fee) will search its records to help you obtain this information. Also, the Copyright Office has a free online searchable database for registrations, renewals, and recordations that have been filed after January 1, 1978. This can be accessed on the Copyright Office website. To obtain this information for filings prior to 1978, you can use the physical card catalog at the Copyright Office (which covers 1870–1977) or the virtual Catalog of Copyright Entries (which covers 1891–1977). A digitization project is currently underway to make the pre-1978 filings available as a searchable database. Until that project is completed, Stanford University has a very helpful Copyright Renewal Database. This makes searchable copyright renewal records received by the Copyright Office between 1950 and 1992 for books published in the United States between 1923 and 1963. Since books (and other works) published before 1923 are in the public domain and those published after 1963 did not have to be renewed, the Stanford database aids in determining whether works that needed to be renewed

Copyright Transfer Form

FOR VALUABLE CONSIDERATION, the receipt of which is hereby acknowledged, _____ (hereinafter referred to as the "Assignor"), located at _____, does hereby transfer and assign to _____, located at _____, his or her heirs, executors, administrators, and assigns, the following rights: _____ _____ in the copyrights in the works described as follows:

Title	Registration Number	Nature of Work
_____	_____	_____
_____	_____	_____
_____	_____	_____
_____	_____	_____
_____	_____	_____

IN WITNESS WHEREOF, the Assignor has executed this instrument on the _____ day of _____, 20____.

Assignor_____

have gone into the public domain. Copyright Office Circular 22, *How to Investigate the Copyright Status of a Work*, is helpful when you may want to determine if a work is in the public domain or try to find the owner of a work.

COPYRIGHT NOTICE

Although no longer required under copyright law, placing a copyright notice on each of your published photographs is advisable. Such notice identifies you as the copyright owner to potential licensees and warns off potential infringers. In addition, the notice prevents any infringer from asking for a lessening of damages because the infringement was innocent and based on the lack of copyright notice. Prior to March 1, 1989 (the enactment of the Berne Convention Implementation Act), publication of a work without copyright notice injected that work into the public domain (unless specific corrective measures were taken within a certain time period), meaning that the work was no longer protected by copyright in the United States.

Publication basically means public distribution, including distribution over the Internet, whether by sale, lending, leasing, gifts, or offering copies to other people for further distribution. There are several benefits to providing copyright notices on your published works. The notice informs the public that the work is protected by copyright, that you are the author of the work, and the year in which the work was first published. By providing this information on each of your published photographs, individuals or companies seeking to license and/or reproduce your photograph are put "on notice" that the particular work is protected by copyright and they must obtain permission from you prior to using it. Offering your photographs to a number of art directors is probably not a public distribution, but there is no harm in putting the copyright notice on the work before sending it out for submission.

The copyright notice has three parts:

1. "Copyright" or "Copr." or ©
2. Your name or an abbreviation from which your name can be recognized, or a pseudonym by which you're known
3. The year date of first publication

An example of a proper notice would be: © Jane Photographer 2016. The year date may be omitted from toys, stationery, jewelry, postcards, greeting cards, and any useful articles. So if a photograph were used on greeting cards, proper copyright notice could be: © Jane Photographer or even © JP.

As copyright notice is intended to provide the public with certain ownership information, it is important that the notice appears in an obvious and accessible location. For a photograph published in a book or magazine, the most obvious place for the notice would be adjacent to the photograph. However, there are a number of other placements that would be considered reasonable. If, for example, the magazine objected on aesthetic grounds to an adjacent copyright notice, the notice could appear as follows:

1. For a photograph reproduced on a single page, notice can go under the title of the contribution on that page or anywhere on the same page if it's clear from the format or an explanation that the notice applies to the photograph.

2. For photographs appearing on a number of pages of a magazine, the notice can go under a title at or near the beginning of the contribution, on the first page of the main body of the contribution, immediately after the end of the contribution, or on any of the pages comprising the contribution if the contribution is no more than twenty pages, the notice is prominent and set apart from other materials on the page, and it is clear from the format or an explanation that the notice applies to the entire contribution.

Copyright Office Circular 3, *Copyright Notice*, gives further details as to the form and placement of copyright notice.

It's a good idea to have a stamp with your copyright notice: © Jane Photographer 20___. Before photographs or transparencies leave your studio, you simply stamp the copyright notice on them. Since the photographs won't have been published yet, the year date you put in the copyright notice should be the year you made the photographs. On publication, either in the United States or abroad, the year of first publication should appear in the notice. If the work is going to be distributed abroad, it is best to use ©, your full name, and the year date of first publication.

A good rule is that every print, video, film, and especially digital file should have copyright notice before leaving your studio. For digital files, a copyright notice layer can be created in PhotoShop in such a way that it appears with the image but can be removed by you if you license the image. Or the file can have the notice adjacent to the photograph or on a page next to the photograph. While probably not adequate as copyright notice, it is also wise to place the copyright notice into the metadata of the file (or in an invisible watermark that

accompanies the image). In the event of infringement, this can help prove the copying that is needed to win your claim.

THE PUBLIC DOMAIN

Photographs and other artworks that are not protected by copyright are in the public domain. This means that they can be freely copied by anyone—they belong to the public at large. This includes photographs whose copyrights have expired, were not timely renewed, or have been lost because they were published without proper notice prior to March 1, 1989, and such omission or error was not corrected in compliance with the copyright law's requirements.

DURATION OF COPYRIGHT

Copyright protection in works created on or after January 1, 1978, will normally last for the creator's lifetime plus seventy years. For example, a photograph taken in 2000 by a photographer who dies in 2025 will have a copyright that expires in 2095.

Copyrights run through December 31 of the year in which they expire.

If you create a work jointly with another photographer, the copyright will last until seventy years after the death of the survivor.

If you create a work anonymously or using a pseudonym, the copyright will last ninety-five years from the date of publication or 120 years from the date of creation, whichever term is shorter. However, you can convert the term to your life plus seventy years by advising the Copyright Office of your identity prior to the expiration of the term.

If you work for hire, the copyright term will be ninety-five years from the date of publication or 120 years from the date of creation, whichever term is shorter. Remember, however, that when you do a work for hire, you are no longer considered the creator of the work for copyright purposes. Instead, your employer or the person commissioning the work is considered the work's creator and completely owns the copyright.

For copyrights on photographs protected under the old federal copyright law (in other words, those works registered or published with copyright notice prior to January 1, 1978), the copyright term will be ninety-five years. However, the old copyright law required that copyrights be renewed at the end of twenty-eight years. A law passed in 1992 made renewals automatic for works first copyrighted between 1964 and 1978. Works created in 1978 or later, of course, don't need to be renewed.

Finally, you may have photographs that you created prior to January 1, 1978, but never registered or published. These photographs were protected by

common law copyright. The new copyright law provides that such photographs shall now have protection for the photographer's life plus seventy years. In no event would the copyright on such photographs have expired before December 31, 2002, and, if the photographs were published on or before December 31, 2002, the copyright will run at least until December 31, 2047.

Since copyrights remain in force after the photographer's death, estate planning must take copyrights into account. You can leave your copyrights to whomever you choose in your will. If you don't do this, the copyrights will pass under state law to your heirs.

TERMINATION OF TRANSFERS

Because copyrights last for such a long time, the copyright law effective on January 1, 1978, adopted special termination provisions to protect photographers and other creators. It isn't possible to know how much a license or right of copyright will be worth in the distant future. So the law provides that for licenses or rights of copyright given by the photographer on or after January 1, 1978, the transfer can be terminated during a five-year period starting thirty-five years after the date of the transfer. If the right of publication is included in the transfer, the five-year period for termination starts thirty-five years from the date of publication or forty years from the date of the transfer, whichever is earlier.

The termination provisions do not apply to transfers made by will or to works made for hire. Also, a derivative work made prior to termination may continue to be exploited even after termination of the transfer in the photograph on which the derivative work is based.

Termination requires that you give notice of your intention to terminate two to ten years in advance of the actual date of termination. If photographs of yours have maintained value for such a long period that the termination provisions could benefit you, it would be wise to have an attorney assist you in handling the termination procedures.

WORK FOR HIRE

You must be aware of one hazard under the copyright law. For an employee, work for hire means that the employer owns all rights of copyright as if the employer had in fact created the photographs. An employee can, of course, have a contract with an employer transferring rights of copyright back to the employee.

However, a freelance photographer may also be asked to do assignments on a work-for-hire basis. This treats the photographer like an employee for copyright purposes but doesn't give the photographer any of the benefits employees normally receive. The American Society of Media Photographers and many

other professional organizations representing creators have condemned the use of work-for-hire contracts with freelancers.

The copyright law safeguards freelancers by requiring that a number of conditions be met before an assignment will be considered work for hire:

1. The photographs must be specially ordered or commissioned;
2. The photographer and the user must both sign a written contract;
3. The written contract must expressly state that the assignment is done as work for hire (but also beware of any other phrases that sound as if you're being made an employee for copyright purposes); and
4. The assignment must fall into *one* of the following categories:
 * A contribution to a collective work, such as a magazine, anthology, or encyclopedia
 * A supplementary work, which includes photographs done to illustrate a work by another author (but only if the photographs are of secondary importance to the overall work)
 * Part of an audiovisual work or motion picture
 * An instructional text
 * A compilation (which is a work formed by the collection and assembly of many preexisting elements)
 * A test
 * Answer material for a test
 * An atlas

So, for a freelance photographer to do work for hire, four conditions must be satisfied: (1) there is a written contract; (2) the parties agree that the assignment is to be done as work for hire; (3) both parties sign the agreement; and (4) the assignment falls into one of the categories shown here in which the copyright law allows work for hire. Unless all four of these conditions are satisfied, the resultant work will not be deemed a work made for hire.

In the 1980s, there was some confusion as to whether a freelance photographer could do work for hire even if there was no written contract, as long as the commissioning party supervised the work. In 1989, the United States Supreme Court, in determining whether or not a work created by a freelance artist is a work made for hire, considered the following factors:

* The skill required
* The source of the instrumentalities and tools
* The location of the work

- The duration of the relationship between the parties
- Whether the hiring party has the right to assign additional projects to the hired party
- The extent of the hired party's discretion over when and how long to work
- The method of payment
- The hired party's role in hiring and paying assistants
- Whether the work is part of the regular business of the hiring party
- Whether the hiring party is in business
- The provision of employee benefits
- The tax treatment of the hired party

These factors in essence require someone to be an employee in order for there to be work for hire in the absence of a written agreement.

When you create a work as a work made for hire, the hiring party will be considered the author and you will be unable to terminate the transfer, as you would otherwise be able to in the case of an assignment of rights. Of course, the broader the assignment of rights (work for hire being the maximum in terms of transferring rights), the greater the payment that you should demand.

CONTRIBUTIONS TO MAGAZINES

If you sell a photograph to a collective work, such as a magazine, without signing anything in writing specifying what rights you are transferring, the law presumes that you have transferred only the following nonexclusive rights:

1. The right to use your contribution in that particular collective work, such as that issue of the magazine.
2. The right to use your contribution in any revision of the collective work.
3. The right to use the contribution in any later collective work in the same series.

If you sold your photographs to a magazine, that same magazine could reprint the photographs in a later issue without paying you, but unless you agree or specify otherwise, the magazine would not be permitted to include your photograph in an electronic database. The right to electronically reproduce the photograph would have to be granted specifically. Nor could the magazine authorize a different magazine to reprint the photographs, even if the same company owned both magazines. If you sold your photographs to an anthology, they could be used again in a revision of that anthology (unless you agree or specify otherwise). However,

they could not be used in a different anthology. Also, the owners of the collective work would have no right to change the photographs when reusing them.

A photographer has completed an assignment for a magazine. No agreement was ever reached about what rights were being transferred to the magazine. However, the photographer has now received a check with a legend on its back stating, "By signing this check, you hereby transfer all rights of copyright in your photograph titled _____ to this magazine." The photographer asks: (1) Can this legend on a check be a valid transfer of copyright? (2) Should I cash the check or return it and demand a check without such a legend? *Answer*: There has been some disagreement among copyright authorities as to whether signing such a check creates the written instrument required for a copyright transfer, but some courts have held that specific assignment language on a check legend is sufficient to effect a transfer of copyright. If it is not your intention to assign all rights in your photograph, you should return the check and request one that does not have the legend. The best practice is to have a clear understanding about rights before you start, so you can simply return any check that recites a greater rights transfer than what you have previously agreed to. The failure of the magazine to pay according to the terms agreed to would be a breach of contract for which the publication would be legally liable.

BENEFITS OF COPYRIGHT REGISTRATION

Under the copyright law, copyright protection subsists in copyrightable works from the moment they are "fixed" in a copy for the first time. If copyright protection exists from the moment you take your photographs, why should you bother to register? The reason is that registration gives you the following benefits:

1. You must register before you are able to file an action for copyright infringement.
2. Registration creates a presumption in your favor that your copyright is valid and the statements you made in the Certificate of Registration are true.
3. Registration in some cases limits the defense that can be asserted by infringers who were "innocent," that is, who infringed in reliance on the absence of copyright notice in your name. You must register prior to an infringement's taking place (or within three months of publication) if you are to be eligible to receive attorney's fees and statutory damages.

HOW TO REGISTER PHOTOGRAPHS

Registration has always required a correctly filled in application form, the specified fee, and deposit materials that show the content of what is being copyrighted.

The registration process has been streamlined, and the Copyright Office now prefers to have registration completed electronically on their website by what is called the eCO Online System (eCO abbreviates "electronic Copyright Office"). To encourage you and other authors to do this, the fee for online registration is now less than the fee for registration using paper forms. The use of paper forms is expensive for the Copyright Office. While the paper forms can be obtained online, the higher fee for using such forms compensates the Copyright Office for the extra expense.

Among the advantages of eCO online registration are a lower basic registration fee (currently $35), the quickest time to complete the registration, status tracking online, secure online payment, the ability to upload certain deposit materials as electronic files, and 24/7 availability. Anyone can use eCO, and most types of works are eligible for eCO (but note that groups of contributions to periodicals cannot use eCO). Currently, eCO will accept registrations for (1) a single work; (2) a group of unpublished works by the same author and owned by the same copyright claimant; or (3) multiple works contained in the same unit of publication and owned by the same claimant (such as a book of photographs). Other online registrations are possible, such as for multiple works or multiple authors, but these are called a "Standard Application" (as opposed to a "Single Application") and carry a fee of $55. The eCO registration process requires filling in the online application form, making payment, and submitting deposit copies.

The deposit copies for eCO can be electronic in a number of situations, including if the work being registered is unpublished, has only been published electronically, or is a published work for which identifying material would be used instead of the work itself.

Identifying material for a work of visual art might be used if the work is three dimensional or oversized (more than ninety-six inches in any dimension). The deposit requirements, including the use of identifying material, are set forth in Circular 40A, *Deposit Requirements for Registration of Claims to Copyright in Visual Arts Material*. If a work is eligible for eCO registration but the deposit cannot be electronic, a hard copy can be used and sent to the Copyright Office. General guidelines to registration can be found in Circular 40, *Copyright Registration for Works of the Visual Arts*.

If eCO registration cannot be used, the alternative is to use paper forms, such as Form VA (for a work of Visual Art). To discourage use of paper forms, the fee for such an application is the highest—currently $85. Since eCO is an online process, a copy of Form VA with instructions is included at the end of this chapter.

Of great interest to photographers is the possibility of registering groups of photographs. This is a way to dramatically reduce the cost of registering each photograph individually. Unpublished photographs always benefited from being eligible for registration as an unpublished group. This remains true whether registration is done by eCO or use of the paper Form VA. To qualify for registration as an unpublished group: (1) the group must have a title; (2) the photographs must be assembled neatly; (3) one author must have created or contributed to all the photographs; and (4) the same party must be the copyright claimant for all the photographs.

More problematic has been registering groups of published photographs. The American Society of Media Photographers played a key role in seeking to enlarge the possibilities for group registration of published photographs. Copyright Office publication FL-124, *Group Registration of Published Photographs*, explains how up to 750 photographs can be registered on one application using Form VA supplemented by Form GR/PPh/CON. To qualify, the following conditions must be met: (1) the same photographer must have taken all the photographs; (2) all the photographs must have been published in the same calendar year; and (3) the copyright claimant for all the photographs must be the same. FL-124 explains that more than 750 photographs can be registered for a single filing fee, but to do so, the date of publication must be included with each photograph deposited.

In addition, photographs published in newspapers or magazines during a twelve-month period can be made into a group on Form GR/CP (which includes Form VA). This is possible if: (1) the same photographer created all the photographs; (2) the author is not an employer for hire; (3) the photographs all were published in the same twelve-month period as contributions to newspapers or magazines; and (4) the copyright claimant is the same for all the photographs.

Your registration takes effect the moment that the proper forms, deposit materials, and fee are received by the Copyright Office, no matter how long it is before you actually receive the Certificate of Registration.

INFRINGEMENT

If someone uses one or more of your copyrighted photographs without your permission, that person is an infringer. Assuming the infringed photograph is properly registered in the Copyright Office, you may bring a legal action against the infringer to stop the infringing activity and/or pay damages for the illegal use of your photograph(s).

You're entitled to your actual damages caused by the infringement, plus any extra profits the infringer may have made that aren't covered by your actual

damages. If it would be difficult to prove your damages or the infringer's profits, you can elect to receive statutory damages, which are an award of between $750 and $30,000 (which can be increased to $150,000 in the case of a willful infringement) for each work infringed, the exact amount being determined in the court's discretion.

Lawsuits for copyright infringement are brought in the federal courts and are expensive for both parties. For this reason, infringement suits are frequently settled before trial.

The test for infringement is two-part: first, whether an ordinary observer would find substantial similarity between the original photograph and the allegedly infringing one, and second, whether the creator of the allegedly infringing photograph had access to the original.

A photographer shows her lawyer the cover of a leading national magazine. On the cover is an illustration of a well-known doctor. The photographer produces her copyrighted photograph from which she believes the illustration on the cover has been copied. She asks: (1) Is this an infringement? (2) What should I do about it? *Answer:* The illustration will be an infringement if an ordinary observer would believe it to have been copied from the photograph. In this case, the attorney believes that it was, in fact, copied. Illustrators frequently work from files of photographs that they keep for reference. When working with a copyrighted photograph, they must change the image to such a degree that the ordinary observer would no longer feel the illustration had been copied. As a practical matter, the photographer's attorney will contact the magazine, which will probably settle. Of course, the magazine may argue that no copying took place, in which case an infringement action will be necessary.

FAIR USE

Not every use of a copyrighted photograph will be an infringement. Fair use allows someone to use your copyrighted photographs in a way that is noncompetitive with the uses that you would normally be paid for. A fair use is not an infringement. The law gives four factors to consider in deciding whether a use is a fair use or an infringement. If you were considering using someone else's photograph, you would weigh these factors to decide whether you should obtain permission for the use:

1. The nature of the use, including whether it is a commercial or non-profit and educational
2. The nature of the copyrighted work

3. How much of the copyrighted work is actually used
4. What effect the use will have on the potential market for or value of the copyrighted work

Fair use is frequently invoked for purposes such as criticism, comment, news reporting, teaching (including multiple copies for classroom use), scholarship, or research. For example, if a critic wants to write about your photography, the critic could use one of your photographs to illustrate the article without obtaining your consent. Similarly, if a news reporter wants to feature you in a news story, the reporter can include one of your photographs in the news story as an example of your work. These are fair uses.

A photographer has been retained by a corporate client to do an annual report. One of the photographs is to be a montage composed of other photographs already in the possession of the client—a lake in Arizona that the company has developed, a young woman in a bathing suit, scenic views of the countryside, and so on. The photographer asks: (1) Is my use of this photograph a fair use, since the montage format creates a different image? (2) If I can't simply use these photographs, what should I do? *Answer*: The use is a commercial use. Changing the size of the photographs, or even cropping them, will not change the fact that they are being reproduced without permission. The photographer should ask the client to provide copyright permissions and a model release that protects the photographer. If the client wants the photographer to handle this, the photographer should contact the copyright owners of the photographs and ask for permission to use them. If a fee is required for the use, as is likely, it can be passed along to the client. At the same time, the photographer should obtain a model release from the woman in the bathing suit. Otherwise, she may bring an invasion-of-privacy lawsuit.

How do you obtain permission to use a photograph? The best way is to have a standard form, such as the following one:

You would send an explanatory cover letter along with an extra copy of the permission form that the copyright owner would sign and return to you. You can also use this permission form when requests are made to use photographs that you have taken. Of course, you would carefully outline the rights you are giving and specify fees that must be paid for the usage.

CLASSROOM EXEMPTION AND COMPULSORY LICENSING

The copyright law provides an exemption from infringement for nonprofit (and in the case of online education, accredited) educational institutions when

Permission Form

The Undersigned hereby grant(s) permission to _____ (hereinafter

referred to as the "Photographer"), located at _____, and

to the Photographer's successors and assigns, to use the material specified in this Permission Form for the following

book, product, or use _____ for

use by the following publisher or client _____.

This permission is for the following material:

Nature of material _____

Source _____

Exact description of material, including page numbers_____

If published, date of publication _____

Publisher _____

Author(s) _____

This material may be used in the Photographer's book, product, or use named above and in any future revisions, derivations, editions, or electronic versions thereof, including nonexclusive world rights in all languages.

It is understood that the grant of this permission shall in no way restrict republication of the material by the Undersigned or others authorized by the Undersigned.

If specified here, the material shall be accompanied on publication by a copyright notice as follows_____

and a credit line as follows _____.

Other provisions, if any: _____

If specified here, the requested rights are not controlled in their entirety by the Undersigned and the following owners must be contacted: _____

One copy of this Permission Form shall be returned to the Photographer and one copy shall be retained by the Undersigned.

_____ _____
Authorized Signatory Date

_____ _____
Authorized Signatory Date

performing or displaying copyrighted works in a classroom setting. This limited exemption applies only to classroom (whether online or face to face) activities between teachers and students and is subject to several other restrictions set forth in the copyright law.

Compulsory licensing also deserves a brief mention. Copyright law allows nonprofit educational television stations, such as those in the Public Broadcasting Service, to use your published photographs without asking your permission. However, the Copyright Office, through its copyright arbitration panels, sets rates of payment that these stations are obligated to pay to you if they make use of your work and specifies what accountings must be made.

MORAL RIGHTS

Moral rights are widely recognized abroad and, as of 1990, have been adopted into the copyright law. Copyright law provides creators of works of visual arts with a right of attribution and integrity—meaning that you have the right to receive credit when photographs of yours are published and the right to have the photographs published without distortion. However, the right of attribution and integrity does not apply to works made for hire. Although this law exists, it has very limited application in the world of commercial photography, and it is therefore still important to contractually protect your right to a credit line and the publication of your work without distortions. With respect to moral rights and fine art photography, see *Legal Guide for the Visual Artist* by Tad Crawford.

WHAT ISN'T COPYRIGHTABLE

Your photographs will almost always be copyrightable. Even a home movie, such as the Zapruder film of the assassination of John F. Kennedy, was copyrighted. A photograph that is an infringement of a copyrighted work is not copyrightable. Ideas are not copyrightable, although the creative expression of an idea is. The idea to photograph a subject in a special way is not copyrightable, for example, but the photograph itself definitely would be copyrightable. Titles, names, and short phrases that may accompany your photographs are usually not copyrightable, because they lack enough creative expression. Also, the courts sometimes hold obscene photographs to be uncopyrightable, although the definition of obscenity presents a problem. The Copyright Office does not pass judgments on obscenity. It's up to the courts to make this determination. Works of a useful nature will not be copyrightable, unless they also have an artistic element. A lamp base would not be copyrightable,

but a photograph on the lamp base certainly would be. Photographs that are purely mechanical in their creation, such as X-rays or microfilmed text, are not copyrightable.

PATENTS AND TRADEMARKS

Patents and trademarks are often confused with copyrights. Protection for photographs comes from the copyright law.

A utility patent can be obtained for inventions of machines or processes that are useful, original, and not obvious to people with skill in that field. A utility patent is far more expensive to obtain than a copyright, since the services of a patent attorney are almost always a necessity. These can cost thousands of dollars, depending on the complexity of the patent. A new process for developing film could qualify for a utility patent, but simply taking a photograph would not. A design patent is somewhat less expensive to obtain, and it protects manufactured items that have ornamental, original, and unobvious designs.

Trademarks are distinctive names, emblems, or mottos that identify to the public the source of goods or services. Using someone else's trademark is forbidden, because the public would then become confused as to whose product or service it was buying. It's wise to consult an attorney before selecting a trademark, since you wouldn't want your trademark to be an infringement of someone else's. Trademarks gain protection simply by being used, although they can also be registered for federal and state protection.

THE PRIOR COPYRIGHT LAW

The new copyright law—effective January 1, 1978—has taken long enough to explain without going back over what the law used to be before January 1, 1978. However, photographs taken before that date were governed by the pre-1978 copyright law. If, for example, you published a photograph without copyright notice under the old law, it immediately went into the public domain. The post-1977 law doesn't revive these lost copyrights. Sales to magazines and rights in commissioned works were also governed by different presumptions. If your photographs taken before January 1, 1978, had copyright protection, after January 1, 1978, they are governed by the post-1977 copyright law.

MORE COPYRIGHT INFORMATION

Some of the best sources for copyright information are the Copyright Office circulars, which are available free and can be found online at the excellent website

of the Copyright Office: http://copyright.gov. The Copyright Office will not, however, give you legal advice about copyright. Extensive coverage of copyright in relation to photographers and other artists can be found in *Legal Guide for the Visual Artist* by Tad Crawford.

Form VA

Detach and read these instructions before completing this form.
Make sure all applicable spaces have been filled in before you return this form.

When to Use This Form: Use Form VA for copyright registration of published or unpublished works of the visual arts. This category consists of "pictorial, graphic, or sculptural works," including two-dimensional and three-dimensional works of fine, graphic, and applied art, photographs, prints and art reproductions, maps, globes, charts, technical drawings, diagrams, and models.

What Does Copyright Protect? Copyright in a work of the visual arts protects those pictorial, graphic, or sculptural elements that, either alone or in combination, represent an "original work of authorship." The statute declares: "In no case does copyright protection for an original work of authorship extend to any idea, procedure, process, system, method of operation, concept, principle, or discovery, regardless of the form in which it is described, explained, illustrated, or embodied in such work."

Works of Artistic Craftsmanship and Designs: You may register "Works of artistic craftsmanship" on Form VA, but the statute makes clear that protection extends to "their form" and not to "their mechanical or utilitarian aspects." The "design of a useful article" is considered copyrightable "only if, and only to the extent that, such design incorporates pictorial, graphic, or sculptural features that can be identified separately from, and are capable of existing independently of, the utilitarian aspects of the article."

Labels and Advertisements: Works prepared for use in connection with the sale or advertisement of goods and services may be registered if they contain "original work of authorship." Use Form VA if the copyrightable material in the work you are registering is mainly pictorial or graphic; use Form TX if it consists mainly of text. **Note:** Words and short phrases such as names, titles, and slogans cannot be protected by copyright, and the same is true of standard symbols, emblems, and other commonly used graphic designs that are in the public domain. When used commercially, material of that sort can sometimes be protected under state laws of unfair competition or under the federal trademark laws. For information about trademark registration, call the U.S. Patent and Trademark Office, at 1-800-786-9199 (toll free) or go to *www.uspto.gov*.

Architectural Works: Copyright protection extends to the design of buildings created for the use of human beings. Architectural works created on or after December 1, 1990, or that on December 1, 1990, were unconstructed and embodied only in unpublished plans or drawings are eligible. Request Circular 41, *Copyright Claims in Architectural Works*, for more information. Architectural works and technical drawings cannot be registered on the same application.

Deposit to Accompany Application: An application for copyright registration must be accompanied by a deposit consisting of copies representing the entire work for which registration is to be made.

Unpublished Work: Deposit one complete copy.

Published Work: Deposit two complete copies of the best edition.

Work First Published Outside the United States: Deposit one complete copy of the first foreign edition.

Contribution to a Collective Work: Deposit one complete copy of the best edition of the collective work.

The Copyright Notice: Before March 1, 1989, the use of copyright notice was mandatory on all published works, and any work first published before that date should have carried a notice. For works first published on and after March 1, 1989, use of the copyright notice is optional. For more information about copyright notice, see Circular 3, *Copyright Notice*.

For Further Information: To speak to a Copyright Office staff member, call (202) 707-3000 or 1-877-476-0778. Recorded information is available 24 hours a day. Order forms and other publications from the address in space 9 or call the Forms and Publications Hotline at (202) 707-9100. Access and download circulars, forms, and other information from the Copyright Office website at *www.copyright.gov*.

Please type or print using black ink. The form is used to produce the certificate.

1 SPACE 1: Title

Title of This Work: Every work submitted for copyright registration must be given a title to identify that particular work. If the copies of the work bear a title (or an identifying phrase that could serve as a title), transcribe that wording *completely* and *exactly* on the application. Indexing of the registration and future identification of the work will depend on the information you give here. For an architectural work that has been constructed, add the date of construction after the title; if unconstructed at this time, add "not yet constructed."

Publication as a Contribution: If the work being registered is a contribution to a periodical, serial, or collection, give the title of the contribution in the "Title of This Work" space. Then, in the line headed "Publication as a Contribution," give information about the collective work in which the contribution appeared.

Nature of This Work: Briefly describe the general nature or character of the pictorial, graphic, or sculptural work being registered for copyright. Examples: "Oil Painting"; "Charcoal Drawing"; "Etching"; "Sculpture"; "Map"; "Photograph"; "Scale Model"; "Lithographic Print"; "Jewelry Design"; "Fabric Design."

Previous or Alternative Titles: Complete this space if there are any additional titles for the work under which someone searching for the registration might be likely to look, or under which a document pertaining to the work might be recorded.

2 SPACE 2: Author(s)

General Instruction: After reading these instructions, decide who are the "authors" of this work for copyright purposes. Then, unless the work is a "collective work," give the requested information about every "author" who contributed any appreciable amount of copyrightable matter to this version of the work. If you need further space, request Continuation Sheets (Form CON). In the case of a collective work, such as a catalog of paintings or collection of cartoons by various authors, give information about the author of the collective work as a whole.

Name of Author: The fullest form of the author's name should be given. Unless the work was "made for hire," the individual who actually created the work is its "author." In the case of a work made for hire, the statute provides that "the employer or other person for whom the work was prepared is considered the author."

What Is a "Work Made for Hire"? A "work made for hire" is defined as: (1) "a work prepared by an employee within the scope of his or her employment"; or (2) "a work specially ordered or commissioned for use as a contribution to a collective work, as a part of a motion picture or other audiovisual work, as a translation, as a supplementary work, as a compilation, as an instructional text, as a test, as answer material for a test, or as an atlas, if the parties expressly agree in a written instrument signed by them that the work shall be considered a work made for hire." If you have checked "Yes" to indicate that the work was "made for hire," you must give the full legal name of the employer (or other person for whom the work was prepared). You may also include the name of the employee along with the name of the employer (for example: "Elster Publishing Co., employer for hire of John Ferguson").

"Anonymous" or "Pseudonymous" Work: An author's contribution to a work is "anonymous" if that author is not identified on the copies or phonorecords of the work. An author's contribution to a work is "pseudonymous" if that author is identified on the copies or phonorecords under a fictitious name. If the work is "anonymous" you may: (1) leave the line blank; or (2) state "anonymous" on the line; or (3) reveal the author's identity. If the work is "pseudonymous" you may: (1) leave the line blank; or (2) give the pseudonym and identify it as such (for example: "Huntley Haverstock, pseudonym"); or (3) reveal the author's name, making clear which is the real name and which is the pseudonym (for example: "Henry Leek, whose pseudonym is Priam Farrel"). However, the citizenship or domicile of the author *must* be given in all cases.

Dates of Birth and Death: If the author is dead, the statute requires that the year of death be included in the application unless the work is anonymous or pseudonymous. The author's birth date is optional but is useful as a form of identification. Leave this space blank if the author's contribution was a "work made for hire."

Author's Nationality or Domicile: Give the country of which the author is a citizen or the country in which the author is domiciled. Nationality or domicile *must* be given in all cases.

Nature of Authorship: Categories of pictorial, graphic, and sculptural authorship are listed below. Check the box(es) that best describe(s) each author's contribution to the work.

3-Dimensional sculptures: Fine art sculptures, toys, dolls, scale models, and sculptural designs applied to useful articles.

2-Dimensional artwork: Watercolor and oil paintings; pen and ink drawings; logo illustrations; greeting cards; collages; stencils; patterns; computer graphics; graphics appearing in screen displays; artwork appearing on posters, calendars, games, commercial prints and labels, and packaging, as well as 2-dimensional artwork applied to useful articles, and designs reproduced on textiles, lace, and other fabrics; on wallpaper, carpeting, floor tile, wrapping paper, and clothing.

Reproductions of works of art: Reproductions of preexisting artwork made by, for example, lithography, photoengraving, or etching.

Maps: Cartographic representations of an area, such as state and county maps, atlases, marine charts, relief maps, and globes.

Photographs: Pictorial photographic prints and slides and holograms.

Jewelry designs: 3-dimensional designs applied to rings, pendants, earrings, necklaces, and the like.

Technical drawings: Diagrams illustrating scientific or technical information in linear form, such as architectural blueprints or mechanical drawings.

Text: Textual material that accompanies pictorial, graphic, or sculptural works, such as comic strips, greeting cards, games rules, commercial prints or labels, and maps.

Architectural works: Designs of buildings, including the overall form as well as the arrangement and composition of spaces and elements of the design.

NOTE: You must apply for registration for the underlying architectural plans on a separate Form VA. Check the box "Technical drawing."

SPACE 3: Creation and Publication

General Instructions: Do not confuse "creation" with "publication." Every application for copyright registration must state "the year in which creation of the work was completed." Give the date and nation of first publication only if the work has been published.

Creation: Under the statute, a work is "created" when it is fixed in a copy or phonorecord for the first time. If a work has been prepared over a period of time, the part of the work existing in fixed form on a particular date constitutes the created work on that date. The date you give here should be the year in which the author completed the particular version for which registration is now being sought, even if other versions exist or if further changes or additions are planned.

Publication: The statute defines "publication" as "the distribution of copies or phonorecords of a work to the public by sale or other transfer of ownership, or by rental, lease, or lending"; a work is also "published" if there has been an "offering to distribute copies or phonorecords to a group of persons for purposes of further distribution, public performance, or public display." Give the full date (month, day, year) when, and the country where, publication first occurred. If first publication took place simultaneously in the United States and other countries, it is sufficient to state "U.S.A."

SPACE 4: Claimant(s)

Name(s) and Address(es) of Copyright Claimant(s): Give the name(s) and address(es) of the copyright claimant(s) in this work even if the claimant is the same as the author. Copyright in a work belongs initially to the author of the work, including, in the case of a work made for hire, the employer or other person for whom the work was prepared. The copyright claimant is either the author of the work or a person or organization to whom the copyright initially belonging to the author has been transferred.

Transfer: The statute provides that, if the copyright claimant is not the author, the application for registration must contain "a brief statement of how the claimant obtained ownership of the copyright." If any copyright claimant named in space 4 is not an author named in space 2, give a brief statement explaining how the claimant(s) obtained ownership of the copyright. Examples: "By written contract"; "Transfer of all rights by author"; "Assignment"; "By will." Do not attach transfer documents or other attachments or riders.

SPACE 5: Previous Registration

General Instructions: The questions in space 5 are intended to find out whether an earlier registration has been made for this work and, if so, whether there is any basis for a new registration. As a rule, only one basic copyright registration can be made for the same version of a particular work.

Same Version: If this version is substantially the same as the work covered by a previous registration, a second registration is not generally possible unless: (1) the work has been registered in unpublished form and a second registration is now being sought to cover this first published edition; or (2) someone other than the author is identified as a copyright claimant in the earlier registration, and the author is now seeking registration in his or her own name. If either of these two exceptions applies, check the appropriate box and give the earlier registration number and date. Otherwise, do not submit Form VA. Instead, write the Copyright Office for information about supplementary registration or recordation of transfers of copyright ownership.

Changed Version: If the work has been changed and you are now seeking registration to cover the additions or revisions, check the last box in space 5, give the earlier registration number and date, and complete both parts of space 6 in accordance with the instruction below.

Previous Registration Number and Date: If more than one previous registration has been made for the work, give the number and date of the latest registration.

SPACE 6: Derivative Work or Compilation

General Instructions: Complete space 6 if this work is a "changed version," "compilation," or "derivative work," and if it incorporates one or more earlier works that have already been published or registered for copyright, or that have fallen into the public domain. A "compilation" is defined as "a work formed by the collection and assembling of preexisting materials or of data that are selected, coordinated, or arranged in such a way that the resulting work as a whole constitutes an original work of authorship." A "derivative work" is "a work based on one or more preexisting works." Examples of derivative works include reproductions of works of art, sculptures based on drawings, lithographs based on paintings, maps based on previously published sources, or "any other form in which a work may be recast, transformed, or adapted." Derivative works also include works "consisting of editorial revisions, annotations, or other modifications" if these changes, as a whole, represent an original work of authorship.

Preexisting Material (space 6a): Complete this space *and* space 6b for derivative works. In this space identify the preexisting work that has been recast, transformed, or adapted. Examples of preexisting material might be "Grunewald Altarpiece" or "19th century quilt design." Do not complete this space for compilations.

Material Added to This Work (space 6b): Give a brief, general statement of the *additional* new material covered by the copyright claim for which registration is sought. In the case of a derivative work, identify this new material. Examples: "Adaptation of design and additional artistic work"; "Reproduction of painting by photolithography"; "Additional cartographic material"; "Compilation of photographs." If the work is a compilation, give a brief, general statement describing both the material that has been compiled *and* the compilation itself. Example: "Compilation of 19th century political cartoons."

SPACE 7, 8, 9: Fee, Correspondence, Certification, Return Address

Deposit Account: If you maintain a Deposit Account in the Copyright Office, identify it in space 7a. Otherwise, leave the space blank and send the fee with your application and deposit.

Correspondence (space 7b): Give the name, address, area code, telephone number, email address, and fax number (if available) of the person to be consulted if correspondence about this application becomes necessary.

Certification (space 8): The application cannot be accepted unless it bears the date and the *handwritten signature* of the author or other copyright claimant, or of the owner of exclusive right(s), or of the duly authorized agent of the author, claimant, or owner of exclusive right(s).

Address for Return of Certificate (space 9): The address box must be completed legibly since the certificate will be returned in a window envelope.

Form VA
For a Work of the Visual Arts
UNITED STATES COPYRIGHT OFFICE

REGISTRATION NUMBER

VA VAU

EFFECTIVE DATE OF REGISTRATION

Month Day Year

DO NOT WRITE ABOVE THIS LINE. IF YOU NEED MORE SPACE, USE A SEPARATE CONTINUATION SHEET.

1

TITLE OF THIS WORK ▼

NATURE OF THIS WORK ▼ See instructions

PREVIOUS OR ALTERNATIVE TITLES ▼

PUBLICATION AS A CONTRIBUTION If this work was published as a contribution to a periodical, serial, or collection, give information about the collective work in which the contribution appeared. **Title of Collective Work ▼**

If published in a periodical or serial give: **Volume ▼** **Number ▼** **Issue Date ▼** **On Pages ▼**

2

a

NAME OF AUTHOR ▼

DATES OF BIRTH AND DEATH
Year Born ▼ Year Died ▼

WAS THIS CONTRIBUTION TO THE WORK A "WORK MADE FOR HIRE"?
❑ Yes
❑ No

AUTHOR'S NATIONALITY OR DOMICILE
Name of Country
OR ❑ Citizen of _____
❑ Domiciled in _____

WAS THIS AUTHOR'S CONTRIBUTION TO THE WORK
Anonymous? ❑ Yes ❑ No
Pseudonymous? ❑ Yes ❑ No
If the answer to either of these questions is "Yes," see detailed instructions.

NOTE
Under the law, the "author" of a "work made for hire" is generally the employer, not the employee (see instructions). For any part of this work that was "made for hire," check "Yes" in the space provided, give the employer (or other person for whom the work was prepared) as "Author" of that part, and leave the space for dates of birth and death blank.

NATURE OF AUTHORSHIP Check appropriate box(es). **See instructions**
❑ 3-Dimensional sculpture ❑ Map ❑ Technical drawing
❑ 2-Dimensional artwork ❑ Photograph ❑ Text
❑ Reproduction of work of art ❑ Jewelry design ❑ Architectural work

b

NAME OF AUTHOR ▼

DATES OF BIRTH AND DEATH
Year Born ▼ Year Died ▼

WAS THIS CONTRIBUTION TO THE WORK A "WORK MADE FOR HIRE"?
❑ Yes
❑ No

AUTHOR'S NATIONALITY OR DOMICILE
Name of Country
OR ❑ Citizen of _____
❑ Domiciled in _____

WAS THIS AUTHOR'S CONTRIBUTION TO THE WORK
Anonymous? ❑ Yes ❑ No
Pseudonymous? ❑ Yes ❑ No
If the answer to either of these questions is "Yes," see detailed instructions.

NATURE OF AUTHORSHIP Check appropriate box(es). **See instructions**
❑ 3-Dimensional sculpture ❑ Map ❑ Technical drawing
❑ 2-Dimensional artwork ❑ Photograph ❑ Text
❑ Reproduction of work of art ❑ Jewelry design ❑ Architectural work

3

a

YEAR IN WHICH CREATION OF THIS WORK WAS COMPLETED
Year ▶ _____
This information must be given in all cases.

b

DATE AND NATION OF FIRST PUBLICATION OF THIS PARTICULAR WORK
Complete this information ONLY if this work has been published.
Month ▶ _____ Day ▶ _____ Year ▶ _____
Nation ▶ _____

4

See instructions before completing this space.

COPYRIGHT CLAIMANT(S) Name and address must be given even if the claimant is the same as the author given in space 2. ▼

APPLICATION RECEIVED

ONE DEPOSIT RECEIVED

TWO DEPOSITS RECEIVED

FUNDS RECEIVED

DO NOT WRITE HERE
OFFICE USE ONLY

TRANSFER If the claimant(s) named here in space 4 is (are) different from the author(s) named in space 2, give a brief statement of how the claimant(s) obtained ownership of the copyright. ▼

MORE ON BACK ▶
• Complete all applicable spaces (numbers 5-9) on the reverse side of this page.
• See detailed instructions. • Sign the form at line 8.

DO NOT WRITE HERE
Page 1 of _____ pages

DO NOT WRITE ABOVE THIS LINE. IF YOU NEED MORE SPACE, USE A SEPARATE CONTINUATION SHEET.

PREVIOUS REGISTRATION Has registration for this work, or for an earlier version of this work, already been made in the Copyright Office?
☐ **Yes** ☐ **No** If your answer is "Yes," why is another registration being sought? (Check appropriate box.) ▼
a. ☐ This is the first published edition of a work previously registered in unpublished form.
b. ☐ This is the first application submitted by this author as copyright claimant.
c. ☐ This is a changed version of the work, as shown by space 6 on this application.
If your answer is "Yes," give: **Previous Registration Number** ▼ **Year of Registration** ▼

5

DERIVATIVE WORK OR COMPILATION Complete both space 6a and 6b for a derivative work; complete only 6b for a compilation.
a. Preexisting Material Identify any preexisting work or works that this work is based on or incorporates. ▼

b. Material Added to This Work Give a brief, general statement of the material that has been added to this work and in which copyright is claimed. ▼

6
a
b
See instructions before completing this space.

DEPOSIT ACCOUNT If the registration fee is to be charged to a Deposit Account established in the Copyright Office, give name and number of Account.
Name ▼ **Account Number** ▼

CORRESPONDENCE Give name and address to which correspondence about this application should be sent. Name/Address/Apt/City/State/Zip ▼

7
a
b

Area code and daytime telephone number () Fax number ()

Email

CERTIFICATION* I, the undersigned, hereby certify that I am the
check only one ►
☐ author
☐ other copyright claimant
☐ owner of exclusive right(s)
☐ authorized agent of _____
Name of author or other copyright claimant, or owner of exclusive right(s) ▲
of the work identified in this application and that the statements made by me in this application are correct to the best of my knowledge.

8

Typed or printed name and date ▼ If this application gives a date of publication in space 3, do not sign and submit it before that date.

_____ Date _____

Handwritten signature (X) ▼

X _____

CHAPTER 21 TAXES

by Tad Crawford

"To produce an income tax return that has any depth to it, any feeling, one must have Lived—and Suffered." The truth of this quip by author Frank Sullivan might be felt most vividly in April, when many photographers scramble to gather the information, and sometimes the funds, to file their income tax returns. This chapter is written with the intent of enabling you to plan, keep proper records on a regular basis, and pay estimated taxes on time. Sometimes, you can take steps near the end of the year to relieve your tax burden, but, more often, the end of the year is too late. You need to keep your tax information up to date on a regular basis throughout the entire year. If you follow the simple recommendations here, tax preparation should be considerably easier, your tax bill might be smaller, and you will be better prepared to handle an IRS audit. Nonetheless, this chapter is not intended to substitute for the advice or services of a qualified tax advisor. Tax regulations change continuously, and few books can aspire to be completely accurate and current when it comes to income tax rules. This chapter is an overview based on current tax law, intended to explain the basic concepts most important to photographers, so you can prepare and carry out a tax strategy that will make your accountant's job easier in April. The IRS publications mentioned in this chapter can be obtained free by request from the IRS or by visiting the IRS website at *www.irs.gov*.

TAX YEARS AND ACCOUNTING METHODS

Your tax year is probably the calendar year, running from January 1 through December 31. This means that your income and expenses between those dates are used to fill out Schedule C, "Profit or Loss from Business." Schedule C is attached to your Form 1040 when you file your tax return.

What's the alternative to using the calendar year as your tax year? You could have what's called a fiscal year. This means a tax year starting from a date other than January 1, such as from July 1 through June 30. Most photographers use the calendar year, and if you do use a fiscal year, you will almost certainly have an accountant. For these reasons, we are going to assume that you are using a calendar year.

But how do you know whether income you receive or expenses you pay fall into your tax year? This depends on the accounting method that you use. Under the cash method, which most photographers use, you receive income for tax purposes when you in fact receive the income. That's just what you would expect. And you incur an expense for tax purposes when you actually pay the money for the expense. So it's easy to know which tax year your items of income and expense should be recorded in.

What is the alternative to cash-method accounting? It's called accrual accounting. Essentially, it provides that you record an item of income when you have a right to receive it and record an item of expense when you are obligated to pay it. Once again, it's unlikely you will use the accrual method, so we will focus on the more typical case of the photographer who uses the cash method.

One final assumption is that you are a sole proprietor and not a partnership or corporation. The benefits and drawbacks of proprietorships, partnerships, corporations, and limited liability companies were discussed in chapter 8. In any event, the general principles discussed in this chapter apply to all forms of doing business.

TAX RECORDS

If you want to avoid trouble with the Internal Revenue Service, you must keep your books in order. One of the most common reasons for the disallowance of deductions is simply the lack of records to corroborate the expenses. Your records can, however, be simple. And you don't have to know a lot of technical terms. You only have to record your income and expenses accurately so that you can determine how much you owe in taxes for the year.

You may use software like Quicken or QuickBooks to help you keep your tax records. These programs are helpful in many ways, because they not only keep track of income and expenses but also place items of income or expense into proper categories and generate reports that are useful for you and your accountant. If you don't use such software, at the least you will want to keep a simple ledger or diary in which you enter your items of income and expense as they arise. This would mean that you enter the items regularly as they occur—at least on a weekly basis—and don't wait until the end of the year to make the entries. If you're consistent this way, you will be able to take some expenses even if they're not documented by receipts or canceled checks. Such substantiation is generally not required for expenses that are less than $75 (as long as the expense is not for lodging). The ledger or diary should include a log of business travel, local automobile mileage, and the details of any entertainment or gift expenses.

You should open a business checking account so that the distinction between personal and business expenditures is clear. If an item raises a question, you will want to make a note in your records as to why it is for business and not personal.

You should also keep a permanent record of expenditures for capital assets—those assets that have a useful life of more than one year—such as a camera, lenses, and computer equipment. This is necessary for you to justify the depreciation expense you will compute for the assets (or the Section 179 expensing discussed later in the chapter). In addition, grant letters, contracts, and especially tax returns should be retained as part of your permanent files.

If you are keeping your records by hand, you might want to set up an Expense Ledger and an Income Ledger. The Expense Ledger could be set up in the form shown on this page. Each time you incur an expense, you make two entries. First you put the amount under Total Cash if you paid with cash, Total Check if you paid by check, or Total Credit/Debit Card if you paid in that way. Then you enter the amount under the appropriate expense heading. In this way, you can be certain of your addition, because the total of the entries under Total Cash, Total Check, and Total Credit/Debit Card should equal the total of the entries under all the columns for specific expenses. If you paid cash for meals for your two assistants on January 2, 2016, the entry of $78 would appear once under Total Cash and once under Meals and Lodging. If, on January 4, you then hired three models for $750 each and paid the agency by check, the entry of $2,250 would appear under Total Check and under Model Fees. Ledger books with many-columned sheets can be purchased at any good stationery store or online. You can also use a spreadsheet program such as Excel to accomplish the same purpose.

If you coordinate the expense categories in your Expense Ledger with those on Schedule C of your income tax form, you can save a lot of time when you have to fill out your tax forms.

How should you file receipts you get for paying your expenses? A simple method is to have a Bills Paid file in which you put these receipts in alphabetical order. An accordion-type file works fine and you'll be able to locate the various receipts easily. Or you could use file folders.

After you have set up your Expense Ledger, you have to set up your Income Ledger. This can be done with the following format:

INCOME LEDGER

Date	Client or Customer	Job No.	Fee	Billable Expenses	Sales Tax	Other
1/3	Acme Advertising	35	$5,700	$2,375	$470	
1/6	Johnson Publishing	43	$1,315	$145		

Date	Item	Total cash	Total check	Total credit/debit card	Office supplies	Salaries	Model fees	Advertising	Props and wardrobe	Entertainment	Rent	Utilities	Commissions	Freelance assistants and stylists	Meals and Lodging	Transportation	Telephone	Equipment	Insurance	Prints	Miscellaneous

We've assumed that you are using the simplest form of bookkeeping. However, if you accurately keep the records we've just described, you'll be able to support your deductions in the event of an audit. For further information about the "permanent, accurate and complete" records the IRS requires, you can consult IRS Publications 552, *Recordkeeping for Individuals*, and 583, *Starting a Business and Keeping Records*.

INCOME

Income for tax purposes includes all the money generated by your business—fees, royalties, sales of art, and so on. Prizes and awards will usually be included in income, unless they're the kind of prizes or awards that you receive without having to make any application. Grants will usually be included in income, except for amounts paid for tuition, books, supplies, and fees for students who are degree candidates. You can find more information about what constitutes income in IRS Publication 17, *Your Federal Income Tax*, chapter 7, "What Income is Taxable." All IRS publications are available free of charge and can be downloaded from *www.irs.gov/Forms-&-Pubs*, or you can visit your local IRS office.

It's worth mentioning that insurance proceeds received for the loss of photographs or expensed equipment are income. And if you barter, the value of what you receive is also income. So trading a photograph for the services of an accountant gives you income in the amount of the fair market value of the accountant's services.

In general, the photographer's income will be *earned ordinary income*, such as that from salary, fees, royalties, sales of art, and so on. *Unearned ordinary income* would be such items as interest on a savings account, dividends from stock, or short-term capital gains (which is profit from the sale of capital assets, such as stocks, bonds, and gold, that you have owned one year or less). The lowest tax rates apply to long-term capital gains, which is profit from the sale of capital assets that you have owned for more than one year. Unfortunately, photographers will almost always have earned ordinary income from their business activities and not long-term capital gains.

The income tax rate, by the way, is progressive. The more money you earn, the higher is the percentage you have to pay in taxes. But the higher percentages apply only to each additional amount of taxable income, not to all your taxable income. So if the tax on your first $3,000 of taxable income is $300 (10 percent), the tax on that first $3,000 will always be 10 percent—even if your highest increment is at $100,000 of taxable income and is taxed at 28 percent. In fact, the tax on a single filer with an income of $100,000 is about $21,000, so the

average rate of tax is 21 percent, even though the lowest amounts of income have a lower rate of tax and the highest amounts of income have a higher rate of tax.

EXPENSES

Expenses reduce your income. Any ordinary and necessary business expense may be deducted from your income for tax purposes. This includes photographic supplies, office supplies and expenses such as paper and postage, messenger fees, prop rentals, transportation costs, business entertainment, secretarial help, legal and accounting fees, commissions paid to an agent, books or subscriptions directly related to your business, professional dues, telephone expenses, rent, and so on. On Schedule C, these expenses are entered on the appropriate lines or, if not listed, under "Miscellaneous."

Because your right to deduct certain expenses can be tricky, we're going to discuss some of the potential items of expense in detail.

Home Studio

If you have your studio at a location away from your home, you can definitely deduct rent, utilities, maintenance, telephone, and other related expenses. Under today's tax laws, you would be wise to locate your studio away from home if possible, because if your studio is at home, you will have to meet a number of requirements before you can take deductions for your studio. To put it another way, if you're going to have your studio at home, be certain you meet the tests and qualify to take a business deduction for rent and related expenses.

The law states that a deduction for a studio at home can be taken if "a portion of the dwelling unit is exclusively used on a regular basis (A) as the taxpayer's principal place of business, (B) as a place of business which is used by patients, clients, or customers in meeting or dealing with the taxpayer in the normal course of his trade or business, or (C) in the case of a separate structure which is not attached to the dwelling unit, in connection with the taxpayer's trade or business." Exclusivity means that the space is used only for the business activity of being a photographer. If the space is used for both business and personal use, the deduction will not be allowed. For example, a studio that doubles as a television room will not qualify under the exclusivity rule. (However, the Tax Court recently allowed a home office deduction when the taxpayer, a musician, "exclusively used a clearly defined portion" of a room for business purposes. This case cannot be relied on because it was decided under a provision of the tax laws aimed at settling disputes under $50,000—and these determinations are not precedents. But it might be worth discussing this with your accountant.) The

requirement of regularity means that the photographer must use the space on a more or less daily basis for a minimum of several hours per day. Occasional or infrequent use certainly will not qualify.

If the workspace is used exclusively and on a regular basis, the studio expenses can qualify as deductible under one of three different tests.

1. First, they will be deductible if the studio is your principal place of business. But what happens if you must work at other employment or run another business in order to earn the larger part of your income? In this case, it would appear that the principal-place requirement refers to each business separately. Is the studio at home the principal place of the business of being a photographer? If it is, the fact that you also work elsewhere shouldn't matter. However, you could not deduct a studio at home under this provision if you did most of your work in another studio, maintained at a different location. Likewise, even if your photographic work requires you to be on location most of your working time, you can deduct your home office as your principal place of business if you use it regularly and exclusively for administrative and management activities of your business and have no other fixed location for your business.

2. The second instance in which the expenses can be deductible occurs when the studio is used as a place of business for meeting with clients or customers in the normal course of a trade or business. Many photographers do open their studio at home to clients in the normal course of their business activities, so this provision might well be applicable.

3. Finally, the expenses for a separate structure, such as a storage shed, would qualify for deduction if the structure were used in connection with the business of being a photographer.

If you are seeking to deduct home studio expenses as an employee rather than a freelancer, you must not only use the space exclusively on a regular basis for business and meet one of the three additional tests just described, but you must also maintain the space for the convenience of your employer. A photography teacher, for example, might argue that a studio at home was required by the school, especially if no studio space were available at the school and professional achievements in photography were expected of faculty members.

The photographer who does use the work space exclusively on a regular basis for one of the three permitted uses just discussed must pass yet one more test before being able to deduct the expenses. This is a limitation on the amount of

expenses that can be deducted in connection with a studio at home. Basically, such expenses cannot exceed your profit from your business as a photographer (with adjustments for any interest expense, real estate taxes, insurance, and utilities that are allocated to the portion of the home used as a studio). The computation is done on Form 8829, *Expenses for Business Use of Your Home*. For additional information, refer to IRS Publication 587, *Business Use of Your Home*.

Educational Expenses

You may want to improve your skills as a photographer by taking a variety of educational courses. The rule is that you can deduct these educational expenses if they are for the purpose of maintaining or improving your skills in a field that you are already actively pursuing. You cannot deduct such expenses if they are to enable you to enter a new field or meet the minimal educational requirements for an occupation. For example, photography students in college cannot deduct their tuition when they are learning the skills necessary to enter a new field. A photographer who has been in business several years could deduct expenses incurred in learning better photographic techniques or even better business techniques. Both would qualify as maintaining or improving skills in the photographer's field.

Professional Equipment

You can spend a tremendous amount of money on cameras, lights, darkroom equipment, and the like. This equipment will last more than one year. For this reason, you cannot deduct the full price of the equipment in the year that you buy it. Instead, you must depreciate it over the years of its useful life. Depreciation is the process by which a part of the cost of equipment is deducted as an expense in each year of the equipment's useful life.

To take a simplified example, you might purchase a camera for $1,000. Based on your experience, you believe that a reasonable estimate of the useful life of the camera is five years. Using the simplest method of depreciation—straight-line depreciation—you would divide five years into $1,000. Each year for five years, you would take a $200 depreciation deduction for the camera. In fact, the calculation of depreciation is more complicated than this, because there are methods of depreciation other than straight line, which result in quicker write-offs. The complexities of these various options are discussed in IRS Publication 946, *How to Depreciate Property*.

However, depreciation is of far less importance than it used to be for any small business. This is because Section 179 of the Internal Revenue Code allows you to write off the full cost in the year purchased of certain property that would

normally have to be depreciated. Such property includes machinery, equipment, a car or truck (subject to special limits), a computer, and similar items. For 2016, the maximum amount of property that could be written off pursuant to Section 179 was increased to $500,000, and the provision was made permanent (instead of having to be extended periodically). Also, the total amount of property expensed under this provision in any one year cannot exceed the taxable income derived from the conduct of the business during that year. Any excess would be carried forward to be deducted in future years. Among the types of acquisitions that do not qualify for Section 179 treatment are land, buildings, heating and air conditioning systems, paved parking areas, and fencing.

If you have a substantial investment in equipment, it would be worthwhile to have an accountant aid you in the depreciation and Section 179 computations.

Travel

Many photographers are required to travel in the course of their work. Some examples of business travel include travel to do an assignment, to negotiate a deal, to seek new clients, or to attend a business or educational seminar related to your professional activities. Travel expenses (as opposed to transportation expenses, which are explained later) are incurred when you go away from your home and stay away overnight or at least have to sleep or rest while away. If you qualify, you can deduct expenses for travel, meals and lodging, laundry, transportation, baggage, reasonable tips, and similar business-related expenses. This includes expenses on your day of departure and return, as well as on holidays and unavoidable layovers that come between business days.

The IRS has strict recordkeeping requirements for travel expenses. These requirements also apply to business entertainment and gifts, since these are all categories that the IRS closely scrutinizes for abuses. The requirements are for records or corroboration showing: (1) the amount of the expense; (2) the time and place of the travel or entertainment, or the date and description of any gift; (3) the business purpose of the expense; (4) the business relationship to the person being entertained or receiving a gift.

If you travel solely for business purposes, all your travel expenses are deductible. If you take part in some nonbusiness activities, your travel expenses to and from the destination will be fully deductible as long as your purpose in traveling is primarily for business and you are traveling in the United States. However, you can deduct only business-related expenses, not personal expenses. If you go primarily for personal reasons, you will not be able to take the travel expenses incurred in going to and from your destination (but you can deduct legitimate business expenses at your destination).

If you are traveling outside the United States and devoting your time solely to business, you may deduct all your travel expenses just as you would for travel in the United States. If the travel outside the United States was primarily for business but included some personal activities, you may deduct the expenses as you would for travel primarily for business in the United States if you meet any of the following four tests: (1) you had no substantial control over arranging the trip; (2) you were outside the United States a week or less; (3) you spent less than one-quarter of your time outside the United States on nonbusiness activities; and (4) you can show that personal vacation was not a major factor in your trip. If you don't meet any of these tests, you must allocate your travel expenses. Expenses that are less than $75 do not require documentation (except for lodging, which does require documentation).

By the way, if your spouse goes with you on a trip, his or her expenses are not deductible unless you can prove a bona fide business purpose and need for your spouse's presence. Incidental services, such as note taking or entertaining, aren't enough.

The IRS is very likely to challenge travel expenses, especially if the auditor believes a vacation was the real purpose of the trip. To successfully meet such a challenge, you must have good records that substantiate the business purpose of the trip and the details of your expenses. For more information with respect to travel expenses, you should consult IRS Publication 463, *Travel, Entertainment, Gift, and Car Expenses*.

Transportation

Transportation expenses must be distinguished from travel expenses. First of all, commuting expenses are not deductible. Traveling from your home to your studio is considered a personal expense. If you have to go to your studio and then go on to a business appointment, or if you have a temporary job that takes you to a location remote from your home and you return home each night, you can deduct these expenses as transportation expenses. But only the transportation itself is deductible, not meals, lodging, and the other expenses that could be deducted when travel was involved. If you have a home office, your expenses to go to another work location in the same business would be deductible (although the IRS will only follow this court decision if the residence is also the principal place of business).

The IRS sets out guidelines for how much you can deduct when you use your automobile for business transportation. The standard mileage rate is 57.5 cents for 2015. In addition, you can deduct interest on a car loan, parking fees, and tolls if spent for a business purpose.

However, you don't have to use the standard mileage rate. You may prefer to expense your vehicle using depreciation or Section 179 and keep track of gasoline, oil, repairs, licenses, insurance, and the like. You may find that using depreciation or Section 179 and actually keeping track of your expenses gives you a far larger deduction than the standard mileage amount.

Of course, if you use your automobile for both business and personal purposes, you must allocate the expenses to the business use for determining what amount is deductible. IRS Publication 463, *Travel, Entertainment, Gift, and Car Expenses* details the deductibility of car expenses.

Entertainment and Gifts

The IRS guidelines for documenting entertainment and gift expenses were already set out when we discussed travel.

Entertainment expenses must be either directly related to your business activities or associated with such business if the expense occurs directly before or after a business discussion.

Business luncheons, parties for business associates or clients, entertainment, and similar activities are all permitted if a direct business purpose can be shown. However, the expenses for entertainment must not be lavish or extravagant. Also, in general, only 50 percent of the expenses for meals and other entertainment expenses will be allowable as deductions. This 50 percent limitation applies to entertainment expenses for meals and beverages incurred while traveling (but meals eaten alone on a trip would be deductible in full).

Business gifts are deductible, and you can give gifts to as many people as you want. However, the gifts are deductible only up to the amount of $25 per person each year.

For both entertainment and gift expenses, you should again consult IRS Publication 463, *Travel, Entertainment, Gift, and Car Expenses*.

BEYOND SCHEDULE C

So far, we've mainly been discussing income and expenses that would appear on Schedule C. Copies of Schedule C, Schedule C-EZ, and Form 8829 are included here for your reference. It's worth mentioning that some accountants for photographers believe that high gross receipts themselves or a high ratio of gross receipts on line 1 to net profits on line 31 may invite an audit. If you incur many expenses that are reimbursed by your clients, these accountants simply treat both expenses and reimbursement as if they cancelled each other out: this results in the same net profit, but your gross receipts are less. The expenses and reimbursements are shown on a page attached to Schedule C or in a footnote

indicating the total amounts at the bottom of the front page of Schedule C. Or you could include the reimbursement as part of gross receipts and then subtract the expenses as deductions.

Schedule C is not the only schedule of importance to the photographer. There are potential income tax savings—and obligations—that require using other forms.

RETIREMENT ACCOUNTS

You, as a self-employed person, can contribute to various types of retirement plans for your business. These include the SEP, simple 401(K), simple IRA, defined benefit, and defined contribution plans. IRS Publication 560, *Retirement Plans for Small Business* covers the distinctions among the plans.

The key point is that amounts you contribute to a plan are deducted from your income on Form 1040. Among key points to consider when setting up a plan are:

- When must a plan be set up in order to have contributions reduce your income in a particular tax year?
- When must a contribution be made to a plan in order to reduce your income for a tax year?
- What kinds of accounts must the money contributed be kept in, such as a custodial account with a bank, a trust fund, or special United States Government retirement bonds?
- What is the maximum contribution you can make to a plan? In 2015 and 2016, this might be as much as $53,000 for some plans.
- If you are an older worker, can you make extra "catch up" contributions?
- If you have employees, to what degree must your plan cover your employees, and what will the cost be?
- Are you penalized for early withdrawals from the plan (such as before age 59½)?

Your contribution reduces your income, but the money will be taxed when you withdraw it for your retirement. At that time, however, you may be in a lower tax bracket. In any case, you will have had the benefit of all the interest or appreciation in value earned by the money that would have been spent as taxes if you hadn't created a retirement plan.

Two additional possibilities are to create a "traditional" IRA or a Roth IRA. You can create either plan any time before your tax return for the year must be

SCHEDULE C (Form 1040)	Profit or Loss From Business		
Department of the Treasury Internal Revenue Service (99)	(Sole Proprietorship) ▶ Information about Schedule C and its separate instructions is at *www.irs.gov/schedulec*. ▶ Attach to Form 1040, 1040NR, or 1041; partnerships generally must file Form 1065.	OMB No. 1545-0074 **2015** Attachment Sequence No. **09**	

Name of proprietor	Social security number (SSN)

A	Principal business or profession, including product or service (see instructions)	**B** Enter code from instructions ▶

C	Business name. If no separate business name, leave blank.	**D** Employer ID number (EIN), (see instr.)

E Business address (including suite or room no.) ▶ --
City, town or post office, state, and ZIP code

F Accounting method: **(1)** ☐ Cash **(2)** ☐ Accrual **(3)** ☐ Other (specify) ▶ ----------------------------

G Did you "materially participate" in the operation of this business during 2015? If "No," see instructions for limit on losses . ☐ Yes ☐ No

H If you started or acquired this business during 2015, check here ▶ ☐

I Did you make any payments in 2015 that would require you to file Form(s) 1099? (see instructions) ☐ Yes ☐ No

J If "Yes," did you or will you file required Forms 1099? ☐ Yes ☐ No

Part I Income

1	Gross receipts or sales. See instructions for line 1 and check the box if this income was reported to you on Form W-2 and the "Statutory employee" box on that form was checked ▶ ☐	1	
2	Returns and allowances .	2	
3	Subtract line 2 from line 1 .	3	
4	Cost of goods sold (from line 42) .	4	
5	**Gross profit.** Subtract line 4 from line 3	5	
6	Other income, including federal and state gasoline or fuel tax credit or refund (see instructions) . . .	6	
7	**Gross income.** Add lines 5 and 6 ▶	7	

Part II Expenses. Enter expenses for business use of your home **only** on line 30.

8	Advertising	8			18	Office expense (see instructions)	18	
9	Car and truck expenses (see instructions)	9			19	Pension and profit-sharing plans .	19	
					20	Rent or lease (see instructions):		
10	Commissions and fees .	10			a	Vehicles, machinery, and equipment	20a	
11	Contract labor (see instructions)	11			b	Other business property . . .	20b	
12	Depletion	12			21	Repairs and maintenance . . .	21	
13	Depreciation and section 179 expense deduction (not included in Part III) (see instructions)	13			22	Supplies (not included in Part III) .	22	
					23	Taxes and licenses	23	
					24	Travel, meals, and entertainment:		
14	Employee benefit programs (other than on line 19) . .	14			a	Travel	24a	
15	Insurance (other than health)	15			b	Deductible meals and entertainment (see instructions) .	24b	
16	Interest:				25	Utilities	25	
a	Mortgage (paid to banks, etc.)	16a			26	Wages (less employment credits) .	26	
b	Other	16b			27a	Other expenses (from line 48) . .	27a	
17	Legal and professional services	17			b	**Reserved for future use** . . .	27b	

28	**Total expenses** before expenses for business use of home. Add lines 8 through 27a ▶	28	
29	Tentative profit or (loss). Subtract line 28 from line 7	29	
30	Expenses for business use of your home. Do not report these expenses elsewhere. Attach Form 8829 unless using the simplified method (see instructions). **Simplified method filers only:** enter the total square footage of: (a) your home: _____ and (b) the part of your home used for business: _____ . Use the Simplified Method Worksheet in the instructions to figure the amount to enter on line 30	30	
31	Net profit or (loss). Subtract line 30 from line 29. • If a profit, enter on both **Form 1040, line 12** (or **Form 1040NR, line 13**) and on **Schedule SE, line 2.** (If you checked the box on line 1, see instructions). Estates and trusts, enter on **Form 1041, line 3.** • If a loss, you **must** go to line 32.	31	
32	If you have a loss, check the box that describes your investment in this activity (see instructions). • If you checked 32a, enter the loss on both **Form 1040, line 12,** (or **Form 1040NR, line 13**) and on **Schedule SE, line 2.** (If you checked the box on line 1, see the line 31 instructions). Estates and trusts, enter on **Form 1041, line 3.** • If you checked 32b, you **must** attach **Form 6198.** Your loss may be limited.	32a ☐ All investment is at risk. 32b ☐ Some investment is not at risk.	

For Paperwork Reduction Act Notice, see the separate instructions. Cat. No. 11334P Schedule C (Form 1040) 2015

Part III **Cost of Goods Sold** (see instructions)

33 Method(s) used to
value closing inventory: **a** ☐ Cost **b** ☐ Lower of cost or market **c** ☐ Other (attach explanation)

34 Was there any change in determining quantities, costs, or valuations between opening and closing inventory?
If "Yes," attach explanation . ☐ Yes ☐ No

35 Inventory at beginning of year. If different from last year's closing inventory, attach explanation . . .	**35**	
36 Purchases less cost of items withdrawn for personal use	**36**	
37 Cost of labor. Do not include any amounts paid to yourself	**37**	
38 Materials and supplies	**38**	
39 Other costs	**39**	
40 Add lines 35 through 39	**40**	
41 Inventory at end of year	**41**	
42 **Cost of goods sold.** Subtract line 41 from line 40. Enter the result here and on line 4	**42**	

Part IV **Information on Your Vehicle.** Complete this part **only** if you are claiming car or truck expenses on line 9 and are not required to file Form 4562 for this business. See the instructions for line 13 to find out if you must file Form 4562.

43 When did you place your vehicle in service for business purposes? (month, day, year) ▶ _____ / ____ / _____

44 Of the total number of miles you drove your vehicle during 2015, enter the number of miles you used your vehicle for:

a Business _____ **b** Commuting (see instructions) _____ **c** Other _____

45 Was your vehicle available for personal use during off-duty hours? ☐ Yes ☐ No

46 Do you (or your spouse) have another vehicle available for personal use?. ☐ Yes ☐ No

47a Do you have evidence to support your deduction? ☐ Yes ☐ No

b If "Yes," is the evidence written? . ☐ Yes ☐ No

Part V **Other Expenses.** List below business expenses not included on lines 8–26 or line 30.

48 **Total other expenses.** Enter here and on line 27a **48**	

Schedule C (Form 1040) 2015

SCHEDULE C-EZ
(Form 1040)

Department of the Treasury
Internal Revenue Service (99)

Net Profit From Business

(Sole Proprietorship)

▶ Partnerships, joint ventures, etc., generally must file Form 1065 or 1065-B.
▶ Attach to Form 1040, 1040NR, or 1041. ▶ See instructions on page 2.

OMB No. 1545-0074

2015

Attachment
Sequence No. **09A**

Name of proprietor

Social security number (SSN)

Part I General Information

**You May Use
Schedule C-EZ
Instead of
Schedule C
Only If You:**

- Had business expenses of $5,000 or less,
- Use the cash method of accounting,
- Did not have an inventory at any time during the year,
- Did not have a net loss from your business,
- Had only one business as either a sole proprietor, qualified joint venture, or statutory employee,

And You:

- Had no employees during the year,
- Do not deduct expenses for business use of your home,
- Do not have prior year unallowed passive activity losses from this business, and
- Are not required to file **Form 4562**, Depreciation and Amortization, for this business. See the instructions for Schedule C, line 13, to find out if you must file.

A Principal business or profession, including product or service

B Enter business code (see page 2)
▶

C Business name. If no separate business name, leave blank.

D Enter your EIN (see page 2)

E Business address (including suite or room no.). Address not required if same as on page 1 of your tax return.

City, town or post office, state, and ZIP code

F Did you make any payments in 2015 that would require you to file Form(s) 1099? (see the Instructions for Schedule C) ☐ Yes ☐ No

G If "Yes," did you or will you file required Forms 1099? ☐ Yes ☐ No

Part II Figure Your Net Profit

1 **Gross receipts. Caution:** If this income was reported to you on Form W-2 and the "Statutory employee" box on that form was checked, see *Statutory employees* in the instructions for Schedule C, line 1, and check here ▶ ☐ | **1**

2 **Total expenses** (see page 2). If more than $5,000, you **must** use Schedule C | **2**

3 **Net profit.** Subtract line 2 from line 1. If less than zero, you **must** use Schedule C. Enter on both **Form 1040, line 12**, and **Schedule SE, line 2**, or on **Form 1040NR, line 13**, and **Schedule SE, line 2** (see instructions). (Statutory employees **do not** report this amount on Schedule SE, line 2.) Estates and trusts, enter on **Form 1041, line 3** | **3**

Part III Information on Your Vehicle. Complete this part **only** if you are claiming car or truck expenses on line 2.

4 When did you place your vehicle in service for business purposes? (month, day, year) ▶ _____ .

5 Of the total number of miles you drove your vehicle during 2015, enter the number of miles you used your vehicle for:

a Business _____ **b** Commuting (see page 2) _____ **c** Other _____

6 Was your vehicle available for personal use during off-duty hours? ☐ Yes ☐ No

7 Do you (or your spouse) have another vehicle available for personal use? ☐ Yes ☐ No

8a Do you have evidence to support your deduction? ☐ Yes ☐ No

b If "Yes," is the evidence written? ☐ Yes ☐ No

For Paperwork Reduction Act Notice, see the separate instructions for Schedule C (Form 1040). Cat. No. 14374D Schedule C-EZ (Form 1040) 2015

Form **8829**		**Expenses for Business Use of Your Home**	OMB No. 1545-0074
Department of the Treasury Internal Revenue Service (99)		▶ File only with Schedule C (Form 1040). Use a separate Form 8829 for each home you used for business during the year. ▶ Information about Form 8829 and its separate instructions is at *www.irs.gov/form8829*.	**20**15 Attachment Sequence No. **176**

Name(s) of proprietor(s) | Your social security number

Part I — Part of Your Home Used for Business

1	Area used regularly and exclusively for business, regularly for daycare, or for storage of inventory or product samples (see instructions)	**1**	
2	Total area of home	**2**	
3	Divide line 1 by line 2. Enter the result as a percentage	**3**	%

For daycare facilities not used exclusively for business, go to line 4. All others, go to line 7.

4	Multiply days used for daycare during year by hours used per day	**4**		hr.
5	Total hours available for use during the year (365 days x 24 hours) (see instructions)	**5**	8,760	hr.
6	Divide line 4 by line 5. Enter the result as a decimal amount . . .	**6**	.	
7	Business percentage. For daycare facilities not used exclusively for business, multiply line 6 by line 3 (enter the result as a percentage). All others, enter the amount from line 3 ▶	**7**		%

Part II — Figure Your Allowable Deduction

8	Enter the amount from Schedule C, line 29, **plus** any gain derived from the business use of your home, **minus** any loss from the trade or business not derived from the business use of your home (see instructions)			**8**		
	See instructions for columns (a) and (b) before completing lines 9–21.		**(a)** Direct expenses	**(b)** Indirect expenses		
9	Casualty losses (see instructions).	**9**				
10	Deductible mortgage interest (see instructions)	**10**				
11	Real estate taxes (see instructions) . . .	**11**				
12	Add lines 9, 10, and 11	**12**				
13	Multiply line 12, column (b) by line 7			**13**		
14	Add line 12, column (a) and line 13				**14**	
15	Subtract line 14 from line 8. If zero or less, enter -0-				**15**	
16	Excess mortgage interest (see instructions) .	**16**				
17	Insurance	**17**				
18	Rent	**18**				
19	Repairs and maintenance	**19**				
20	Utilities	**20**				
21	Other expenses (see instructions). . . .	**21**				
22	Add lines 16 through 21	**22**				
23	Multiply line 22, column (b) by line 7		**23**			
24	Carryover of prior year operating expenses (see instructions) . .		**24**			
25	Add line 22, column (a), line 23, and line 24			**25**		
26	Allowable operating expenses. Enter the **smaller** of line 15 or line 25			**26**		
27	Limit on excess casualty losses and depreciation. Subtract line 26 from line 15			**27**		
28	Excess casualty losses (see instructions)		**28**			
29	Depreciation of your home from line 41 below		**29**			
30	Carryover of prior year excess casualty losses and depreciation (see instructions)		**30**			
31	Add lines 28 through 30			**31**		
32	Allowable excess casualty losses and depreciation. Enter the **smaller** of line 27 or line 31 . .			**32**		
33	Add lines 14, 26, and 32			**33**		
34	Casualty loss portion, if any, from lines 14 and 32. Carry amount to **Form 4684** (see instructions)			**34**		
35	**Allowable expenses for business use of your home.** Subtract line 34 from line 33. Enter here and on Schedule C, line 30. If your home was used for more than one business, see instructions ▶			**35**		

Part III — Depreciation of Your Home

36	Enter the **smaller** of your home's adjusted basis or its fair market value (see instructions) . .	**36**	
37	Value of land included on line 36	**37**	
38	Basis of building. Subtract line 37 from line 36	**38**	
39	Business basis of building. Multiply line 38 by line 7.	**39**	
40	Depreciation percentage (see instructions).	**40**	%
41	Depreciation allowable (see instructions). Multiply line 39 by line 40. Enter here and on line 29 above	**41**	

Part IV — Carryover of Unallowed Expenses to 2016

42	Operating expenses. Subtract line 26 from line 25. If less than zero, enter -0-	**42**	
43	Excess casualty losses and depreciation. Subtract line 32 from line 31. If less than zero, enter -0-	**43**	

For Paperwork Reduction Act Notice, see your tax return instructions. Cat. No. 13232M Form **8829** (2015)

filed (without regard to extensions, so this will usually be April 15) and pay in your money at the same time. There are limits on how much you can contribute. People over fifty may be able to make extra contributions. If you make too large an income, you will be restricted from contributing to an IRA.

The traditional IRA allows you a deduction from income for your contribution to the IRA. The contribution to a Roth IRA, on the other hand, is not deductible, so after-tax dollars go into the plan. The advantage of the Roth IRA is that distributions coming out of the plan are not taxed (provided that such distributions are made after the five-year period commencing with the first year in which a contribution was made and that you are 59½ or older). This means that any appreciation in value of the plan assets will escape taxation. If you can afford to contribute to a Roth IRA, it seems a better investment than the traditional IRA.

You can obtain more information about retirement plans from the institutions that administer them. In addition to IRS Publication 560, *Retirement Plans for Small Business*, other helpful publications are IRS Publication 17, *Your Federal Income Tax*, IRS Publication 590-A, *Contributions to Individual Retirement Arrangements (IRAs)*, and IRS Publication 590-B, *Distributions from Individual Retirement Arrangements (IRAs)*.

CHILD AND DISABLED DEPENDENT CARE

If you have a child or disabled dependent for whom you must hire help in order to be able to work, you should be able to take a tax credit for part of the money you spend. This is more fully explained in IRS Publication 503, *Child and Dependent Care Expenses*.

CHARITABLE CONTRIBUTIONS

Photographers cannot, unfortunately, take much advantage of giving charitable contributions of their photographs or copyrights. Your tax deduction is limited to the costs that you incurred in producing what you are giving away (assuming you haven't already expensed those costs). You are penalized for being the creator of the photograph or copyright, since someone who purchased either a photograph or copyright from you could donate it and receive a tax deduction based on the fair market value of the contributed item.

BAD DEBTS

What happens if someone promises to pay you $1,000 for a photograph that you deliver but then never pays you? You may be able to sue him or her for the money, but you cannot take a deduction for the $1,000, because you never recorded the money as income since you're a cash-method taxpayer. The whole

idea of a bad-debt deduction is to put you back where you started, so it applies mainly to accrual-basis taxpayers. If you lend a friend some money and don't get it back, you may be able to take a nonbusiness bad-debt deduction. This would be taken on Schedule D as a short-term capital loss, but only after you had exhausted all efforts to get back the loan.

SELF-EMPLOYMENT TAX

In order to be eligible for the benefits of the social security system, self-employed people must pay the self-employment tax. This tax is computed on Schedule SE, *Self-Employment Tax*. Additional information about the self-employment tax can be found in IRS Publication 533, *Self-Employment Tax*. To answer specific questions about social security, you can visit the website of the Social Security Administration at www.ssa.gov.

ESTIMATED TAX PAYMENTS

Self-employed people should make estimated tax payments on a quarterly basis. In this way you can ensure that you won't find yourself without sufficient funds to pay your taxes in April. Also, you are legally bound to pay estimated taxes if your total income and self-employment taxes for the year will exceed taxes that are withheld by $1,000 or more (subject to certain safe harbor provisions). The estimated tax payments are made on Form 1040-ES, *Estimated Tax for Individuals*, and sent in on or before April 15, June 15, September 15, and January 15. The details of estimated tax payments are explained in IRS Publication 505, *Tax Withholding and Estimated Tax*.

PROVING PROFESSIONALISM

The IRS may challenge you on audit if they find that you've lost money for a number of years in your activities as a photographer. It's demoralizing when this happens, since the auditors will call you a hobbyist and challenge your professionalism. However, you have resources and should stand up for yourself. In fact, you should probably be represented by an accountant or attorney to aid you in making the arguments to prove you're a professional.

First, if you have a profit in three years of the five years ending with the year they're challenging you about, there's an automatic presumption in your favor that you intend to make a profit. That's the crucial test for professionalism—that you *intend to make a profit*. But, if you can't show a profit in three years of those five, there is no presumption saying you are a hobbyist. Instead, the auditor is supposed to look at all the ways in which you pursue your photographic business and see whether you have a profit motive. In particular, the regulations set out nine

factors for the auditor to consider. You should try to prove how each of those factors shows your profit motive. But don't be discouraged if some of the factors go against you, since no one factor is dispositive. Here we'll list the nine factors and briefly suggest how you might argue your professionalism:

1. *The manner in which the taxpayer carries on the activity.* Your record keeping is very important. Do you have good tax records? Good records for other business purposes? Professional efforts show professionalism. Seeking a representative, stock agency, or gallery all show intent to sell your work. Membership in professional associations suggests you are not a hobbyist. Similarly, grant and contest applications show your serious intent to make a profit. The creation of a professional studio and use of professional equipment also suggest you are not a hobbyist. Maintaining your prices at a level consistent with being a professional is important, but on the other hand, the price level must not be so high as to prevent your obtaining assignments and selling your work.

2. *The expertise of the taxpayer or his or her advisers.* You would normally attach your resume to show your expertise. You would make certain to detail your study to become a photographer—whether you studied formally or as someone's assistant. Any successes are significant. Have you sold your work, done assignments for clients, given shows in galleries? Reviews or other proofs of critical success are important. Teaching can be a sign of your expertise. Obtaining statements from leading photographers or one of the professional organizations as to your professionalism aids your cause. Even the place where you work can be important, if it is known as the location of many successful photographic studios. You should use your imagination in seeking out all the possible factors that show your expertise.

3. *The time and effort expended by the taxpayer in carrying on the activity.* You must work at your photography on a regular basis. Of course, this includes time and effort related to marketing your work and performing all the other functions that accompany the actual shooting of the photographs.

4. *The expectation that assets used in activity may increase in value.* This factor is not especially relevant to photographers. You might argue, however, that the photographs and copyrights you are creating are likely to increase in value. This is most believable if you place your photographs with stock agencies for resale or sell prints as original works.

5. *The success of the taxpayer in carrying on other similar or dissimilar activities.* If you have had success in another business venture, you should explain the

background and show why that leads you to believe your photography business will also prove successful. If the success was in a closely related field, it becomes even more important. You might expand this to include your successes as an employee, which encouraged you to believe you could be successful on your own.

6. *The taxpayer's history of income or losses with respect to the activity.* Losses during the initial or start-up stage of an activity may not necessarily be an indication that the activity is not engaged in for profit. Everyone knows that businesses are likely to lose money when they start. The point is to show a succession of smaller and smaller losses that, in the best case, end up with a small profit. You might want to draw up a chart ranging from the beginning of your photographic career to the year at issue, showing profit or loss on Schedule C, Schedule C gross receipts, the amount of business activity each year, and taxable income from Form 1040. The chart should show shrinking losses and rising gross receipts. This suggests that you may start to be profitable in the future. By the way, you can include on the chart years after the year at issue. The additional years aren't strictly relevant to your profit motive in the year at issue, but the auditor will consider them to some degree.

7. *The amount of occasional profits, if any, that are earned.* It helps to have profits. But the reason you're being challenged as a hobbyist is that you didn't have profits for a number of years. So don't be concerned if you can't show any profitable years at all. It's only one factor. Also, keep in mind that your expectation of making a profit does not have to be reasonable; it merely has to be a good-faith expectation. A wildcat oil outfit may be drilling against unreasonable odds in the hopes of finding oil, but all that matters is that the expectation of making profit is held in good faith. Of course, you would probably want to argue that your expectation is not only in good faith but reasonable as well, in view of the circumstances of your case.

8. *The financial status of the taxpayer.* If you're not wealthy and you're not earning a lot each year, it suggests you can't afford a hobby and must be a professional. That's why showing your Form 1040 taxable income can be persuasive as to your profit motive. If you are in a low tax bracket, you're really not saving much in taxes by taking a loss on Schedule C. And if you don't have a tax motive in pursuing your photography, it follows that you must have a profit motive.

9. *Elements of personal pleasure or recreation.* Since so many people have fun with cameras, it may be hard for the auditor to understand that you are

working when you use one. Explain that photography is a job for you as the auditor's job is one for him or her. The pleasure you get out of your work is the same pleasure that auditors get out of theirs, and so on. If you travel, you're especially likely to be challenged, so have all your records in impeccable shape to show the travel is an ordinary and necessary business expense.

The objective factors in the regulations don't exclude you from adding anything else you can think of that shows your professionalism and profit motive. The factors are objective, however, so statements by you as to your subjective feelings of professionalism won't be given too much weight. An important case is *Churchman v. Commissioner*, 68 Tax Court No.59, in which an artist who hadn't made a profit in twenty years was found to have a profit motive.

GIFT AND ESTATE TAXES

The subject of gift and estate taxes is really beyond the scope of this book. It's important to plan your estate early in life, however, and the giving of gifts can be an important aspect of this planning. In addition to considering the saving of estate taxes and ensuring that your will (or trust) indicates those whom you wish to benefit, you must also plan for the way in which your work will be treated after your death. These issues, including the giving of gifts and the choosing of executors, are discussed in *Legal Guide for the Visual Artist* by Tad Crawford. Good general estate planning guides include *Your Living Trust and Estate Plan* and *Your Will and Estate Plan*, both by Harvey Platt.

HELPFUL AIDS

All IRS publications are available free of charge by request or by visiting the IRS website at *www.irs.gov.* Two publications of special interest are IRS Publication 17, *Your Federal Income Tax,* and IRS Publication 334, *Tax Guide for Small Business.* Keep in mind, however, that these books are written from the point of view of the IRS. If you're having a dispute on a specific issue, you should obtain independent advice as to whether you have a tax liability.

A good, basic guide for income taxation, estate taxation, and estate planning is contained in *Legal Guide for the Visual Artist* by Tad Crawford. For preparing a current return, a good and comprehensive guide for the general public is *J.K. Lasser's Your Income Tax*, which is updated annually with changes for the current tax year.

CHAPTER 22 INVASION OF PRIVACY AND RELEASES

by Tad Crawford

THE LAWS GUARANTEEING privacy are a key area for you to understand. Photographers record images of people in every conceivable human situation for an immense variety of uses. Frequently, you will need to obtain a release from the person you are photographing. This is because of that person's right of privacy, a right that can be invaded in the following ways:

1. By using a person's photograph, likeness, or name for purposes of advertising or trade
2. By disclosing embarrassing private facts to the public
3. By using a photograph in a way that suggests something fictional or untrue
4. By physically intruding into a person's privacy—for example, by trespassing to take a photograph

The law of privacy abounds with subtle interpretations. The best advice is to obtain a release if you have any doubt about whether the way you're taking the photograph or the use you intend to make of it could be an invasion of privacy. A number of standard release forms are gathered for your use at the end of this chapter. However, there are many situations when you clearly will not need a release. This chapter will give examples of many common situations the photographer faces, so you'll understand whether or not a release is needed.

It should also be mentioned that the Internet has in no way decreased the likelihood of invading someone's privacy. If anything, it has added many more opportunities in the form of blogs, social media, and emails by which the right of privacy can be violated. This observation also holds true for defamation, which is discussed in the next chapter.

PRIVACY

The creation of privacy as a legal right came about in 1903 by a statute enacted in New York State. Since that time, almost every state—with a few exceptions as of this writing—has either enacted a similar statute or recognized the right of privacy in court decisions.

The law with respect to privacy can differ from state to state, but New York has been the leader in the privacy area, and most law with respect to privacy is the same in all jurisdictions. If you're wondering about a situation in which the law appears unclear, you should use a release or consult a local attorney.

Privacy is the right to peace of mind and protection from intrusions or publicity that would offend the sensibilities of a normal person living in a community. It is an individual right granted to living people. If a person's privacy is invaded by a photographer, that person must bring suit—not the spouse, children, or anyone else. The right to sue for an invasion of privacy ends upon the death of the individual whose privacy was invaded. If the lawsuit for the invasion was started prior to death, some states allow the legal representative to continue the lawsuit, while other states dismiss the suit. Very few states, however, permit a lawsuit to be started after a person's death for an invasion of the deceased person's privacy. Also, because the right belongs to individuals, the names of partnerships or corporations are not protected by the privacy laws.

ADVERTISING OR TRADE PURPOSES

The New York statute provides, "Any person whose name, portrait or picture is used within this state for advertising purposes or for the purposes of trade without . . . written consent . . . may maintain an equitable action in the supreme court of this state . . . to prevent and restrain the use thereof; and may also sue and recover damages for any injuries sustained by reason of such use." What are advertising or trade purposes? For advertising, we naturally think of advertisements for products or services. For trade, the immediate association is with a photograph on a product that is being sold to the public. For example, when photographer Ronald Galella sent out a Christmas card with a photograph he had taken of Jacqueline Onassis on the card, a court found this to be an advertising use and an invasion of her privacy. Even an instructional use can, in certain cases, be for advertising purposes. A woman was photographed for a railroad company and appeared in a poster instructing passengers how to enter and leave the railcars safely. The court, in a three-to-two divided vote, decided that the unselfish purpose of the poster could not change its nature as advertising. The woman's privacy had been invaded.

If a photographer hangs a photographic portrait in the studio window with a sign advertising portrait services, the photograph is being used for advertising purposes. The New York statute has a special provision, however, permitting a photographer to exhibit specimen photographs at the studio unless a written objection is made by the person in the photograph.

An example of a trade use would be placing a person's photograph on post-cards for public sale. Such use is intended to create a desirable product that the public will purchase.

The problem is that advertising and, especially, trade purposes become more difficult to identify when the photographs are used in media protected by the First Amendment. Freedom of speech and press narrow the right of privacy.

THE PUBLIC INTEREST

Public interest is the other side of the coin. The public interest is served by the dissemination of newsworthy and educational information. It is not limited to matters of current news but extends to whatever the public is legitimately inter-ested in. Using a photograph to illustrate a news story about a person who has won a prize for public service in no way requires a release. A photograph of a scientist could be used with an article in a book commenting on the scientist's discoveries, even if these discoveries are not current news.

Unfortunately, it isn't always so easy to know whether a purpose is for adver-tising or trade as opposed to being for the public interest. The best way to get a feeling of what is permitted and what isn't is by examining situations that are likely to come up.

PHOTOGRAPHING IN PUBLIC PLACES

You can usually photograph in public places without any restrictions on your right to do so. Of course, if you're making a movie or photographing in such a way as to disrupt the community's normal flow of activity, you may need to get a permit from the local authorities. The main problem is not taking the pictures but using them. Even though you took someone's photograph in a public place, you cannot use it for advertising or trade purposes without the person's consent. On the other hand, you are free to use such a photo in the public interest, such as for newsworthy purposes, without worrying about releases.

BYSTANDERS AT PUBLIC EVENTS—REQUIREMENT OF RELATEDNESS

Let's say you're taking some photographs of a parade. Along the route of the parade are bystanders who are watching the floats and listening to the bands. Your photographs of the parade itself naturally include a lot of shots of bystand-ers. Can you include bystanders in the photographs of the parade when the arti-cle is published? Yes, you can, and you don't need a release. This is because the parade is newsworthy. When someone joins in a public event, he or she gives up some of the right to privacy.

But what if the magazine wants to use a photograph of the bystander on its cover—not just as one face among others, but singled out? Is this focusing on that bystander to such a degree that you'll need a release? This happened at *New York* magazine when the editors used the photograph of a bystander on their cover beneath the caption "The Last of the Irish Immigrants." The bystander had, in fact, been photographed at the St. Patrick's Day Parade in New York City, but he was not Irish. And, while his name did not appear on the cover or in the article, he sued for the use of the photograph. Essentially, he argued that the use would have been in the public interest if it had just been to illustrate an article, but falsely implying that he was Irish and placing the photograph on the cover made the primary purpose to sell the magazine—a trade use.

New York's highest court didn't agree. Even though the photograph was on the cover, it was illustrating an article about an event of genuine public interest. And the photograph was related to the contents of the article. This is a crucial requirement: that the photograph in fact be appropriate to illustrate the article. Since the bystander participated in the parade by being there, the use of the photograph on the cover was not an invasion of his privacy.

This same challenge comes up frequently with book jackets. The well-known football quarterback Johnny Unitas sued for invasion of privacy when his photograph appeared on the jacket of a book about football. The court held for the publisher, saying that the photograph was related to the contents of the book and therefore was not for purposes of trade.

Going a step further, what about the cover of a company's annual report with the photograph of a customer purchasing an item in one of the company's retail stores? The customer turned out to be a lawyer who sued for the invasion of his privacy. The court stated that no case had ever held the annual report—required by the Securities and Exchange Commission—to be for purposes of advertising or trade. The court indicated that, if pressed, it would have decided that this use of a photograph of a customer in a retail store was related to the presentation of a matter in the public interest.

USES THAT ARE NOT RELATED

An Illinois case provides a good example of the possibility of an invasion of privacy by an unrelated use. An imprisoned criminal was slipped a pistol by his girlfriend, escaped from jail, and fatally shot a detective trying to recapture him. A magazine retold the story three months later in an article titled "If You Love Me, Slip Me a Gun." A photograph of the deceased detective's wife was used to illustrate this story, showing her grief-stricken over her husband's death. An appeals court concluded that this use could be found to be unrelated to the thrust of the

story and shocking to basic notions of decency. The issue was whether use of the photograph served the public interest by providing newsworthy or educational information or merely served the publisher's private interest in selling more copies of the magazine. There is no doubt, by the way, that the photograph of the widow would have been in the public interest to illustrate a factual article about the death of her husband in the line of duty. But use in a sensationalized way that was not related to the article could make it for purposes of trade—to sell copies of the magazine by capitalizing on the widow's grief.

A classic case of unrelated use involved an article about street gangs in the Bronx in New York City. The photograph illustrating the article showed a number of people in a street scene in that area. The people who sued, and won, were in no way connected with street gangs, so the use of the photograph was for trade purposes.

FICTIONAL USE

If a photograph is used in a false way, it can't be legitimately related to an article in the public interest. The photograph can be perfectly innocent—for example, a young lady looking across a bay on a moonlit night. Now, suppose a writer exercises all his or her ingenuity and comes up with a wild, entirely fictional story. Using the photograph to accompany the story raises the risk of an invasion-of-privacy lawsuit. The use of the photograph is not to illustrate a story or article in the public interest. Legally speaking, it is merely to entertain by highlighting an imaginative yarn. In fact, the general rule is that media used solely for entertainment are far more likely to invade someone's privacy than media used in the public interest. A novel, a fictional film, or a television serial are held to be solely for entertainment value. The risk of invasion of privacy is greater in those cases than in a biography, a documentary, or a television news program. A fictional use of a photograph is for trade purposes, since its only goal is considered to be the enhancement of sales.

It would definitely be an invasion of privacy to use the photograph of a businessman carrying a briefcase to illustrate the escape of a desperate and violent bank robber with the loot. But what if that same photograph—of an ordinary businessman on his way home from the office—is used to accompany an article praising him for accomplishments he has not attained? It might say that he has just come from an international convention of scientists and is carrying in his briefcase the remarkable invention for which his peers have so justly applauded him. But the man isn't a scientist and has no invention. This fiction could be extremely embarrassing. It all adds up to an invasion of privacy. Famous baseball pitcher Warren Spahn successfully prevented publication of a biography of him because it

contained so many mistakes. Not surprising, except for the fact that the mistakes were all laudatory—all designed to make him even more of a hero than he already was. Praise will not avoid an invasion of privacy, unless the praise has a basis in fact.

INCIDENTAL ADVERTISING USES

You've photographed a famous baseball player for the pages of a sports magazine. The photographs properly accompany an article about the performance of the player's team. But then the magazine surprises you. They take those same photographs and use them to advertise the magazine. You feel shaky when you see the advertisement, because you never got a release. You knew it was for editorial use and you didn't see why you needed one.

This type of case has come before the courts a number of times—with an athlete, an actress, a well-known author, and others. The courts have uniformly held that no invasion of privacy takes place in these situations if the purpose of the advertisement is to show that the magazine carries newsworthy articles. The photographs for the original article were not an invasion of privacy, because they were in the public interest. If the advertisement is to inform the public about the types of newsworthy and educational articles that the magazine runs, the advertisement is protected in the same way as the original article. This is true even if the advertisement is not advertising the specific issue in which the article appeared, but rather advertising the magazine generally.

But you have to be very careful here. If the photographs are not used in the same way they were when they accompanied the original article, you may end up with an invasion of privacy. Obviously, it would be an invasion of privacy to take the same photographs and say that the person endorsed the value of the magazine. Or to use the photographs on posters that are sold to the public. Advertising incidental to a protected editorial use—to show that the publication serves the public interest because of the nature of its contents—is a narrow exception to the general rule banning the use of photographs for advertising or trade purposes without the consent of the person portrayed.

A related case occurred when a newspaper photographed a paid model to illustrate a new bathing suit for a fashion item. The photograph included in the background several ten-year-old boys who happened to be at the swimming pool. The text accompanying the photograph ended by describing the bathing suit as "a bikini, very brief pants plus sawed-off tank top. Colored poor-looking brown, the suit is by Elon, $20, Lord & Taylor." Lord & Taylor did not pay to have the item appear. Rather, the newspaper published it as a newsworthy piece of information. The court agreed that the item was in the public interest and that the use of the boys in the photograph was not for advertising or trade

purposes. So the boys lost their invasion-of-privacy suit. If Lord & Taylor had paid for the fashion "news" item to be run, the result would presumably have been different. Even though the item would seem to have been published for its current interest, it in fact would be an advertisement in disguise if paid for. This would have violated the boys' rights.

In a classic case, actor Dustin Hoffman sued *Los Angeles* magazine for invasion of privacy when the magazine used a computer-altered image of the actor in an evening gown and high heels without his permission. The image was accompanied by the caption, "Dustin Hoffman isn't a drag in a butter-colored silk gown by Richard Tyler and Ralph Lauren heels." The defendant argued that the material was protected by the First Amendment and based not on Dustin Hoffman but on the character that he had played in the film *Tootsie*. Although the magazine gave the cost of the clothing and where to purchase it, the court concluded that it was not an advertisement but an "editorial comment on classic films and famous actors." The decision was rendered in favor of the defendant.

PUBLIC DISCLOSURE OF EMBARRASSING PRIVATE FACTS

The public disclosure of embarrassing private facts can be an invasion of privacy. Peculiar habits, physical abnormalities, and so on can easily be captured by the photographer. There is no benefit to the public interest, however, in making public such information about a private citizen. On the other hand, if the information is newsworthy, no invasion of privacy will occur. The examples discussed here show how disclosures that normally would invade privacy are protected when newsworthy.

One case involved a husband and wife photographed in the ice cream concession they owned. The man had his arm around his wife and their cheeks were pressed together—a romantic pose. This photograph was then used to illustrate a magazine article about love. The court decided that the photograph was not embarrassing or offensive. In fact, the couple had voluntarily assumed the pose in a public place. And, in any case, it did relate to an article serving the public interest. So the couple lost their invasion-of-privacy suit.

In another case, a body surfer well known for his daring style gave an interview in which he told of his peculiar behavior—eating insects, putting out cigarettes in his mouth, pretending to fall down flights of stairs, and fighting in gangs as a youngster. When he found out that these odd traits would be included in the magazine article, he sued on invasion-of-privacy grounds. The court decided that these facts could be included in the article because they were relevant in explaining his character. And his character was of public interest since it related directly to his exploits as a body surfer. But if his body surfing had not

been legitimately newsworthy, the disclosure of facts of that kind could certainly have been an invasion of privacy.

CRIMINALS AND VICTIMS

The commission of a crime and the prosecution of criminals are certainly newsworthy, since they are of legitimate concern to the public. Photographs of alleged or convicted adult criminals can thus be used in the course of reporting news to the public. However, many states protect the identity of juvenile defendants and victims of certain crimes, such as rape. You have to check your own state's laws to determine what restrictions you may face. It's worth noting that the United States Supreme Court has decided that the disclosure of the identity of a deceased rape victim did not give grounds for an invasion-of-privacy action. The court pointed out that the victim's identity was a matter of public record. The embarrassment caused to the victim's father who initiated the lawsuit could not outweigh the value of communicating newsworthy information to the public. And a state court decision denied a fourteen-year-old rape victim recovery in an invasion-of-privacy suit based on the disclosure of her identity as a victim of a rape. The reasoning is again that the identity is newsworthy and, therefore, cannot be an invasion of privacy.

PUBLIC FIGURES

Public figures must sacrifice a great deal of their right of privacy. This follows from the fact that public figures are, by definition, newsworthy. The public wants to know all about them. The media are merely serving this public interest by making the fullest disclosure of the activities of public figures. So the disclosure of a private fact—which would be an invasion of privacy if a private citizen were involved—may very well be newsworthy and permissible if a public figure is being discussed. For example, a braless tennis professional competing in a national tournament momentarily became bare-chested while serving. A photographer captured this embarrassing moment and the photograph appeared nationwide. The event was newsworthy. But in a similar case—a private citizen's skirts being blown up in the funhouse at a county fair—the event was not newsworthy and publication of the photograph was an invasion of privacy.

Who is a public figure? Anyone who has a major role in society or voluntarily joins in a public controversy with the hope of influencing the outcome is a public figure. This includes politicians, famous entertainers, well-known athletes, and others who capture the public imagination because of who they are or what they've done—whether good or bad. Beyond this, however, it also encompasses private citizens who take a stand on a controversy of public interest, such

as a housewife publicly campaigning to defeat the budget of a local school board. However, the United States Supreme Court has decided in one case that "public figure" does not include a woman who is in the process of getting divorced from a well-known businessman. When the grounds for her divorce decree were incorrectly reported in a national magazine, the court found she was a private citizen who had not voluntarily become involved in activities of public interest—despite her social status and the fact she had voluntarily given several press conferences to provide information about her divorce to the press.

The more famous the public figure, the greater the right of privacy that the public figure sacrifices. The president of the United States has almost no right of privacy, since practically everything about the life of the president is of interest. A housewife speaking out about a matter of public interest, however, would sacrifice far less of her right of privacy than the president.

One of the leading invasion-of-privacy cases arose from photographer Ron Galella's pursuit of former first lady Jacqueline Onassis. Faithful to the creed of the paparazzi, he jumped and postured about her while taking his photographs, bribed doormen to keep track of her, once rode dangerously close to her in a motorboat while she was swimming, invaded her children's private schools, leaped in front of her son's bicycle to photograph him, interrupted her daughter on the tennis courts, and romanced a family servant to keep himself current on the location of the members of her family. Could she prevent Galella from harassing her in this way? Or did her status as a public figure make her fair game for whatever tactics a paparazzo might choose to employ?

The court's decision struck a compromise between Mrs. Onassis's right to privacy and the legitimate public interest in knowing of her life. It prohibited Galella from blocking her movements in public places or from doing anything that might reasonably be foreseen to endanger, harass, or frighten her. But it did not stop him from taking and publishing his photographs, because that served the public interest.

However, in 1982, a new action was brought by Mrs. Onassis against Galella on the grounds that he had violated the 1975 court order on at least twelve occasions. Although the First Amendment protected the photographer's right to take photographs of a public figure, the contempt citations might still have resulted in Galella being imprisoned and paying heavy fines. To avoid this, Galella agreed never to photograph Mrs. Onassis or her children again.

The right of the public to know the appearance of public figures is simply an extension of the rules relating to what is newsworthy and informational. It's important to realize, however, that public figures keep their right of privacy with respect to commercial uses. If you use a public figure's photograph to advertise

a new aftershave lotion, you have definitely committed an invasion of privacy. In fact, celebrity rights and the right of publicity discussed in the next chapter show that public figures can actually have a property right in their names, portraits, or pictures.

If an invasion of privacy is found to have occurred, the intention behind the invasion won't matter in the ordinary case involving a private person who is not involved in a matter of public interest. But the courts have determined that a higher standard should apply to false reports of matters in the public interest, including reports involving public figures. To recover for invasion of privacy in cases involving public figures, the public figure must show that the false report was published with knowledge of its falsity or a reckless disregard as to whether or not it was true. This can be a difficult standard to meet, but it reflects the concern of the United States Supreme Court to protect the First Amendment rights of the news media.

STALE NEWS

At some point, news becomes stale and the use of someone's photograph is no longer newsworthy. For example, motion pictures of a championship boxing match were no longer newsworthy when, fifteen or twenty years after the bout, they were used as part of a television program titled "Greatest Fights of the Century." The boxer's claim, based on invasion of privacy, could not be defeated on the ground that the program disseminated news. Similarly, the story of a sailor who saved his ship by sending a wireless message was newsworthy when it happened. But to use the sailor's name and have him portrayed by an actor in a commercial film released one month later was a trade use and an invasion of the sailor's right of privacy. Its dissemination was no longer protected as newsworthy.

On the other hand, a child prodigy remained newsworthy twenty-five years later, despite having vanished completely from public sight. In fact, the prodigy hated his early fame and had sought obscurity, but the court concluded that the public interest would be served by knowing whether his early promise was ever realized. A magazine article about him, although it embarrassed him and brought him into the public view in a way he dreaded, was not an invasion of his privacy.

RECOGNIZABLE PERSON

One way photographers avoid invasion-of-privacy problems is by retouching photographs so the people aren't identifiable. If you can't identify someone, no invasion of privacy can occur.

A novel case involved a photograph of the once well-known actress Pola Negri used to advertise a pharmaceutical product. The advertiser argued that

the photograph of the actress had been made forty years before the lawsuit. Since she had aged and her appearance was quite different, no invasion of privacy could take place. Needless to say, the court rejected this argument. Whether the photograph was made last year or forty years ago doesn't matter if it is put to an advertising use and the person pictured is still alive.

A recognizable likeness, even if not an exact photograph as originally made, can also constitute an invasion of privacy. For example, *Playgirl* magazine ran a picture showing a nude black man sitting in the corner of a boxing ring with his hands taped. Although the picture was captioned "Mystery Man," it clearly was a likeness of boxer Muhammad Ali. In fact, an accompanying verse referred to the figure as "the Greatest." The picture was fictional and offensive. It certainly was not newsworthy or instructive, since it didn't even accompany an article. The court decided that an invasion of Ali's privacy had occurred. The nude picture was for purposes of trade—to attract the public's attention and sell the magazine.

PARTS OF THE BODY

If a person must be recognizable for an invasion of privacy to occur, it follows that you can photograph unidentifiable parts of the body for advertising and trade use without fear of causing an invasion of privacy. Arms, legs, the backs of heads, and so on are all right as long as the person is neither identified nor identifiable.

But why do most agencies still insist on a release from models in these cases? Simply because the release serves as the contract between the photographer and the model. It gives written proof that the model agreed to render services for a specified fee that you (or the agency) agreed to pay. While you may not have to be concerned about an invasion of privacy suit, it also saves you from having to worry about a breach-of-contract suit.

DOGS, HORSES, CARS, AND HOUSES

What about photographing property belonging to someone else, such as a German Shepherd or the interior of a house? This shouldn't be an invasion of privacy, especially if the owner isn't identified in any way by the photograph. For example, you could photograph a horse running in a field and use the photograph in an advertisement. The owner would have no right to object, since the right of privacy protects people, not animals. By the same token, there's no reason why you shouldn't be able to use a car, the interior of a house, or other private property in an advertisement as long as the owner cannot be identified. But if you promised to pay for the right to photograph the person's property, or if you took or used the photographs in violation of an understanding that you reached with the owner, you may very well face a breach-of-contract lawsuit. As a practical

matter, you should seriously consider obtaining a release if you plan to use the photograph for advertising or trade uses, since it could also serve as your contract with the owner and would eliminate any risk of a lawsuit—however frivolous.

TRESPASSING

You can't trespass to get photographs, even if the photographs are newsworthy. A trespass—an unlawful entry on a person's property—can serve as the basis for an invasion-of-privacy lawsuit. And it doesn't matter whether you publish the photographs, since the invasion is based on the trespass, not the publication.

A Florida case involving a police raid on a controversial private school stated this prohibition colorfully. The police had television news cameramen accompany the raiding party that rousted students and faculty from bed. The cameramen took embarrassing footage that was televised. The court said that to permit such conduct

> could well bring to the citizenry of this state the hobnail boots of a Nazi storm trooper equipped with glaring lights invading a couple's bedroom at midnight with the wife hovering in her nightgown in an attempt to shield herself from the scanning TV camera. In this jurisdiction, a law enforcement officer is not as a matter of law endowed with the right or authority to invite people of his choosing to invade private property and participate in a midnight raid of the premises.

But in a similar case, a newspaper photographer, at the request of police, took photographs of the silhouette of the body of a girl who had died tragically in a fire. Her mother learned of the death by seeing the published photographs taken inside the burned-out home. She sued for an invasion of her own privacy. The court concluded that the photographs were newsworthy and, under the circumstances, the photographer had not committed a trespass in coming on the mother's premises without her permission.

Trespass cannot be justified simply because a public figure is involved. Breaking into a senator's office to obtain newsworthy information is an invasion of privacy. The First Amendment does not protect you against illegal acts committed in the course of getting newsworthy or informative photographs.

INTRUSION INTO PRIVATE PLACES

Photographing a private citizen without consent in the seclusion of his or her home may of itself be an invasion of privacy. Certainly, there are public places that can become as private as the home. A person using a public restroom or going into a hospital does so with the understanding that he or she will have the

same privacy as at home. Because of this, photographs taken in these places can be an invasion of privacy.

One case involved employees of *Life* magazine seeking to expose a quack doctor. Pretending to be patients, they gained access to the doctor's home and took photographs with hidden cameras. Subsequently, *Life* used the photographs in an exposé about the doctor. While the story was newsworthy, the intrusion was an invasion of privacy. And the court said that the later publication of the photographs could be used as a factor in increasing the damages flowing from the invasion.

Photographs taken of patients also present problems. For example, the publication of a patient's photograph to accompany an article written by the doctor could be regarded as for the purposes of advertising the doctor's skills. Or the exhibition of a film showing a birth by Caesarian section could be a trade use if admission is charged. However, if the use is in the public interest, such as an article about a new medical development or an instructive film (especially if no admission fee is charged), you are on safer ground. To avoid uncertainty, you will usually want a release from the patient.

SURVEILLANCE

Surveillance of people who have a personal injury claim against an insurance company is not uncommon. The purpose is to show that the injuries sustained by the person in an automobile or other accident are not as severe as claimed. The insurance company will often retain a private investigator and a photographer who will use a motion picture or video camera to record the claimant's physical condition.

In such cases, the surveillance is not an invasion of privacy as long as it is conducted in a reasonable manner. For example, following at a reasonable distance behind a claimant's car and photographing her while driving and in other public places would not invade her privacy. In fact, the court felt that there is a social value in the investigation of claims that may be fraudulent. However, harassment or outrageous conduct could violate a claimant's privacy.

BUSINESS PREMISES

The right of privacy does not protect corporate or other business names. The taking and use of photographs of business premises cannot, therefore, be an invasion of the privacy of the corporation or other business. It could be a trespass, unfair competition, or breach of contract, however, as discussed in the next chapter.

Two cases illustrate this. In one case, a satirical magazine used a photograph of a real bar to illustrate a fictitious story titled "The Case of the Loquacious Rapist."

The actual name of the bar—"Busy Bee"—appeared in the photograph, although the fictional bar in the accompanying satire was called "The Stop and Frisk." There simply was no invasion of privacy here. Nor did an invasion of privacy occur when a photograph of the business name "Jollie Donuts" and the premises of the doughnut shop appeared in a nationally televised broadcast. This was not the name, portrait, or picture of a person. What about a patron who is photographed on the business premises? Can he sue? After a bomb threat, a government building was evacuated and a number of the employees went to a nearby hotel bar. A television camera crew photographed a government employee in the bar and broadcast the film on the evening news. The employee lost his invasion-of-privacy suit, since he had become, however involuntarily, an actor in an event of public interest.

EXHIBITION OF PHOTOGRAPHS

Photographers often exhibit in galleries, raising the question whether an exhibition can be an invasion of privacy. The very fact that the New York statute made a special exemption to allow exhibition of specimen photographs under certain conditions suggests that this type of exhibition is an advertising use when the conditions aren't met. It is publicizing the photographer's services.

The courts have also found that the *sale* of postcards, portraits, or posters based on someone's photographic portrait is a trade use. A single photograph or limited edition exhibited for sale in a gallery might also be a trade use. It could be argued, however, that the exhibition and sale of a photographic work of art is in the public interest, much like the sale of a photograph in a book collecting examples of a photographer's work. Looking at it from this point of view, the courts might consider the media used, the nature of the subject matter, and the extent of the invasion. Presumably, a person striking a voluntary pose in a public place would have a much harder time recovering than someone who was photographed in an embarrassing pose in a private place. Courts have found photographs taken through unblocked windows or from street surveillance cameras not to be an invasion of privacy when the art was exhibited. That doubt exists in this area, however, suggests the wisdom of obtaining a release. If the photograph were exhibited in a museum for educational purposes and not for sale, it would not appear to be a trade use. Several cases state that the exhibition of a film without an admission charge is not a trade use. So it is less likely that an invasion of privacy would occur if an exhibition were for educational purposes and the photograph not offered for sale. However, an embarrassing photograph taken in a private place might still cause an invasion of privacy.

What about a poster—or photograph exhibited in a gallery—of a political figure campaigning? While the poster was offered for sale, the court decided that it

served the public interest by disseminating knowledge about political candidates. The candidate, by the way, was comedian Pat Paulsen, who had licensed the right to make posters to a competitive company. If Paulsen had not been running for public office in 1968 when the distribution occurred, he might have found protection under the right of publicity discussed in the next chapter.

Not only is the area of exhibition likely to see more lawsuits in the future, but also the laws may differ from state to state. Again, the safest course is to obtain a release.

DAMAGES

It can be difficult to measure what damages should be payable to someone who wins an invasion-of-privacy suit. After all, the injury is to peace of mind and the right to seclusion. Yet a person suing for invasion of privacy has a right to recover substantial damages, even if the only damage suffered is his or her mental anguish. The fact that the damages are difficult to ascertain or can't be precisely determined in terms of money is not a reason to deny recovery for the invasion. Nor are the damages limited to compensation for the mental anguish that a person of ordinary sensibilities would suffer in the situation. The damages can extend beyond this to cover any actual financial losses. The exact amount of damages is decided on a case-by-case basis, depending on the facts involved.

If someone commits an invasion of privacy, it really doesn't matter what the motives were. It's the acts constituting the invasion that create a right to sue. The New York statute does state that anyone who "knowingly" invades another's privacy may be subject to punitive damages. These are extra damages awarded not to compensate the person who has been injured but rather to punish the offender and prevent similar acts in the future.

RELEASES

New York's statute requires that a release be in writing, but in most other states an oral release will be valid. The release gives you the right to use someone's photograph without invading his or her right of privacy. You would be wise always to have written releases, such as those that appear at the end of this chapter. This is because the releases must be appropriate for the use you intend to make of the photograph. Also, the details of oral understandings tend to fade from memory and can be difficult to prove in court.

The release must be signed by the proper person—normally, the subject of the photograph. But if that person is a minor, the parent or guardian must sign. Most states have adopted eighteen, rather than twenty-one, as the age of reaching majority, but you should check the law in your own state. In a significant

case, Brooke Shields sought to disavow releases signed by her mother for a nude photo session in a bathtub when Shields had been ten. The court concluded that the release signed by the parent was binding and could not be disavowed. When using minors as models, you should also be very careful to comply with state legal requirements regarding special permits, chaperones, not shooting during school hours, hours of employment, and the like.

The release should specify what use will be made of the photograph. For example, the model might consent to the use of the photograph "for advertising dress designs in trade magazines." Use of the photograph in other situations, such as advertising cigarettes on a billboard, would at the least be a breach of contract. So you might want to broaden the release by use of a phrase such as "any and all purposes, including advertising in all forms."

The release should give permission to the party that will actually use the photograph—not just you but also the advertising agency or other businesses to which you might assign the right of usage. So you will want to recite that the release gives consent not only to you but also to agents, assigns, and legal representatives.

You should always get your own release form signed, even if an advertising agency or a new client gives you its form that you also have the model sign. If, for some reason, you are relying on the client's form and not getting your own form signed, you should check very closely to see that the client's form protects you. If you feel it doesn't, you should request that the client indemnify you—that is, agree to pay your losses and expenses that may result if the release is, in fact, inadequate to protect you.

The payment of money to the model isn't necessary for a valid release, but it may be a wise step to take. In this way, a release differs from a contract, since you must give something of value if you want to make a contract binding. Normally, for a release, you would give a fee and, if you do, you naturally should state that in the release. One revealing case involved a woman who received no fee for consenting to use of her photograph in advertising for a perfume. Twenty years later, she was able to revoke her consent, despite the money spent by the manufacturer to obtain a trademark and develop the market for the product. In fact, you might want not only to pay to prevent the revocation but also to specify in the release how long the subject's consent is to be effective. When a man agreed at the age of twenty-four to the advertising use by a health spa of before-and-after photographs of himself, the advertising use of such photographs ten years later was an invasion of privacy. Nor did the man even revoke his consent in this case. But he hadn't received a fee, and the court felt his consent lasted only for a reasonable time after the making of the photographs.

Tough cases develop when photographs are altered. Does the release permit such changes? Or are they perhaps allowed by trade custom?

A model agreed to do an advertisement for a bookstore. The release gave an irrevocable consent to the bookstore and its assigns to use her photograph "for advertising purposes or purpose of trade, and I waive the right to inspect or approve such . . . pictures, or advertising matter used in connection therewith." The bookstore's advertisement showed the model reading in bed and was captioned "For People Who Take Their Reading Seriously." The bookstore then violated its contract with the photographer by assigning rights of use to a bed-sheet manufacturer known for its offensive advertisements. The manufacturer altered the advertisement so the model in bed was in the company of an elderly man reading a book titled *Clothes Make the Man* (described by the court as a "vulgar" book). The implication was that the model had agreed to portray a call girl for the bed-sheet advertisement. These changes in the content made a different photograph in the view of the court and gave the model a right to sue for invasion of privacy. So while the photograph could be assigned for other advertising uses, it could not be altered in such an objectionable manner. To protect yourself from liability, it's wise to limit in your confirmation or invoice forms the uses that can be made of the photograph to those permitted in the release you've obtained. It is important to note that the photographer had no liability in this case, since he had not participated in the acts that violated the model's privacy.

On the other hand, a basketball player signing a release allowing the advertising use of photographs of himself in "composite or distorted" form could not complain when a glass of beer was added to make an advertisement for beer. Nor could an actress complain when the photographs used for a movie poster were altered to emphasize the sexuality of the woman portrayed. Since the actress had consented to the use of her "likeness" in advertising for the movie, the court felt trade usage permitted the sexual emphasis. But in a very similar case involving a movie actor shown in a composite photograph notifying his admirers by telegraph where to see his new film, the court said the actor's release for publicity only extended to a true photograph—not a composite portraying something that never occurred. This points out how dangerous it can be to rely on trade custom. If trade custom conflicts with a clear written contract, it won't even be admissible in court. So a carefully drafted release is a far safer approach.

When using a release, always fill in the blanks—the date, the model's name, your name, any addresses, any fees, and so on. It's important that you keep records enabling you to relate the release to the photographs for which it was given. This can be done by use of a numbering system matching the releases to the digital files or negatives or transparencies. Or you might create a database

that matches the date of the images to the date of the signed release you obtained at the shooting session.

You should make a practice of getting the release signed at the session. Don't put it off, even if you're not exactly certain what the final use of the photograph will be. Also, while you don't have to have a witness for the release, it can help in proving proper execution of the release. You may also want to include an image of the model with the release, which will identify the model and, if a driver's license is used, the proof of the model's age.

The releases shown here follow the principles that we've discussed. The forms can, of course, be modified to meet special needs that you may have.

MODEL RELEASE—SHORT FORM

In consideration of $ _____, receipt of which is acknowledged, I, _____ (print Model's name) do hereby give _____ (the Photographer), his (her) assigns, licensees, and legal representatives the irrevocable right to use my name (or any fictional name), picture, portrait, or photograph in all forms and media and in all manners, including composite or distorted representations, for advertising, trade, or any other lawful purposes, and I waive any right to inspect or approve the finished product, including: written copy, that may be created in connection therewith. I am of full age.* I have read this release and am fully familiar with its contents.

Witness: _____

Signed: _____

Address: _____

Address: _____

Date: _____, 20_____

Consent (if applicable)
I am the parent or guardian of the minor named above and have the legal authority to execute the above release. I approve the foregoing and waive any rights in the premises.

Witness: _____

Signed: _____

Address: _____

Address: _____

Date: _____, 20_____

Attach visual reference for model here, such as a photocopy of a driver's license or other identifying image.

*Delete this sentence if the subject is a minor.
The parent or guardian must then sign the consent.

MODEL RELEASE—LONG FORM

In consideration of _____ Dollars ($ _____), and other valuable consideration, receipt of which is acknowledged, I, _____ (print Model's name) do hereby give _____ (the Photographer), his or her assigns, licensees, successors in interest, legal representatives, and heirs the absolute and irrevocable right to use my name (or any fictional name), picture, portrait, or photograph in all forms, including, in whole or in part, in all manners, and in all media, whether now known or hereinafter discovered, without any restriction as to changes or alterations (including but not limited to composite or distorted representations or derivative works made in any medium) for advertising, trade, commercial, promotion, exhibition, editorial, or any other lawful purposes. I acknowledge that I have no rights with respect to the photograph(s) and I waive any right to inspect or approve the photograph(s) or finished version(s) incorporating the photograph(s), including written copy, if any, that may be created and appear in connection therewith. I hereby release and agree to hold harmless the Photographer, his or her assigns, licensees, successors in interest, legal representatives, and heirs from any liability by virtue of any blurring, distortion, alteration, optical illusion, or use in composite form whether intentional or otherwise, that may occur or be produced in the taking of the photographs, or in any processing tending toward the completion of the finished product, unless it can be shown that they and the publication thereof were maliciously caused, produced, and published solely for the purpose of subjecting me to conspicuous ridicule, scandal, reproach, scorn, and indignity. I agree that the Photographer owns the copyright in these photographs and I hereby waive any claims I may have based on any usage of the photographs or works derived therefrom, including but not limited to claims for either invasion of privacy or libel. I am of full age* and competent to sign this release. I agree that this release shall be binding on me, my legal representatives, heirs, and assigns. I have read this release and am fully familiar with its contents.

Witness: _____ Signed: _____
 Model

Address: _____ Address: _____

Date: _____, 20 _____

Consent (if applicable)
I am the parent or guardian of the minor named above and have the legal authority to execute the above release. I approve the foregoing and waive any rights in the premises.

Witness: _____

Signed: _____
 Parent or Guardian

Address: _____

Address: _____

Date: _____, 20 _____

*Delete this sentence if the subject is a minor.
The parent or guardian must then sign the consent.

> **Attach visual reference for model here, such as a photocopy of a driver's license or other identifying image.**

Invasion of Privacy and Releases **213**

RELEASE—BY OWNER OF PROPERTY

In consideration of the sum _____ of Dollars ($_____), receipt of which is acknowl-
edged, I do hereby irrevocably authorize _____, of _____ (address), City
of _____, County of _____, State of _____, his (her) legal repre-
sentatives, assigns, and those acting under his (her) permission and on his (her) authority, to copy-
right, publish, and use in all forms and media and in all manners for advertising, trade, promotion,
exhibition, or any other lawful purpose whatsoever still, single, multiple, or moving photographic
portraits or pictures of the following property that I own and have sole authority over to license for
the taking of photographic portraits or pictures:

regardless of whether said use is composite or distorted in character or form, in conjunction with
my own or a fictitious name, or reproduction thereof is made in color or otherwise or other deriv-
ative works are made through any medium.

 I do hereby waive any right that I may have to inspect or approve the finished product or the
advertising or other copy that may be used in connection therewith or the use to which it may be
applied.

 I hereby release, discharge, and agree to hold harmless _____, his (her) legal
representatives, assigns, and all persons acting under his (her) permission or authority, from any
liability by virtue of any blurring, distortion, alteration, optical illusion, or use in composite form
whether intentional or otherwise, that may occur or be produced in the taking of the pictures, or
in any processing tending toward the completion of the finished product, unless it can be shown
that they and the publication thereof were maliciously caused, produced, and published solely for
the purpose of subjecting me to conspicuous ridicule, scandal, reproach, scorn, and indignity.

 I do hereby warrant that I am of full age and have every right to contract in my own name in
the above regard. Further, I have read the above authorization and release, prior to its execution,
and I am fully familiar with the contents thereof.

Witness: _____

Signed: _____

Address: _____

Address: _____

Date: _____, 20 _____

CHAPTER 23 BEYOND PRIVACY

by Tad Crawford

INVASION OF PRIVACY is not the only risk you face when taking and publishing your photographs. Both private individuals and the public are protected by other laws drawn from a variety of sources. This chapter will elaborate on what you must know about in addition to privacy so you can pursue your professional activities without violating any laws or legal rights.

RIGHT OF PUBLICITY

The right of publicity is possessed by athletes, entertainers, and other people who seek to create a value in their name or likeness by achieving celebrity status. It is different from the right of privacy, which protects peace of mind and the right to live free of unwanted intrusions. The right of publicity is a property right based on the value inherent in a celebrity's name or likeness. The right of privacy protects everyone. The right of publicity protects only those who have succeeded in becoming celebrities. The right of privacy cannot be assigned. The right of publicity, like other property rights, can be assigned. The right of privacy ends when the person whose privacy was invaded dies. The right of publicity can survive the celebrity's death and benefit his or her heirs or assignees.

If you photograph a baseball player for a company that manufactures baseball cards, the company is going to need a license from the player in order to use the photograph on its baseball cards. Or, if you photograph a football player for a company that wants to use the photograph in a game for children, a license from the player will be needed to avoid having the game violate his right of publicity. In one interesting case, a baseball player gave a license to a sporting goods company and its assignees to use his name, facsimile signature, initials, portrait, or nickname in the sale of its gloves, baseballs, and so on. The sporting goods company sold baseballs to a meat company for use in a promotion with meats. They also gave the meat company the right to use the player's name and likeness in connection with the promotion. The player sued to prevent the meat company from using his name and likeness in this way, but he lost because he had assigned his right of publicity without limiting what types of companies it could be assigned to.

The right of publicity protects against commercial exploitation. It cannot prevent the reporting of events that are newsworthy or in the public interest. For

a guide to what is newsworthy or in the public interest, you can refer back to the many examples given in the chapter on privacy.

The courts have said that the right of publicity will survive a celebrity only if that person exploits the right while alive. This means that celebrities must take steps to exercise these rights—for example, by means of contracts to use their name or likeness for endorsements or on products—if assignees or heirs are to be able to assert the right after the celebrity's death. If a celebrity's right of publicity would be violated by the commercial use of a photograph, a license should be obtained from the celebrity.

CELEBRITY RIGHTS LAWS

In 1984, California used the right of publicity as the basis to enact a celebrity rights law. A number of other states have followed California's lead. The basic approach of these laws is to protect the publicity rights of deceased people for up to fifty years after their death (increased now to seventy years after death in California). This applies to people whose name, voice, signature, or likeness had commercial value at the time of death, whether or not that commercial value had been exploited during life. Prohibited uses cover commercial exploitation to sell merchandise or services, including advertising. Typical exemptions from the coverage of the law would include works in the public interest, material of political or newsworthy value, and single and original works of fine art.

These celebrity rights laws impinge on the freedom of expression guaranteed to artists by the First Amendment. Since creative works are likely to be disseminated nationally, it may be that the most restrictive celebrity rights law will govern whether the artist must seek permission from the people to whom the decedent has transferred the celebrity rights or, if no transfer has been made, the heirs of the decedent.

LIBEL

Libel is communicating to the public a false statement about someone, which damages the person's reputation. Computer-manipulated photographs can create a false image and damage someone's reputation. So can errors in the lab.

But the most common area of libel in photography is the association of an innocent photograph with a text that is libelous. There is, by the way, no reason why the photographer would be responsible in such a case if he or she had nothing to do with the offending text. For example, a photograph might show a man and a woman riding in a carriage. It can't possibly say anything false. But suppose the picture is printed in a newspaper, and the caption says the man and woman are husband and wife, and this isn't true. In fact, the woman is married

to someone else. A woman in such a case sued the newspaper, claiming that the public impression would be that she was not married to her real husband. If that were the case, she would have been living with him in sin. This was not true and injured her reputation. The case arose in 1929 in England, where the court agreed with the woman and gave judgment for her. What is damaging to the reputation can change from one time and place to another.

The First Amendment cuts into the individual's protection against libel. In a libel suit brought by a public official or public figure over a report that is newsworthy, the person suing must show that the false statement was made with reckless disregard for whether it was true or false or with actual knowledge that it was false. This is a very difficult standard to meet. The question of who is a public figure, already discussed under invasion of privacy, becomes important in libel because of the higher standard of proof required. For private individuals who become involved in matters of public interest, the states may set a lower standard. For example, in order to recover, the private individual might have to show only negligence in the publication of the false material. For private individuals suing for libel over a matter not in the public interest, proof that the defendant knew the statement was false would be necessary only to get the extra damages, called punitive damages.

Libel is in general of less concern to photographers than to writers. However, if you fear that use of a photograph may libel someone, you should consult an attorney and consider obtaining a release from the person who might bring the libel suit.

PRIVATE PROPERTY/BUILDINGS

In the last chapter, we discussed whether photographs of dogs, horses, automobiles, interiors of houses, and other private property could cause an invasion of privacy. As long as the owner was not identified, it did not appear that his or her privacy could be invaded. Several cases, however, illustrate some risks other than invasion of privacy that you should keep in mind.

A photographer was commissioned to photograph a woman's dog. The woman purchased several prints, and, as far as she was concerned, the transaction was finished. The photographer, however, sold the dog's photographs to an advertising agency that used them for dog biscuit advertisements in local and national newspapers. The woman sued the photographer, his agent, the advertising agency, the dog biscuit company, and the newspapers based on the use of the photographs of the dog. The court decided that the photographer and his agent had breached the original contract with the woman, since the customer is the owner of all proprietary rights in works done on commission. Because of

this, the photographer and his agent would have to pay damages for their breach of contract, while the other defendants would merely be barred from running the advertisement again.

If the dog had been wandering the streets and the photographer had taken the picture on his own initiative, the owner would presumably not have had any right to object to a subsequent advertising use, since the photographer would have owned all the proprietary rights. An intriguing point here, however, is that the copyright law has changed since this case was decided. After January 1, 1978, the photographer owns the copyright in the photographs of the dog, whether the owner commissions the photographs or the dog is running free in the streets. Could this change the result of the case if it were to come up again? Probably not, because the courts would be likely to conclude that an implied provision of the contract to photograph the dog is that the photographs will be only for the owner's use. Despite the photographer's owning the copyright, the contract would implicitly forbid reuse for purposes other than those intended by the owner.

The other case may be unique, but it's certainly worth taking into account. It arose out of the New York World's Fair of 1964. A postcard company took photographs of the buildings, exhibits, and other activities going on inside the fairgrounds. These were then sold on postcards, albums, and related items. Admission was charged for entrance to the World's Fair, and, in fact, the World's Fair Corporation had entered into a contract with another company to exploit similar photographs of the buildings, exhibits, and so on. In addition to this, the postcard company had bid for the right to make the photographs and sell the commercial items both inside and outside the fairgrounds. On considering these special facts, the court decided that an injunction should be granted to prevent the postcard company from continuing its commercial exploitation. The court likened the buildings and exhibits to a show in which the World's Fair Corporation had a property interest. Two of the five judges dissented, however, and said they didn't think anything could prevent selling items incorporating photographs of the exteriors of the buildings. This case is probably limited to its unique facts—an unsuccessful bidder commercially using photographs of unusually attractive buildings on private grounds to which admission is charged. It could hardly prevent you from making postcards from photographs of the Empire State Building or the New York City skyline. But the cautious photographer will take the case into account before launching a similar enterprise.

In another case, the Rock and Roll Hall of Fame argued that it had a trademark in the unique shape of its building, and, therefore, photographer Charles Gentile should be prevented from selling his posters of the Rock and Roll Hall of Fame. The court agreed that the building, designed by I. M. Pei, was unique

and distinctive with "a large, reclining triangular facade of steel and glass, while the rear of the building, which extends out over Lake Erie, is a striking combination of interconnected and unusually shaped, white buildings." Gentile's posters sold for $40 and $50, while the Hall of Fame's own poster sold for $20, but the photographs in the posters were very different treatments of the building. The court concluded that the building, while fanciful, was not fanciful in the way that a trademark identifies a company as the source of goods or services to the public and that, indeed, there had been no showing that the public might have come to associate the building's design as a trademark connected to products or services offered by the Hall of Fame. In what the court admitted to be an unusual case, Gentile was allowed to sell his posters.

TRESPASS

The preceding chapter reviewed when trespasses might give individuals a right to recover for invasion of privacy. That discussion noted that businesses were not protected by a right of privacy. However, businesses are protected against trespasses, even when the news media are involved.

In one case, a television news team was doing a report on a New York City restaurant charged with health code violations. The camera crew and its reporter burst noisily into the restaurant. The reporter gave loud commands to the crew who turned their lights and camera on in the dining room. In the resulting tumult, the patrons waiting to be seated left the restaurant, many of those seated covered their faces with their napkins, and others waiting for their checks simply left without paying. For this trespass, the court decided the television station would have to pay damages to the restaurant. Beyond this, however, the jury had originally awarded $25,000 as punitive damages, but this was reversed because an important witness for the defense hadn't been heard. A new trial was ordered at which punitive damages would be awarded if the jury concluded that the television crew had acted with reckless indifference or an evil motive in trespassing. The First Amendment, the court noted, does not give the news media a right to trespass.

UNFAIR COMPETITION

Unfair competition seeks to prevent confusion among members of the public as to the source of goods or services. It is a right that is highly flexible. For example, titles are not copyrightable. Yet unfair competition could be used to prevent one title from too closely imitating another. If the public came to identify a work by one title—such as *The Fifth Column,* by Ernest Hemingway—no one could use a similar title for a competing work. An obvious application would be to prevent one photographer from using the name of another in order to pass off his or

her own work. So, if Jane Photographer is well known, another photographer adopting her name would be unfairly competing. Nor could one photographer imitate the style of another and try to pass off the work. In a case involving cartoon strips, the court stated that using the title of a cartoon strip and imitating the cartoonist's style was unfair competition.

There is another aspect to the doctrine of unfair competition. In some cases photographers have tried to use unfair competition to prevent distorted versions of their work from being presented to the public by licensees. The reasoning is that the distorted version is not truly created by the photographer. Presenting it to the public injures the photographer's reputation and unfairly competes with his or her work. Such an attempt to create moral rights from American legal doctrines is difficult at best.

OBSCENITY

Censorship has a long history. Few people realize today that the censors' fascination with pornography is relatively recent, dating from the era of Queen Victoria. Prior to that, censors focused on suppressing sedition against the Crown and heresy against the Church.

In the United States, censorship conflicts with the First Amendment's guarantees for free speech and free press. The result is an uncomfortable and rather arbitrary compromise as to what sexually oriented materials can be banned. Works of serious artistic intention are protected from censorship under guidelines set forth by the United States Supreme Court. Specifically, the factors in determining obscenity are:

(a) whether "the average person, applying contemporary community standards" would find that the work, taken as a whole, appeals to the prurient interest . . .; (b) whether the work depicts or describes, in a patently offensive way, sexual conduct specifically defined by the applicable state law; and (c) whether the work, taken as a whole, lacks serious literary, artistic, political, or scientific value.

The laws affecting obscene materials prohibit such uses as possession for sale or exhibition, sale, distribution, exhibition, importation through customs, and mailing. Distributors are usually the defendants. Especially on the contemporary community standard as applied by the average person, it is difficult to know what the result of an obscenity prosecution may be from one locality to the next.

A number of statutes outlaw the use of children in the photographing of sexually explicit acts, whether or not the acts are obscene. Whether these laws would

apply to photographs of minors used in an educational context would appear to raise substantial First Amendment questions. Beyond this, however, the courts have ruled that pornographic materials intended for an audience of minors can be subjected to higher standards than those of the average citizen.

The First Amendment does provide procedural safeguards in cases raising issues of obscenity. Essentially, before materials may be seized as obscene, an adversary hearing must be held at which both sides are able to present their views with respect to whether or not the items are obscene. Only after this review can law enforcement officials confiscate materials that have been determined to be obscene.

FLAGS AND PROTECTED SYMBOLS

State and federal flags are protected from desecration by both state and federal statutes. Desecration includes mutilation, defacement, burning, or trampling on such a flag. It also covers the use of any representation of a flag for advertising or commercial uses, such as product packaging or business stationery. Each statute has special exceptions, so that laws have to be checked state by state.

The police power to prevent desecration of the flag is not absolute but must be weighed against the right of the individual to have freedom of expression. When the use of a flag is a form of speech, the First Amendment may protect conduct that would otherwise be criminally punishable as a desecration. If you are considering the use of flags, especially for advertising or commercial purposes, you should definitely seek advice from an attorney to be certain that you aren't committing a criminal offense.

In addition, both state and federal statutes protect a variety of official or well-known names and insignias from unauthorized use, especially if the use is commercial. Federal law places restrictions on symbols such as the great seal of the United States, military medals or decorations, the Swiss Confederation coat of arms, the Smokey Bear character or name, and the Woodsy Owl character or name or slogan. While the prohibited uses vary, they often include advertising, product packaging, or uses that might mislead the public. For an artist to use such an emblem, insignia, or name may require legal advice or obtaining an opinion from the appropriate government agency as to whether the use is allowed.

As with flags, these restrictions may be found unconstitutional if their enforcement would limit the First Amendment rights of citizens and the government cannot show a compelling reason for such limitations. The safest course is to consult with the secretary of the appropriate agency if you are planning to use its emblem, insignia, or name. If this doesn't seem practical or problems arise, you should get help from your own attorney.

State statutes also protect many badges, names, or insignia of governmental agencies and various orders and societies. As a general rule, if you are going to make use of any insignia belonging to a private group or governmental body, you should check in advance to be certain you are not violating the law. Contacting the group is a good way to start, but ultimately you may again want advice from an attorney.

COINS, BILLS, AND STAMPS

Counterfeiting statutes limit the freedom with which you can reproduce currency and stamps. The purpose of the counterfeiting statutes, of course, is to prevent people from passing off fake currency or stamps. Because of this, you can probably make copies as long as you are certain there is no chance of the copies being mistaken for real currency or stamps. However, to be completely safe, you would be wise to follow the restrictive guidelines that have been set out in the law. According to the Treasury Department:

> The Department will henceforth permit the use of photographic or other likenesses of United States and foreign currencies for any purposes, provided the items are reproduced in black and white and are less than three-quarters or greater than one-and-one-half times the size, in linear dimension, of each part of the original item. Furthermore, negatives and plates used in making the likenesses must be destroyed after their use.

You may notice that coins aren't mentioned at all. This is because photographs, films, or slides of United States or foreign coins may be used for any purposes, including advertising. Such photographs of coins don't present the type of risk that the counterfeiting statutes are designed to guard against.

Restrictions similar to those for money also apply to reproductions of stamps.

The United States Secret Service has responsibility for enforcing the laws relating to counterfeiting. Its representatives will give you an opinion as to whether the particular use you intend to make is legal, but their opinion would not prevent a later prosecution by either the Department of Justice or any United States Attorney.

DECEPTIVE ADVERTISING

The Federal Trade Commission Act, passed in 1914, provides that "unfair methods of competition are hereby declared unlawful." One of the important areas in which the Federal Trade Commission has acted is misleading, or

false, advertising. If you work for advertising agencies, the total impression of the advertisement must not be false or misleading. While some puffery of or bragging about products is permitted, the advertisement must not confuse even an unsophisticated person as to the true nature of the product. It isn't difficult to imagine how photography can be used to mislead. One example would be the use of props that don't fairly represent the product, such as a bowl of vegetable soup with marbles in the bottom of the bowl to make the vegetables appear thicker. This isn't permissible. On the other hand, the advertising agency doesn't want to create trouble for its client. So in most cases, the agency's legal staff will take the necessary steps to ensure the advertising is not misleading or deceptive.

Aside from the activities of the Federal Trade Commission, there are a number of ways that advertising is controlled. Other federal laws govern the advertising and labeling of a number of specific products. State laws form a patchwork of regulations over different products. The Council of Better Business Bureaus has adopted its own *Code of Advertising* to ensure that fair standards are followed. Many individual industries have set standards to govern the advertising of their products, although the application of these standards to local distributors or dealers can be difficult. Often the media that sell advertising will refuse to accept advertisements that are not considered in good taste. The National Advertising Review Council seeks to maintain high standards by providing guidance with respect to the truth and accuracy necessary in national advertising.

While the National Advertising Review Board cannot force an advertiser to change an advertisement, it can bring peer pressure to bear. A typical case involving the board was an advertisement for dog food, which photographically depicted "tender juicy chunks" that appeared to be meat but in actuality were made from soybeans. The board's investigative division demanded that the deceptive advertising be corrected. After sufficient time for a response had passed without the division's hearing from the dog food company, officials referred the matter to the appeals division. After the referral, however, the dog food company did respond and stated that the advertising in question had been changed to eliminate the elements found to be deceptive. Because of this, the appeals division dismissed the complaint. This is a good illustration of the disposition of a typical complaint.

Most advertising agencies want to avoid problems as much as you do. You should be able to rely on their expert attorneys for guidance in any area that raises questions. And if you truthfully present the product, you certainly shouldn't have anything to worry about.

PHOTOGRAPHING IN COURTROOMS

Photography is sometimes permitted in courtrooms. Concern about the effect of such filming, photography, and broadcasting is still expressed by many attorneys, and some jurisdictions even forbid photographing anywhere in court buildings. However, a number of states have now enacted rules permitting the coverage of court proceedings. These rules vary with each court. The best way to find out whether cameras are allowed is to contact the clerk of the court in which you wish to photograph. If he or she advises you that cameras are permitted, you'll also be able to find out the applicable conditions and rules.

CHAPTER 24 SETTLING DISPUTES AND FINDING ATTORNEYS

by Tad Crawford

DISPUTES CAN BE demoralizing and harmful to your business, whether because of money lost, opportunities missed, or time wasted. Yet there are sound approaches to avoiding or settling disputes. One of the best ways to avoid disputes is to have a carefully drafted, written contract before you begin working for a client. When the terms guiding the relationship have been clearly spelled out, there is less possibility of a dispute arising and a greater likelihood any disagreement can be quickly settled. If you do need an attorney, there are effective ways in which you can find the right attorney for your particular needs.

PAYMENT DISPUTES

Payment disputes with clients are among the most common problems to plague photographers. In fact, poor cash flow is at the core of so many photographers' business problems. If you do assignment photography, it may seem that you're locked into industry practice with respect to billing and being paid after completion of an assignment. But many professionals do request advances, especially against expenses, so that they don't have to finance clients for months at a time. Photographers who take portraits for sale to clients should insist on payment when the sitting is completed—whether by cash, check, or credit card—or at least demand a deposit against final payment upon delivery of finished prints. Credit cards will cost you several percentage points (varying from card to card), but this may be more than offset by increased sales and the certainty of collection.

But if you're forced to extend credit (as in the case of ad agencies) or do so as a convenience for your customers, what will this mean for your business? The longer an amount owed to you is overdue, the less likely you are to collect it. A debt that is overdue sixty to ninety days will probably be paid to you; however, if the debt is overdue a year, you probably only have about a 50 percent chance of collecting the money, and this percentage falls as more time passes.

So you must have a firm policy about extending credit and pursuing collections. You should grant credit only to clients who have a good reputation (based on occupation, address and length of residence, bank references, professional credit rating agencies, and personal references), a sound financial position, and measurable success in their own business (especially if the client is an agency or

a corporate client that will expect to be billed as a matter of course), and who are willing to accept conditions that you may place on the extension of credit (such as maximum amounts of credit you extend, maximum amounts of time for payment, and similar provisions). By the way, if you feel you don't want to extend credit to a client who absolutely expects it, you should not do business with that client. You must constantly check your credit system to make sure it's functioning properly (more than half your accounts should pay in full on receipt of your statement).

COLLECTION PROCEDURES

If you have a client who won't pay, you have to initiate collection procedures. You start with a reminder that the account has not been paid. This can simply be the sending of your invoice stamped "Past Due." Or you might use a pleasant form letter to bring the debt to the attention of the client. If this fails, you should make a request to your client for an explanation. Obviously, it isn't an oversight that the client has failed to pay. There may be a valid explanation for not paying. In any case, you must find out—usually by sending a letter requesting the necessary information. If the client still does not pay, you can assume that you're not going to collect without applying pressure. What kind of pressure? Whatever kind—within the bounds of the law—that you judge will get your money without your having to use an attorney or collection agency. You can escalate through all the following options:

- Letters
- Emails
- Faxes
- Telephone calls
- Registered letters
- Cutting off credit
- Threatening to report to a credit bureau
- Threatening to use an attorney or collection agency
- Using an attorney or collection agency

Of course, you should never threaten people unless you intend to back up your words. You must act decisively if, after threatening to take a certain action, you still are not paid. You will bear an expense in using an attorney or collection agency to collect, but you may still be able to get part of the money owed you. And you will have a reputation as someone who won't stand for clients who don't pay what they owe.

FINDING THE RIGHT ATTORNEY

What do you do when you need a lawyer? Maybe a client refuses to make payment in full. Or you've been handed a contract and don't want to try to navigate through the legalese without some expert advice. Or you opened your favorite magazine and saw one of your photographs, which was very nice except that you never got paid by the magazine or by anybody else. Or somebody smacked into your car and the insurance company doesn't want to settle. Or you've just had your first child and are wondering whether you need a will.

Many photographers already have a lawyer and are pleased with his or her performance. But what if you don't have a lawyer; where do you turn? That depends on the nature of your legal problem. This is a time of greater and greater specialization in the field of law. You have to evaluate whether your problem needs a specialist or can be handled by a lawyer with a general practice. For example, suppose you haven't been paid for an assignment you successfully completed. Any lawyer with a general practice should be able to handle this for you. What if you've been offered a book contract for a collection of your photographs? Here you'd be wise to find a lawyer with a special understanding of copyright law and the publishing field. Or you think that you should draft your will. Do you have a lot of assets, including special property in the form of expensive equipment and highly valuable images, or do you have a very modest estate? If your estate is complex, you'll want to use an estate-planning specialist, particularly if you're concerned about who will own your photographs and how they will be treated after your death. But if your estate is modest and you're not especially concerned about what happens to your photographs, a general practitioner should be able to meet your needs.

One implication of legal specialization, by the way, is that you may not use the same lawyer for each legal matter you have to solve. On the other hand, if you have a good relationship with your regular lawyer, he or she should direct you to specialists when you need them. This is probably the best way of making sure you have access to the expertise that is called for.

LAWYER'S FEES

Before discussing ways of contacting the lawyer you need, it's worthwhile to stop a moment and discuss the cost of legal services. You *can* afford these services, but you have to be careful. In the long run, using lawyers at appropriate times will save you money and, quite possibly, a lot of anguish.

How do you find out what a lawyer charges? Ask! If you're worried about paying for that first conference, ask on the phone when you call. If you're worried about what the whole legal bill will run, get an estimate the first time you sit down with the lawyer. Keep in mind that some lawyers will work on a contingency

arrangement if you can't afford to pay them. This means that they will take a percentage of the recovery if they win but not charge you for their services if they lose. Or they may combine a flat fee with a contingency or require you to pay the expenses but not pay for their time. Some will even barter legal services for photographs. In other words, it isn't all cut and dried.

And you don't necessarily need a law firm with five names in the title—maybe a legal clinic can do the trick, or one of the volunteer lawyers for the arts groups. So let's move ahead to the problem of contacting the right lawyer for you.

INFORMAL REFERRALS

If you have a family attorney, that person should either handle whatever legal issue you face or refer you to a specialist. If you don't have an attorney to ask, ask a friend, another photographer, or your uncle who won that lawsuit the summer before last. A person usually knows when he or she has received good legal service. If your problem is similar, that person's lawyer may be right for you. You certainly know other professionals in the photography business. If you start asking them, you'll probably come up with a good lead.

This may not sound scientific, but it's the way most people do find lawyers, and it's not a bad way. It gives you a chance to find out about the lawyer's skills, personality, and fees. It gives you confidence because the recommendation comes from someone you know and trust. Of course, when you talk to the lawyer, make sure that he or she is the right person for your special problem. If he or she hasn't handled a case like yours before, you may want to keep looking. Or if a particular lawyer doesn't feel your problem is what he or she handles best, you should request a referral to another lawyer.

VOLUNTEER LAWYERS FOR THE ARTS

All across the country, lawyers are volunteering to aid needy photographers, writers, composers, and other artists. There's no charge for these legal services, but you have to meet certain income guidelines and, perhaps, pay the court costs and any other expenses. If you qualify, that's great, but even if you don't qualify for free help, you may get a good referral to someone who can help you.

Rather than listing all the volunteer lawyers groups, we're giving you the names of three of the most active. You can call the group nearest you to find out whether there are any volunteer lawyers for the arts in your own area.

- *California Lawyers for the Arts.* Fort Mason Center, C-255, San Francisco, CA 94123, (415) 775-7200; and 1641 18th Street, Santa Monica, CA 90404, (310) 649-4111; *www.calawyersforthearts.org.*

- *Volunteer Lawyers for the Arts.* 1 East 53rd Street, Sixth Floor, New York, NY 10022, (212) 319-2787; *www.vlany.org.*
- *Lawyers for the Creative Arts.* 213 West Institute Place, Suite 403, Chicago, Illinois 60610, (312) 649-4111; *www.law-arts.org.*

PROFESSIONAL ASSOCIATIONS

There is great value in belonging to an appropriate professional organization of photographers. But whether or not you belong, you might still try contacting such an organization in your area to ask for a lawyer who understands photographers' legal problems. The society's members have probably had a problem similar to yours at one time or another. The executive director or office manager should know which lawyer helped that member and how the matter turned out. If they can't give you a name immediately, they can usually come up with one after asking around among the members. Needless to say, you're going to feel more comfortable asking if you belong to the organization. Professional organizations are listed in the appendix B.

LEGAL CLINICS

Legal clinics are easy to find, since they advertise their services and fee schedules in media such as newspapers and the Yellow Pages, where they are listed under "Attorneys" or "Lawyers." Searching for "Legal Clinics" online and adding your zip code will also bring you information about clinics in your area. Another good way to find a clinic is through your network of friends and acquaintances, some of whom have probably either used a clinic or know of one to recommend. In many ways, a clinic is just like any other law firm. The good clinic, however, will have refined its operation so it can handle routine matters efficiently and in large volume. This allows the institution of many economies, such as using younger lawyers and paralegals (who are assistants with the training necessary to carry out routine tasks in a law office), having forms and word-processing equipment, and giving out pamphlets to explain the basic legal procedures relevant to your case. Not all clinics, by the way, call themselves "clinics." They may simply use a traditional law firm name but advertise low-cost services based on efficient management.

What types of matters can the legal clinic handle for you? Divorce, bankruptcy, buying or selling real estate, wills, and other simple, everyday legal problems. What types of problems should you not take to a clinic? The complicated or unusual ones, such as book contracts, invasion-of-privacy suits, questions about copyright, and so on. The clinic can be efficient only when it handles many cases like yours. The special problems faced by the photographer will not

be the problems a clinic can handle best. And if you're wondering whether there are legal clinics specially designed for photographers and other creators of artistic works, the answer is "Not yet." But it's not a bad idea, especially for an urban area where many photographers earn their livelihood.

LAWYER REFERRAL SERVICES

A lawyer referral service is usually set up by the local bar association. Again, an online search with your zip code should be effective. You can also look in the Yellow Pages under "Lawyer Referral Service." If it's not listed there, check the headings for "Attorneys" and "Lawyers." If you still can't find a listing, call your local or state bar association to find out whether such a lawyer referral service is being run for your area.

Unfortunately, the local referral services are not of uniform quality. Two criticisms are usually levied against them: first, not listing lawyers by area of specialty, and second, the frequent practice of listing lawyers who need business rather than the best legal talent available. Even referral services that do list lawyers by specialty may not have a category that covers photographers' unique needs. But the advantages of a good referral service shouldn't be overlooked. A good service puts you in touch with a lawyer with whom you can have a conference for a small fee. If you don't like that lawyer, you can always go back to the service again. Some services do assign lawyers on the basis of specialty and, in fact, send out follow-up questionnaires to check on how the lawyers perform. This tends to improve the quality of the legal services. And a number of services require the lawyer to have malpractice insurance so you can recover if the lawyer is negligent in representing you. Such services are certainly another possible avenue for you to take in searching for a good lawyer.

COLLECTION AGENCIES

While we're on the subject of lawyers, it's certainly worth briefly mentioning a few alternatives. As noted earlier, if you are having trouble collecting some of your accounts receivable, you might consider using a collection agency. Such agencies are easy to find by online searching. They will go after your uncollected accounts and dun them with letters, phone calls, and so on, until payment is made. Payment for the agency is either a flat fee per collection or a percentage of the amount recovered. These percentages vary from as little as 20 percent to as much as 45 percent. If the agency can't collect for you, you're right back where you started and need a lawyer.

What are the pros and cons of using collection agencies? On the plus side is the fact that you have a chance at recovering part of the money owed to you

without the expense of hiring a lawyer. The negative side is the agency's fee and the fact that some agencies resort to unsavory practices. Needless to say, this may lose you clients in the long run. But a reputable collection agency may be able to aid you by recovering without the need to go to court.

MEDIATION AND ARBITRATION

If a photographer has a dispute with a client, there are several steps short of a lawsuit that can be taken, including mediation or arbitration.

In mediation, parties seek the help of a neutral party to resolve disputes. They are not bound, however, by what the mediator proposes. Arbitration requires that the parties agree to be bound legally by the decision of the arbitration panel. If someone who has lost an arbitration proceeding refuses to pay, the arbitration award can be entered in a court for purposes of enforcement.

Mediation is especially useful when the participants have an emotional investment in a project or an interest in maintaining their relationship in the future. The mediators work to help both sides hear each other's concerns and develop a sense of overall fairness. By improving their communication through the mediation process, the participants are often able to continue to work together for their mutual benefit.

Photographers who are negotiating contracts should consider adding a clause calling for alternative dispute resolution methods in the event of a dispute. A contract might include the following provision: "All disputes arising out of this agreement shall be submitted to mediation before _____ (or before a mutually selected mediation service) in the following city _____ pursuant to the laws of the State of _____."

Arbitration leads to a binding resolution. An arbitration award may be enforced by a state court and is difficult to appeal. If a photographer chooses to include arbitration in a contract, the provision could specify the following:

All disputes arising out of this agreement shall be submitted to final and binding arbitration. The arbitrator shall be _____ (or a mutually selected arbitrator) and the arbitration shall take place in the following city _____ pursuant to the laws of the State of _____. The arbitrator's award shall be final, and judgment may be entered upon it by any court having jurisdiction thereof.

The photographer may choose to use the American Arbitration Association or another mediation or arbitration provider. For example, the California Lawyers for the Arts have offered both mediation and arbitration services. If

the photographer has a specific organization in mind to serve as mediator or arbitrator, it would be wise to review the contractual phrasing to see if the arbitration provider would prefer to use other rules or state laws. For example, if the American Arbitration Association is selected, the language would be changed as follows: "All disputes arising under this Agreement shall be submitted to binding arbitration before the American Arbitration Association in the following location _____ and settled in accordance with the rules of the American Arbitration Association." The American Arbitration Association will provide additional information about its services and procedures. It has offices at 120 Broadway, New York, NY 10271; *www.adr.org*; (800) 778-7879.

Since it might be easier to go to small claims court for amounts within the small claims jurisdictional limit, the following clause might be added at the end of the arbitration provision: "Notwithstanding the foregoing, either party may refuse to arbitrate when the dispute is for a sum of less than $____." The amount of the small claims limit would be inserted as the dollar amount. This should be decided on a case-by-case basis. If the small claims court in the photographer's area is quick and inexpensive, it may be preferable to sue there for amounts less than the maximum amount for which suit can be brought in small claims court.

It would be ideal, by the way, if the mediation or arbitration panel had a knowledge of business practices in photography. Choosing the right people to serve, or the right organization, may make it possible to accomplish this goal.

SMALL CLAIMS COURTS

When small sums of money are involved, and your claim is a simple one, using a lawyer may be too expensive to justify. Most localities have courts that take jurisdiction over small claims, those ranging from a few hundred dollars in some areas to a few thousand dollars in other areas, and you can represent yourself in these small claims courts. To find the appropriate small claims court in your area, look in the phone book under local, county, or state governments. If a small claims court is not listed there, a call to the clerk of one of the other courts is a quick way of finding out whether there is such a court and where it's located.

The procedure to use a small claims court is simple and inexpensive. There will be a small filing fee. You fill out short forms for a summons and complaint. These include the defendant's accurate name and address, the nature of your claim stated in everyday language, and the amount of your claim. If you aren't sure of the defendant's exact business name and it isn't posted on the premises, the clerk of the county in which the defendant does business should be able to help you. The clerk will set a date for the hearing and send the summons to the defendant requiring an appearance on that date. If you have witnesses, you

bring them along to testify. If the witnesses don't want to testify, or if you need papers that are in the possession of the party you're suing, ask the court to issue a subpoena to force the witnesses to come or the papers to be produced. Of course, you bring along all the relevant papers that you have, such as confirmation forms, invoices, and so on.

The date for your hearing will probably be no more than a month or two away. Many small claims courts hold sessions in the evening, so don't worry if you can't come during the day. The judge or referee will ask you for your side of the story. After both sides have had their say, the judge will often encourage a settlement. If that's not possible, a decision will either be given immediately or be sent to you within a few weeks. The decision can be in favor of you or the other party, or it can be a compromise. After winning, you may need the help of a marshal or sheriff to collect from a reluctant defendant, although most losers will simply put their check in the mail. Of course, the laws governing small claims courts vary from jurisdiction to jurisdiction, so it's helpful if you can find a guide specially written for your own court. Search online, of course, but if you can't find anything, ask the clerk of the court whether such a guide exists. Or you might give a call to your Better Business Bureau or Chamber of Commerce.

PART VI.

BEYOND THE STUDIO

IN THIS FINAL part, we explore some of the issues that may pop up after you start your career, and we offer some ideas to help you vary your activities based on your needs and the options that are available to photographers today.

"Growing as a Photographer" is an excerpt from the remarkable book *How to Grow as a Photographer: Reinventing Your Career* by Tony Luna. In addition to enjoying a successful career as a photographer and teacher, he works as a creative consultant for photographers and other artists. His book is rich with interviews with many luminaries including Pete Turner, Douglas Kirkland, Barbara Bordnick, and Jerry Uelsmann. At some point in your career, you should read this thoughtful book. We're appreciative that Tony allowed us to include his chapter on how to create a timeline that helps you envision how your career and personal life intersect and ways that you can rekindle your passion for photography.

"Staying Fresh" provides suggestions for photographers who find themselves in a rut or creative funk. Sometimes what's required is a change in subject matter, while other times an out-of-the-studio experience may be the ticket to a new perspective. No one approach will work for all photographers, but this chapter contains a lot of ideas that may be helpful to you.

Photographers have been flirting with film and video for decades. Gordon Parks, for example, turned from his initial success as a photographer for *Life Magazine* to directing films, including the original *Shaft*. Anyone who understands how to compose and light a still photograph obviously has a great start toward making the transition to film or video or adding those services to an existing repertoire. In the chapter "Opportunities in Video and Multimedia," we take a look at the way those opportunities have exploded in recent years.

While freelance photography can be an exciting career, there are also drawbacks. Unless you have ongoing sales from stock photography, it's likely that you're only making money when you're actually working. There's no such thing as benefits like paid vacation or sick time for freelancers. Some photographers find that having a job with benefits still allows them time on evenings and weekends to pursue their photography part time. The last chapter in the book, "Transitioning from the Freelance Life," is excerpted from Michal Heron's book, *Creative Careers in Photography: Making a Living With or Without a Camera*. It examines job

opportunities for which the freelance photographer's experience is an important qualification.

In sum, this concluding part of the book is devoted to continuing and enriching your career as a freelance photographer. With a little care and an occasional review of your goals and your strengths, that career might last a lifetime. Good luck.

CHAPTER 25 GROWING AS A PHOTOGRAPHER

by Tony Luna

Editor's Note: In an earlier chapter in his book, author Tony Luna sets out a sequence of three recurring phases. The first is one that he calls the Creative Ascent. As you can imagine, that's a good time indeed. Then, "after a while (usually years), you are approached by clones of the first wave of clientele and you are asked to do the same type of work that typified your climb to stardom. You use essentially the same setup of lights, the same lenses, the same approach—because it is what everybody wants. Eventually that work is no longer challenging, but you talk yourself out of your lack of enthusiasm because they are still calling on you. This period is the Plateau of Mediocrity. You put up with it, you are good at what you do, and it doesn't take a lot out of you to repeat the exercise. Still, the more you repeat it, the more of an exercise it is, an act of going through the thoughtless paces, giving them what they want, but leaving you creatively wanting. There's no doubt about the execution, only a shallow sense of security." His final phase is the Valley of Despair. That's a place where you want to keep the visit as short as possible.

The chapter that follows is excerpted from chapter three of *How to Grow as a Photographer*, entitled "Finding Your Passion . . . Again and Again and Again."

CHANGE DOESN'T ONLY occur when we are faced with something catastrophic in our lives. It can happen silently over a period of time, building momentum until it morphs into something totally unexpected. Creative people need to be aware that there must be an element of their passion associated with every type of change they encounter. Without that element of passion, they will find something lacking in their new role, and it will leave them unsure of themselves, unbalanced in the universe, unable to feel complete. Our passion, no matter what form it takes, has to be acknowledged, accepted, nurtured, and shared, over and over again—and with each completion of this cycle it grows more powerful, and more unique. If we ignore it, it goes into hibernation, waiting for us to give it the respect it deserves. In this chapter, we will look at several ways in which you may consider how well you are attending to the call of your passion.

It is imperative for us to consider our personal work history in order to gain an understanding of how we have, or have not, dealt effectively with the transitions we have chosen, or have been forced to choose.

CREATING THE TIMELINE

At one point in my career, it occurred to me that I could assist people in appreciating the roots of their passion by helping them visualize their past experiences, so they could isolate and recognize their periods of creative highs and lows. If early on I had created a timeline of my career's progress, I believe I could have been more proactive—and I could have been more productive, more prepared for the inevitable encounters with change. This may seem like pie-in-the-sky thinking, but I'm talking about developing a way in which one is not constantly looking over one's shoulder but instead is using past experiences as a means for looking ahead, without losing sight of what one cares passionately about. This task requires the combination of a storyteller's talent and a designer's ability to conceptualize visually. The storyteller provides the narrative, and the designer takes all the historical data and fashions a comprehensible chart, map, or representation. One can then step back and meditate on the choices one has made in one's career.

For example, when starting out on any major new project, I like to spend a little time sketching—first on a notepad and then more formally on a big easel—a visual representation of where I am now and my eventual goal, so I can begin to make lists of things to prioritize. Then I can begin scheduling the times when things have to be accomplished and the milestones that will eventually have to be met.

For this endeavor, I figured anyone who was interested in creating a career map, if you will, would need a representation that would synthesize data from their own past. This, in turn, would allow them to take a hard look at that data in the clear light of the present, and it would give them the freedom to consider the feasibility of what they want for their future—the stuff of their dreams.

THE WORK-HISTORY TIMELINE AND THE PERSONAL TIMELINE

When I start working with a client, the first assignment I have them execute is the creation of a personal work-history timeline. This lets us get a perspective on where they have been in their careers, what they consider to be their important accomplishments, and also what distractions and obstacles they have encountered along the way. I tell them they can design it any way they choose, but it must have a baseline, time segments, and anything they consider as significant events in their work history, such as new jobs, promotions, new clients, achievements,

problem times, resigning a client, leaving a job—in short, anything that prompted a change in career direction. We start out with the work-history timeline because it is the easiest to comprehend.

I remind my clients or students they can design their timelines any way they wish. This, in itself, reveals a great deal. Some will do a straight-line continuum that resembles the timelines you would see in a history textbook—Paleolithic, Neolithic, Bronze Age, etc. Others create a tree trunk, which illustrates their main form of expression, along with arabesque branches that show all the little excursions that caught their fancy along the way. And still others create a series of columns and lists, with titles like Education, Professional Experience, Skills, Accomplishments, and Interests, as though they had taken their resume categories and turned them ninety degrees on their side. All of these visual expressions are equally relevant, because they help us to see our career experiences in a condensed perspective. We might visualize our lives as goal oriented on a linear path, or as a series of episodes that have meaning only when looked at in their totality. Or maybe we see our lives as connections between hard work and destiny, somewhere between sweat equity and happenstance. Whatever the form, these work-history timelines give us a picture of a life with dimension, a life with alternatives.

Next, things get a little more complicated: I ask them to create their personal history timeline. Maybe you can, as one of my students did in a workshop, place your work experiences above the timeline, and your personal experiences below the line. The interrelationship was very revealing, as we could see a tug of war that existed between perceived allegiances. At times, work and personal histories could be seen as working cooperatively and in harmony with each other; at other times, there were tensions between work and family, or work and other interests.

Practically speaking, the timeline assignments are a reality check, because they reveal what a person feels is most important in the individual's own shorthand way, because it is necessary to assign a personal level of importance to each event. The real significance of the timeline assignment is that it is a tool to get people talking. That talking leads to little self-revelations where priorities surface, and those lead to bigger truths.

LIST OF SKILLS

Once the timelines are in place, the next thing to consider are the skills that you have acquired along the way. By studying the timelines, it is relatively easy to begin listing the obvious and the not-so-obvious skills that came along with each experience. You may have good darkroom skills that helped enhance your digital postproduction skills. You might have shot photographs at first and then

been asked to write a story to go along with the shots, so now you have journal-istic abilities. Maybe you were asked to shoot live action along with stills on sev-eral jobs and have now broadened your image-capturing possibilities to include film or video. Skills don't have to be exclusively technical in nature. They can include managerial, accounting, production, communication, interpersonal, and other professional skills. And don't forget other skills that are important in our increasingly global economy, such as foreign languages and cultural aware-ness. Transferable skill sets can make the difference between a mediocre job and an exciting career.

LIST OF INTERESTS—THE ROOTS OF PASSION

With the timelines and the skills list in place, the next step in our preliminary journey of self-discovery is the development of a list of interests. This is revealing because we voluntarily select our interests; no one forces us to do these things, and we do them because we enjoy doing them, plain and simple. Doing things voluntarily is at the base of passion, so it is important to understand why and how we are drawn to certain things and not to others.

So how do you find your passion? The answer is, you don't find it. You allow it to find you, and you stay open to recognizing it when it comes your way. You can't force it. You can urge it by educating yourself; you can attract it by immersing yourself in it; you can cajole it by practicing it—but you can't order it to do your bidding. You have to prepare yourself for passion and wait for it to introduce itself to you. As a friend once told me, "If you are waiting for your ship to come in, then don't wait at the airport."

This is where the fine art of playing becomes such an important factor. When we first play at something we do so because it is enjoyable. At first we fool around with our newfound toy, and then we find we have lost all sense of time while being immersed in this new adventure. Eventually we can't wait to be interacting with this thing that brings us so much joy. The adrenaline that kicks in gives us extra energy, and we find we can keep playing beyond being tired. If we do well at our play, we praise ourselves or we get praise from others. Once we reach one threshold of satisfaction, we want more and we push ourselves harder. It is part of the Creative Ascent, the joy of newness, of discovery, of growth. Play is at the heart of passion, because it encourages us to reach beyond our perceived limitations and set new goals. That is why the Plateau of Mediocrity is so discour-aging: the newness becomes routine, growth is stunted, and there is nothing left to discover. After a while, mediocrity cannibalizes what is left of desire, and play becomes joyless hard work with diminishing returns.

You have to get back to the rudiments of play if you want to summon your passion. Many people have to look back to what they enjoyed in their youth to find their passion. Richard Avedon, who contributed so much to our industry, was quoted as saying, "If a day goes by without my doing something related to photography, it's as though I've neglected something essential to my existence, as though I had forgotten to wake up."

There are other simple questions that can open your mind to rediscovering your passion. I ask my students and clients to write down what sections they instinctively gravitate toward when they go to the bookstore; or what kind of sites on the Internet they seek out; or what kind of stations they have preset on their car radios. They are simple questions, but the answers tell a lot about the person. In the bookstores, do they look for biographies, picture books, children's books, or technical books? When they are online, are they searching out chat rooms or sports websites, financial news, entertainment gossip, or the latest fashion styles? Are they addicted to listening to the latest news reports, or political talk shows, or music on the radio (if so, what kind of music)? The deeper we go, the more we find out what is important, even if it seems trivial, because we keep returning to it—not because we have to, but because we want to.

As a kid I used to spend a lot of time during the summer in the city library. I grew large (I've never grown up; I've just grown large) in San Bernardino, California, where the summers are brutal and the library was safe and had the best air conditioning. My sister and I would check out large quantities of books as members of the various vacation book clubs for kids, and pretty soon I had gone through the suggested reading lists for children my age. I remember making up a game where I would slowly walk down the long aisles with my eyes closed and pretend that I was sending out radar waves that would tell me when to stop. Then I would reach up on a shelf, randomly pull down a book, and read a few pages from the introduction. If the subject matter interested me I would read on; if it didn't, I would put it back and continue with my game. That started me on a long interest in books and the exotic adventures and wide range of knowledge they contained. Eventually, I found that there were certain sections that held more interest for me, and I would concentrate on the books those sections contained. In a way, the books spoke to me, as long as I was ready to accept their calling.

Another revealing question is asking where someone likes to go on vacation. Again, the answers tell us if the person prefers to stay close to home or is adventurous. Does the person strike out alone or travel with others? Does the person travel to established destinations or to remote, exotic places? As a photographer,

you could be earning a livelihood while taking pictures anywhere in the world, even your own backyard.

What are your hobbies, pastimes, and interests? Hobbies are a perfect example of something a person would do out of a universe of choices. Interestingly enough, Leonardo da Vinci used to create rebus games for his own entertainment. Imagine, Leonardo da Vinci needed entertainment! He would write a few words backward and in Latin, then draw little pictures in place of some of the words and create puzzles that needed decryption. That kind of mental exercise kept him nimble in his thoughts and allowed new thoughts to enter his mind—thoughts that were vastly ahead of their time. The brain processes myriad bits of information simultaneously, and from time to time it has to work in another direction, another dimension; then it has to have time for rest before it can come up with a new variation on an old theme or something entirely new.

We must not overlook the importance of serendipity in discovering our passion. Serendipity is the ability to make accidental discoveries, and that ability is at the heart of rediscovering your passion. If you are too committed to one outcome, you might overlook the alternative that is sitting in front of you. In conversations I've had with many well-known photographers, I've often heard tales of discoveries that came about by chance. This led me to ask, "Are these discoveries accidental, or are they more available than we think they are? Are we just too creatively myopic, or too rushed, to perceive them? Are we so bombarded with stimuli that we can't see the worlds of wonder and possibility that are waiting right next to us?"

One other very useful method, one of my favorites, for helping someone find the basic elements of their passion is to have them get involved in a mentoring program. I ask my clients, "If you could mentor people in your artistic field, what kind of class would you create for them?" Then I try to find that kind of program for them. The results are always personally and socially fulfilling, and the outcome is predictable. When an artist sees the light that comes into the eyes of a young person he is mentoring, then he relives the joy he himself has lost. Let me illustrate this with a story. I helped start a nonprofit arts program for children after the riots in Los Angeles in 1992. During our first meeting with a group of kids for a photography class, we were ill equipped for the number of kids that showed up and did not have enough cameras. One of the mentors came up with a brilliant idea. The mentor asked the kids to go back home, get some sunglasses, and then return. They all returned with all sorts of sunglasses. We took a grease pencil, drew a rectangle on the inside of one lens on each of the sunglasses, and proceeded to deliver a class in one-point perspective. We then marched the kids out onto the street where they walked around until they

saw, through their sunglasses, an example of one-point perspective. They looked funny crouching down along the sidewalk as they screeched out, "Hey, look, the palm trees line up, and the parking meters meet up with them down the street!" The mentor taught a visual lesson but also learned a life lesson about the joy of seeing something new even in the context of the familiar. That kind of joy can do more for a frustrated artist than anything else in the world. It renews faith in the world and in the purpose of the medium.

One other question that I like to ask of my clients in order to bring out their personal definition of their passion is "What would you create with your art if you won the lottery?" The reason for the question is obvious. A great obstacle to exercising our passion is the obligations, mostly financial, that make following our heart unsustainable. But if we were not encumbered with money issues, what would we create? I don't know of anyone who has not thought about what they would do if they won the lottery. We have all probably considered how our lives would change if we hit the big one. So if you could create anything, and didn't have to worry about money, what would it be? A gallery showing of your latest portraiture? A visual history of your hometown? A tabletop book of your trip to an exotic island? All of these projects could be financed with some introspection, a vision, a few connections, and some planning—and you would not have to win the lottery to do that.

LESSONS LEARNED

Now here comes the fun part. Find the biggest surface you can write on. Maybe it's an old piece of foam core, a blackboard, a dry-erase board, a mirror, or a sliding glass door—the biggest, least confining surface you can scribble on and not worry about cleaning off later. Now tape, thumb tack, or rewrite the results you developed above on the timeline of your work history, a timeline of your personal experiences, a list of your skills, and a list of your interests. Get it out there big as life, because it is about your life. Arrange it any way you want, but put it out there where you can stand back and get a good long look at it.

What do your career and personal timelines tell you about what needs to be addressed first before you can make a career transition? Personal relationships (marriage, family, and friends), health matters (illness or accidents), economic factors, and other aspects of life all have an enormous impact, and it is useful to see how they are perceived and interwoven with your work timeline.

The beauty of this exercise is in the thought processes we bring to it, how we describe our reminiscences, and how we evaluate what we have accomplished. What are the lessons we can learn from putting it all in one place, so that we can look at it as objectively as we can? Do we observe ourselves as victims or masters

of our fate? Will Rogers once said, "If you find yourself in a hole, stop digging." Do we see ourselves as shadows of what we wanted to be, or as apparitions of our aspirations? Some of us see changes as the clash of infuriatingly hard choices, while others see change as a flowing river that one just blithely rides upon.

The truth is that life is a mixture of our fanciful expectations and our realized aspirations. The truth lies not in the extremes but somewhere in between. I always laugh when a new talent is described as "an overnight success," because there were probably years of hard work and sacrifice that preceded that so-called overnight success. This, however, is often overlooked in the bright lights of instant fame. In a classic quote, Albert Einstein once wrote to a colleague, "I do know that kind fate allowed me to find a couple of nice ideas after many years of feverish labor."

As you create your timeline in earnest, this dominating question emerges: Have you been using the development of your passion as a major determining factor in making your life decisions? If you have been, then you will find it easier in the future to make the transitions that will keep you contributing and productive. If you have not, then you will find hollow satisfaction in other endeavors. Tough but true.

MAKING SENSE OF THE INQUIRIES

Obviously what we have just done is to match up your perception of your passion with the realities of living. This has been a short feasibility study to see if you are ready and able to move on to another level of expression. And one thing has become abundantly clear for the person who chooses a life in which creativity plays a major role: your passion has to be continuously monitored; it has to be discovered again and again and again, ad infinitum.

Now that you have it all in front of you, what do you see? What emerges from these fragments when they are woven together? My guess is that there is a tapestry more intricate than you anticipated. Is there too much information, or too many circumstances that make the image hard to comprehend? Then maybe you have to find a way to make it all simpler. Is there a hole where something meaningful should be? Then maybe you have to bring together the elements around the hole and mend the emptiness. What continuously got in the way of your growth as an artist? What did you allow to distract you from pursuing your abilities and possibilities? Are those things, those habits, those excuses, still playing a role in your life? Have you been treating your passion as a hobby, or is it time to take it more seriously and raise it to the next level? If it is a passion, you will find the time.

Once you recognize that there is a problem, and you accept the reality that you must do something about it, the next stage in the creative process is logical.

You have to determine what you have going for yourself, and you have to get your assets together in a focused way. You have to honestly reacquaint yourself with your strengths and your weaknesses and address how you will use that knowledge to achieve your goals. Do you have what it takes to be competitive in the new marketplace? How do you capitalize on your skill sets and apply them to the new technologies?

Let's say that after much soulful assessment about your skills, experiences, and interests, you have come to a decision that there is something so intriguing about photography that still keeps calling you, and you know in your heart of hearts that you must heed its call. It could be the travel involved in photography or the technology that interests you. Or maybe it is the lure of meeting the important people who make up our world that piques your interest. But you also realize that you will have to learn new techniques, new ways of doing things, things that will take you out of your comfort zone. The prospect of doing all that work seems daunting, and you don't know where to begin.

Education, in any field, is an ongoing endeavor, and photography is no exception. I have met photographers who, figuratively speaking, haven't put down a camera since they were first introduced to one, and I have met people with widely divergent backgrounds who took up photography after attaining degrees in other fields but didn't feel complete until they brought the camera into their lives. And that is what is beautiful about the photography field: you can enter it at any time; you can change directions within it; and you can be anything you want in the photography arena. Because photography is not one thing—it is a language that unifies us all. We live in a visually hungry world, and photography provides us with a window on every aspect of our world. On top of that, photography as a field of endeavor is very egalitarian. All anyone cares about is: Does the image communicate? Does it motivate? Does it instruct? Does it make us laugh? Does it make our blood boil? Does it magnify our humanity? There's a common thread that runs through the conversations I've had with accomplished photographers: right from the onset, when they became committed to photography, everything they had done in their past was somehow worked into their becoming a better, more well-rounded photographer. Their beginnings may have been humbler, but they successfully parlayed their experiences into broadening their photographic skills.

CHAPTER 26 STAYING FRESH

by Chuck DeLaney

EVERY PROFESSION PRESENTS the risk of getting run down by either too much repetitive work or too heavy a workload. This holds true for lofty fields such as law, teaching, and medicine as well as for more routine jobs in retail, hospitality, or the service industry. Even though photography is a creative undertaking, photographers are not exempt from getting "burned out."

Consider the wedding photographer as an example. A lot of the principal work takes place on evenings and weekends, so it may be hard to spend time with family and friends when they are relaxing. Even if the photographer works only twenty-six weekends a year and takes the other twenty-six off, that's still a lot of very demanding weekends spent working. There is often a lot of tension behind the scenes in even the happiest wedding, and the photographer is frequently in the thick of it. On the big day, the wedding photographer has to learn a lot of names, spend a lot of time guiding the subjects through various types of pictures and poses, and coordinate with a wedding planner or the catering hall staff, and perhaps a DJ or band leader as well. The day may start hours before the wedding at the bride's home and end in the late evening as the reception winds down and the happy couple departs.

In addition to the long days spent photographing weddings, there's a lot of sales work involved in finding new customers and upselling to customers who have already signed a wedding agreement, much of which is often done in the evening. Add to that the need to order prints, lay out albums, and help brides and grooms make decisions about the photos that have been taken. It's a lot of work.

There are people who are impervious to the stress and strains of wedding photography. My late friend Archie McDearmid worked as a wedding photographer for more than thirty years and would still often get a tear in his eye at a joyful wedding. For others, after five or ten years in the field, it's time to make a change.

The demands on commercial and advertising photographers can also take a toll. Art directors can be very precise and sometimes difficult. The accounting department can be slow to pay your invoice. Last year's client may want to pay less for the same kind of work this year, because there's a new photographer offering

to undercut your price—or at least the client claims there is. Photographers who work in the area of fine arts can suffer from a creative block, not unlike writer's block.

What's a photographer to do? Quitting the business is always an option, but unless you're determined to do that, it's better to find ways to stay fresh. The subjects related to the health of your body that we covered in chapter 11, such as the ways to relieve stress from spending too much time in a crouched position, are applicable to everyone. Finding what will keep your spirit and mind fresh, ready to handle the day-to-day tasks you encounter and keep your creative juices flowing, is a different undertaking. What works for one person may provide no benefit for another. The ideas that are presented here should be viewed as suggestions. If something sounds appealing, give it a try. If you don't think it's the right path for you, look elsewhere.

Take note that these suggestions are not designed to address serious, urgent problems. If your business is deeply in debt, or if you're making excessive use of alcohol or recreational drugs, for example, you may need to seek professional help to address the underlying situation.

TAKE A CLASS

In this instance, the idea is to take a class that has nothing to do with photography. Engage your mind in a totally different area. Study something that will stimulate you and take your mind, at least for a while, away from your work and daily routine. As you get involved with a topic that has no direct relationship to what you do on a day-to-day basis, you may find that insights pop up that will be applicable to the work that you do. But don't go looking for that kind of cross-reference. Let it come to you naturally if it happens to do so. Don't go hunting for relevancy.

It might be a class in a physical discipline—some form of yoga, for example. Perhaps it's a dance class or some other kind of exercise class that will engage you in a way that allows your mind to disengage for a while. In addition to the benefit of stress reduction, you may meet individuals that you might not otherwise encounter. Another option would be some kind of meditation class. Depending on where you live, there may be a wide variety of offerings. A simple online search should present many choices.

Another approach might be to take a class in a subject that has nothing to do with photography but which interests you. Whether it's chemistry, astronomy, psychology, or the history of architecture, engaging your brain in a subject that takes your mind completely away from your normal frame of reference can be refreshing. It doesn't have to be a heavy academic class, and in fact, it probably

shouldn't be. You're not trying to get into graduate school. Non-traditional learning opportunities may abound, particularly if there's a medium- to large-sized city near where you live. Another option might be to look for distance-education classes that you can take online. However, particularly if you've been spending a lot of time alone in the studio or hunched over your computer, it would probably be better to get yourself into a classroom with other students, so you can enjoy the human interaction and the benefits that can be gained from differing viewpoints.

While a search engine can provide all kinds of listings for schools, courses, and study groups, make sure that the agenda of any class you take is aboveboard. You're not looking to stumble upon a cult or get into some expensive pay-as-you-go program that promises great benefits if only you stick with it and spend ever-increasing amounts of money.

TAKE A PHOTOGRAPHY CLASS

Maybe the way to turn a page and find something invigorating in photography is to take a class in an area of photography that isn't familiar to you. Have you ever used a view camera? Are you interested in alternative processes? There are many opportunities to try something new. You can take a course or workshop in a location near you, or you can go to a "destination" workshop such as the Santa Fe Photographic Workshops or the programs offered at a Montana bed-and-breakfast by Photographers Formulary. It may be that a change of scenery is just what you need. There are many programs around the country as well as international tours and workshops that might allow you to discover new locations and different types of subject matter. If the idea of a travel program with other photographers sounds like a bad idea, you could travel by yourself or with a group that's not geared to photographers. The goal is a change of scenery and a change of pace.

RETURN TO FILM

Maybe it's just time to take a step backward and shoot some film. Perhaps purchasing ten rolls of Tri-X and digging out your old film SLR is just the ticket. You may have to find a developing tank as well, but maybe going back to the era when the results weren't immediately visible in the LCD panel would be a positive change for a while.

JOIN AN ASSOCIATION

If you've been toiling on your own, it may be time to consider joining an association that will get you out of the studio, bring you into the company of others, and provide fresh insights. A list of photography organizations can be found in

the appendix. These tend to be based around a particular type of work—North American Nature Photographers Association, for example—but it may be that spending time with people who do the same kind of work that you do—though in different parts of the country—will provide you with a different viewpoint and some fresh ideas that you can bring back to your work.

It's also possible that you would benefit from joining some other type of community-based association. It could be a civic group that's intended for general community betterment, such as a local chapter of the Rotary or Lions Club, or an organization with a common goal, such as Toastmasters. Perhaps you have a strong feeling about one of society's problems—whatever the social ill, there's probably a group that is organized to address it. Whether it's animal adoption or rescue groups for a given dog breed, people with a specific disease or condition, or homelessness or domestic violence, options to get involved abound. Perhaps you can offer your skills as a photographer on a volunteer basis. That would be a good idea if it sits well with you. On the other hand, invoking your photographic skills might be the last thing you want to do. Perhaps you just want to help build a house, read to a sick person, or be a big brother or sister to someone who needs a positive adult influence in their life.

To take on something of this sort doesn't mean you have to make a lifetime commitment. Give it a try for six months or a year. If it doesn't work out, move on.

SELF-ASSIGNMENT

Part of the weight of working for a specific set of clients is that you're likely to make the same kinds of images repeatedly. If time permits, finding a self-assignment might be the best way for you to get out of a rut and work in an area that's not familiar and doesn't feel repetitive. If time is tight, that's OK, because a self-assignment can also be open-ended. Joel Meyerowitz, for example, made his name as a street photographer, but during his career he has assembled collections of work, such as his book *A Summer's Day*, which is a collection of summertime images taken over a number of years.

There are many benefits to a self-assignment. First and foremost, you don't have to please anyone other than yourself. In addition, you're free to make mistakes, get sidetracked, or take a break. There are no deadlines, no limits, and no rules, unless you choose to impose some. It's possible that you might be interested in an assignment that addresses a social issue, whether it's poverty, an illness, or the decaying infrastructure of the town where you live.

At least at first, it may make sense to not have a rigid plan. After all, your regular work involves completing assignments in a way that will be satisfactory to

others and meet their requirements. Rather than impose a set of requirements on yourself, take some time to explore. If you don't have a specific topic in mind, maybe a season of street photography is a good place to start. Few of us give ourselves permission to just wander around with a camera. You probably did it when you were first starting out, before all the responsibilities and structure and deadlines got in the way. Why not recapture that feeling of experimentation and discovery? You can start a self-assignment with nothing more than a resolution to take some photos in a specific area with no particular purpose in mind. Let the structure reveal itself to you as you go along.

If that seems too free form, consider an approach that still gives you a lot of leeway. Spend a few days or a week at the state fair watching the crowds or talking to the carnies. Make it a point not to take any photographs until you decide what interests you. You could do the same thing at a racetrack, a local park, or a train station. Spend time investigating what's going on, and then decide on the specifics of your assignment.

It's important that you let your self-assignment move at its own pace. It may become a work in progress that lasts a lifetime. It may turn out to be a big success in some way, or it may just languish on a worktable for a decade or two. You won't know which direction it will take when you start.

OPPORTUNITIES IN VIDEO AND MULTIMEDIA

by Chuck DeLaney

As HAS BEEN noted earlier in this book, the evolution of digital photography and the Internet has changed the way photography is practiced. As sweeping as the changes have been in the world of still photography, the changes in the field of moving images—now mostly captured in some form of video format—have caused an even greater disruption to the old way of doing business. In addition, the video audience has expanded dramatically in ways that were unimaginable not so long ago.

THEN AND NOW

Just forty years ago, in most cities, television consisted of three commercial network stations and an "educational" one. Cable television had been developed using a real cable that delivered a clear television signal to areas where the local terrain made reception difficult. Most television programs were thirty or sixty minutes long (fewer actually, allowing for commercials), unless there was a longer-running movie or sporting event scheduled. Videotape was relatively new. Television stations, networks, or highly capitalized production studios created all the programming.

The production and distribution of movies was also tightly controlled because of high costs. Films were produced in Hollywood, and release prints, mostly on 16mm and 35mm film, were shipped around the country and released in theaters. After a few years, a hit movie would begin to appear on television. Almost all films were ninety minutes or longer. "Shorts" were hard to market and found a very limited audience. The only shorts being created by the industry were commercials, usually fifteen, thirty, or sixty seconds.

It's a different world now. We can skip over the interim developments such as the camcorder, VHS and Betamax players, five hundred cable channels, and multiscreen theaters. Those changes were really only incremental. The digital revolution has changed the way video is captured, shattered the set lengths of many types of programming, and brought competition to the traditional networks from all directions.

In sum, the game and the rules have changed, and anyone can have their own channel on YouTube or Vimeo. Short form video exists as entertainment

or documentary. Whether it's a forty-second cat video or a cell phone capture of alleged police brutality, everyone can be a filmmaker and distributor. The ability to put your work before the public is as close as your smartphone. Your local newspaper can be a television station. You can be a television broadcaster.

The new generation of equipment that can be used to capture high definition video is a remarkable accomplishment, but the democratization of distribution options is an even bigger story. The grainy monochromatic video of Rodney King being beaten by the Los Angeles Police Department back in 1991 was captured by a citizen documentarian, but it had to rely on news programs to broadcast it to the world. Now, consider the smartphone footage of Eric Garner being taken down by NYPD officers, or Walter Scott being shot in the back while running away from a police officer in South Carolina. Those videos can go viral in a matter of minutes, and any website, whether it's run by a broadcast outlet, newspaper or radio station, or a bunch of teenagers in a garage, can provide streaming video of the latest events live or on demand.

Even large "made for television" events like an awards show can be punctuated by short video clips posted by a star or a fan on Instagram or some other platform. The audience is often watching several "screens" at once, hoping that short bits on a phone or tablet will amplify the content on the main screen. In essence, viewers become the decision makers about what they will watch, rather than broadcast executives or producers.

THERE'S STILL A LOT OF BAD VIDEO

A great deal of the video is still of dubious quality, because it's being captured by amateurs and is usually shaky because it's hand held. The big difference in capture is that the equipment being used now is ubiquitous—about two-thirds of adult Americans have a smartphone. Also, the cost of a video-enabled smartphone or other recording device is a fraction of what it was twenty years ago.

While the smartphone is the tool of choice for most people, broadcast-quality programming is now often produced using digital still cameras that possess video capture capability. The smaller size of the still camera body, usually a digital SLR, coupled with the wide variety of lenses available for the major SLR brands, have caused production companies to embrace them as video-capture devices regardless of the size of the budget. Major television shows have been produced using digital SLRs as the only video cameras.

An interesting footnote is that back in the 1990s, "experts" predicted that it would only be a matter of time before there was a video device that could yield "photo quality" still images as well, but it turned out to be the opposite. The still camera killed the camcorder, not the other way around.

Another sobering point is that many of us are almost always on television all the time. In urban settings, the surveillance cameras that monitor vehicle and pedestrian traffic outdoors combined with the variety of cameras that are mounted indoors in stores, malls, and transit stations means our activities are being constantly recorded. If there is a "Big Brother," he's arrived.

WHAT DOES THIS MEAN TO YOU?

Whether the camera is a smartphone, an inexpensive point-and-shoot model, or a quality digital SLR, still photographers are likely to have video-capture capability in their cameras whether they choose to use it or not. So the logical question is—why wouldn't you use it?

There are several good reasons why you should consider delving into video and multimedia production.

First, as a skilled photographer, you already know how to make great still images. And, that's where film and video start—the phenomenon of persistence of vision that causes the human eye/brain combination to see a rapidly presented series of still images as a steady stream that appears to be one smooth movement rather than a jerky series of separate images. The modern standard is twenty-four frames per second to achieve a smooth image in film or video.

The second reason to develop video skills is because video content is extremely popular on the Internet. This wasn't always the case. It wasn't so long ago that broadband connections and server capacity couldn't handle video as seamlessly as they do today. You don't have to be that old to remember when video needed to buffer, and even a short clip would be interrupted with delays while a single image was frozen on the screen and the audio came to a halt. Those days are over. Now video content is approaching 70 percent of all Internet traffic and is projected to keep growing. Many users rely on online video for both information and entertainment purposes, which is very bad news for television stations, cable companies, and newspapers.

Third, video makes it possible to tell a story in a way that guides the viewer through the story with more control than a picture story or photo essay can. People look at still photographs—whether in print or online—as they wish. Viewers spend time looking closely at some images, move quickly through others, and possibly skip some altogether. That's not to say that still photography will disappear. Many news and entertainment websites rely on compilations of the most interesting news photos of the week or the twenty hottest female celebrities at the Oscars. Still images can still pack a lot of punch. But, in terms of controlling the viewer's experience, a well-made video controls how long the viewer looks at each image, and the use of camera movement and editing can guide the viewer

through the experience in very powerful ways, and the addition of a sound track adds another dimension.

Whether the purpose is to entertain, to inform, or to propagandize, video is a great way to control the viewer's overall experience.

LEARNING THE BASICS

"The cinema is truth at twenty four frames per second and every cut is a lie."
—French filmmaker Jean Luc Godard.

One of the most significant aspects of every video that is more than a single shot stems from the power of editing and the mental association between adjacent clips of video. This was discovered more than a century ago when the early film-makers saw the power of *montage*, in the association between one series of images and the next. You've seen these all your life. The classic experiments of early Russian filmmakers such as Sergei Eisenstein revealed that a short clip of the face of a sad-looking man, followed by a clip of a pot of soup on a stove conveyed to the audience that the man was hungry. Think of the Hollywood cliché of the 1930s in which a shot shows a flurry of newspapers coming off a printing press, followed by a cut to a sensational headline that shouts "big plot development" to the viewer.

So as a photographer, you've already mastered the basic elements of creating the image within the frame—composing the scene and lighting it. What's left to learn? There are a number of topics that are unique to making film and video—for example, the variety of shot types, including establishing shots, medium shots, close-ups, and extreme close-ups. Then there's pacing and the variety—the length of time each clip appears on screen and the mix between the various shot types, along with editing techniques and sound-recording methods. Another important topic is the impact of the different moves a video or film camera can make—panning, zooming, and tracking the subject.

There are students who spend several years and thousands of dollars attending film school, and there are some excellent training programs. While that may be a pleasant way to spend time and meet people when you're young, it's not necessary for you to return to school at this point in your career to learn how to make great video. Some of the skills that filmmakers use, such as budgeting for a production or directing actors, are very similar to skills you already have. When the craft was entirely dependent on film, and the great expense of shooting it, processing it, making prints, editing bits of a work print into a rough cut and then a fine cut, and finally having a release print made, film school helped

students learn those lessons with lower cost and also gave them access to equipment that was very expensive. Now, there's nothing to stop you from learning as you go, via trial and error.

Reviewing even the basics of the different shot types, editing techniques, and audio-recording tools is beyond the scope of this book. To learn more, you could attend a class or two, or look into online offerings. There's also a short book, *The Bare Bones Camera Course for Film and Video*, that covers all the basic concepts of capturing good images, recording usable audio, and editing the material into a finished product. It's a remarkable book (full disclosure, it's published by Allworth Press), and I urge you to consider using it if you decide you want to develop video skills.

MULTIMEDIA OPTIONS

The combination of sound and images doesn't have to be limited to video. You could create a timed audio track to accompany still images—a slideshow. This will provide some of the control power that video offers, because the viewer will watch as the images move from one to another at a pace of your choosing. A presentation of this type can be a stand-alone product, or it can be used as part of a video program. Sometimes there are situations when there isn't video available to illustrate something, so the visual part of the program switches from video images to still images enhanced by a soundtrack. As an example, think of any of the documentaries made by the Burns dynasty, starting with the original Ken Burns production *The Civil War*.

ADDING VIDEO TO YOUR WORK

The value of producing video for some types of photography work is obvious. For example, the wedding photographer may as well produce the video for the happy couple as well as take the still images and create the all-important wedding album.

There was a time, let's say the late 1980s and early '90s, when video makers and "still" photographers uncomfortably shared the reception hall at a wedding. The hostility was not unlike the range wars of the 1880s that pitted the cattlemen against the farmers and homesteaders looking to stake a claim on what had been grazing land. The two activities just couldn't coexist. The crews got in each other's way, the video lights made trouble for the still photographer, and it was generally a mess. Photography studios started offering video, but the capital costs could be daunting and the new skills presented a learning curve. Now, the same cameras and lenses can be used for both video and still capture. The people present at a wedding won't know what's being recorded by which camera. This can create more spontaneity.

If the wedding invitation includes a website, why not produce a short video clip or two that can be part of the invitation? It can easily be recorded during an engagement session. Even if there's no website, why not offer several short, well-produced clips that the engaged couple can post on Facebook or other social media? In addition to the actual wedding video, there may be time at the reception to record interviews with some of the older guests—grandparents, aunts, and uncles of the couple that can be edited into a separate document.

If you have commercial clients, might they have video needs for online or local television advertising? One advantage is that many people who might be able to use video in their business promotion or advertising don't know that it can be produced at a relatively reasonable price, particularly now that much of the same equipment that you use in your regular business can also be used for video production.

RISING COMPETITION AND FALLING RATES

There was a time when video and filmmakers could charge quite well for their work. It was common to pay so much a day for a camera operator or a sound-recording expert, and also to pay a day rate for a camera or audio "package," which would include a camera or audio recorder along with batteries, cables, microphones, and any other standard accessories. In fact, some still photographers back in the 1980s decided to turn to video on the theory that they would be able to make more money making video than taking still photos.

Those days, if they ever existed, are gone. While the cost of Hollywood and union crews may be higher, the last time I was looking to hire a crew for an industrial job a few years ago, the rates for both people and for packages had actually gone down from what they were twenty years before. This stems from increased competition and the lower cost of equipment today.

Don't think of moving into video as a way to get rich. Think of it as a way to broaden the services that you offer to your existing client base and as a way to attract new clients in the future.

CHAPTER 28 TRANSITIONING FROM THE FREELANCE LIFE

by Michal Heron

BUYERS, SELLERS, AND DEALERS

One very heartening thought, as you approach the field of photography, is to realize how very many places photographs are used—even some you may never have considered—and, along with that, how many different types of careers involve working with photographs. If you aren't quite sure what's best for you, consider these ways to work with photographs. It's possible to blend and to mix and match a variety of these professions to find a satisfying career.

The careers for picture professionals are varied and intriguing. They include the photo buyers, who are the people who search out, find, and decide on the photographs to be used for everything from magazine covers to mugs. Those who sell and/or provide photographs can be stock agents, photographic reps, or dealers in fine art. Each has a vital role to play in the business of photography.

Different companies and various parts of the industry have their own names for the people who find and select the photographs.

The World of the Photo Buyer

There are many professions, interesting and rewarding, where it's your job to acquire or buy (or license rights to) a photograph. There are two basic ways to acquire a photograph. The first is to assign or commission new photography from a photographer.

As it relates to the picture professional, the advantage to assignment photography is that you will get fresh pictures, never seen before. But there are no guarantees, and there is always the risk that something could go wrong. The advantage to using stock is that it exists. No unpleasant surprises, no disappointments, no pig in a poke—you know what you're getting.

One of the more interesting aspects of being a photo buyer is the interaction with colleagues. It's quite common for a group of professionals (possibly art director, creative director, art buyer, and photo researcher) to confer to come up with the best approach to a photo solution.

Who Buys Photographs?

Photography buyers work in many industries with a variety of titles. Many photo buyers, but not all, have art-school educations with training in the graphic arts, design, and photography. An interesting place to see the involvement of different creative professionals in a photograph is in the *PDN* (*Photo District News*), which covers advertising, books, stock, and web photography. The photos are shown along the concept or a description of the assignment and the name of the client. Credit is given to the photographer and all the key people who worked on the project. You'll see that sometimes mention is made or credit given to the photo buyer, to the creative director, to the art director, or to a photo editor. Each may have a slightly different cast of people who collaborated on the photographic project. This attribution gives an interesting mini history of a photograph's evolution into publication. Under their various titles, the work of acquiring photos can be done by:

- Creative director
- Art director
- Art buyer
- Graphic designer
- Corporate communications director
- Photo editor
- Photo researcher
- Internet/Intranet content managers
- Editorial marketing staff
- Book authors

Creative Director

A *creative director* at a smaller advertising agency may be involved with photo assignments along with other responsibilities. But this would be much less likely for a creative director in a large agency.

Art Director

An *art director* is quite commonly involved in the selection of a photographer and in developing the concept for the photographic style in an ad campaign. He or she often works very closely with the photographer and may be on location for the shoot.

Art Buyer

An *art buyer* for an ad agency can have widely differing levels of responsibility. In some cases, art buyers review portfolios and have significant influence in the

final decision of which photographer to use. In other agencies, the art buyer's role is limited to bringing in samples of those photographers selected for review.

Graphic Designer

A *graphic designer* in a design firm, or perhaps an assistant designer, will choose a photographer and work out the concept for a shoot. Graphic design firms are known for working on corporate annual reports and brochures. Recently they are emerging as a part of the ad-agency scene, as some advertising agencies are buying up small design firms. In addition, some corporations are acquiring design firms to form part of their in-house advertising capabilities.

Corporate Communications Directors

Corporate communications directors or *corporate marketing directors* are responsible for the look of the publications that represent their company to the world and to their stockholders. They will work closely with a graphic designer but often have significant involvement in the selection of a photographer and in following through on the shoot.

Photo Editor

A *photo editor* can be found working for a newspaper, magazine, or book publisher, often in a staff position. The term can mean different things in different companies. The job will include making the final selections from assignment photographs for use in the publication. Photo editors may do their own photo research, or they may choose which stock photos to publish from the selection provided by a photo researcher.

Photo Researcher

A *photo researcher* works for and with virtually all other types of buyers and clients including ad agencies, design firms, publishers of books, magazines, newspapers, encyclopedias, and content developers sometimes known as book packagers. The services they provide include photo research, not only of contemporary photography but also of historical photographs, prints, drawings, and other fine art works. Photo researchers or their assistants will also handle rights and permissions for the visuals researched, gathering the digital files needed by the client, and may also handle image and archive management.

There are staff positions in photo research, particularly in the larger book publishers, but many photo researchers are independent professionals working as freelancers. Others have started small businesses to provide greater depth of

service for their clients. One example is the photo research firm of Feldman & Associates, Inc. (*www.feldmans.net*).

Early in my career, before I became a photographer, I worked as an art and photo editor for a publishing company, with photo research as one of my responsibilities. I fell in love with it. Just imagine looking through the archives of individual photographers, news organizations, and stock agencies representing every imaginable style and subject matter, as well as digging into art museum and historical-society files. If it's visual, then at some stage a photo researcher will most likely have to find it. Photo research becomes an education unto itself, as photo requests can lead down paths to some unusual and even arcane subjects. (During my photo research work in historical archives, I became enamored of early photography.)

A good background for a photo researcher is a mixture of photography and graphic arts or art history. But a thorough liberal-arts education gives the breadth of knowledge that's useful for a researcher.

Photo research was also a great training for my future work as a photographer, in that it allowed me to see the work of the "best of the best" among photographers. You learn very quickly to push for the highest standards when you've been exposed to that level of quality. Simply good work isn't good enough. Researching in the work of the top photographers gives you a measure to use against your own progress.

Net Content Managers

Internet/Intranet content managers are the people that post information and updates to websites as well as keep them running. (An Intranet is an internal website for companies. It's usually different from the external site and may have information of more interest to employees.)

Content managers make sure that the site's links and downloads are all functioning. They often have to find images to correspond to information that will relate on the site. Or they may have to seek out artwork to help illustrate pages. The content managers might research the images and get the image files, but they also have to work with the images to make them work for the web—resizing, working with the color, and making sure the image works with all the text and fits in with the look of the site.

Editorial Marketing Staff

In many large corporations, the marketing department is huge and includes an *editorial marketing staff*. These people are members of the marketing team responsible for the editorial work on all the marketing brochures and documents they

give to clients. In this context, they may buy (license rights to) a lot of photos to go with the text. This could be a job given to a photo researcher, whether staff or freelance, but as the need is usually for only a few images a week, the job is often handled by the marketing staff.

Book Authors

Book authors, particularly textbook authors, don't technically buy (or license rights to) images, but they often do preliminary research and initiate the photo list that a researcher might follow. They are constantly researching clippings, cartoons—all sorts of visuals—to illustrate their books. In addition, some have assistants who do this type of visual research.

Acquiring and working with photographs is a satisfying way to build a career or to blend with your life as a photographer—there is real symbiosis in the mutual benefit.

The World of the Photo Seller

Photography sellers are those who make images available for sale or licensing. They actively seek out buyers/clients to provide the service of assignment photography or to present selections of stock photos. In addition to the individual photographer, the people selling and providing photos are:

- Representatives ("Reps")
- Stock agents
- Fine art galleries and curators

Representative/Marketing Coordinator/Creative Management

Just running a photography business, however large or small, is an all-consuming undertaking. The photographer has enough to do—planning and executing shoots, processing and manipulating images—without adding another task. So imagine the relief if someone else would handle the "business" end of the business. Not many photographers have someone to do that work unless they have a partner or spouse in the business. Otherwise, the photographer has to add to the load by doing marketing, searching out new clients, and negotiating jobs. In addition to the serious difficulty of finding time for these tasks, there is a reluctance on the part of many photographers to represent themselves to clients. The process can make them uneasy, sometimes resulting in a less-than-favorable impression.

Enter the photographer's representative or the creative manager. The commonly used term is "rep," which is useful shorthand. However, career people

who represent photographers often prefer more dignified terms such as "manager" or "creative management." The feeling has been that the term "rep" meant just dragging around a portfolio and doing the drop-offs and pickups. A serious "rep" handles a complex number of tasks that vary with the needs of each of the photographers they represent. If you want an interesting, challenging career, working in creative management might be a strong possibility. You become the voice of the photographer. Often you can present them and their work in a better light than they can themselves.

A representative or creative manager will do many things, including advise a photographer on the content and presentation of a portfolio, search for new clients, assist in estimating the job and negotiating fees, be present on the shoot to hand-hold the client, and virtually anything else that will help the photographer prosper.

A good representative is like an advocate, someone on the photographer's side who reduces stress and removes the energy-draining aspects of the business. The worth of a manager is in the subtle ways it frees the photographer to be creative. Managers build confidence because the photographer doesn't have to face a possible lukewarm reception or even outright rejection.

Opportunities and Qualifications

One way to start is by looking around among your colleagues in photography school or other young photographers in your area. Put together a group of like-minded aspiring professionals with different and complementary strengths. For example, a newly established rep with a stable of newly established picture professionals—all new, all in it together, sharing expenses—could make it work. You might have a combination of two or three photographers, one rep, and one stylist. The group could include anyone with mutual interests and mutual professional needs. Several factors make the idea viable. Because there is less need for legwork in the current marketing arena, a lot can be accomplished through direct mail, email, online and social media marketing, and drop-off of a portfolio or a mini-portfolio used as a travel portfolio.

Figuring out the money is tricky, but with imagination and a good business sense, you could create a viable arrangement. The classic arrangement of a rep receiving a percentage of the photographer's fees doesn't work when there are no (or few) fees. Consider working out a balance of hourly rate plus commission. For example, each photographer in the group could invest in a certain number of hours (at an hourly rate) to cover the marketing coordinator's efforts. Then an additional payment would come as a percentage of work brought in. It would be a modest percentage until the photographer is established at a higher earning level.

In the early stages, it is frugal going, but that's true for many entry-level creative people. As the photographers progress and fees go up, it's viable. This process is worth starting even in college or photography school.

Some photography students are drawn to being out front, talking to people. They have the people skills and confidence needed to approach clients and show portfolios. It's always easier to be enthusiastic about someone else's work, where there is less danger of a bruised ego. So, examine your strengths and passions. Maybe you'd be dynamite as a marketing coordinator representing photographers.

Stock Photo Agent

There have been dramatic changes in recent years in the way stock photography is sold—and in the careers that support the stock industry. The classic stock agent was a person who built a relationship with a photographer and fostered his or her productivity to the benefit of both. There was a bond of trust and a common goal. In the best of stock photo agencies, it became a partnership—and not uncommonly a friendship. Those same qualities are important today, but the close contact is less intimate than in the past. The success of your work as a member of a stock agency still depends on your people skills and critical eye for photography (in almost equal parts).

Careers in a Stock Agency

It takes many people to run a good stock agency:

Stock agents will review portfolios to identify photographers with talent and ability to produce saleable stock. They will negotiate a contract. Depending on the size of the agency, the stock agent may be the agent/owner or an upper-level management person.

Stock agency editors will review the photo submissions of member photographers, deciding which to keep on file. This is one of the most rewarding jobs in the stock business, because it's the hub of the creative part of the business. In working with the photographer, there is a considerable exchange of information leading to better stock. Though agency editors are not technically sellers, because they are more involved in nurturing a relationship with the photographer, they are nevertheless getting material prepared for selling (licensing).

Marketing and sales representatives carry out an important function, especially since the emergence of the mega agencies. In these agencies, each client who uses the stock agency will be assigned a marketing "rep" to provide customer service and to act as liaison with the agency researcher. Often these reps work on a combination of salary and commission, so good service to a major client will pay benefits.

Stock agency researchers will search the agency files for images to match the client's photo requests and post them to a digital light-box for review by the client buyer. The days are long gone when a client would physically go to an agency and review pieces of film through a loupe on an actual light-box. With the conversion of stock-agency film archives to digital files, the relationship of the researcher within a stock agency has changed. Now, since virtually all photos are available electronically, there can be direct access by the client to the files on the agency's website. So a client can use a researcher's help to search the files—or they can do it themselves.

Still, a common scenario is that a professional researcher/buyer will submit a photo-research request list to an agency's marketing rep. This request is turned over to a photo-agency staff researcher, who will "pull" a selection of topics or concepts to fit the request. (Lest this become confusing, remember that we have two types of researchers here. One is working for the client finding photographs, and the other is working inside the stock agency finding material from agency files to show to the client researcher.) Next, the stock agency researcher will post them on a digital light-box on the agency's website. Sometimes there will be email exchanges between the agency researcher and the client researcher (or even phone calls) to clarify what's needed. The thinking behind this approach is that the agency researcher knows his/her own file and key-wording system better than the client researcher and can be more efficient in gathering a good selection for the buyer. If the right material doesn't show up, the buyer researcher has the option of also searching directly on the website.

However some client researchers prefer to search the agency website themselves using key words to navigate the system, thus bypassing the need for a person within the agency to help with the research. This is the method typically chosen by either an exceptionally knowledgeable client/researcher or sometimes the exceptionally uninformed one.

The latter group consists of clients who misguidedly hope to save money by having a secretary or assistant go directly to photo-agency websites. Most clients have the sense to conduct their search for photos by using experienced photo researchers.

The *director of photography* will consult with the stock agent (or owners) and sales reps to identify photo topics needed in the files. He will direct agency-staff producers or freelance producers hired for a project to schedule and budget photo shoots. They will consult in selecting which agency photographer is to be assigned to the shoot.

Stock-photo producers in a larger agency will work under the guidance of the director of photography who will decide what topics and concepts are needed. In a smaller agency, photo producers will handle the decisions and production

for the agency and work with member photographers to obtain specific styles and concepts in stock photos needed to round out the agency's files.

As never before, *technology specialists* are essential to the running of a stock agency. Website management is a full-time process at the heart of the photo agency. In addition, people who know stock-photography content and the underlying concepts are valuable for the key wording of images. Photographers are requested to furnish some keywords when they submit an image, and pinpointing the right keywords for concepts can increase sales.

Fine Art Galleries and Curators

Having come into its own in recent decades, fine art photography has provided a flourishing business in buying and selling prints. Though the fine art photography establishment tends to hold itself aloof from the commerce associated with assignment photography, the fact is that fine art photography is big business. Prices have risen sharply in recent years to levels never before imagined.

Collectors buy vintage prints of established artists as well as new work from emerging, contemporary photographic artists. Some collect out of love for the work; others collect because it's an investment strategy.

Gallery Owner/Manager

Galleries display fine art photography for sale. Gallery owners manage the business of finding and selling fine art photography.

Gallery owners are constantly searching for genuine new expressions, a unique voice in visual form. Part of their search involves looking at the portfolios of many hopeful fine art photographers. The search is exhaustive and not many are chosen. Since space and time to present an exhibition are limited, gallery owners must judge the impact and likely staying power of a new artist. There is a massive amount of work in handling this and the installation of new shows, publicity for a show, arrangements for an opening reception, and then the sales of prints. Frequently, a gallery assistant helps with these tasks—being an assistant in a gallery is a promising way to learn the insides of collecting. (A little known side use of stock photography comes about when fine art gallery owners and artists license stock photography to aid in the installation of shows, for instance, as backdrops to the paintings or sculpture. This is separate from fine art photography.)

Photography Dealer

Working with gallery owners or individual collectors, a photography dealer buys and sells photographic fine art prints. Websites are a major source for the dealer to present available work to the collector.

Art Advisor/Curator/Consultant

Known by many names but expert in one thing—the fine arts—an art advisor or curator provides services frequently sought by individual collectors or institutions.

For the fine art photography student, a career as a curator in photography may be an excellent way to blend an interest in the gallery world with a pursuit of his or her own photography. There are many academic programs for curators. One particularly well-regarded program at the University of New Mexico in Albuquerque turns out a significant number of curators. Building a collection is fascinating work. For more information about curators and art dealers, there is an organization called Art Dealers Association of America (ADAA). You can visit the organization's website at *www.artdealers.org*.

In addition to selecting the photography to add to a collection, a museum photo curator or photo-department head assigns photographers to take photographs of works of art, installations, and museum activities. Museum photo departments may also license photographs in their collection for editorial use—and in rare cases for advertising use.

Historical Photo Archivist

In historical societies and libraries across the country, there are photo collections that are preserved and documented by archivists or curators. In addition to those preserving the collections, there are photo departments in these historical societies and libraries that make prints available to the public for reproduction in books and magazines. There are photo departments in institutions across the country including state as well as county historical societies and regional and nationally known museums. Major organizations such as the Library of Congress and National Archives are just the beginning.

These photo archives contain treasures, some well known and widely shown, others quietly resting in back-room files. Working with these icons of fine photography and artifacts of our past would be a rich and rewarding career.

LOCATION AND SUPPORT SERVICES

All photographers depend on help from assistants, technicians, and retailers. In this section, we'll look at the support-system careers that are needed during the actual shoot time, as well as the ongoing services provided by retail stores and manufacturers.

Some photographers work alone much of the time—photojournalists, documentary photographers, or nature photographers may not need much more to create their fine photographs than the equipment they carry.

However, a photographer shooting production assignments for a client counts on the help of a team of specialists, which can vary from one assistant on a standard shoot to a full-scale production with six, eight, or more professionals doing their parts. There is a lot of electricity when a creative group gathers together on the day of a shoot. Each person performs a valued, even essential, function. It may not be quite as hectic or time sensitive as it is, say, for the pit crew of a NASCAR race, but the contribution of the specialists assisting on a photographic production is critical nonetheless. It can be a great deal of fun to be part of the team. Also, these are career opportunities that are well suited to a career blended with your own fine art or personal photography.

Some of the team members work long in advance doing preparation for the photography; others are needed only for the shoot day. The role of the photographer's assistant has been covered in Part I, so here we will look at the other jobs that can be fulfilled by creative professionals.

Other Assistants

Time

A requirement I have with all supporting staff is that they must be where we are supposed to be, on schedule, without fail. As most photographers will tell you, being *on time* means being *early*. Even if you can prove that King Kong closed the highway for thirty minutes, you would still be better off allowing extra time for the unforeseen by leaving home thirty minutes ahead of schedule.

This on-time-means-early business isn't just uptight behavior on the part of the photographer. Precious minutes wasted early in the day can compound problems later in the day that actually *are* out of your control. For example, a model may not arrive "hair ready" and unexpectedly needs an extra fifteen minutes. If you have squandered time earlier, you can start slipping seriously behind schedule. Allow for mishaps, traffic, train delays—anything, so you'll be waiting when the photographer or client arrives ready to start the day focused and relaxed. Even if the photographer tends to slip in a little late, if you can be counted on to arrive when you should, it will be points in your favor.

Full-Time Professional Assistants

Although most assistants use their experience to further their goal of becoming a photographer by learning what's needed to become full-time professional shooters, there are a handful that make a full-time career of assisting. And it's not a bad life. Usually, they are excellent at the work and often capable of doing the photographer's job if they chose to do so. They know the lighting, can rig

most anything you can think of, have the ability to improvise at a moment's notice, and anticipate everything you need. I once had a professional assistant in Florida who could estimate the time it would take for the sun to come out from under the clouds. So while the models and I were fidgeting and wondering how fast the clouds would move, he'd study the skies through double sunglasses and report: four minutes to sun, or twelve minutes—or on less fortunate occasions state "that's it for today." He was uncannily accurate.

One reason for staying an assistant is that you can participate in the creative work of photography but still avoid pressures from a client. You're not out front for the praise or the blame. You don't have to go out and market yourself—since the word gets around and an excellent assistant is never idle, giving you the satisfaction of being much sought after. Travel is another perk for the full-time professional assistant. When photographers have the budget to take an assistant on a location shoot here or overseas, they inevitably opt for the top person available—the professional assistant.

Digital Assistant

These days, depending on the size and budget of the photo production, photographers will have one photo assistant to handle lighting and other traditional assisting duties and an additional person to do the computer work. This person will download cards into the laptop, organize them into folders by shot name, and begin making sure the digital images are ready for the photographer to review when there is a break in the shoot. (Whether you are working on location or in the studio, you need to keep up with the shoot by downloading digital files as you go.)

On small shoots, one person may do both traditional assisting and handle the downloading, so digital expertise is an essential component in what you have to offer when you look for assisting work. If you are very skilled, you may be hired by the photographer to do the postproduction workflow at the end of the day or in the days after the shoot. I've done this repeatedly—found an assistant adept at both location assisting and computer work. When they turned out to have real skill, I hired them for extra days to help out on postproduction.

Production

On a large-scale shoot the producer is the hub of everything. Working sometimes weeks before a shoot begins, the producer is the person who makes sure everything happens when, where, and how it's supposed to.

A producer must be incredibly detail oriented, able to schedule and budget accurately, and juggle a lot of things at one time, while still appearing calm. The

producer instills a sense of confidence in the photographer and client by making sure all details are planned out in advance and by being able to come up with instant solutions when things go awry—and with so many details, things do go awry. As a producer, it helps if you have some knowledge of photography, since ultimately the person you are solving problems for is the photographer. You might need to know what types of fabric photograph well, know what colors are good with certain skin tones, and be able to notice reflective backgrounds that will cause problems in a location. You are always thinking for the photographer.

The role of the producer is to:

1. Visualize the job from start to finish to plan for what is needed and to estimate the cost of the job.
2. Estimate in collaboration with the photographer and or rep.
3. Decipher from the layout what is needed to execute the shoot, including the necessary crew: production assistant, location scout, casting talent, hair, make-up, prop, and wardrobe stylists; and the necessary special people: baby wranglers, pyrotechnics experts, set builders, animal handlers, etc.
4. Interview and hire the crew, including making referrals to the photographer for assistants, digital techs, labs, and equipment-rental houses.
5. Get all permits required for location shoots.
6. Coordinate the shoot day. Plan for comfort and commodities for the crew and client (coffee, snacks, meals, water).
7. Assign someone to get model and property releases and handle unexpected crises.
8. Handle all finances related to the shoot.
9. Negotiate shoot site details and pay for locations and staff.
10. Make sure the job stays within schedule and on budget.

The Crew

After a photographer chooses an assistant, a digital assistant, and a producer, there are still many more jobs to be filled, collectively known as the crew. On a large production, as is common with advertising photography, you might need six or eight specialists. On smaller productions, one stylist may handle several roles. Though there is a lot of responsibility and the work can be pressured, these jobs are a lot of fun—working with other professionals to bring a creative vision to life is quite a treat. To get experience in all these specialties, you usually start as an assistant to a producer to learn the ropes. The following sections describe various other members of the team.

Crewmembers can be provided by a producer, who should be able to schedule them so that things are done on time. The producer will also manage the budget for all these activities. Working on a big production may not be for everyone, but it's exciting to see a scene come to life when the crew does its work.

Location Scout

A *location scout* works with the photographer to clarify the style of location needed, taking reference photos of potential locations and checking permission requirements or location fees. The scout indicates on all scouting photos the time of day it was shot and the direction (N, S, E, W), to give an idea of the sun position at a given time. The scout also describes any reflective surfaces on interiors or any impediments to placing lighting equipment. The location scout will usually handle permissions from the location or property, finding out about any fees, and get a property release signed.

Props and Wardrobe

Prop buyers or *wardrobe buyers* do just that: buy what's needed on the list from the photographer. You'll need to know the exact time period, style, and general look for the items or clothes you're getting. Your creative input is important in getting the right style and color to complement the scene envisioned. It will help if you can see a layout. You might find yourself haunting prop houses (in larger metro areas), regular stores, flea markets, and thrift shops. The less exciting part is returning props after the production. Since some props will be rented, they will be returned to the rental house. Other times, props are purchased and not used, so they must be returned to the store for credit. Before long, you know where to get anything and everything. One time I was on a shoot in Paris when the editorial content was changed last minute. We suddenly needed an American cowboy hat—in France. Our French stylist had it on location in two hours. Knowing your turf and how to find things will make you very valuable. It's not bad getting paid to shop.

Casting Professionals

Finding the right models can be critical to the success of certain types of photographs. A *casting professional* (often known as the casting director), knows a full range of model agencies—those specializing in glitzy folks, real people, theatrical people, children, and even animals. The person in charge of casting gathers headshots or composite cards from a variety of model agencies. Usually the photographer will want to follow up with one or more auditions to make a

selection. At the casting call, the casting director may take reference shots for later use. In addition to the potential model's appearance, you can get an idea about attitude and physical attributes—are they stiff or loose, pleasant and easy to work with, or tiresome and whiney. All this comes through, and the casting director can save a photographer from headaches by weeding out potentially difficult talent.

Stylists

Hair stylists and *makeup stylists* are specialists widely used on photo shoots. They learn their skills from assisting a stylist or by working in theater. *Food stylists* know where to get the freshest looking fruit and vegetables and the most photogenic meats, often cut to their specifications. Perhaps the food has to fit on a certain-sized plate and still look appetizing. You won't get that in the grocery store cooler. Food stylists often prepare "stand in" meals to be used for lighting and tests. Then, when everything is technically correct, they cook another meal with the same ingredients to be shot the minute it's ready, while it's still fresh looking.

Baby Wranglers and Animal Handlers

Aren't these great job titles? It's often said that the most difficult shoot you can arrange is one with toddlers or animals. Boiled down to basics, the *baby wrangler* does what the mother only hopes to do in real life: keep the baby happy, calm, and quiet until needed on the set. A baby wrangler comes armed with a variety of toys and noisemakers used advantageously when the photographer is ready for a good expression. *Animal handlers* do much the same thing but with different toys. Don't get lured into using an untrained animal. If an animal isn't trained, it could cost a bundle in time and money. Even with animals, go for the professional handler and a trained animal.

Set Builders

Set builders provide anything from basic carpentry to a sophisticated ability to create interiors quickly and with a credible look.

Services off the Set

At first glance it may not seem glamorous to work in a lab or sell in a retail camera store or represent a manufacturer, but the fact is that all of these people work with photography and photographers. They fill essential roles. Often, they have to be skilled in several areas of photography.

The major service areas are described in the following sections.

Retail Sales

Much of the retail business has moved from personal contact in a store to online buying. The price advantages are significant, but something has been lost. The advice of a knowledgeable retailer has value. There is still a place for a supplier who goes beyond quoting price to help the photographer with analysis and information gleaned from working with other professionals. In some geographic areas, there are still customers who prefer to walk into a store, pick up equipment and feel it, heft it in the hand, and get a sense of the controls. Would you buy a car without a test drive? Finally, it's a good day job while trying to break in as a photographer.

Custom Photo Labs

Custom labs are alive and well, but not all of them are thriving. There are few film-only labs left. Almost all have responded by establishing digital departments. Some photographers who have always done their own printing will continue to do so. Many are able to do more of their own printing more easily with the new breed of professional-grade inkjet printers. As in the days of film, many photographers have their printing done by professional printers, either because they haven't developed the expertise or don't want to take the time. Lab work is exacting and creative. There is artistry in making a fine print.

Retoucher or Digital Artist

For the person with superb skills in Photoshop, there are numerous career opportunities, from basic retouching to complex photo compositions. We sometimes do a great disservice to people who work manipulating digital-photographic files. We tend to lump them under the rubric "retoucher." That's fine for someone taking wires out of a sky or wrinkles from a CEO's jacket. But the contribution of a digital artist can be on a par with that of a photographer. A digital artist has not just skill but also a delicate touch in bringing to reality an imaginary concept by the photographer. If you have the skills, and it's obvious what's needed is superlative ability in Photoshop, then you could be highly sought after in this area.

Manufacturer's Representative

Quite often, companies who make equipment designed for use by photographers will hire photographers to market it, or to be their *manufacturer's rep*, also called a *customer-relations representative*. This is a career to investigate if you want a regular income with benefits and still be involved with photography. All photographers need help and advice, and as a representative for a manufacturer,

you're in a unique spot. You can help answer a photographer's questions and pass on problems, complaints, or design suggestions to your company from the photographers you contact. And in some companies, your role might be to try out new equipment or demonstrate it at professional meetings. If you are working for a manufacturer, an interesting part of your job is to get feedback from working pros. If you are a photographer with a question, you can get in touch with a manufacturer's rep by attending meetings they sponsor for organizations such as ASMP, APA, ASPP, or PPA. If an event is sponsored by Nikon, Canon, or Fuji, surely the rep will be there; you can make personal contact and get a phone number for future questions. If you are working for a manufacturer, an interesting part of your job is to get feedback from working pros.

CAREERS IN TEACHING AND WRITING ABOUT PHOTOGRAPHY

There's a sage bit of advice often given to would-be novelists: "Write about what you know." So, too, in photography: before you can teach or write about photography, you must know it.

Being a Photography Educator

It almost seems as if teaching is in the genetic makeup of people who love photography. In professional photographers, the impulse is especially strong. A remarkable number of photographers spend at least a part of their careers teaching.

Some photographers become instructors from the beginning of their careers, making education a major portion of their life in photography. Others turn to teaching at the end of their careers, using the culmination of their experience in the commercial world to provide valuable lessons for newcomers. Others balance teaching and professional photography work, blending the two, throughout their careers.

Within the world of photography education there are various roles to be played. Instructors in photography often have different strong points to their teaching: some are adept at teaching the technical skills of the craft, whereas others are skilled in teaching the composition, graphic quality, and emotional impact of photography. Finally there are those who have years of experience running a business in photography and who share the secrets of handling marketing, stock, copyright, and business forms.

Some people even take a straight path into teaching. These are the students who attend a photography school, learn the skills, and enjoy the academic atmosphere so much that they stay on to become teaching assistants and then full-time instructors. In addition to colleges, instructors are needed in photography specialty schools and for workshops and online schools.

Qualifications

One appealing aspect to teaching photography is that the same level of teacher training you need in other academic settings is not always required. Certainly, colleges and universities will usually require at least a master's degree in photography or fine arts for their full-time instructors and professors in the art and photography departments. Though it's useful to have a degree, it may not be essential. Your knowledge of the field and an ability to articulate that knowledge may be sufficient. Colleges, photography schools, and workshops have spots for visiting instructors who are able to teach from their professional experience in photography, including technical, aesthetic, and business skills.

Technical schools, online schools, and workshops make use of many established professionals who do not have degrees but offer the inspiration and real-life career guidance in photography. So, though you may not choose to be a teacher at this moment, as you gain experience in the field, the opportunities for teaching will open up to you.

Writing about Photography

Both writers and photographers use their skills to tell stories: there is a natural affinity. In the nineteenth century, from the earliest moments in the development of photography, there were writers ready for the new medium—ready to comment on its usefulness or critique its artistic value. Some of those writers went on to use photography, sometimes to illustrate writing itself! That continues today. For a profession that carries the maxim "a picture is worth a thousand words," the many thousands of words written about many of those pictures may belie the maxim. Or do they? Perhaps they, the writer and photographer, have been meant to be bedfellows from the start.

At any rate, many of us who love taking pictures also love writing about the process. We proselytize our ideas, extol the virtues of equipment, or explain new trends in photography. As a photography professional, you learn from written materials. Your special interests in photography may lure you into writing about that specialty.

The number of books on all aspects of photography is staggering. In looking at the magazines and trade press, month after month, you see articles on subjects from trends in fashion photography to developments in imaging software. And that's just for professional consumption. The national press includes regular features about photography. Many photography dealers have websites with articles on photography. Even *Consumer Reports*, in addition to its evaluation of equipment, offers teaching articles about photography on a regular basis on its website. Photography is truly of global interest.

The photography trade publication *Photo District News* (*PDN*) is essential for anyone involved in professional photography. You can't start reading it too early. Browsing through three or four of the monthly issues will give you an idea of the written material available to you as well as the range of reporters, writers, and writing styles they use.

The types of writing in the photographic world include:

- Columnist in the trade press, photography magazines, or newspapers
- Reporter for photographic trade press, magazines, and newspapers
- Commentary on fine art photography trends, reviews of gallery shows
- Technical writers on new equipment for magazines and newspapers
- Writers on digital topics, from workflow and data-asset management to creative uses of Photoshop
- Photography critic writing for photography magazines and newspapers, both for the trade and for the general public
- Writers of books about photography, including the history of photography, fine artists in photography, the "how to" technical books on photography as well as art critique

Teaching and writing are ways photographers express their consuming interest in photography. It may be too altruistic to attribute this tendency to a love of sharing with others what we hold as a passion—but certainly that is what many of us feel.

The *ASMP Member Code of Ethics* provides professional guidelines for members as they deal with colleagues, subjects and clients. The Code describes the recommended responsibilities of working photographers to their profession as well as to the individuals they work for and with.

Responsibility to Colleagues and the Profession:

1. Maintain a high quality of service and a reputation for honesty and fairness.
2. Oppose censorship and protect the copyrights and moral rights of other creators.
3. Foster fair competition based on professional qualification and merit.
4. Never deliberately exaggerate one's qualifications, nor misrepresent the authorship of work presented in self-promotion.
5. Never engage in malicious or deliberately inaccurate criticism of the reputation or work of another photographer.
6. Never offer or accept bribes, kickbacks or other improper inducements.
7. Never conspire with others to fix prices, organize in illegal boycotts, or engage in other unfair competitive practices.
8. Donate time for the betterment of the profession and to advise other photographers.

Responsibility to Subjects:

9. Respect the privacy and property rights of one's subjects.
10. Never use deceit in obtaining model or property releases.

Responsibility to Clients:

11. Conduct oneself in a professional manner and represent a client's best interests within the limits of one's professional responsibilities.
12. Protect a client's confidential information. Assistants should likewise maintain confidentiality of the photographer's proprietary information.

13. Accurately represent to clients the existence of model and property releases for photographs.
14. Stipulate a fair and reasonable value for lost or damaged photographs.
15. Use written contracts and delivery memos with a client, stock agency or assignment representative.
16. Give due consideration to the client's interests before licensing subsequent uses.
17. Do not manipulate images for use in a journalistic context in a manner that can mislead viewers or misrepresent subjects.

APPENDIX B ORGANIZATIONS FOR PHOTOGRAPHERS

THIS APPENDIX GATHERS information about a number of the leading membership organizations for photographers as well as some other organizations of interest to photographers.

American Photographic Artists (APA); *apanational.org*. The purpose of APA national is to promote high professional standards and ethics and to communicate and exchange information among APA chapters, APA chapter members, and APA members-at-large. APA national works toward the advancement of advertising and commercial photographers by exchanging information and ideas, resolving common problems, and strengthening the relationships between photographers, advertising agencies, clients, and suppliers. All APA chapters and APA national are independently managed and funded.

American Society of Media Photographers (ASMP); *www.asmp.org*. This organization, with chapters throughout the country, promotes the photographic profession through advocacy, education, and information exchange on rights, ethics, standards, and business practices. Its services include publications, insurance, surveys, member support with clients, business counseling, and marketing assistance. It is the copublisher, with Allworth Press, of *ASMP Professional Business Practices in Photography*, now in its seventh edition.

American Society of Picture Professionals (ASPP); *www.aspp.com*. The ASPP has a wide membership base and a number of chapters, which include photographers, stock agencies, researchers, and buyers. The organization publishes a quarterly magazine, the *Picture Professional,* a newsletter, and an annual directory and provides a job-posting service for members on its website.

Art Directors Club (ADC); *www.adcglobal.org*. Established in 1920, the Art Directors Club is an international nonprofit membership organization for creative professionals, encompassing advertising, graphic design, new media, photography, illustration, typography, broadcast design, publication design, and packaging. Programs include publication of the Art Director's Annual, a

hardcover compendium of the year's best work compiled from winning entries in the Art Directors Annual Awards. The ADC also maintains a Hall of Fame, ongoing gallery exhibitions, speaker events, portfolio reviews, scholarships, and high school career workshops.

The Association of International Photography Art Dealers (AIPAD); *www.aipad.com*. Acting as the collective voice of photography art dealers, AIPAD maintains ethical standards, promotes communication within the photographic community, encourages public appreciation of photography as art, concerns itself with the rights of photographers and collectors, and works to enhance the confidence of the public in responsible photography. AIPAD members provide a wide range of services to the public, such as exhibitions, expert opinions, and consultations.

California Lawyers for the Arts; *www.calawyersforthearts.org*. California Lawyers for the Arts empowers the creative community by providing education, representation, and dispute resolution.

Digital Media Licensing Association (DMLA); *pacaoffice.org*. DMLA's goal is to develop uniform business practices within the stock picture industry, based upon ethical standards established by the council. DMLA serves member agencies, their clients, and their contributing photographers and illustrators by promoting communication among picture agencies and other professional groups. Through these improved channels of communication, the council hopes to make available information necessary to improve and protect the business of its members. An annual directory of the membership is available.

The Foundation Center; *foundationcenter.org*. The Foundation Center Network is an independent national service organization that provides authoritative sources of information on private philanthropic giving. There are Foundation Centers in New York City, Washington, DC, Cleveland, San Francisco, and Atlanta, with more than one hundred cooperating library collections.

Lawyers for the Creative Arts; *www.law-arts.org*. Lawyers for the Creative Arts provides free legal services to financially eligible clients in all areas of the arts—visual, music, dance, literary, digital media, arts education, and much more. It helps individuals and organizations with business issues, contracts, copyrights, trademarks, and many other legal areas.

National Press Photographers Association (NPPA); *nppa.org*. The NPPA membership services include major medical and equipment insurance as well as a variety of publications. The NPPA offers student, professional, and international memberships.

North American Nature Photography Association; *www.nanpa.org*. NANPA's mission is to provide education, foster professional and ethical conduct, gather and disseminate information, and develop standards for all persons interested in the field of nature photography. NANPA further seeks to promote nature photography as an art form and a medium of communication for the sciences, nature appreciation, and environmental protection.

Professional Photographers of America (PPA); *www.ppa.com*. PPA publishes Professional Photographer Storytellers and Photo Electronic Imaging Magazine. PPA offers a variety of memberships for photographers of various specialties, including portrait, wedding, industrial, and specialist categories, and has more than fourteen thousand members in sixty-four countries.

Society for Photographic Education (SPE); *www.spenational.org*. SPE is a nonprofit membership that provides a forum for the discussion of photography-related media as a means of creative expression and cultural insight. Through its interdisciplinary programs, services, and publications, the society seeks to promote a broader understanding of the medium in all its forms and to foster the development of its practice, teaching, scholarship, and criticism.

Volunteer Lawyers for the Arts (VLA); *vlany.org*. VLA is dedicated to providing free arts-related legal assistance to low-income artists and not-for-profit arts organizations in all creative fields. Five-hundred-plus attorneys in the New York area annually donate their time through VLA to artists and arts organizations unable to afford legal counsel. VLA also provides clinics, seminars, and publications designed to educate artists on legal issues that affect their careers. California, Florida, Illinois, Massachusetts, and Texas, to name a few, have similar organizations. Check "Lawyer" and "Arts" phone directory listings in other states or search on the web.

Wedding and Portrait Photographers International (WPPI); www.wppionline.com. WPPI publishes a monthly newsletter, has print competitions, and sponsors an annual convention.

COPYRIGHT NOTICES

SELECTED BIBLIOGRAPHY

The American Society of Media Photographers (ASMP). *ASMP Professional Business Practices in Photography*. 7th ed. New York: Allworth Press, 2010.

Brinson, J. Dianne, and Mark F. Radcliffe. *Internet Legal Forms for Business*. Menlo Park, CA: Ladera Press, 1997.

Crawford, Tad. *Business and Legal Forms for Fine Artists*. 4th ed. New York: Allworth Press, 2014.

Crawford, Tad. *Business and Legal Forms for Photographers*. 4th ed. New York: Allworth Press, 2009.

Crawford, Tad. *Legal Guide for the Visual Artist*. 4th ed. New York: Allworth Press, 1999.

Crawford, Tad, and Susan Mellon. *The Artist-Gallery Partnership: A Practical Guide to Consigning Art*. Rev. ed. New York: Allworth Press, 2008.

Crawford, Tad, and Kay Murray. *The Writer's Legal Guide*. 4th ed. New York: Allworth Press, 2013.

DeLaney, Chuck. *Photography Your Way: A Career Guide to Satisfaction and Success*. New York: Allworth Press, 2005.

DuBoff, Leonard D. *The Law (in Plain English) for Photographers*. 3rd ed. New York: Allworth Press, 2010.

Engh, Rohn. *Sell and Re-Sell Your Photos*. Cincinnati: Writer's Digest Books, 1991.

Engh, Rohn. *SellPhotos.com*. Cincinnati: Writer's Digest Books, 2000.

Farace, Joe. *The Photographer's Internet Handbook*. Rev. ed. New York: Allworth Press, 2001.

Frost, Lee. *Photos That Sell: The Art of Successful Freelance Photography*. New York: Watson-Guptill Publications, 2004.

Grant, Daniel. *The Business of Being an Artist*. 5th ed. New York: Allworth Press, 2015.

Heron, Michal. *Creative Careers in Photography: Making a Living With or Without a Camera*. New York: Allworth Press, 2006.

Heron, Michal, and David MacTavish. *Pricing Photography: The Complete Guide to Assignment and Stock Prices*. 4th ed. New York: Allworth Press, 2014.

Jacobs, Lou. *The Big Picture: The Professional Photographer's Guide to Rights, Rates & Negotiation*. Cincinnati: Writer's Digest Books, 2000.

Kieffer, John. *The Photographer's Assistant*. Rev. ed. New York: Allworth Press, 2000.

Krages, Bert. *Legal Handbook for Photographers: The Rights and Liabilities of Making Images*. 3rd ed. Amherst, NY: Amherst Media, 2012.

Leland, Caryn R. *Licensing Art and Design: A Professional's Guide to Licensing and Royalty Agreements*. Rev. ed. New York: Allworth Press, 1995.

Lilley, Edward R. *The Business of Studio Photography: How to Start and Run a Successful Photography Studio*. New York: Allworth Press, 2009.

Luna, Tony. *How to Grow as a Photographer: Reinventing Your Career*. New York: Allworth Press, 2006.

McDonald, Tom. *The Business of Portrait Photography*. Rev. ed. New York: Amphoto, 2002.

Photographers Market. 2017 ed. Cincinnati: Writer's Digest Books, 2016.

Piscopo, Maria. *The Photographer's Guide to Marketing and Self-Promotion*. 5th ed. New York: Allworth Press, 2017.

Platt, Harvey J. *Your Living Trust and Estate Plan: How to Maximize Your Family's Assets and Protect Your Loved Ones*. 5th ed. New York: Allworth Press, 2013.

——————. *Your Will and Estate Plan: How to Protect Your Estate and Your Loved Ones*. New York: Allworth Press, 2003.

Oberrecht, Kenn. *How to Start a Home-Based Photography Business*. 6th ed. Guilford, CT: Globe Pequot Press, 2010.

Rossol, Monona. *Overexposure: Health Hazards in Photography*. Rev. ed. New York: Allworth Press, 1991.

Schroeppel, Tom. *The Bare Bones Camera Course for Film and Video*. 3rd ed. New York: Allworth Press, 2015.

Sedge, Michael. *The Photojournalist's Guide to Making Money*. New York: Allworth Press, 2000.

Wexler, Ira. *The Business of Commercial Photography: A Professional's Guide to Marketing and Managing a Successful Studio, with Profiles of 30 Top Commercial Photographers*. New York: Amphoto, 1997.

Zimberoff, Tom. *Photography: Focus on Profit*. New York: Allworth Press, 2002.

INDEX

A

"About the Photographer," 107, 113
Adobe Photoshop, 32
Advertising Agencies, 92–93
Advertising Freelance, 93
aftermarket lenses, 44–45
Agency Access, 93–94
Agency Compile, 93
AgencyScoop, 93
AIGA, 94
Alien Bees, 42
American Arbitration Association, 280–281
American Photographic Artists (APA), 28,
 35, 327
American Society of Media Photographers
 (ASMP), 28, 33, 151, 211, 327
American Society of Picture Professionals
 (ASPP), 327
Anderson Ranch, 12
animal handlers, 319
Applied Arts, 96
apprenticeship
 assisting, 23–29
 freelancing and full-time assisting,
 23–25
 photographic assistant, 20–23
 and professional photography commu-
 nity, 23–25
architectural and interior photography, 30–31
architectural photography, 24
art advisor/curator/consultant, 314
art buyer, 306–307
art directors, 306
Art Directors Club (ADC), 327–328
Askinasi, Joseph, 79–80, 85
ASMP Code of Ethics, 325–326
ASMP Professional Business Practices in Photography, 155
assignment estimate/confirmation/invoice
 forms, 158–159, 164–165
assignment pricing
 creative fee, 179–180
 miscellaneous charges, 181
 noncreative fee, 180
 reimbursable expenses, 180–181
Assignment/Confirmation/Invoice, 201

assistants
 the crew, 317–319
 digital assistants, 316
 full-time professional assistants, 315–316
 importance of being on time, 315
 production assistants, 316–317
assisting
 full time, benefits of, 25–28
 taking advantage of what's available, 28–29
attitude and success, 8–10
attorney, finding
 finding the right attorney, 276
 informal referrals, 276–277
 lawyer referral services, 279
 lawyer's fees, 276–277
 legal clinics, 278
 professional associations, 278
 volunteer lawyers for the arts, 277–278
Avedon, Richard, 66, 289

B

babies and children photography, 31
baby wranglers, 319
bad debts, 238–239
Berne Convention Implementation Act
 (1989), 203–205
Better Business Bureau, 282
blogs, and marketing message, 108, 115–116
body position and posture, 81
book authors, as buyers, 309
Bordnick, Barbara, 108
bottom line, 50
Bourke-White, Margaret, 66
"burn out" avoiding, 294–295
Business and Legal Forms for Photographers (Crawford),
 158–163
business card, 69–70
business considerations, 47
Business Journal Book of Lists, 93
business licensing and registration, 62
business name, choosing, 66–67
business plan
 expansion, 53–54
 sources of funds, 51–53
 starting considerations, 49–50

"Business Plans," 54
business premises, privacy of, 255–256
business protection
 business properties, 75–76
 injured or sick "employees," 74–75
 injury to third parties, 74
business structures, 59–62
buyers, sellers and dealers
 art buyer, 306–307
 art directors, 306
 book authors, 309
 corporate communications directors, 307
 creative directors, 306
 editorial marketing staff, 308–309
 fine arts galleries and curators, 313–314
 graphic designer, 307
 location and support services, 314–321
 net content managers, 308
 photo editor, 307
 photo researcher, 307–308
 world of the photo buyer, 305

C

California Lawyers for the Arts, 328
call to alert and lead capture, 114
Canon, 44–45
career choices, 12–13
career of, 5–6
careers in teaching and writing
 photography educator, 321–322
 writing about photography, 322–323
Case of the Short Arm, 79–80
cash flow, 50
casting professionals, 318–319
catalog photography, 31–32
celebrity photography, 32
celebrity rights laws, 265
Chamber of Commerce, 282
Chamber of Commerce Directory, 93
charitable contributions, 238
child and disabled dependent care, 238
Chouinard, Yvon, 16–19
client trust and social media, 121–122
Clinton, Bill, 67
Code of Advertising, 272
coins, bills and stamps, 271
collection agencies, 279–280
collection procedures, 275
commercial photography, 13, 23–24
Communication Arts Annuals, 92
Communication Arts magazine, 96

compulsory licensing, 215
computer programs and computer-manipu-
 lated imagery, 32
computer work and health, 82–83
Constant Contact, 115
contact information, 107, 113–114
contract forms, 170
 assignment estimate/confirmation/
 invoice, 158–159, 164–165
 delivery memo, 161–162, 171–172
 license of rights, 162, 173–174
 model release, 162–163, 175
 portrait photography contracts, 168–169
 for sale of fine art photography, 161
 wedding photography contracts,
 159–160, 166–167
contracts, negotiating
 developing expertise in contracts, 151
 negotiating steps, 152–154
 using negotiation skills, 154–157
 What is a contract? 152
conversational marketing, 120–121
copyright
 assignments, 200–201
 benefits of registration, 209
 classroom exemption, 213–215
 contributions to magazines, 208–209
 definition of, 197
 duration of, 205–206
 electronic rights, 199
 fair use, 212–213
 infringement, 211–212
 material that isn't copyrightable, 215–216
 moral right, 215
 more information, 216–217
 notice of, 203–205
 patents and trademarks, 216
 prior copyright law, 216
 public domain, 205
 registering photographs, 209–211
 rights to copyrighted photographs, 198
 searching status of a work, 201–202
 termination of transfers, 206
 transferring limited rights, 199–200
 work for hire, 206–208
 works that are copyrightable, 197–198
Copyright Notice (US Copyright Office), 204
Copyright Registration for Works of the Visual Arts (US
 Copyright Office), 210
Copyright Transfer Form, 201–202
corporate clients (client direct), 93

corporate communications directors, 307
Corporate Communications Network, 93
corporate/industrial photography, 33
corporation, regular, 60–61
Council of Better Business Bureau, 272
Creative Ascent, 285, 288–285, 289
creative directors, 306
Creative Jobs, 94
crewmembers (assistants)
 baby wranglers and animal handlers, 319
 casting professionals, 318–319
 hair and makeup stylists, 319
 location scout, 317
 props and wardrobe buyers, 318
criminals and victims, 250
crowdfunding, 52
custom photo labs, 320

D

da Vinci, Leonardo, 290
deceptive advertising, 272–273
DeLaney, Chuck, 3
delivery memo, 161–162, 171–172
Deposit Requirements for Registration of Claims to
 Copyright in Visual Arts Material (US Copyright
 Office), 210
DesignFirms, 94
diet and nutrition, 84–85
digital assets, 70–71
digital images, marketing, 89–90
Digital Media Licensing Association (DMLA),
 37, 328
Digital Millennium Copyright Act (1998), 197
director of photography, 312
disability insurance, 77

E

eCO Online System (electronic Copyright
 Office), 210–211
Editor & Publisher Databook, 94
editorial marketing staff, 308–309
editorial/magazines/publications, marketing
 to, 93–94
editorial/photojournalism, 25, 33
education
 career choices, 12–13
 choosing a program, 13–19
 learning curves, 11–12
 value of, 11
 workshops, 12
education checklist, 14–16

Einstein, Albert, 42
Eisenstein, Sergei, 302
electronic rights, 199
email marketing, 114–115
equipment
 aftermarket lenses, 44–45
 choices and upgrades, 38–39
 lenses, 43–45
 lighting, 42
 packing tips, 46
 prime lenses, 44
 security tips, 45–46
 used equipment, 39–42
estimated tax payments, 239
event photography, 13
exercise, 85–86
"Expanding Your Business," 54
expansion needs, 53–54
Expense Ledger, 224
expenses
 educational expenses, 229
 entertainment and gifts, 232
 home studio, 227–229
 professional equipment, 229–230
 transportation, 231–232
 travel, 230–231
eyestrain, 83

F

Facebook, 66
fair use, 212–213
fashion and beauty photography, 33–34
Federal Trade Commission Act (1914), 272–273
Feldman & Associates, Inc., 307–308
fictional use, 247–248
"Finding Your Passion . . . Again and Again
 and Again," 285
fine art photography, 34
fine art photography, contract for selling, 161,
 170
First Amendment, 254
 advertising or trade purposes, 245
 editorial usage, 162–163
 and incidental advertising, 249
 libel, 265–266
 and obscenity, 269–270
 and public persons, 251–252
 trespass, 268
flags and protected symbols, 270–271
Form VA (United states Copyright Office),
 218–221

forms
 Expenses for Business Use of Your
 Home, 237
 Schedule C, 234–235
 Schedule C-EZ, 236
Fred Marcus Studio, 66
freelance and full-time assisting, 25–26
"Frequent Startup Questions," 54

G

Galella, Ronald, 244, 251
gallery owner/manager, 313
Gebbie Press All-In-One Directory, 94
Gentile, Charles, 267–268
gifts and estate taxes, 242
Godard, Jean Luc, 302
"Grand Unifying Theory," 13
Graphic Artists Guild, 94
graphic design firms, marketing to, 94–95
graphic designer, 307
Group Registration of Published Photographs (US
 Copyright Office), 211
growth, as a photographer
 creating the timeline, 286
 lessons learned, 291–292
 list of skills, 287–288
 lists of interest, 288–291
 making sense of inquiries, 292–293
 work-history and personal timelines,
 286–287

H

health
 body position and posture, 81
 Case of the Short Arm, 79–80
 dealing with heavy objects, 82
 diet and nutrition, 84–85
 emotional help, 86
 exercise, 85–86
 eyestrain, 83
 importance of, 79
 tabletop photography and health, 83–84
 travel and outdoor work, 84
 working at the computer, 82–83
heavy objects, dealing with, 82
historical photo archivist, 314
holding fee, 182
home page, 106–107, 112
HOW, 96
How to Depreciate Property (IRS), 229–230
How to Grow as a Photographer (Luna), 285

How to Shoot Great Travel Photos (McCartney), 30
How to Shoot Stock Photos That Sell (Heron), 176

I

"if onlys" fighting, 6–7
illustration/people for advertising photography,
 34–35
image
 business cards, 69–70
 choosing a name, 66–67
 creating a logo, 67–68
 digital assets, 70–71
 importance of design, 65–66
 letterhead, 70
 type fonts, 69
In Defense of Food (Pollan), 84
income, 226–227
Income Ledger, 224–225
informal referrals, attorneys, 276
infringement, of copyright, 211–212
Instagram, 66
insurance protection
 business protection, 74–76
 disability insurance, 77
 finding the right agent, 72–73
 importance of, 72
 life and accidental-death insurance, 77
 personal protection, 76–78
 personal umbrella policy, 77
 sickness and injury insurance, 76–77
 strategy for buying insurance, 73–74
Internal Revenue Service (IRS), 13, 50
International Association of Business Com-
 municators, 93
internet/intranet content managers, 308
investment sites, 52
investors, problems with, 51

J

Jordan, Michael, 67

K

Karsh, Yousuf, 66
Kaye, Danny, 5
Kieffer Nature Stock, 20

L

Lasser, J. K., 242
lawyer's fees, 276–277
lawyers for the arts, volunteer
 California Lawyers for the Arts, 277

Lawyers for the Creative Arts, 278
 Volunteer Lawyers for the Arts, 278
Lawyers for the Creative Arts, 328
lead-generation
 be consistent, 127–128
 being seen as resource, 124
 choosing right social networks, 123–124
 connection quality beats quantity, 126–127
 and driving visitors to lead capture system, 124–125
 importance of authenticity and being genuine, 125–126
 tips for improving, 122–123
learning communities, 16–19
learning curve, 11–12
lease, negotiating, 57–58
Legal Guide for the Visual Artist (Crawford), 58, 215, 217, 242
Leibowitz, Annie, 66, 108
lenses
 lens maximum aperture, 43
 renting, 43
 zoom lenses, 43–44
letterhead, business, 70
libel, 265–266
License of Rights, 162, 173–174, 201
life and accidental-death insurance, 77
lighting equipment, 42
Lilley, Ed, 176
limited liability company (LLC), 59, 61–62
limited partnership, 60
LinkedIn Groups, 93–95
loans, problems with, 51–52
location and leases, business, 56–58
location scout, 317
logo, creating, 67–68
loss or damage fees, 182–183

M

magazines, contributions to, 208–209
Mailchimp, 115
Maine Photographic Workshops (Now Maine Media Workshops), 12
"Managing Your Business," 54
Mann, Sally, 109
manufacturer's representative, 320–321
Marcus, Andy, 66
Marcus, Brian, 66
Marcus, Fred, 66
market research, primary, 91–95
market research, secondary, 95–96

marketing
 digital images, 89–90
 primary research, 91–95
 product leads, 96
 secondary research, 95–96
 stock photography, 90
 your message, 90–91
marketing and sale representatives, 311
Mastering Flash Photography (McCartney), 30
Mastering the Basics of Photography (McCartney), 30
McCartney, Susan, 30
McDearmid, Archie, 294–295
mediation and arbitration, 280–281
medical/scientific photography, 35
Meola, Eric, 108
message, marketing your own, 90–91
model release, 162–163, 175
montage, 302
multimedia options, 303
Music Labels & Publishers, 95

N

Nachtwey, James, 108
National Advertising Review Board, 272
National Advertising Review Council, 272
National Press Photographers Association (NPPA), 35, 329
National Trade and Professional Associations of the United States, 95
nature/wildlife/landscape photography, 35
negotiating contracts. *See* contracts, negotiating
negotiation skills, 154–157
New York, 246
New York World's Fair of 1964, privacy case, 267
news/sports photography, 35–36
Newsweek, 36
Nikon, 44–45
North American Nature Photography Association, 297, 329

O

obscenity, 269–270
Onassis, Jacqueline, 244, 251
opportunities in video and multimedia
 adding video to your work, 303–304
 bad video, 300–301
 considerations for, 301–302
 learning the basics, 302–303
 multimedia options, 303
 rising competition and falling rates, 304
 then and now, 299–300

organizations for photographers, 327–329
overhead, calculating, 189–190
 defining and calculating, 183–186
 personal needs, 186
 profit as overhead, 186–189

P

packing tips, equipment, 46
Palm Beach, 12
paper products/book publishers/trade maga-
 zines, marketing to, 94–95
Parks, Gordon, 109
partnership, 60
Patagonia, Inc, 16–19
patents and trademarks, 216
Paul C. Buff, Inc., 42
payment disputes, 274–275
Pei, I. M., 267–268
Penn, Irving, 66
People, 32
people and fashion photography, 24
permission form, copyright, 214
personal property insurance, 77
personal protection
 disability, 78
 sickness and injury, 77–78
personal umbrella policy, 77–78
Photo District News (*PDN*), 323
photo editor, 307
photo sellers, world of
 representative/marketing coordinator/
 creative management, 309–311
 stock photo agent, 311–313
Photogenic, 42
Photographer's Market, 94
photographic assistant
 benefits of, 22–23
 definitions of, 20–21
 responsibilities of, 21–22
Photographic Lighting Simplified (McCartney), 30
photographing in courtrooms, 273
photography
 attitude and success, 8–10
 as a career, 5–6
 as a creative outlet, 4
 and education for, 11–19
 finding your passion, 6
 nature of, 4–5
 negatives and "if onlys," 6–7
 as a passion, 3–4
photography dealer, 313

Photography Your Way: A Guide to Career Satisfaction and
 Success, 129–148
Photography Your Way (DeLaney), 3
Picture Archive Council of America (PACA), 37
Pinterest, 66
Piscopo, Maria, 86
Plateau of Mediocrity, 285
Playgirl, 253
Pollan, Michael, 84
"portfolio reviews," 100
portfolios
 choosing material for, 99–100
 defining, 98–99
 importance of planning, 104
 planning, 99
 showing commercial, 100–101
 steps for writing scripts, 102–104
 steps to showing, 102
 wedding and portrait, 101–102
portrait photography, 25
portrait photography contracts, 160, 168–169
portrait studios, 13
pricing factors
 market type (Client/Market), 191–192
 overhead, 192
 photographic elements, 192–193
 photos, value of, 190
 the salad test, 190–191
 usage needed, 192
 value to clients, 193–194
 value to you, 194
pricing photography
 assignment pricing, 179–181
 considerations for, 176–178
 day rate versus shooting time, 178–179
 overhead, 183–189
 pricing factors, 190–194
 stock pricing, 182–183
 wedding/portrait pricing, 176–177
Pricing Photography (Heron and MacTavish), 176
prime lenses, 44
privacy, 252–253
 advertising or trade purposes, 244–245
 business premises, 255–256
 bystanders at public events, 245–246
 considerations, 243
 criminals and victims, 250
 damages, 257
 dogs, horses, cars and houses, 253–254
 exhibition of photographs, 256–257
 fictional use, 247–248

incidental advertising uses, 248–249
and intrusion into private places, 254–255
parts of the body, 253
photographing in public places, 245
public disclosure of embarrassing private
facts, 249–250
public figures, 250–252
public interest, 245
releases, 257–260
right of, 243–244
stale news, 252
surveillance, 255
trespassing, 254
uses that are not related, 246–247
private property/buildings, privacy laws, 266–268
product photography, 24
Professional Photographers of America (PPA),
37, 329
professional photographic community
architectural photography, 24
commercial photography, 23–24
editorial photography and photojournal-
ism, 25
people and fashion photography, 24
product photography, 24
wedding and portrait, 25
professionalism, proving for tax purposes, 239–242
props and wardrobe buyers, 318
Public Broadcasting Service, 215
public domain, 205
public figures, 250–252
Publishers & Book Sellers Association, 95

Q

QuickBooks, 223
Quicken, 223

R

recognizable person, 252–253
Recordation of Copyright Transfers and Other Documents
(US Copyright Office), 201
Recordkeeping for Individuals (IRS), 224
records, taxes, 223–226
Regan, Ken, 32
registering photographs, 209–211
releases, 257–260
model release -long form, 262
model release -short form, 261
release -by owner of property, 263
representative/marketing coordinator/creative
managers, 309–311

reproduction, license or use fee, 182
requirement of relatedness, 245–246
research fee, 182
retail photography, 13
retail stores, 320
retirement accounts, 233–238
retoucher or digital artist, 320
right of publicity, 264–265
Ritts, Herb, 109
Rock and Roll Hall of Fame, privacy case, 267–268
Rogers, Will, 292

S

Salgado, Sabastião, 33, 109
Santa Fe Workshops, 12
SBA Answer Desk, 55
Scavullo, 66
Schedule C, beyond, 232–233
Schedule C, "Profit or Loss from Business,"
222–223
School of Hard Knocks, advantage of, 11
SCORE. *See* Service Corps of Retired Business
Executives (SCORE)
search engine optimization (SEO), 111–112
security tips, equipment, 45–46
self employment tax, 239
selling yourself
dealing with low-ball competitions,
147–148
how to, 131
importance of, 129–131
selling yourself, eight rules for, 134–135
Don't Forget to Ask for the Sale- the
Close, 138–142
Never Offer Anything "Free," 137
People Buy from People, 132
Prospect Must be Qualified, Listen to
Them, 134
Sell the Benefits, Not the Product, 137–138
Silence Can Be Golden, 135–137
Suspects Aren't Prospects, 132–133
selling yourself, tactics for
Tactic Five: Upsell Them, 146–147
Tactic Four: Have a Price Conditioner,
145–146
Tactic One: Don't Ask Yes/No Questions,
143
Tactic Three: Everyone Loves a Present,
144–145
Tactic Two: Use a Time Hammer,
143–144

Service Corps of Retired Business Executives (SCORE), 55
services, off the set, 319–321
set builders, 319
Shields, Brooke, 258
sickness and injury insurance, 76–77
Sigma, 44–45
Small Business Administration (SBA), 53–55
small claims courts, 281–282
Snapchat, 66
social media marketing, 108, 116
 and client trust, 121–122
 conversational marketing, 120–121
 growth in and need for, 117–119
 lead-generation, 122–127
 not broadcasting, 119–120
 as part of larger system, 127–128
Society for Photographic Education (SPE), 329
sole proprietor/sole proprietorship, 59–60
Sonny Bono Copyright Extension Act (1998), 197
specialities, photographic
 architectural and interior photography, 30–31
 babies and children, 31
 celebrities, 32
 computer programs and computer-manipulated imagery, 32
 corporate/industrial, 33
 fashion and beauty, 33–34
 fine art, 34
 generalists, 34
 illustration/people for advertising photography, 34–35
 medical/scientific photography, 35
 nature/wildlife/landscape photography, 35
 news/sports photography, 35–36
 still life and food, 36
 stock photography, 36–37
 studio portraiture, 37
 travel/location photography, 37
 wedding/event, 38
Sports Illustrated, 36
stale news, 252
Standard Directory of Advertisers, 93
Standard Directory of Advertising Agencies, 92
Standard Rate & Data Service, 94

Starting a Business and Keeping Records (IRS), 224
State Sales Tax Bureau, 63–64
staying fresh
 avoiding "burn out," 294–295
 join an association, 296–297
 return to film, 296
 self-assignment, 297–298
 take a class, 295–296
 take a photography class, 296
still life and food photography, 36
stock agency editors, 311
stock agency researchers, 312
stock photo agents, 311–313
stock photography, 36–37
Stock Photography Business Forms (Heron), 176
stock photography, marketing, 90
stock pricing
 holding fee, 182
 reproduction, license or use fee, 182
 research fee, 182
stock-photo producers, 312–313
studio portraiture, 37
stylists, food, 319
stylists, hair and makeup, 319
subchapter S corporation, 60
Sullivan, Frank, 222
surveillance, 255

T

tabletop photography and health, 83–84
Tamron, 44–45
tax years and accounting methods, 222–223
taxes
 bad debts, 238–239
 beyond schedule C, 232–233
 charitable contributions, 238
 child and disabled dependent care, 238
 estimated tax payments, 239
 gifts and estate taxes, 242
 helpful aids, 242
 income, 226–227
 proving professionalism, 239–242
 retirement accounts, 233–238
 sales and miscellaneous, 62–63
 self employment tax, 239
 tax records, 223–226
 tax years and accounting methods, 222–223
Technical Services Bureau of the New York Department of Taxation, 63

termination of transfers, 206
The Association of International Photography Art Dealers (AIPAD), 328
The Bare Bones Camera Course for Film and Video (Allworth Press), 303
The Business of Studio Photography (Lilley), 176
The Foundation Center, 328
The Photographer's Assistant (Kieffer), 20
The Photographer's Guide to Marketing and Self-Promotion (Piscopo), 86, 98–104
Time, 36
Tokina, 44–45
Total Cash, 224
Total Check, 224
Total Credit/Debit Card, 224
trade credit, 52
trademarks and patents, 216
transferring limited rights, 199–200
Travel, Entertainment, Gift, and Car Expenses (IRS), 229–232
travel and health, 84
Travel Photography (McCartney), 37
travel/location photography, 37
trespass, 268
trespassing, 254
Turner, Pete, 108
Twitter, 66
type fonts, choosing, 69

U

Uelsmann, Jerry, 108
undercapitalized, 50
unfair competition, 268–269
United States Copyright Office, 197, 201, 215, 217
Us, 32
used equipment, 41–42
 assessing, 40–41
 where to find, 40

V

Valley of Despair, 285
video, adding to your work, 303–304
video, bad, 300–301
video and multimedia, opportunities in. *See* opportunities in video and multimedia
video capture devices, 300–301
Visual Artists Rights Act (1990), 197
vitamins, and health, 85
volunteer lawyers for the arts, 277–278

Volunteer Lawyers for the Arts (VLA), 329

W

websites
 "About the Photographer," 107
 blogs, 108, 115–116
 building and hosting, 110–111
 contact information, 107–108
 first impression - home page, 106–107
 importance of, 105–106
 search engine optimizing and advertising, 111–116
 social media, 108, 116
 taking inventory of your site, 108–110
 viewing of work, 107
 web analytics, 111
websites, as marketing tools
 "About the Photographer," 113
 call to alert and lead capture, 114
 contact information, 113–114
 content marketing, 114
 email marketing, 114–115
 home page, 112
 portfolios, 112
Wedding and Portrait Photographers International (WPPI), 38, 329
wedding photography contracts, 159–160, 166–167
wedding/event photography, 13, 25, 38
"What Income is Taxable" (IRS), 226
White Lightning, 42
work for hire, 206–208
Workbook Directory, 93–94
workshops, 12
Writer's Market, 94
WritersNet, 94

Y

Your Federal Income Tax (IRS), 226, 242
Your Income Tax (Lasser), 242

Z

zoning, 56–57
zoom lenses, 43–44

BOOKS FROM ALLWORTH PRESS

The Art and Business of Photography
by Susan Carr (6 x 9, 256 pages, paperback, $24.95)

The ASMP Guide to New Markets in Photography
by Susan Carr (6 x 9, 304 pages, paperback, $24.95)

ASMP Professional Business Practices in Photography
by American Society of Media Photographers (6 x 9, 480 pages, paperback, $35.00)

Business and Legal Forms for Photographers, Fourth Edition
by Tad Crawford (8 ½ x 11, 208 pages, paperback, $29.95)

The Education of a Photographer
Edited by Charles H. Traub, Steven Heller, and Adam B. Bell (6 x 9, 256 pages, paperback, $19.95)

How to Create a Successful Photography Business
by Elizabeth Etienne (6 x 9, 240 pages, paperback, $19.95)

How to Grow as a Photographer
by Tony Luna (6 x 9, 224 pages, paperback, $19.95)

Mastering the Business of Photography
by Tony Luna (6 x 9, 208 pages, paperback, $19.95)

The Photographer's Guide to Marketing and Self-Promotion, Fifth Edition
by Maria Piscopo (6 x 9, 280 pages, paperback, $24.99)

The Photographer's Guide to Negotiating
by Richard Weisgrau (6 x 9, 208 pages, paperback, $19.95)

The Photography Exercise Book
by Bert Krages (7 ¾ x 9 ¼, 216 pages, paperback, $24.99)

Pricing Photography
by Michal Heron and David MacTavish (11 x 8 ½, 160 pages, paperback, $29.95)

Starting Your Career as a Freelance Photographer, Second Edition
by Tad Crawford and Chuck DeLaney (6 x 9, 272 pages, paperback, $19.99)

To see our complete catalog or to order online, please visit *www.allworth.com*.